THE ART OF BUDDHISM

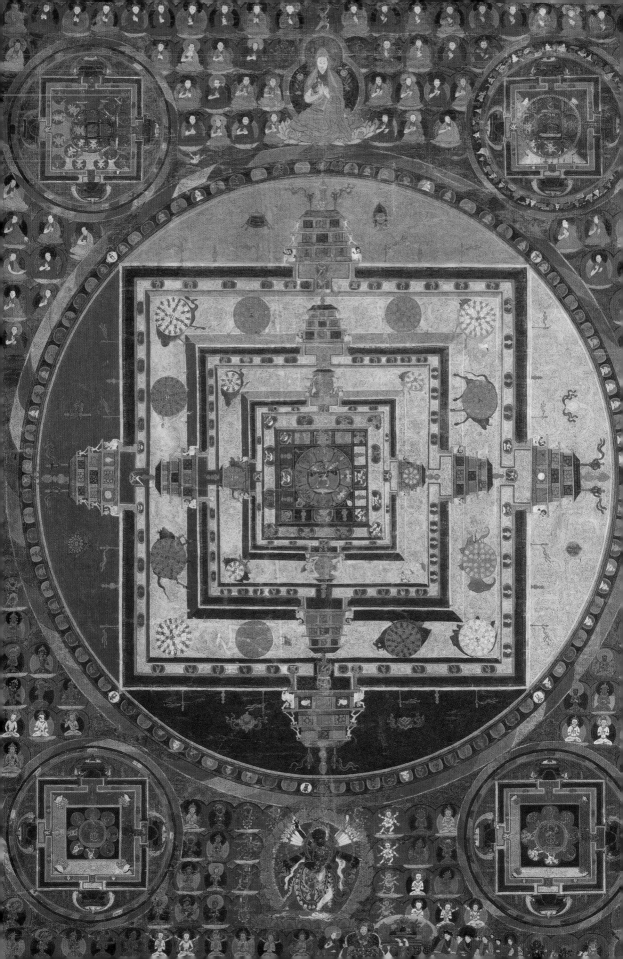

The Art of
BUDDHISM

AN INTRODUCTION TO
ITS HISTORY & MEANING

DENISE PATRY LEIDY

SHAMBHALA
BOSTON & LONDON
2008

Shambhala Publications, Inc.
Horticultural Hall
300 Massachusetts Avenue
Boston, Massachusetts 02115
www.shambhala.com

9 8 7 6 5 4 3

Design by Margery Cantor
Printed in China

♾ This edition is printed on acid-free paper that meets the American
National Standards Institute z39.48 Standard.
♻ Shambhala Publications makes every effort to print on recycled paper.
For more information please visit www.shambhala.com.

Distributed in the United States by Penguin Random House LLC
and in Canada by Random House of Canada Ltd

Library of Congress Cataloging-in-Publication Data
Leidy, Denise Patry.
 The art of Buddhism: an introduction to its history and meaning/
Denise Leidy.—1st ed.
 p. cm.
 Includes bibliographical references and index.
ISBN 978-1-59030-594-2 (hardcover)
ISBN 978-1-59030-670-3 (paperback)
 1. Art, Buddhist. 2. Buddhism and art. I. Title.
N8193.A5L45 2008
704.9′48943—dc22
2007044953

CONTENTS

ACKNOWLEDGMENTS

THIS BOOK reflects the vivacity of Buddhist studies over the past thirty years, and it owes a large debt to the scholarship of others, many of whom are acknowledged in the bibliography. I am particularly indebted to James C. Y. Watt and Miyeko Murase for their guidance throughout the course of my career; and to Steve Kossak, Willem Dreesmann, Masako Watanabe, Kurt Behrendt, and Soyoung Lee for valuable conversations during the writing of this book. (Thanks are also due to my husband John and son Alex for their fortitude.)

The patient and painstaking editing of David O'Neal, Katie Keach, and Gretchen Gordon; the design work of Margery Cantor; and the production and art supervision of Lora Zorian improved this book in many ways.

In addition, I would like to thank the many institutions and collectors that have allowed me to publish their wonderful objects and share them with others. Finally, I am deeply indebted to the Ars Longa Stichting Foundation of the Netherlands for their subvention of the costs involved in acquiring and publishing the illustrations in this survey of Buddhist art. I thank them for their generosity and vision.

INTRODUCTION

Siddhartha/Shakyamuni: His Lives and Teachings

BUDDHISM—which began with the life of one man, Siddhartha Gautama (revered today as Buddha Shakyamuni), and his austere emphasis on personal discipline and spiritual growth—remains the one complex of images and ideas that unites the Asian world. As it spread from India throughout Asia, Buddhism was adapted to different cultures; evolved into various practice traditions; and expanded to include celestial buddhas, savior bodhisattvas, and a marvelous assemblage of teachers and protectors.

Like others beings, at least according to a worldview prevalent in India for millennia, Shakyamuni endured many lifetimes, often taking the forms of animals or men. In each life, he practiced virtues such as compassion and generosity, accumulating the merit that would ultimately lead to his final rebirth, during which he became an awakened being or a buddha. (The understanding that past actions can determine a future life or lives is central to Indian thought and is generally termed *karma*.) In his penultimate lifetime, Shakyamuni was reborn as a prince named Vessantara. During that lifetime, he gave away his wife, his children, and an elephant thought to ensure the wealth of his kingdom. His unprecedented generosity led to his final life, during which he attained enlightenment.

Arguments continue regarding the date of Siddhartha's birth. Early scholars, relying on texts in Pali, accepted 563 B.C.E. Pali is a canonical language written in several scripts and thought to represent a homogenization of dialects spoken in India before and after Siddhartha's lifetime. However, recent studies based on archaeological evidence and Chinese texts, suggest a date between 485 and 450 B.C.E.

Siddhartha was the son of a woman named Maya and her husband, the ruler of a small polity in present-day Nepal. His miraculous birth from his mother's side was heralded with flowers raining from the sky and other auspicious signs, and the newborn infant promptly took four steps symbolizing his dominion over the cosmos. As was traditional, the young Siddhartha was taken to a soothsayer, who foretold his future as either a world ruler or a great teacher.

Not surprisingly, Siddhartha's father and aunt (his mother died soon after his birth) attempted to ensure that he became a ruler rather than a teacher. The boy was raised in a palatial environment, engulfed by worldly goods and pleasures, and protected from the harsh realities of daily existence. Nonetheless, during an excursion (or in some texts, several excursions) from his royal compound, he encountered sickness, old age, and death, and also saw one of the ascetic wanderers who were prevalent in India at that time. Shaken, the young prince understood that life is filled with inescapable change and suffering, and he subsequently fled from his home, leaving behind his beautiful young wife and newborn son, in an attempt to penetrate more deeply into the meaning of existence.

Siddhartha lived during a time of great social turmoil, when an agricultural lifestyle was being replaced by an urban, mercantile society; challenges to the prevailing beliefs and practices, which included ceremonial sacrifices to a host of gods performed by members of a hereditary caste, were widespread. The wanderer Siddhartha had seen during his crucial excursion(s) outside the palace was one of many such figures, who were known as *parivajrakas;* they left their homes to seek spiritual salvation and were supported by alms. Siddhartha studied with several of the more famous of these wanderers and also spent six years with five of them practicing harsh austerities, such as only eating one grain of rice per day. Finally, when he was near death, he realized that he had not yet attained the enlightenment he sought. He accepted milk from a young woman (which caused him to be rejected by his fellow ascetics), sat beneath a pipal tree, and vowed not to move again until he had attained awakening.

Despite repeated attempts by negative forces such as fear or discontent (symbolized by the semidivinity Mara and his minions), Siddhartha persevered, meditated, and ultimately became a buddha (one who is awakened) in one evening. He recollected not only his own past lives but also those of others, understood the relationship between causes and actions, and became omniscient. After his

awakening, he spent about seven weeks meditating before he decided to teach others what he had learned. His first sermon, given at Sarnath, transformed the lives of the five ascetics who had previously rejected him, and they become his first followers.

The greater understanding that Siddhartha achieved is often termed the Four Noble Truths: existence is fundamentally painful, this pain is the result of the desire (or thirst) for things and states of beings, this pain can be relieved, and an Eightfold Path of practice and understanding is the cure. The Eightfold Path—right view, right thought, right speech, right action, right livelihood, right effort, right mindfulness, and right concentration—guides practitioners through several lifetimes (ideally as human beings) and helps them gain enough merit to finally escape the endless circle of birth and rebirth into a transcendent state of being known as nirvana. Underlying this path are practices such as morality (*shila*), spiritual wisdom (*prajna*), and meditation (*samadhi*), and virtues such as generosity, knowledge, and compassion, which provide the foundation for all branches of Buddhism, even those that developed centuries after Siddhartha became enlightened.

The Buddha's charisma and the depth of his understanding quickly attracted an additional fifty-five disciples, who were known as both *shravakas,* those who listen to the teachings, and arhats, those who have heard and understood the teachings and have advanced on the path to enlightenment. He spent approximately forty-five years walking through northern and northeastern India and teaching a wide range of individuals. During this time, Shakyamuni met periodically with different groups of his followers—often during the rainy season—to recite the teachings and the rules of the order and to discuss transgressions of these rules. At least twenty rainy seasons were spent in a pleasure garden in the kingdom of Koshala that had been bequeathed to the order by a wealthy lay follower. It seems likely that devotions of some sort, such as offering flowers to Shakyamuni, were part of the practice at the time.

When he was around eighty, Shakyamuni ate poorly prepared or spoiled food, possibly pork or truffles, and died lying on his side in a grove of trees near Kushinagara, a moment that is known as his final transcendence (*parinirvana*) because he would no longer suffer rebirth in any form. His corpse was cremated seven days after his death, and the remains were divided among the rulers of ten kingdoms and placed beneath large domed structures made of earth or brick that are known as stupas. Devotion to these relics,

which involved pilgrimage between the various sites that held them, was an important aspect of early practices because the relics were understood to contain the essence of the Buddha and his teachings.

His death spurred discussions in the sangha (those of his followers who had taken monastic vows) regarding how to maintain the teachings in the absence of the master, and a council of five hundred learned disciples was convened in Rajagriha to address the future of the order. Despite grumblings from some members, the council decided to adhere to the teachings and practices established by the Buddha. Two other such meetings—one held around 345 B.C.E. at Vaishali and another thirty-seven years later at Pataliputra—focused on rules of behavior, especially minor infringements such as handling money or eating after midday. The latter meeting was held under the auspices of Ashoka (r. 269–232 B.C.E.), ruler of the extensive Mauryan Empire, who is credited with helping to spread Buddhism throughout India as well as into Southeast Asia.

This council marked the first formal division of the order, which had by that time grown substantially and divided into branches (some small) called *nikayas*. Differences regarding the proper behavior of a monk led to a split between a more conservative group known as the Sthavira—thought to be the precursors of the current Theravada tradition—and a larger constituency known as the Mahasanghika, whose redefinitions of the rules of order reflect the development of changes in practice that led to the creation of new branches of Buddhism (now known as Mahayana and Vajrayana) during the first half of the first millennium.

Texts also record that another council was convened in the second century by Kanishka, one of the most powerful rulers of the Kushan Empire (second century B.C.E. to third century C.E.), which included Afghanistan, Pakistan, and much of northern India. Both Ashoka and Kanishka are revered in Buddhist sources as devoted patrons of the religion; the period between their reigns saw the flowering of texts and images that provide the principal sources for the study of Buddhism today. The Buddhist canon (known as the *tripitaka*) contains more than two thousand texts and includes records of the teachings of Buddha Shakyamuni; commentaries (*shastras*); rules for monastic discipline; metaphysical speculations on existence and reality; and biographies of Shakyamuni, monks, and other devotees. Many texts are preserved in different versions, and they are recorded primarily in Pali, Chinese, and Tibetan. (Not every text is found in all three languages.) The Pali canon serves as

the basis of practice in Sri Lanka and mainland Southeast Asia; Chinese is used in Korea and Japan.

Unlike the Pali version, the Chinese and Tibetan canons contain texts known as tantras (the Sanskrit *tantra* means "woven" or "fabric"). These texts include meditations and visualizations focusing on a mind-boggling array of tutelary and protective figures who are thought to be able to overcome obstacles quickly and help one attain awakening in a single lifetime. The writing and mastery of texts is a monastic practice limited to a small number of scholarly clerics, who specialized either in the writings of a particular tradition or in a group of related works. It is unlikely that many individuals have been completely versed in all Buddhist writings.

Based to a greater or lesser degree on the written word, artistic traditions have encapsulated Buddhist thought, making it accessible to viewers who often—particularly in earlier centuries—did not share the literacy found in monasteries. Visual narratives detailing the lives of Shakyamuni and other advanced practitioners and teachers show a paradigm of a life lived according to Buddhist tenets. Stupas, cave sanctuaries, and monasteries provide sanctified places for meetings between devotees and awakened beings who are either immanent as relics or accessible in symbols such as sculptures. Paintings, sculptures, and other objects thought to embody the wisdom of the Buddha and his followers provide both a focus for devotion and a visual definition of the ineffable state of being that is enlightenment. Other icons, such as images of bodhisattvas and protectors or portraits of teachers, illustrate the continuing presence of role models and helpers in all Buddhist traditions.

Intended as an introduction for general readers and undergraduate students, this book discusses the spread of Buddhism throughout Asia and traces the evolution of Buddhist art from its inception during the reign of Ashoka to the nineteenth century. It focuses on the dialogues between cultures that underlie the dissemination of Buddhism and on the fascinating interplay of ideas, practices, and images that mark the religion's development. This volume also stresses the importance of visual culture in understanding the history of Buddhist thought.

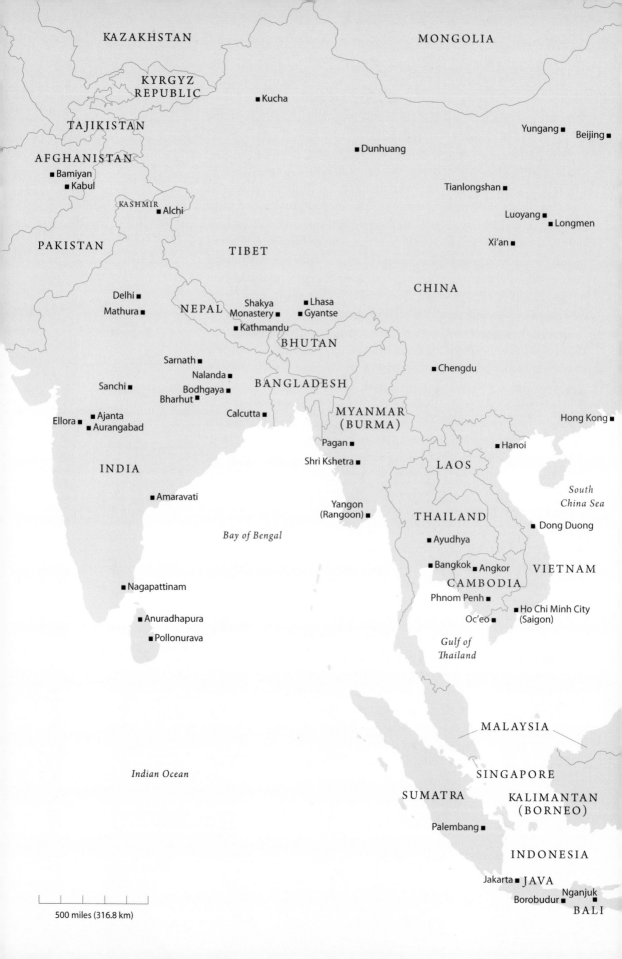

KAZAKHSTAN

MONGOLIA

KYRGYZ
REPUBLIC

■ Kucha

Yungang ■ ■ Beijing

TAJIKISTAN

AFGHANISTAN

■ Dunhuang

■ Bamiyan
■ Kabul

Tianlongshan ■

KASHMIR ■ Alchi

Luoyang ■ ■ Longmen

PAKISTAN

TIBET

Xi'an ■

CHINA

Delhi ■

NEPAL

Shakya ■ Lhasa
Monastery ■ Gyantse

Mathura ■

■ Kathmandu

BHUTAN

Sarnath ■

■ Chengdu

Sanchi ■

Nalanda ■

BANGLADESH

Bodhgaya ■

Bharhut ■

Ellora ■ ■ Ajanta
■ Aurangabad

Calcutta ■

MYANMAR
(BURMA)

Hong Kong ■

Pagan ■

■ Hanoi

Shri Kshetra ■

LAOS

INDIA

Amaravati ■

South
China Sea

Yangon
(Rangoon) ■

THAILAND

■ Dong Duong

Bay of Bengal

■ Ayudhya

VIETNAM

■ Bangkok ■ Angkor

Nagapattinam ■

CAMBODIA

Phnom Penh ■

■ Anuradhapura

■ Ho Chi Minh City
(Saigon)

Oc'eo ■

■ Pollonurava

Gulf of
Thailand

Indian Ocean

MALAYSIA

SINGAPORE

SUMATRA

KALIMANTAN
(BORNEO)

Palembang ■

INDONESIA

Jakarta ■ JAVA

 Nganjuk

Borobudur ■ Nganjuk ■

BALI

500 miles (316.8 km)

Sea of
Japan

NORTH
KOREA

■ Pyongyang

JAPAN

■ Seoul

■ Tokyo
■ Kamakura

■ Mt Hiei
Kyoto ■
■ Nara

Yellow
Sea

■ Seokguram

SOUTH
KOREA

■ Kongwangshan

■ Shanghai
■ Hangzhou

TAIWAN

Pacific Ocean

PHILIPPINES

IRIAN JAYA

PAPUA NEW GUINEA

SULAWESI
(CELEBES)

AUSTRALIA

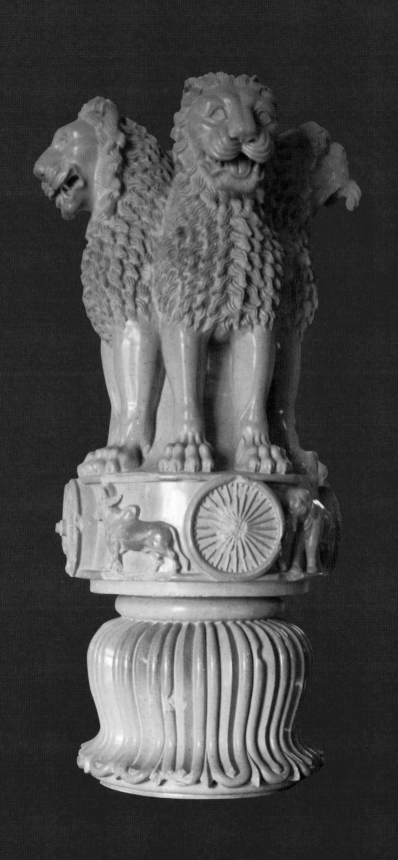

CHAPTER 1

Pillars and Stupas
Second Century B.C.E. to Third Century C.E.

WORDS INCISED into rocks and pillars provide the first visual evi-
dence for the practice of Buddhism in India. They were carved at the
behest of Ashoka (r. 269–232 B.C.E.), the powerful third ruler of
the Mauryan dynasty (323–185 B.C.E.). He controlled an empire (the
largest until British rule) that ranged from Bangladesh in the east to
Afghanistan in the north and included much of the southern part of
the subcontinent. The impact of Ashoka's adoption of Buddhism is
often likened to that of the Roman emperor Constantine's accep-
tance of Christianity in 312 C.E. One of the most famous rulers in
Indian history, Ashoka's decision to promote Buddhism and govern
according to religious principles stemmed from his dismay at the
destruction and bloodshed wrought by his conquest of the eastern
coastal regions in 267 B.C.E.

 Ashoka sought to rule according to virtues such as generosity,
patience/tolerance, and vigor that encompassed his understanding
of the dharma. (The word *dharma* is used to describe both the
teachings of the Buddha and their underlying moral laws.) He tried
to improve his subjects' lives in order to free them to follow spiritual
pursuits by founding hospitals, opening wells and rest stations for
travelers, and other similar acts. Ashoka instituted pilgrimages
to sites that were important in the life of Siddhartha Gautama,
the historical Buddha Shakyamuni, and sent missionaries to the
southernmost reaches of the subcontinent, Sri Lanka, and other
parts of Southeast Asia, as well as—without any apparent effect—to
points west such as Syria, Libya, and Macedonia.

 In 254 B.C.E., he had fourteen edicts on topics related to the
dharma carved on rock faces in public areas throughout his empire
and instructed officials to read them during festivals. Edicts placed
at sites on the subcontinent were written in Brahmi, while the one

FACING PAGE
*Detail of a capital
from a column.*
See page 11.

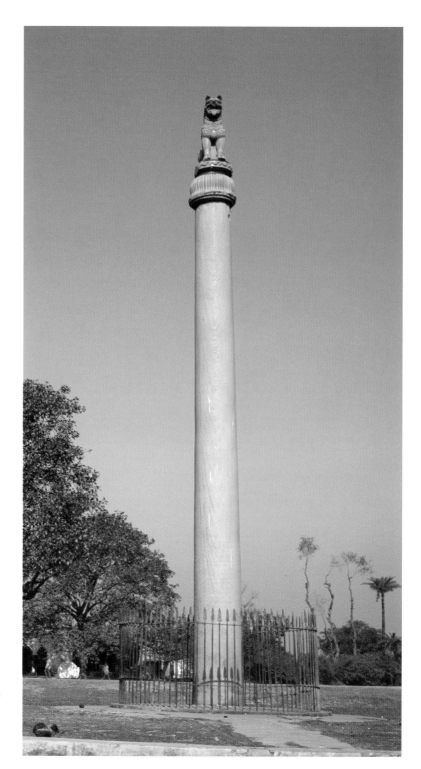

FIGURE 1.1
A Column.

India, Bihar, Lauriya
Nandangargh, Mauryan period,
third century B.C.E. Inscriptions
on towering pillars such as this
urged the nobility and the
populace to better behavior as
defined by the emperor Ashoka.

found at Kandahar in Afghanistan was presented in both Greek and Aramaic. Seven additional edicts promulgating Buddhist virtues and behaviors were later carved into towering pillars, some of which had been erected by Ashoka's predecessors. Others were newly created, carved from tan sandstone quarried from Chunar near the capital of Pataliptura, and placed in locations pertinent to the life and teachings of Shakyamuni.

The column [1.1] erected at Lauriya Nandangargh around 242 B.C.E. is typical. It stands thirty feet high and consists of a long shaft that tapers slightly at the top and a bell-shaped capital decorated with a lion resting on its haunches. Four lions are placed back-to-back on the seven-foot capital [1.2] that once adorned a similar column (now destroyed) built slightly earlier at Sarnath, the site of Shakyamuni's first teaching. A large wheel, a traditional symbol of rule that is synonymous with the act of teaching—known as "turning the wheel of the law"—once rested above the lions. Emblems of royal power and prestige, lions are sometimes identified as references to the historical Buddha, who was at times known as the "lion of the Shakya clan."

A lion, an elephant, a bull, and a horse, separated by smaller wheels, decorate the plinth of the capital, which rests on an inverted bell-shaped base. They may be directional images illustrating the extent of Ashoka's empire and his desire to spread the dharma throughout the world. The exuberant stylized manes, grinning faces, and rigid postures of the lions seated on the capital contrast with the softer, more modeled forms of the smaller animals walking on the plinth. This disparity attests that nonnative artists, presumably from either Iran or colonial Greece, worked for the cosmopolitan rulers of the Mauryan dynasty. The stylization of the lions reflects outside influences, while the naturalistic rendering of the smaller animals illustrates indigenous taste. The use of stone as a building material, which began with the Ashokan columns, is also attributed either to an awareness of other traditions or to the presence of foreign-trained artists on the subcontinent.

Many of the inscriptions on the columns record Ashoka's use of Buddhism to legitimize his rule and unify his realm. Others that stress proper behavior and the possibility of rebirth in a heaven are the earliest surviving compositions by a layman. They provide interesting insights into the practice and understanding of Buddhism beyond the confines of monastic establishments: "Man is unstable in his wishes and unstable in his likings . . . Even for a person to

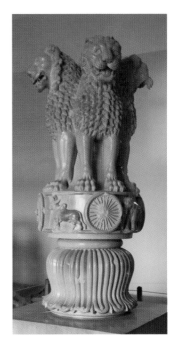

FIGURE 1.2
A capital from a column.
Sarnath, Uttar Pradesh, India, Mauryan period, mid-third century B.C.E. Lions were symbols of royalty in India and western Asia. In Buddhist art, they also serve as references to Shakyamuni and, by extension, to the achievement of enlightenment.

whom lavish liberality is impossible, the virtues of mastery over the senses, purity of mind, gratitude, and fidelity are always meritorious."[1]

The texts composed in monastic environments, on the other hand, are more scholarly works, such as commentaries on sutras or metaphysical analyses regarding the nature of existence and its multitudinous components. Others record the rules regulating the more rigorous lifestyles of monks and nuns.

Laypeople accrued merit by supporting monks and their practice. Lay patronage helped to build the first Buddhist monasteries, which in many cases evolved from residences constructed to house monks during the monsoon seasons when the peripatetic lifestyles espoused by Shakyamuni became difficult and possibly perilous. In addition to practicing generosity through their support of the clergy and thereby gaining the merit necessary for spiritual development, laypeople lived virtuous lives that followed, at a minimum, five precepts: refraining from harming living creatures and from taking what is not given, and avoiding sexual misconduct, false speech, and intoxicants. Monks, on the other hand, gained merit by teaching others about Buddhism and more prosaic skills such as writing and by their practice of meditation and other disciplines. Monasteries were also centers for the study of various disciplines, including medicine, thereby helping others in a more tangible fashion. Both laypeople and monastics assembled to practice together at selected points during the year, and laypeople frequently followed monastic rules at such times.

Devotees continued to support the building of monuments after the dissolution of the Mauryan Empire. The Shungas, who controlled much of north and northeast India during the second and first centuries B.C.E., were one of the many groups that rose to power during this period. First constructed during Ashoka's reign, possibly as part of the mythical eighty-four thousand he had built, the stupas at Bharhut and Sanchi [1.3, 1.8] were expanded and refurbished by the Shungas. Inscriptions at both sites indicate that this was a haphazard process, with monks and nuns, merchants (some of whom had traveled great distances to reach the site), craft guilds, and others contributing certain architectural elements or images to the monuments.

Stupas, which derive from pre-Buddhist traditions, are semicircular burial mounds covering the remains of a great leader or teacher; they are comparable in many respects to the barrows of the

Celtic world and the kurgans of Central Asia. Although inaccessible, they often contain a pillar to mark the location of relics, which are generally buried in an underground chamber at the center of the structure. Texts record that Shakyamuni's relics were divided after his final transcendence (*parinirvana*) and placed under stupas, as were those of other early Buddhist practitioners. Over time, the understanding of relics expanded to include corporeal remains, objects used by enlightened persons, and other articles that symbolize the immanence of the Buddha and his teachings. Stupas symbolize his *parinirvana,* at which point he escaped from the cycle of reincarnation. However, it is the relics rather than the monuments that embody and continue the Buddha's spiritual essence or charisma and that are the focus of devotion at such sites. Pilgrimage played an important devotional role in early and later India, and stupas were also the sites of festivals, which would have included music, dance, and drama.

Now largely destroyed, the brick stupa at Bharhut [1.3] in Madhya Pradesh in northern India once stood sixty-six feet high and was encircled by an eighty-eight-foot railing. Four towering gates marked the cardinal directions. The railing, part of which still stands, defined the enclosure as a sacred space and created a path for the clockwise circumambulation between the railing and the stupa that was the principal form of worship at the site. The post-and-lintel–like construction and the jointing of the stone railings and gateways derive from wooden architectural traditions. The stupa at Bharhut was undecorated, but a host of images—including those from tales of Shakyamuni's previous incarnations, known as *jatakas,* and stories of his final existence and teaching career—embellishes the back and front of the gateway and railing fragments.

A figure carved in high relief and standing at the front of one of the railings encircling the monument [1.4] is one of a group of apotropaic figures known as *yakshas.* Originally local deities associated with potent or sacred sites, *yakshas* and their female counterparts (*yakshis*) evolved to become supernatural protectors of the earth and its treasures; they were thought to influence such perennial human concerns as fertility, wealth, and health. *Yakshas, yakshis,*

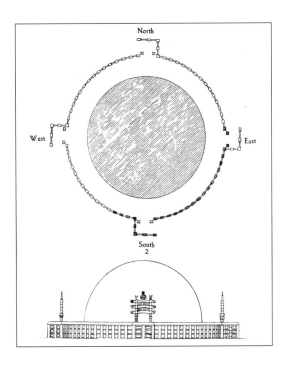

FIGURE 1.3
The plan and elevation of the Bharhut stupa.
Madhya Pradesh, India, Shunga period, second century B.C.E.

and other such figures are found on both Buddhist and Hindu monuments and in all periods of Indian history. They illustrate the persistence of widespread chthonic traditions that provided the background for the development of Indian religious thought.

A nearby inscription identifies the figure as Kubera, the leader of these earth spirits and the focus of individual devotion as early as the third or second century B.C.E. He and the two other figures on the side and back of the pillar are identified as the gifts of a person named Buddharakhita, who had abandoned attachment. Kubera, like all *yakshas,* is represented as a strong young man and wears the elaborate turban and elegant jewelry of a young aristocrat, or possibly a wealthy merchant. A transparent, saronglike garment, known as a *dhoti,* falls below his knees, has a long pleat in the center, and is covered with a thick sash at the hips. The precision used to define the drapery folds and elements of the jewelry provides an interesting counterpoint to the softly rounded torso, arms, and legs. This interest in detail and the shallowness of the relief may derive

FIGURE 1.4
Yaksha Kubera and Yakshi Chanda.

Detail from the east gate, Bharhut Stupa, Madhya Pradesh, India, Shunga period, second century B.C.E. Representations of young, fertile men and women, emblematic of the powers of the earth, play an important role in all Indian religious traditions, including Buddhism.

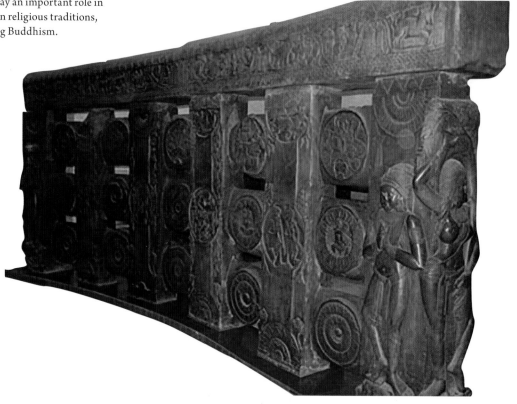

from ivory carving; craftsmen trained in that material were most likely recruited to work in the relatively new medium of stone.

Chanda, the voluptuous *yakshi* on the right of the pillar, is also identified by the inscription. Scantily clad, she wears two thick necklaces; a sash of pearls or beads; and a heavy, jeweled girdle. Her long hair is braided and covered with a decorative cloth. She reaches up to grab the branches of the tree protecting her head, a reference to longstanding Indic beliefs regarding the ability of a beautiful woman to bring a tree into bloom with her fertile touch. Chanda stands on the back of a camel, and Kubera is atop a crouching dwarf. These images provide some of the earliest examples of the practice of assigning such creatures to serve as vehicles for gods. In later traditions, including Buddhist ones, both bestial and humanoid vehicles help distinguish divinities from one another.

Shakyamuni is not shown in human form in any of the reliefs preserved from the stupa at Bharhut or from the slightly later monument at Sanchi. Instead, he is symbolized by such objects as a throne, a tree, a wheel, or footprints. It is not clear why the Buddha is not represented in human form in early Buddhist art, and the issue has long been the subject of debate. It is possible that showing Shakyamuni as human was thought to lessen his achievement of enlightenment when he transcended mortal concerns after 549 incarnations. His unseen presence may have been deemed more potent than the guise of an ephemeral human being.

Often known as the Great Departure, Siddhartha's leave-taking from his palace in order to seek understanding, one of the more important moments in his final lifetime, is shown on the front of a railing pillar [1.5] from Bharhut that is now owned by the Norton Simon Foundation. The narrative reads from top to bottom. At the top, two women, possibly semidivine, stand on lotuses in a palace-like setting. A small footprint at the to the lower right represents Siddhartha as he is leaving the palace complex. In the following scene, the groom Chandaka leads a riderless horse that also symbolizes Siddhartha. Four columns, presumably representing outer walls or gates, create a break in the narrative, and the back of a horse, placed beneath these pillars, illustrates Siddhartha's exit from the family compound. Two figures stand at the bottom of the pillar: one is playing a two-sided drum, and the other holds his hands in a gesture of respect (*anjali mudra*). The same gesture is also used by several of the ancillary figures in the composition. They may represent divinities or semidivinities celebrating Siddhartha's decision to

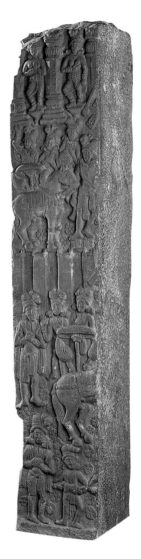

FIGURE 1.5
Siddhartha's Great Departure from his home and family.

Detail from a railing pillar, Bharhut Stupa, Madhya Pradesh, India, Shunga period, second century B.C.E. The Buddha is shown as a horse without a rider in this early narrative illustration of a moment from his final lifetime.

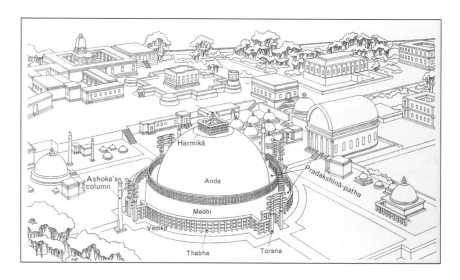

FIGURE 1.6
*A reconstruction of
the Sanchi complex.*

Madhya Pradesh, India, Shunga
period, first century B.C.E. to first
century C.E.

seek awakening, become the Buddha Shakyamuni, and ultimately
provide a path for others.

The Great Stupa, or Stupa 1, at Sanchi in Madhya Pradesh is
similar in structure to the one at Bharhut. Strategically located at
the confluence of several trading routes, the Sanchi complex [1.6]
contained an Ashokan pillar set in front of the Great Stupa, other
buildings erected during Ashoka's reign, stupas marking the remains
of some of Buddha Shakyamuni's disciples, and several edifices that
were built later. During the Sunga period, the Great Stupa was
enlarged to its present diameter of 120 feet [1.7]; the brick dome was
covered with stone, and the balcony, three umbrellas at the top, and
the stone railing were added. The umbrellas are sometimes inter-
preted as symbols of the Buddha, his teachings (dharma), and the
community of monks (sangha)—the traditional three jewels
(*triratna*) of Buddhism. (Taking refuge in the three jewels is the first
vow of a Buddhist, and one that is continually reaffirmed.) Four
magnificent stone gateways, each about thirty-five feet high, were
also built, probably sometime in the first century B.C.E., although
some art historians argue that they came a century later.

As at Bharhut, auspicious emblems such as *yakshas* and *yakshis,*
elephants and lions, and densely peopled narratives depicting
moments from the past lives and final life of Shakyamuni cover the
gateways at Sanchi. The images are found on all four sides of the pil-
lars, as well as on the front and back of the crossbars, which terminate
in curvilinear forms. (The shape may reflect the existence of a type
of scroll painting that is no longer known in India.) Clergy and laity

supported construction at Sanchi, with individuals and groups paying for selected motifs and scenes. The organization of the images reflects this style of patronage. Shakyamuni's lives are presented randomly rather than in a chronological or biographical sequence. Scenes from his past lives are interspersed with those illustrating his final life and teaching career and a few that tell the story of Ashoka's devotion to the Buddha. Certain events are depicted more than once, suggesting that they may have been particularly popular during the period when the gateways were built and decorated.

For example, the *jataka* that tells the story of the Buddha in his life as the six-tusked white elephant king Chaddanta is found on three of the four gateways. During that lifetime, Shakyamuni lived peacefully with his two wives and a prosperous herd of eighty thousand. One day he unknowingly caused blossoms from a *sal* tree to fall gently on his older wife. Enraged by this auspicious event, the jealous younger wife prayed for revenge. She was reborn as a queen in Benares, and in that lifetime asked her husband for some ivory. The king dispatched hunters to find Chaddanta, kill him, and acquire his tusks. Although the hunt was successful, the hunters could not remove the six magical tusks. When she was informed of

FIGURE 1.7
Stupa 1 (Great Stupa).
Sanchi, Madhya Pradesh, India, Shunga period, first century B.C.E. to first century C.E. The relics buried beneath the towering mound, not the monument, are the focus of devotion.

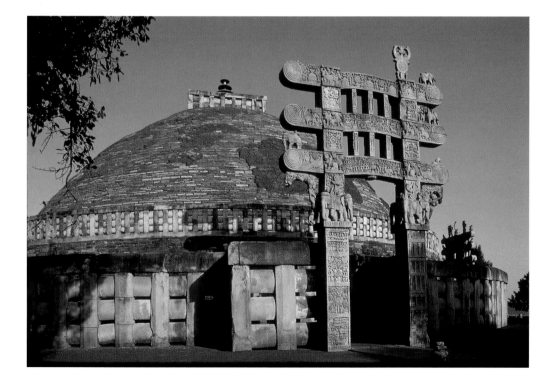

this development, the queen remembered her earlier life and, filled with grief at the consequence of her thoughtless actions, died:

> His tusks no sooner did she see—
> Her own dear lord of old was he—
> Than straight her heart through grief did break
> And she, poor fool, died for his sake.[2]

The queen in question was also reborn during Shakyamuni's final lifetime when she practiced austerities and meditated in an attempt to become more spiritually advanced. Siddhartha recognized her and used the story of their former lives to teach others the consequences of past actions. As is the case with all of the *jatakas,* the narrative is designed to reinforce specific virtues—in this case, moral or proper behavior, which must be cultivated in the quest for awakening:

> When he, almighty and all wise,
> Broke into smiles before their eyes,
> Straightway these holy Brethren thought,
> Sure Buddhas never smile for nought,
>
> "She whom you used to see," he said,
> "A yellow-robed ascetic maid,
> Was erst a queen and I," he cried
> "Was that king elephant who died."
> .
> "That elephant of long ago
> Was I, the king of all the band,
> And, Brothers, I would have you so
> This Birth aright to understand."[3]

One version of the *Chaddanta jataka* covers the backside of the central crossbar on the south gate at Sanchi. Chaddanta's life in the jungle is shown at the beginning of the narrative, which is read from left to right. In the detail reproduced here [1.8], he stands to the left of a banyan tree, bathing in a lotus pool with his herd. In the next scene, Chaddanta, identified by his six tusks, walks toward the right with his family. His attendants carry an umbrella and a flywhisk to symbolize his rank. In the last scene, the six-tusked elephant faces left, away from the partially hidden hunter holding a bow and arrow,

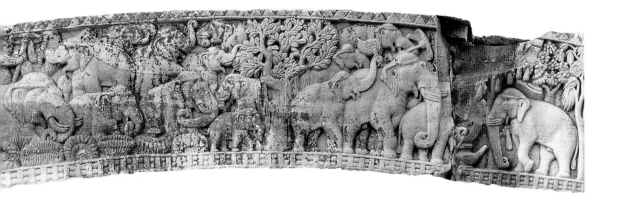

who will soon end the Buddha's existence in that form. The end of the story is not depicted but was presumably known to viewers.

Repetition of the central character and changes in direction from left to right are also used in the depiction of Siddhartha's Great Departure found on the front face of the central architrave of the east gate [1.9]. Like the scene at Bharhut discussed earlier [1.5], this one begins in Siddhartha's palace, which is a multistoried building with numerous arched windows and balconies. Once again, a horse and umbrella symbolize Siddhartha's presence. The horse is shown five times in the narrative, first leaving the palace and then in the next two scenes in which four figures lift the hooves, a reference to the earth spirits who carried the horse out of the compound to prevent his hooves from making any sound and alerting others who might prevent Siddhartha from leaving. The fourth image stands before two large footprints and an umbrella that represents the moment when Siddhartha dismissed his horse and groom and began his journey toward enlightenment. The fifth is the only depiction in which the horse is shown facing left. He lacks the royal umbrella because his master is no longer with him as he returns to the palace.

Brief inscriptions, possibly intended to help literate monks guide a viewer around the monument, identify the scenes at Bharhut. Those at Sanchi, which is also meant to be circumambulated, have no inscriptions, possibly because the stories illustrated had become widely known. At both sites, the emphasis is on the temporary appearance of a being in search of awakening and his actions in that quest. The *jatakas* and final life story recount the moral actions that led to Shakyamuni's enlightenment over numerous lifetimes. It is the actions, the virtues that underlie them, and their consequences that are stressed, not the historical sequence or a set of immutable facts.

FIGURE 1.8
Siddhartha's life as the elephant Chaddanta (Chaddanta jataka).

Detail from a crossbar, south gate, Stupa 1, Sanchi, Madhya Pradesh, India, Shunga period, first century B.C.E. to first century C.E. Siddhartha/ Shakyamuni, the founder of Buddhism in this cosmic era, lived many lifetimes in many forms before acquiring enough merit to become enlightened.

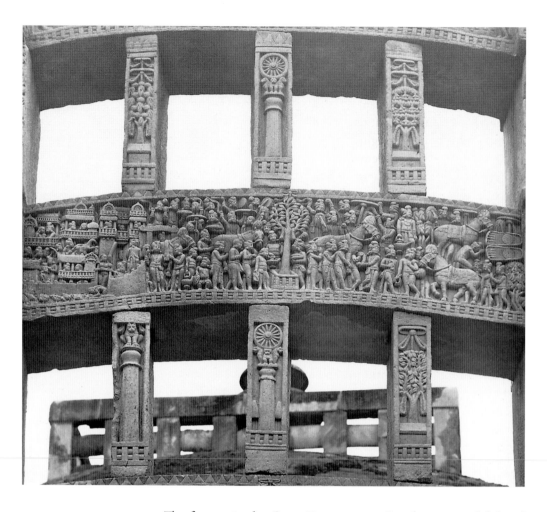

FIGURE 1.9
Siddhartha's Great Departure from his home and family.

Detail from a crossbar, east gate, Stupa 1, Sanchi, Madhya Pradesh, India, Shunga period, first century B.C.E. to first century C.E. The building shown at the left of the scene suggests the richness of Indian architecture during the Shunga period.

The figures in the Great Departure at Sanchi are youthful and strong, and they wear garments and elaborate turbans similar to those seen in the figures at Bharhut. Clothing and adornments are less detailed than those in the earlier monument; however, the composition of the Great Departure at Sanchi is more complex and contains more figures shown in a variety of positions. Some are shown from the front; others are depicted from the sides; and a few, such as the groom leading the riderless horse home, twist slightly to suggest both depth and movement. There is no obvious rationale for the numerous additional figures in this scene. It has been suggested that such crowded compositions may illustrate festivals or public performances re-creating the events of the Great Departure rather than the event itself. It is also possible that the figures are intended to add poignancy to Siddhartha's decision to leave home in search of

awakening. They may be intended to illustrate the varied pleasures inherent in the phenomenal world, which he rejected in his solitary quest for deeper understanding.

Movement and energy dominate the representation of Mara's army on the back of the central crossbar of the north gate [1.10] at Sanchi. Siddhartha's defeat of these demon hoards, which occurred just before he attained enlightenment, is one of the seminal moments in his final lifetime and remains an important theme in Buddhist visual arts. Mara and his army symbolize the delusions, ignorance, and other impediments to greater understanding, and Siddhartha's defeat of these forces was the final step in the many lifetimes he spent becoming a perfected being. The woman standing in the small gateway to the far left is most likely Sujata. According to several texts, she offered milk or food to Siddhartha after he had left his fellow ascetics but before he sat under the tree to meditate. The empty throne placed before the tree covered with garlands and capped by an umbrella symbolizes the presence of the meditating Siddhartha. The young man and woman standing to the right of the throne are Mara's daughter and young son sent to distract the absent (but symbolically present) Siddhartha from his crucial, final meditation. They are shown twice, once standing next to the throne and again as they leave after having failed to distract the soon-to-be Buddha.

Mara is the larger figure toward the center of the scene seated with one leg bent and the other hanging down. In addition to sending his children and others to interrupt Siddhartha's meditation, Mara also summoned rains and other phenomena. Here he is surrounded by members of his army, including an astonishing group of gigantic and slightly ghastly figures at the right: "the wicked Mara ... engaged a great fourfold army, powerful, eager for battle, terrible, thrilling,

FIGURE 1.10
Siddhartha's defeat of Mara's army (Buddha Maravijaya).

Detail from a crossbar, north gate, Stupa 1, Sanchi, Madhya Pradesh, India, Shunga period, first century B.C.E. to first century C.E. Siddhartha's defeat of the demon Mara and his hoards occurred during his final meditation, from which he awoke as the Enlightened One, or Buddha.

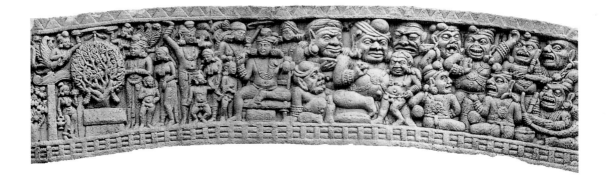

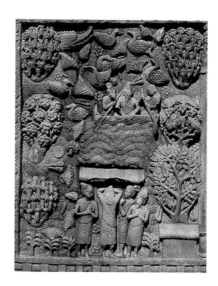

FIGURE 1.11
Shakyamuni's conversion of the Kashyapa brothers.
Detail from a railing pillar, east gate, Stupa 1, Sanchi, Madhya Pradesh, India, Shunga period, first century B.C.E. to first century C.E. In a rare use of the magical powers he had acquired as part of his spiritual awakening, Shakyamuni walked on water during his conversion of the Kashyapa brothers.

never seen or heard of before . . . their heads and eyes blazing, the bellies, hands and feet displaced, their face radiant, their faces and teeth terribly distorted, their terrible fangs bared . . . Some were of wondrous and terrible appearance, blazing, brown, black, blue, and yellow."[4]

The representation of the Buddha's conversion of the three brothers of the Kashyapa clan [1.11], one of the most extraordinary moments in the teaching career he chose after his awakening, is carved on a pillar of the east gate. In early Indian culture, it was accepted that the practice of meditation and austerities provided one with miraculous or psychic powers. Although Shakyamuni and his disciples had such abilities, they rarely used them because doing so was thought to distract from one's spiritual evolution. In a rare moment, however, Shakyamuni deliberately used his powers to help the Kashyapa brothers reach a deeper understanding. The brothers were the leaders of a large group of ascetics who worshipped fire and

believed that the attainment of magical/religious powers was a sign of spiritual advancement. During his time with them, Shakyamuni destroyed a poisonous snake, caused firewood to appear, and parted the waters of a flooded river to walk on its bed. Although the brothers were astounded to see him walking amid the waters, they remained unconvinced about the soundness of his path. When he made it clear that he was aware of their unvoiced questions, they became his followers. In the scene depicted at Sanchi, the three brothers are shown standing on the banks of a river and again in a boat. Shakyamuni is depicted as a log floating on turbulent waters. The river is filled with lotuses, ducks and other aquatic birds, and one alligator-like creature (known as a *makara*) lurks behind a tree in the upper left corner. The care taken to differentiate the leaves and blossoms of the six lush trees that delineate the edges of the scene is typical of the vibrancy given to the natural world on the gateways at Sanchi as well as at other early sites.

Although the stupas at Bharhut and Sanchi are the best-known and most-studied monuments of this type, numerous other examples and remnants of such structures exist in India, Pakistan, and Afghanistan. A crossbar from a gateway [1.12] to an unidentified stupa, now preserved in the Mathura Museum, is particularly important and intriguing because it contains one of the earliest known depictions of Buddha Shakyamuni in human form. Figural images first appeared with symbolic ones in the decoration of these monuments, and the Buddha is shown symbolically in the scenes on the other side of the crossbar. The appearance of the Buddha in human form in the decoration of a stupa suggests that, like aniconic imagery found on the monument, figural images of Buddha Shakyamuni were understood both as illustrations of moments from his final lifetime and teaching career and as embodiments and reminders of his charisma and spiritual attainments.

FIGURE 1.12
A seated buddha and attendants.

Detail from a crossbar, gate to an unidentified stupa, Mathura area, Uttar Pradesh, India, first century B.C.E. The small person seated in a cave is one of the earliest known examples of a figural representation of the Buddha.

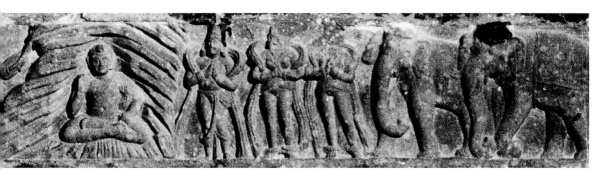

In the anthropomorphic representation, the Buddha is seated on a grass mat in a dramatically rendered cave and accompanied by standing figures holding their hands in the gesture of respect. He has the broad shoulders and strong physique seen earlier in depictions of *yakshas*, which served as prototypes for the development of figural images of Buddha. The long, saronglike garment covered by a large rectangular shawl that is worn over the Buddha's left shoulder became the standard monastic garb throughout Asia. His legs are in a yogic posture with his right foot on his left thigh and his left foot on his right thigh. This is known as both the lotus posture (*padmasana*) in early traditions and as the vajra throne pose (*vajraparyankasana*) in later Buddhist art; it illustrates the attainment of spiritual knowledge during a meditative state. The soles of his feet point outward, helping date the image between the late first century B.C.E. and the first century C.E. Shakyamuni's left hand rests on his left leg; his right hand is raised with the palm facing out, which may be an early variant of the gesture of reassurance (*abhaya mudra*) that is widely used in Buddhist art. His hair is twisted into a knot that resembles a seashell (*kapardin*), a style that is a primary characteristic of early figural images of Buddha in northern India [2.2].

The scene on the crossbar illustrates the visit of Indra, standing to the right and identified by a tall crown, to Buddha Shakyamuni while Buddha Shakyamuni was in meditation. Indra, who is found in both early Indian and later Hindu traditions, is an important god believed to control thunder, rain, and clouds. Like the *yakshas*, he and other divinities were incorporated into Buddhism as attendants to and protectors Shakyamuni and other deities. In the relief, he leads a procession, which includes two celestial females and three elephants. Male and female devotees, some bringing offerings and others holding their hands in the gesture of respect, are shown to the left.

Like those at Bharhut and Sanchi, the stupa at Amaravati in Andhra Pradesh is associated with earlier monuments, including a pillar, constructed during the reign of Ashoka. Amaravati was located near important commercial routes, particularly seaports that supported extensive maritime trade, and this brought contact with the expanding Roman world. Inscriptions at the site indicate that two-thirds of the donations for the work at Amaravati came from lay donors, often women. Unlike the stupas farther north, however, Amaravati had imagery on both the gateways leading to the monument and on the rectangular casing slabs that covered the

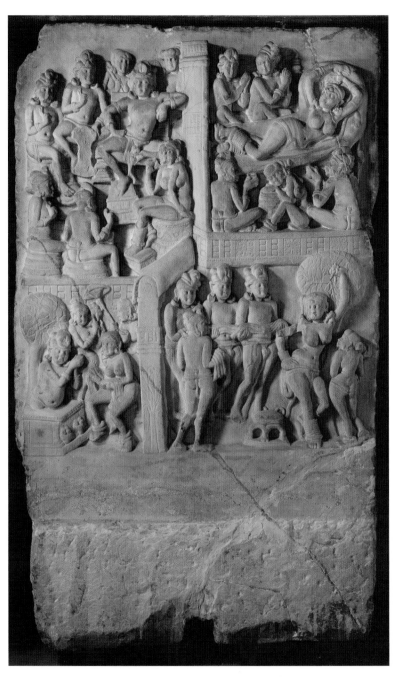

FIGURE 1.13
Scenes from the life of Shakyamuni.

Stupa casing, Amaravati, Andhra Pradesh, India, Satavahana period, second century C.E. The Buddha's miraculous conception, which occurred while his mother was dreaming of a white elephant, is one of the scenes on this panel, which once adorned a stupa.

stupa. A casing from the second century [1.13] records the story of the conception and birth of Siddhartha. The open composition is divided into four scenes placed in sketchily detailed architectural settings. The long-limbed, sensuous figures wear clothing and

jewelry similar to that found in carvings at the northern sites, but they have a plasticity and sense of movement that is distinctive to the Amaravati region. In the upper right corner, Maya, Siddhartha's mother, reclines on a bed and dreams that a white elephant is entering her womb. At the upper left, her husband and his courtiers analyze the implications of this incredible dream. In the lower right corner, Maya holds the branches of a tree as she gives birth to the infant Siddhartha, symbolized by the long cloth decorated with tiny footprints held in the hands of her four male attendants. These male figures may also allude to the guardians of the four directions, representing the newborn's dominion over the cosmos. At the lower left, the newborn, again signified by a cloth with footprints, is presented to the sage of the Shakya family and the local *yaksha*. The latter is the potbellied figure shown emerging from the trunk of a tree. It is at this meeting that Siddhartha's future as either a great teacher or a world ruler is predicted.

Archaeological evidence suggests that Amaravati was an important Buddhist center as early as the third century B.C.E.; however, the site underwent several phases of refurbishment and reconstruction. Final construction of the stupa is attributed to the powerful Satavahana family, which ruled the region in the second and early third centuries C.E. Many of the drum casings dating to the third-century renovation of the site were recycled from earlier construction campaigns, and new imagery was carved on the previously unused sides. Unlike the earlier examples, which show a variety of themes, the later slabs inevitably depict the stupa itself. The schematization of the iconography is thought to reflect greater monastic control of the site in the second and third centuries.

Representations of Amaravati Stupa on the casing slabs covering the drum and archaeological information have been used to reconstruct the appearance of the Great Stupa at Amaravati, which no longer exists. A typical reconstruction shows a massive dome supported by a round platform with a radius estimated at 165 feet [1.14]. Beneath the balcony and umbrella, the top of the dome was decorated with medallions and garlands. The lower part of the stupa is covered with rectangular casings. Railings with gateways marking the four cardinal directions surrounded the stupa, and a group of five columns stood at each of the four entrances. The ambulatory path between

FIGURE 1.14
A reconstruction of Amaravati Stupa.
Andhra Pradesh, India, Satavahana period, second century C.E.

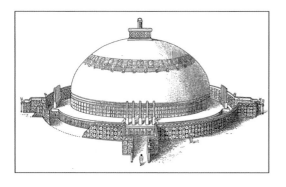

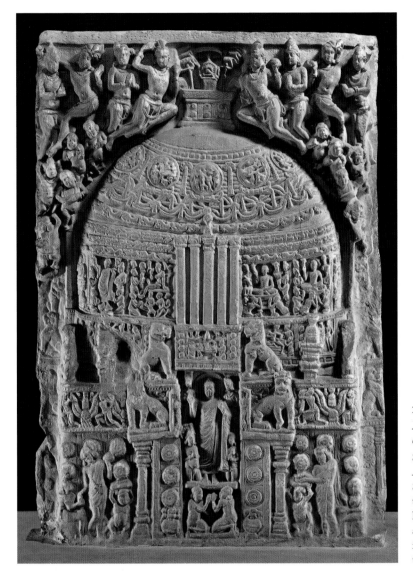

FIGURE 1.15
*Buddha Shakyamuni
and scenes from his life.*

Stupa casing, Amaravati,
Andhra Pradesh, India,
Satavahana period, second to
third century. Scenes from the
lifetime of the historical Buddha
are shown in encapsulated form
in the medallions decorating the
top of the stupa.

the railings and the stupa was thirteen feet wide and lined with
limestone panels.

Human beings stand beneath the stupa and semidivinities
fly above it in the imagery found on a casing from the last stage of
construction [1.15]. As was also true in northern India, the Buddha
was represented as a human being in the later period of construction
at Amaravati. Maya's dream during which she conceived the Buddha,
his Great Departure, and the First Sermon are shown in a synoptic
manner in three of the five small circular medallions that decorate

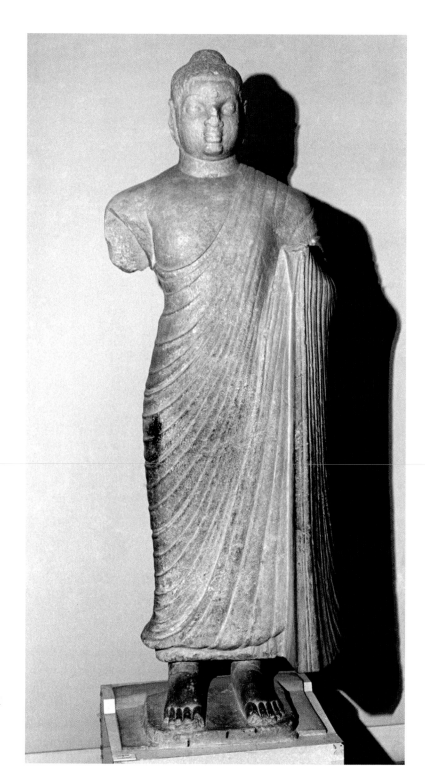

FIGURE 1.16
Buddha Shakyamuni.
Amaravati region, Andhra
Pradesh, India, Satavahana
period, late second to third
century. This style of Buddha,
and in particular the heavy
hem of the robe, had a profound
impact on sculptures produced
in Sri Lanka and Southeast
Asia for centuries. Amaravati
Site Museum.

the top of the stupa. Four rectangular casings are shown in the center of the stupa. The two at the right show Buddha Shakyamuni seated on a throne surrounded by worshippers. His birth and details from the story of his conversion of his younger half-brother, Nanda, on the eve of the latter's wedding (a prominent theme in Andhra Pradesh) decorate the casings to the right. Other scenes showing the adoration of the Buddha or scenes from his lives are also found on the lower part of the stupa and its platform.

The five pilasters that divide the two groups of scenes illustrate the columns found at the gateways to the stupa. Typical of the art of Amaravati, four towering lions cap the pillars of the railings. An image of a standing Buddha that is relatively larger than the other icons is seen in the center of the lower part of the stupa. Four figures, two standing behind him and one kneeling on either side, attend the Buddha. Unlike the other images, which play a critical narrative role, the meaning of the larger icon standing in the center of the carved relief is unclear. However, he appears to be emerging from the stupa, and it is possible that such images illustrate a manifestation of the relics that are housed within the structure.

Both the large Buddha in the decoration of the drum casing and a freestanding or independent sculpture from the area [1.16] stand facing forward with their feet slightly apart. They wear long lower garments covered by heavy shawls that drape over the left shoulder and under the right, and in both examples the edges of the shawls fall in distinctive, heavy swags. This type of representation of the Buddha, which is distinctive to the Amaravati area, has remained important in southern India, Sri Lanka, and much of Southeast Asia for centuries [6.12].

The rationale underlying the dramatic change in the second and third century from symbolic or interpretive images of the Buddha to anthropomorphic ones is unknown and extremely controversial. In addition to those found at Amaravati and other sites in Andhra Pradesh, freestanding (as opposed to those that are parts of narratives on monuments) human representations of buddhas were also produced in northern India in the second century and to some degree in Pakistan and Afghanistan after the third. Monks and nuns commissioned many of the second-century Indian sculptures, and it appears that, as in the south, changes in monastic practices contributed to this extraordinary shift of emphasis in the imagery of Buddhist art, which after the third century inevitably depicted buddhas and other deities in idealized human forms.

CHAPTER 2

The Buddha Image
Second to Seventh Century

THE VAST corpus of Buddhist texts is surprisingly silent regarding the creation of human images of the Buddha. Although a few early references exist, they contain no explanation for the seismic transition from symbolic to figural imagery but simply confirm that it occurred. The reference in the *Divine Achievements (Divyavadana)*, an anthology of the lives of Shakyamuni compiled in northern India around the second century, is typical. It recounts a conversation in which Siddhartha instructed his disciples to draw his likeness on a piece of cloth and to use the image as the focus for their offerings. A late-second-century Chinese translation of one version of the *Perfection of Wisdom Sutra (Prajnaparamita-sutra)* also takes the making of images for granted. It states that such icons were made to help men revere the Buddha and thereby acquire religious merit.

Figural depiction of the Buddha is part of a broader, if not completely understood, change in Indian religious thought in the first centuries of the Common Era. Human images of Hindu and Jain divinities also appeared at the time, and it is possible that such representations reflected the growing importance of the concept of *bhakti,* which stresses a personal relationship with a deity. The earliest texts affiliated with the Buddhist tradition known as Mahayana were recorded from the late first century B.C.E. to the second century C.E., further attesting to the transformation in religious thought that marked the period. Now practiced principally in the Himalayas, East Asia, and Vietnam, Mahayana (or "the Great Vehicle") defines different emphases within Buddhism. Unlike earlier sutras, which often record events and places important in the lives of Shakyamuni, Mahayana texts claim to have been preached in abstract locations divorced from linear time. They celebrate Shakyamuni as one of several transcendent—as opposed to historical—buddhas and

FACING PAGE
A buddha, possibly Shakyamuni.
See page 50.

advocate the pursuit of enlightenment for the benefit of others. Many of the texts emphasize meditation and have a strong visual component that stresses the ability to see buddhas and other divinities as a result of such practices. Mahayana followers celebrate the path of the bodhisattva, one whose essence (*sattva*) is spiritual wisdom (*bodhi*) and who has attained enlightenment in order to help others on the path. It is not clear when the word *bodhisattva* was first used in Buddhist writings, and over time, the term acquired many meanings. In early writings, it is used to describe Siddhartha prior to his enlightenment as well as other practitioners who were also trying to become buddhas. In latter traditions, *bodhisattva* also identifies both human and celestial saviors, who have achieved perfect understanding but choose to remain in the phenomenal world to help and guide other sentient beings.

No textual or epigraphic evidence of the Mahayana tradition exists in India until the fifth century, and it appears to have initially been a minority movement within mainstream Buddhism. (The latter is also termed Hinayana—"the Lesser Vehicle"—a pejorative locution culled from Mahayana texts, or *nikaya* Buddhism, a reference to the different monastic orders prevalent in early India.) Nonetheless, the creation of human images of the Buddha, new emphases in the representation of the life story of Siddhartha Gautama, and depictions of celestial buddhas and other deities parallel changes that also underlie the development of Mahayana. It is worth noting that although no texts are preserved in India, Chinese translations of early Mahayana sutras—which stress meditation and the taking of certain vows, particularly those emphasizing the desire to help others gain enlightenment—date to as early as the second century.

The creation of numerous sculptures of buddhas in northern India, Pakistan, and Afghanistan in the second and third centuries is linked to the patronage of the powerful Kushan Empire (late first century B.C.E. to third century C.E.). First mentioned in Chinese sources, the name Kushan derives from that of a tribe known as the Guishuang. The latter were part of the Yuezhi confederation of semi-nomadic horse traders. Around 175 B.C.E. the Yuezhi were pushed out of their lands on China's northwestern frontier by another mestizo group known, again from Chinese sources, as the Xiongnu. By the first century C.E., the Kushans had traversed much of Central Asia and, under Kujula Kadphises (who ruled in the early part of the century), had gained control of the ancient region of Bactria in present-day Afghanistan. From this base, they moved south and

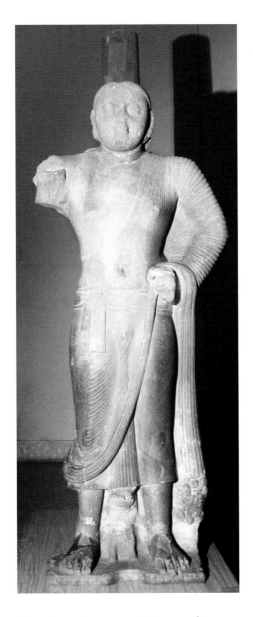

FIGURE 2.1
Bodhisattva/
Buddha Shakyamuni.

Katra, Uttar Pradesh,
India, Kushan period, ca. 130.
According to the inscription,
a monk named Bala, defined
as a learned master, was part
of a group that commissioned
this monumental sculpture.

east, eventually ruling what is now Pakistan (known as Gandhara in early writings) and much of northern India.

Kanishka I, whose reign probably began around 127, was the third emperor of the Kushan dynasty and one of the most powerful. Although he is remembered in Buddhist texts as a patron and protector of the religion, imagery on the coins minted during his reign includes Indian and Persian deities as well as Buddha Shakyamuni. Kanishka ruled from two centers: one at Mathura in India and a

second at Peshawar near the Khyber Pass between Pakistan and Afghanistan. Divergent styles of Buddhist imagery are associated with each area. Sculptures from Mathura, which are few in number, conform to a basic type. A greater number of sculptures and a wider range of image types were produced in Gandhara. Most of the pieces made in Mathura have inscriptions, which are scarce on the works produced in Pakistan.

The seashell-like hairstyle first seen in the image of a seated Buddha on a crossbar from the Mathura region [1.12] is inevitably found on second- and third-century images of Buddha Shakyamuni from that area; as a result, such sculptures have traditionally been described as *kapardin,* or seashell, buddhas. A colossal standing image [2.1] dedicated by a monk named Bala around the year 130 and installed at Sarnath is the most famous example. It is one of several towering images commissioned by a group led by Bala and placed in locations that were important to Siddhartha's lifetime. The inscription, repeated on the base and on the pillar behind the sculpture, identifies Bala as a master of the three baskets (*tripitaka*)—the Buddhist canon—and indicates that he was a learned monk. The Buddha stands facing forward and wears a long, pleated, saronglike garment secured at the waist by a thick sash, and a large, thin shawl that falls over part of his chest and his left shoulder and arm. He has a round, youthful face with bold features and open eyes. The straight-on stance, direct gaze, and earthbound physicality project a sense of immediacy and awareness typical of sculptures produced in the Mathura region in the second and third centuries.

An inscription carved on the base of a beautiful seated buddha of the same type [2.2] states that the nun Amoha-asi dedicated the sculpture to the welfare and happiness of all sentient beings. The buddha, who is larger than the other figures, sits in a meditative posture with his left hand on his left knee and his right hand held up with the palm open. This gesture suggests that he is interacting with, possibly teaching or reassuring, the potential viewer. The two wisdom bearers (*vidyadharas*) above the seated figure and the three lions on the base guard the seated buddha, while two standing figures attend him. Thick sashes worn diagonally over the lower garments and narrow scarves encircling the upper arms distinguish the attendants from the buddha. The turbans and jewelry (for example, the shape of the necklaces) differentiate them from one another. Such attendants are common in Mathura-style sculptures showing seated buddhas. They are sometimes identified as devotees

FIGURE 2.2
Bodhisattva/
Buddha Shakyamuni.

Mathura region, Uttar Pradesh, India, Kushan period, second century. Sculptures of this type, which are often identified as bodhisattvas in inscriptions, are also some of the first figural representations of Buddha Shakyamuni.

and other times as Indic divinities such as Indra and Brahma. The powerful physiques define all three figures as spiritually advanced beings, as do the wheels incised on the feet of the seated image. Traditional Indic marks (*lakshanas*) of a great being, such wheels are common in Buddhist imagery, as are the elongated earlobes. Moreover, the *kapardin* hairstyle may be a precursor to the cranial protuberance (*ushnisha*), another such mark that represents supernal wisdom, found in all representations of buddhas.

Although they are often discussed as images of Buddha Shakyamuni, the sculptures commissioned by Bala and Amoha-asi are specifically identified as bodhisattvas in the inscriptions, as are the majority of the works produced around Mathura in the second and third centuries. This identification raises interesting questions regarding the understanding of the terms *buddha* and *bodhisattva* at that time. The bodhi tree, identified by its heart-shaped leaves, in the background of the sculpture commissioned by Amoha-asi and the installation of Bala's massive figure at Sarnath are biographical references to the ultimate lifetime of Shakyamuni: the tree marks the location where he attained enlightenment, and Sarnath is where he preached the First Sermon. It seems likely, therefore, that

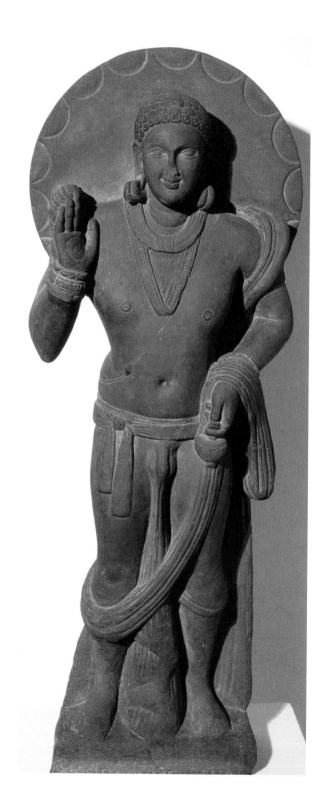

FIGURE 2.3
Bodhisattva Maitreya.
Ahichattra, Uttar Pradesh, India,
Kushan period, second century.
Maitreya is a bodhisattva in this
world age; however, he will be the
teaching buddha of the next.

the sculptures portray the Buddha after he had achieved enlightenment but prior to his final transcendence (*parinirvana*). Presumably, there was a distinction made between the historical Siddhartha who lived his final life as a bodhisattva and his transcendent manifestation as the Buddha Shakyamuni, which respectively preceded and followed the period in question. It is interesting to note that most of the sculptures produced in the Mathura region were commissioned by a small group of monks and nuns, many of whom had relationships with one another. It is possible that members of this group—who commissioned images of the Buddha that simultaneously depicted his adherence to the bodhisattva path and his awakening and attainment of Buddhahood on that path—were among the clergy who contributed to the changes in Buddhist thought at the time, some of which may have spurred the development of the Mahayana tradition.

Inscriptions on the base and on the flask, a traditional attribute held in his left hand, identify a standing figure as Bodhisattva Maitreya [2.3]. Maitreya, whose name means "loving-kindness," plays a unique role in Buddhism. He is the primary bodhisattva mentioned in early texts and the first represented in the visual arts. In addition, Maitreya is the only being represented in the later visual arts as both a bodhisattva and a buddha because he is a bodhisattva in this world era and will be the teaching buddha of the next. The sculpture of Maitreya shares the strong, youthful body of the *kapardin*-type buddha but is distinguished by the decorated belt around his waist and his elaborate necklace, armlets, bracelet, and earrings. Maitreya's adornments, which are similar to those worn by rulers and other wealthy individuals, indicate that he is part of the phenomenal world, as does the upraised right hand, which again suggests a relationship with the viewer. The halo, an ancient Near Eastern solar symbol that was transmitted to both the East and the West, encircles Maitreya's head and upper body and emphasizes his spiritual advancement. This state is also symbolized by his idealized physique; the small, shell-like curls of his hair; his elongated earlobes; and the mark of a wheel on his right palm.

Images of buddhas and bodhisattvas were produced in Afghanistan and Pakistan both during and after the Kushan period. Home to a multiethnic population and desirable for its strategic location (direct access to the overland Silk Road and links to ports on the Arabian Sea), the northwest region of South Asia had suffered many conquests. Prior to the arrival of the Kushans, parts or all of the

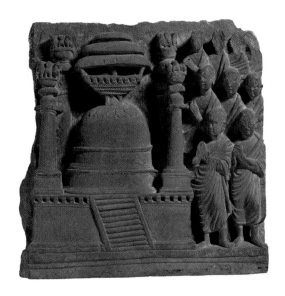

FIGURE 2.4
Worship of a stupa.

Stupa casing, site unknown,
Pakistan, Kushan period,
second century. Pakistani
stupas often have stairways
and columns placed at the
four corners of the base.

region had been ruled by the Mauryas (third century B.C.E.), Alexander the Great (329–326 B.C.E.), his Indo-Greek successors (third to second century B.C.E.), and several Central Asian peoples. As mentioned in chapter 1, the Indian ruler Ashoka erected columns to promote Buddhism in the region and is also thought to have built several stupas there. Greek themes and styles were first introduced with Alexander the Great's conquest of the area and remained popular through contact with the expanding Roman Empire (27 B.C.E.–393 C.E.). Under the Kushans, these influences joined Indian traditions and those associated with the Iranian world and Central Asia in a great pool of stylistic forms available to artists. This fascinating and continuous blending of artistic traditions makes the dating of sculptures from the northwest highly problematic. Multiple stylistic prototypes are often discernible in a single work, and reliance on Greco-Roman or Indic traditions does not provide sufficient information because both continued in the region for centuries.

As was true in others parts of the subcontinent, however, the earliest pieces from the northwest were often found on stupas, and earlier images do not depict Shakyamuni in human form. Moreover, like the stupas at Amaravati and related sites to the south, those in the northwest were embellished with sculptures. This may reflect the fact that both regions had ties to the Roman world, noted for its sculptural decoration on funerary monuments and sarcophagi. A small casing that most likely decorated the base of a drum from an unidentified Pakistani monument [2.4] shows a group of monks worshipping a stupa that symbolizes the presence and spiritual essence of the absent Buddha. The monks wear long, saronglike undergarments topped by large, rectangular shawls that cover both shoulders. The thickness of the shawls and the manner in which they are worn are typical of the northwest, which has a colder climate than other parts of India. The casing also illustrates the form of a stupa from that region. The domed structure is set on a tall, square base and is accessible via a staircase; it is topped by a square balcony covered with a dramatic three-tiered parasol. Columns with lions decorating the capitals mark the four corners of the platform. Although no casings are shown in this representation, they were

generally found along the bottom half of the drum of the stupa, in front of the balcony, and, after the second century, on false gables placed at the front of the monument.

The vertical shape of a casing depicting Siddhartha's miraculous birth, from Loriyan Tangai in Pakistan [2.5], suggests that it once decorated the front of the balcony on a stupa from that site. The representation of the newborn Buddha in human form helps date the piece to the second or third century, when figural representations became common, as they did farther south. Maya, the Buddha's mother, stands at the right, grasping the branches of a tree in a gesture that derives from earlier representations of auspicious figures such as *yakshas* [1.4]. The baby emerges from her side and is shown again standing, a reference to the four steps Siddhartha took to the north, south, east, and west just after he was born, and which reflected his dominion over the cosmos. Maya and the three other adult figures in the composition wear the clothing and adornments of aristocrats and other wealthy persons. Two of the figures have cockaded turbans common to India, while the third has long, curly locks that may derive from Greco-Roman artistic traditions. All three figures, as well as the two small images of the Buddha, have halos, suggesting the inherent sanctity of this historical moment.

The combination of a wheel (shown at the top of a column) and a figural representation of a seated buddha, in another casing from a stupa at Loriyan Tangai [2.6] is typical of the blend of symbolic and figural imagery often found in Pakistan in the second and third centuries. The two small deer nestled at either side of the pillar supporting the wheel and the five monks seated near the Buddha identify the scene as a representation of the First Sermon, which occurred in the deer park at Sarnath. The five monks, who were Siddhartha's companions in the practice of austerities, were also the first to hear his teaching and become members of the Buddhist order. The Buddha is seated in a yogic posture with his right hand raised in the gesture of reassurance and the left resting in his lap. In later Buddhist art, hand gestures are often used to indicate specific biographical moments, and this seminal scene is commonly identified

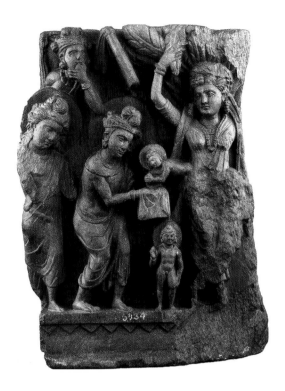

FIGURE 2.5
The birth of Siddhartha/ Shakyamuni.

Stupa casing, Loriyan Tangai, Pakistan, Kushan period, second to third century. The Buddha's miraculous birth from his mother's side and his equally astounding first steps are shown in the narrative relief.

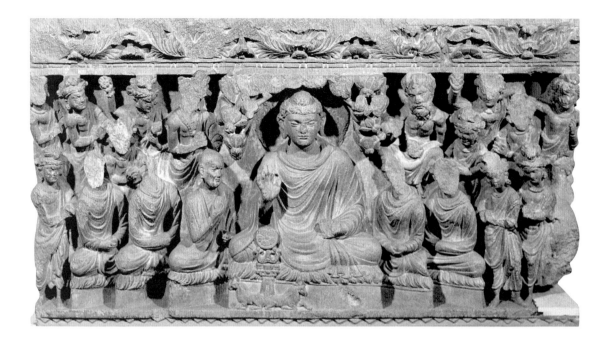

FIGURE 2.6
Siddhartha/Shakyamuni preaching the First Sermon.

Stupa casing, Loriyan Tangai, Pakistan, Kushan period, second to third century. A wheel and two deer symbolic of the deer park at Sarnath identify this scene as the Buddha's first teaching.

FIGURE 2.7
OPPOSITE

The parinirvana of Siddhartha/Shakyamuni.

Stupa casing, site unknown, Pakistan, Kushan period, second to third century. Siddhartha/ Shakyamuni's final transcendence, when he escaped from the endless cycle of reincarnation, was an important theme in Buddhist art throughout Asia.

by the gesture of "turning the wheel of the law," or *dharmachakra mudra* [2.14]. The shaved heads further distinguish the monks from the other small standing figures, who represent lay disciples; the one at the upper right has the beard and scanty clothing of an ascetic.

The Buddha is also shown in human form in a scene representing his *parinirvana* that once decorated the front of a false gable from a stupa at an unidentified site [2.7]. As is standard such representations, the Buddha is shown lying on his side, here on a bed or couch covered with a richly decorated textile. Two monks with shaved heads and clerical garb are shown in front of the bed and another at the foot. Two additional monks stand behind the bier. Staffs, one with a bag for carrying goods, are placed between two of the monks in front of the funerary bed, suggesting that they have just arrived, while the incense burner placed to the left alludes to the performance of pertinent rites. Five layman, identified by their abundant locks, jewelry, and elegant clothing, stand behind the body. Four of the monks and all of the disciples writhe, bow, or gesticulate, displaying their grief at the passing of the Teacher. The other monk, seated quietly on the right, is Sucandra; he understands that the final passing of Shakyamuni Buddha represents his escape from the inevitable cycle of birth and death and is therefore not a cause for grief or despair. The bust of a woman in a leafy medallion found above the

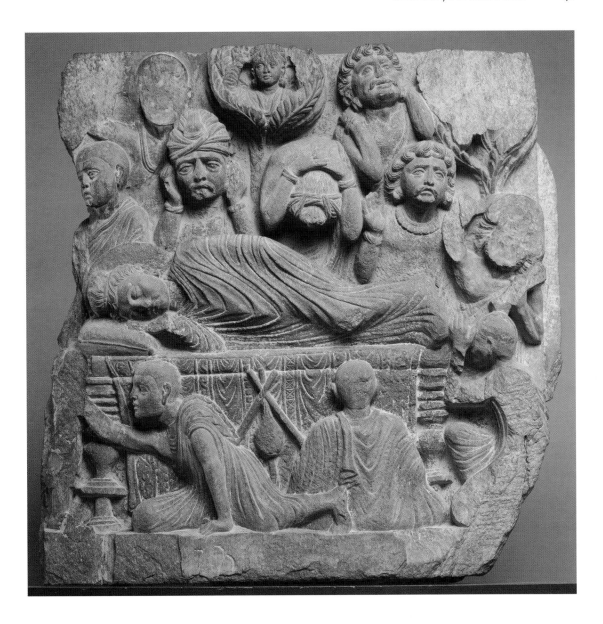

scene shows the deceased Maya descending from a heaven to visit her son one last time on the occasion of his final death.

Sculptures showing Shakyamuni in human form, which became popular in the northwest in the third and fourth century, are based on those first found in the narrative reliefs that decorated stupas. A standing buddha that is now in the British Museum [2.8] wears the large, rectangular shawl and undergarment worn by Shakyamuni on the narrative panels discussed earlier and also has a small,

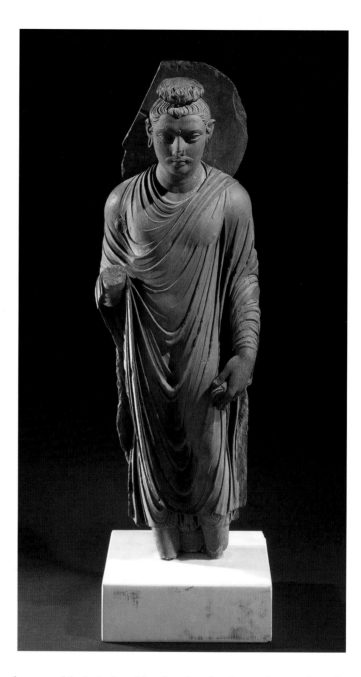

FIGURE 2.8
A buddha, presumably Shakyamuni.

Takht-i-Bahi, Pakistan, third century. The softness of the robes worn by the Buddha illustrates the persistence of Greek artistic traditions introduced to Pakistan after Alexander the Great's conquest of neighboring Afghanistan.

undecorated halo behind his head. Like those depicted in the narrative scenes, this icon bears marks indicative of spiritual superiority, including an *ushnisha* hidden by the arrangement of the wavy hair, an *urna* (a tuft of hair in the center of the forehead that later becomes a third eye, also indicative of wisdom), and elongated ear-

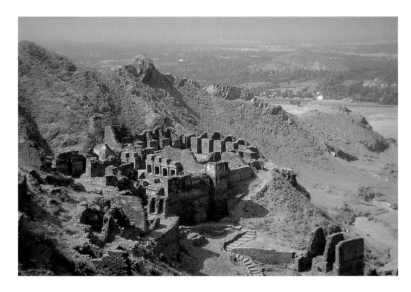

FIGURE 2.9
*A view of Takht-i-
Bahi complex.*

Pakistan. Monasteries such
this contained stupas, as well
as assembly halls and living
quarters for monks.

lobes. Like the buddhas made in Mathura, those produced in
Pakistan have open eyes that create a sense of immediacy with the
viewer. The organic treatment of the folds of the drapery worn by
the freestanding buddha demonstrates the persistence of Greco-
Roman traditions in the northwest.

This sculpture was found at Takht-i-Bahi, a major center in the
Peshawar Basin, which was active for several centuries and is now
largely in ruins [2.9]. Takht-i-Bahi, which is divided into upper and
lower courtyards, contained stupas of various sizes, as well as shrines
for individual images, assembly halls, libraries, kitchens, living quar-
ters for monks, and areas for visitors. The sculpture of the buddha
was most likely placed either on the exterior of a stupa or in one of
the many nichelike image shrines at the site. Although this piece
and comparable works have been preserved and studied as individual
icons, they were often part of a larger group of seated or standing
images placed in a row. The multiplication of these images and the
lack of a narrative context for them are not well understood. It is
frequently assumed that all such early (second- to fourth-century)
icons are representations of Buddha Shakyamuni. However, there is
no explanation for the repetition of the images, and they may repre-
sent the achievement of enlightenment rather than a specific indi-
vidual. It is also possible that the images represent the innumerable
celestial buddhas who occupy various times and spaces as mentioned
in texts and who became important during the development of
Mahayana practice traditions.

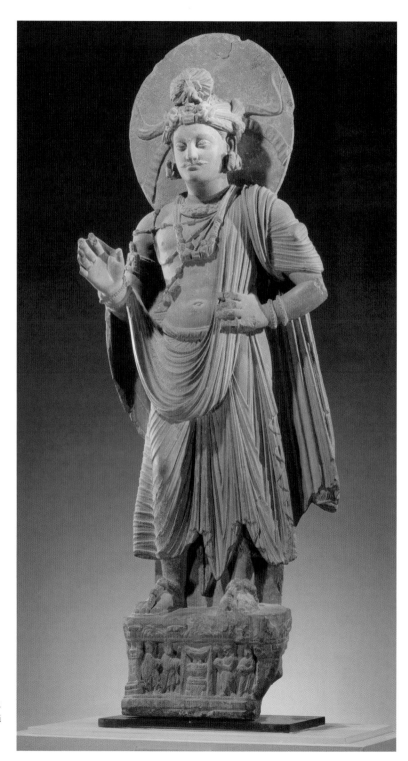

FIGURE 2.10
A bodhisattva,
possibly Shakyamuni.
Shahbaz Garhi, Pakistan, third to
fourth century. Mustaches, which
are commonly found on Pakistani
bodhisattvas, are rarely seen in
Indian art.

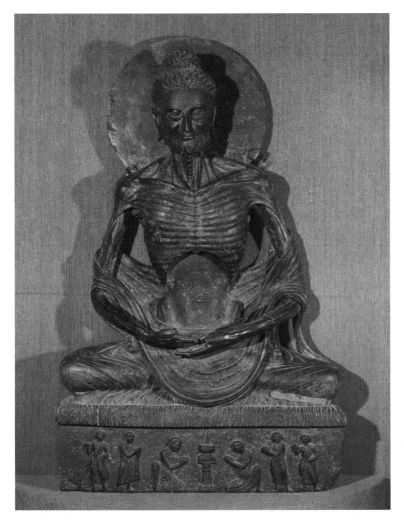

FIGURE 2.11
Siddhartha as an ascetic.
Sikri, Pakistan, third to fourth century. Representations of Siddhartha as an ascetic were produced in Pakistan, central Asia, and China in the third and fifth centuries.

A lovely sculpture of a bodhisattva, now in Paris [2.10], graced the walls of a building or the interior of an image shrine in an unidentified compound. A long scarf—worn over a saronglike garment—falls over his right arm and across his waist and is then wrapped over his left shoulder. The bodhisattva has a mustache and wears several detailed pieces of jewelry, including earrings, armlets, bracelets, and several decorative strings (one with an amulet box), as well as beautifully detailed sandals. His turban or scarf is tied at the back with ribbons and capped with a cockade that has an image of Garuda, the semidivine bird-god of India. This type of headdress is often thought to help identify the sculpture as an image of Siddhartha. (Gandharan representations of Bodhisattva Maitreya

are characterized by long, wavy hair that symbolizes the matted locks of an ascetic.) There is an interesting juxtaposition between the large sculpture of Siddhartha in human form and the begging bowl, set on a pedestal under a draped cloth on the square base, which is symbolic of his presence. It is possible that the sculpture represents the presence of the bodhisattva in the phenomenal world, while the bowl signifies a continuity beyond space and time. Two men and two women bring gifts to the enthroned icon, suggesting that devotion to nonfigural symbols continued despite the creation of human renderings of buddhas and bodhisattvas. The dramatic rendering of the ribbons of the turban, which splay to either side of the bodhisattva's head, reflect the influence of traditions from the art of Iran during the Sassanian period (224–651). The Sassanian conquest in the early part of the third century led to the dissolution of the Kushan Empire; however, the practice of Buddhism continued throughout the region under the rulers of different local kingdoms. The lack of central control may have contributed to the vibrancy and innovation found in Buddhist art produced in Pakistan and Afghanistan during the third and fourth centuries.

Small figures on the base of a rare sculpture of Siddhartha's physical depletion after practicing austerities [2.11] are shown worshipping a sacred flame. This is an allusion to Zoroastrianism, an Iranian religion that was incorporated into Buddhism in Afghanistan and Pakistan and that may have become more prominent after the third century. The powerful sculpture features an emaciated figure with long hair and a beard seated on a grass mat, symbolic of ascetic practices. His withered body, sunken abdomen, and prominent spine emphasize the suffering inherent in his deprivations. The sculpture is thought to represent the moment when Siddhartha was nearly exhausted by his practices but before he chose to meditate and find another way, but the halo and other marks of advancement—such as the *urna* and elongated earlobes—allude to his achievement of Buddhahood. The imagery underlying this gripping sculpture transcends temporal limitations, showing simultaneously the practice of austerities by the historical Siddhartha Gautama and the effect of those actions, his enlightenment. The creation of sculptures celebrating such harsh measures suggests that some type of physical deprivation had become prominent within Buddhist circles in fourth-century Pakistan; similar icons from Central Asia and China in the fourth and fifth centuries have also been found, reflecting a renewed emphasis in varying centers on asceticism at the time.

FIGURE 2.12

OPPOSITE

A Buddha field, or pure land (buddhakshetra).

Mohamed Nari, Pakistan, fourth century. This elegant relief may be one of the earliest visual renderings of a Buddhist pure land, a paradisiacal realm created and maintained by a buddha or other awakened being.

An enigmatic group of sculptures that depict a buddha preaching to a vast multitude indicates further changes in Buddhist thought and practices in the northwest in the third and fourth centuries. The central buddha on an example found at Mohamed Nari [2.12] in Pakistan is noticeably larger than the many other figures that crowd the composition. He sits on a lotus pedestal, a symbol of both purity and transcendence, which first appeared in the visual arts in the late second century and became standard thereafter. Two figures holding garlands, possibly attached to the square banners just above them, stand at either side of the buddha. Two of the six celestial beings flying above him hold a wreath and appear ready to place it on his head. (The act of placing wreaths on a buddha's head is also seen in works from fifth-century India and may be the precursor to the crowned buddhas that were produced throughout Asia after the eighth century.) Additional buddhas in circles filled with smaller images of standing buddhas are seated at the upper right and left corners. The meaning of the seated buddhas and the smaller standing images has been the subject of some controversy. Although Shakyamuni is known to have multiplied his physical form as a means of teaching others during his final lifetime, it is unlikely that the smaller icons represent this event. They are more likely manifestations of the spiritual powers of the seated buddhas, who are celestial rather than historical figures. It is also unclear whether the seated buddhas are manifestations of the primary icon or simply other buddhas occupying the same sacred space. A fourth buddha, who appears to be teaching, is seated under a tree at the upper left.

Four bodhisattvas sit in architectural niches, while others are shown on individual lotus pedestals. The majority of these figures sit in relaxed poses in which one leg is bent and the other lowered to the ground. A variation of this pose, in which the right foot is placed over the opposite knee, became common in China in the late fifth and sixth centuries and is often understood to represent Bodhisattva Maitreya or some bodhisattva in the Tushita Heaven awaiting his final birth during which he will become enlightened. In Mahayana Buddhism, each of the celestial buddhas is capable of creating and maintaining a heaven or perfected world (often known as a "pure realm" or "pure land"), and the Tushita Heaven is the one associated with Maitreya. It is possible that the stele found at Mohamed Nari is one of the first representations of such a sacred realm, which is filled with buddhas, bodhisattvas, and other beings. However, the identity

of the primary buddha in the sculpture—and by extension that of the pure land—is much debated. The principal buddha holds his hands in a variant of the *dharmachakra mudra,* in which the raised right hand partially covers the left, and the thumb and forefinger of the left are joined to form a circle. This gesture, which replaces the use of the wheel in representations of the First Sermon, is usually used to show either Buddha Shakyamuni or, after the eighth century, his transcendent manifestation Buddha Vairocana ("illuminator") in the act of preaching [7.4]. However, neither of these buddhas is usually associated with a pure land in later Buddhist art. If the buddha is Shakyamuni/Vairocana, then the rest of the imagery is a representation of this buddha as a generative figure creating a cosmos filled with buddhas, bodhisattvas, and other deities and human beings.

On the other hand, the small male and female figures swimming in the lotus pond at the bottom of the sculpture parallel such figures in Chinese and Japanese representations of the pure land of Buddha Amitabha ("infinite radiance"), and the sculpture from Mohamed Nari has tentatively been identified as an image of that paradise. Alternatively, the large number of women may indicate that the pure land is that of Buddha Akshobhya ("immovable one"), because females are mentioned prominently in texts describing that realm. It is possible that further study will provide an incontrovertible explanation of the iconography found on this piece and related works. At the moment, however, it is safer to see them as reflections of changes in religious thought that led to an emphasis on a buddha (or buddhas) as generative figures capable of creating and maintaining either an idealized realm or the cosmos itself.

As was mentioned earlier, the conquest of most of the northwest by the Sassanian rulers of Iran in the third century ultimately led to the dissolution of the Kushan Empire, with smaller polities ruling different regions of northwest and northern India for the next hundred years. Many of the smaller states continued to support the

FIGURE 2.13
A buddha, possibly Shakyamuni.

Uttar Pradesh, India, Gupta period, ca. 435. A bump at the top of the head and elongated earlobes are among the primary physical characteristics of a buddha that helped to illustrate his state of spiritual development.

FIGURE 2.14
*A buddha, possibly
Shakyamuni.*

Sarnath, Uttar Pradesh, India,
Gupta period, ca. 465–485.
Justifiably one of the most
famous representations of
the Buddha in Asian art, this
nearly life-size sculpture
illustrates an influential style
that spread throughout Asia
during the sixth, seventh, and
eighth centuries.

creation of art for Buddhist centers; this was particularly true in Afghanistan, where the production of stucco sculptures flourished. In the first part of the fourth century, much of northern India was under the rule of the Gupta dynasty. This period—which lasted from about 319, when the name of the dynasty was first announced, to about 500, when King Buddhagupta died—was one of prosperity and patronage of the arts. Sanskrit, the language of the Mahayana texts, became the state language, and poetry and other literary arts thrived.

Although the Gupta rulers practiced Hinduism, Buddhist establishments also benefited from their patronage, as did a major school of sculpture, centered in the city of Sarnath. The elegant proportions and strong physique of a buddha [2.13] now in the Metropolitan Museum of Art typify the art of Sarnath in the second quarter of the fifth century. The figure has a slightly articulated waist and long legs, and he wears a thin undergarment and full shawl. The use of the shawl to cover both shoulders and the depiction of its folds as a series of raised thin lines interspersed with flat areas of drapery reflect influences from the earlier Kushan traditions of the northwest and help date the piece to around 435. The buddha's partially closed eyes are typical of the Gupta style and give the sculpture a sense of introspection and serenity not found in earlier images, which typically had open, staring eyes. The elaborate decoration on the damaged halo—which includes beading, a diamond pattern, and a lush floral scroll—also characterizes the mature style of Gupta India, as do the dense, thick, snail-shell curls of the hair, another of the physical indications of buddhas and other enlightened beings.

The lack of folds in the clothing worn by a nearly life-size seated buddha from Sarnath [2.14] date the piece to sometime between 465 and 485. A large halo surrounds the buddha's head, and he holds his hands in another variant of the teaching gesture; here the central finger of the left hand touches the joined thumb and forefinger of the right. The identification of the scene as the First Sermon is reiterated by the wheel, two deer, and six donors or devotees found

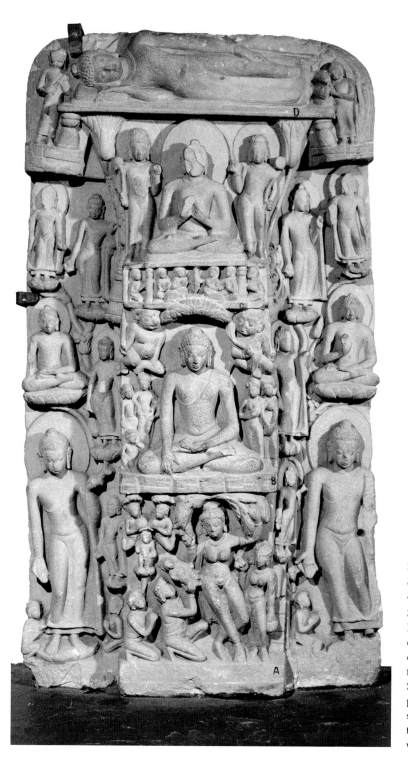

FIGURE 2.15
Scenes from the life of Siddhartha/Shakyamuni.
Sarnath region, Uttar Pradesh, India, Gupta period, late fifth century. By the fifth century, different moments from the final lifetime of Siddhartha/ Shakyamuni, which had previously been rendered in separate scenes, were sometimes assembled into a single work of art.

on the base of the sculpture. The back of the throne is decorated with two rampant leonine creatures (*sardulas*) and the heads of two crocodile-like beasts (*makaras*). Similar thrones, which probably symbolize the Buddha's dominion over the cosmos, are often used in later Indian works as well as in sculptures and paintings produced in the Himalayas. The addition of the throne to the religious imagery and the minute scale of the figures on the base suggest that this piece represents Shakyamuni as a transcendent buddha as well as a historical figure.

Popularly known as the "Sarnath Buddha," the sculpture is widely recognized as one of the most successful and beautiful works of the period for two reasons. First, it superbly balances a sense of realism that brings the historical figure to life and abstraction that alludes to his attainment of Buddhahood. Second, it brilliantly embodies a state of being that is fundamentally indescribable:

FIGURE 2.16
OPPOSITE
Bodhisattva
Avalokiteshvara.
Sarnath region, Uttar Pradesh, India, Gupta period, late fifth century. The small seated buddha in the headdress identifies this sculpture as a representation of Avalokiteshvara, the embodiment of compassion and the most popular bodhisattva in Asia.

but who is wise tears from his soul this *Trishna* [false thirst]
feeds his sense no longer on false show, files his firm mind to seek not, strive not, wrong not:
. .
From whirling on the wheel; aroused and sane
As is a man wakened from hateful dreams.
Until—greater than king, than gods more glad
The aching craze to live ends, and life glides—
Lifeless—to nameless quiet, nameless joy
Blessed nirvana—sinless, stirless rest,
That change which never changes.[1]

Sculptures of encapsulated scenes from the final lifetime of Shakyamuni, as opposed to those of specific narrative moments, were first produced during the Gupta period. The figures in the center of a stele, as well as some of the smaller images at the sides, record several primary events [2.15]. The Buddha's birth from his mother's side and the bathing of the infant by two semidivine *nagas* (half-human, half-snake protective creatures) fill the center area at the bottom of the stele; Siddhartha's defeat of Mara and the First Sermon are found in the middle; and a reclining figure that symbolizes the *parinirvana* of the historical Buddha is at the top. Both the defeat of Mara and the First Sermon are identified by the Buddha's gestures. The former is shown by his right hand reaching down to touch the

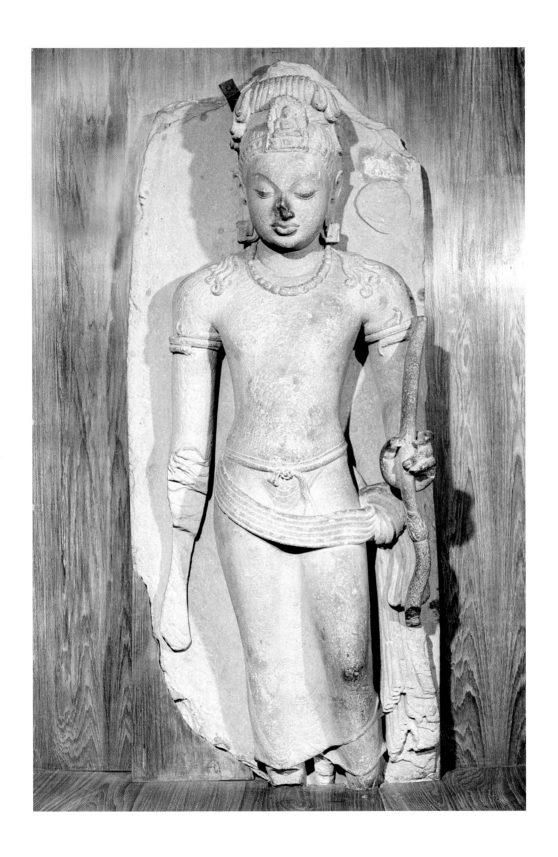

earth. Known as *bhumisparsha mudra* (earth-touching), this gesture became the primary signifier of that moment in Shakyamuni's last life. The gesture of turning the wheel of the law identifies a scene of the First Sermon. Additional standing and seated buddhas, both large and small, are placed along the edges of the stele. They may either allude to other moments in the sacred biography or represent the multiplication and diffusion of the Buddha's spiritual energies. The juxtaposition of several biographical moments in one sculpture and their synoptic treatment suggest that by this time, events from the final lifetime of Siddhartha Gautama became symbols for the process of enlightenment rather than detailed or narrative records of the lifetime of a specific historical figure.

Representations of a host of different bodhisattvas and their varying manifestations illustrate further changes in Buddhist practice during the Gupta period. Worship of celestial bodhisattvas is typical of Mahayana, while the representation of multiple manifestations of these figures foreshadows the development of esoteric traditions. *Esoteric* is a general term used to describe Buddhist beliefs, practices, and icons, such as those preserved in Tibet, that have multiple and often hidden meanings and that require the guidance of a teacher to understand. The small figure of a buddha seated in meditation in the headdress of a bodhisattva in the Indian Museum in Calcutta [2.16] identify him as Bodhisattva Avalokiteshvara. The name means "one who perceives the sounds of the world" and helps define Avalokiteshvara, the most popular deity in Buddhism, as the embodiment of compassion. The buddha in the headdress, identified by the meditative position of his hands, is Amitabha, the head of Bodhisattva Avalokiteshvara's religious family or lineage. The organization of deities into such lineages, each of which is headed by a celestial buddha, is another example of the growing complexity of Buddhist thought.

The jewelry, the elegant sash tied below his waist, and the bent right knee that conveys a slight sense of movement indicate Avalokiteshvara's accessibility to the devout. He has a youthful mien and matted hair. The lotus stem (now damaged) in his left hand is one of the principal attributes of the bodhisattva of compassion. The missing right hand was probably held downward with the palm out in the gesture of beneficence (*varada mudra*). The bodhisattva's slender, elegant body and diaphanous drapery are comparable to those of the famous Sarnath Buddha and date the piece to the late fifth century.

The classic style of the Gupta period spread, contributing significantly to the development of both Buddhist and Hindu art in India and throughout Asia. Buddhist sculptures similar in style to those at Sarnath have also been found in Nepal, which was part of the empire during the Gupta period, as well as in centers to the east and west. An extraordinary bronze sculpture [2.17], found during the construction of a railway at Sultanganj in the eastern province of Bihar, is larger than life-size and weighs more than a ton. It was made using the lost wax method commonly employed in India, in which beeswax or some other soft material was carved to the desired shape and covered with increasingly coarse layers of clay. The assemblage was fired, causing the original wax carving to melt away and leaving only a baked clay shell, which was filled with molten metal. After the metal had cooled and hardened, the clay exterior was broken open, revealing the sculpture inside.

Subtle differences distinguish this bronze buddha from the stone works produced at Sarnath: the posture is more rigid; the shoulders are marginally broader in proportion to the overall physique; the features, particularly the nose, are elongated; and the hairline forms a peak on the forehead. The thin creases used to suggest the folds of the shawl reflect the persistence of early-fifth-century styles in the treatment of drapery. The attention paid to the stylized edges, on the other hand, helps date the sculpture to the seventh century.

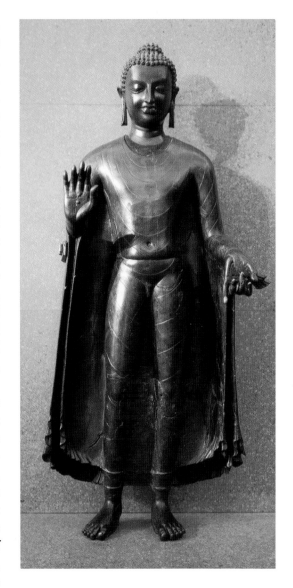

FIGURE 2.17
A buddha.

Sultanganj, Bihar, India, seventh century. This colossal bronze sculpture was unearthed during the construction of a railroad.

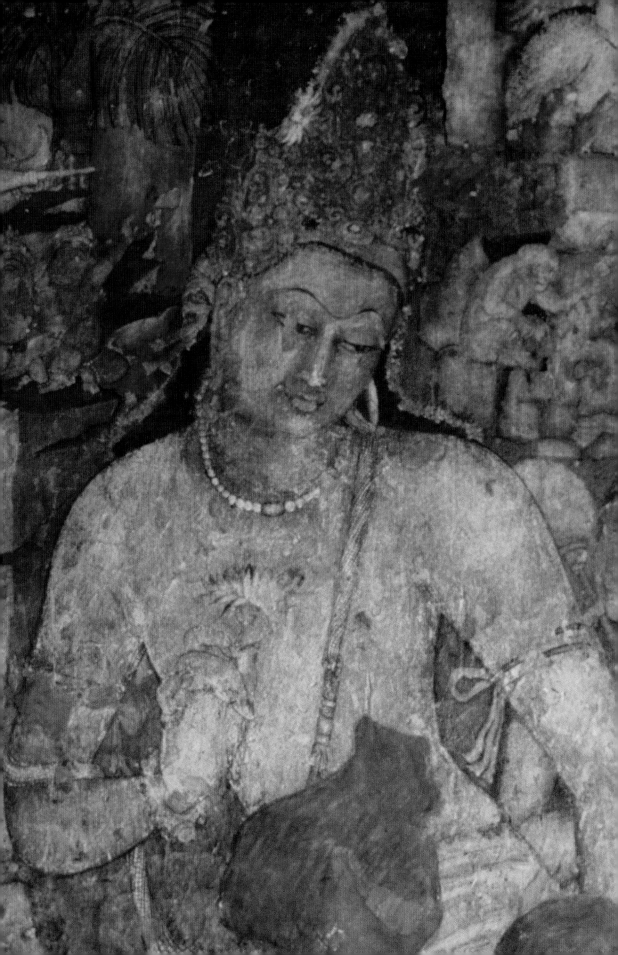

CHAPTER 3

Caves and Caravans
India, Afghanistan, Central Asia, and China

INDIA

THE GUPTA-PERIOD style of Buddhist images that developed in the Sarnath area is also seen in works from the western reaches of India, particularly in sculptures and paintings that decorate the cave sanctuaries at Ajanta and related centers in Maharashtra Province. Ajanta [3.1], which is situated in the western Ghat mountains along the Waghora River, consists of twenty-six cave sanctuaries, most of which were carved late in the fifth century. Also known as cave temples, such manmade structures have been found in India and Afghanistan, at various sites along the Silk Road, and in China. They range from single chambers to enormous monastic compounds that include halls for worship and teaching, living quarters for monks and visitors, and additional rooms such as libraries and kitchens. As way stations for travelers, these sanctuaries played an important role in the dissemination of Buddhism through Central Asia and into China. In addition, many of the more elaborate structures contain sculptures and paintings that give a more detailed, comprehensive look at iconography than is possible from the study of individual works of art, which have often been removed from their original locations. The sculptures and paintings in cave temples provide crucial information for the study of Buddhist thought, particularly from the fourth through sixth centuries, the period during which Buddhism flourished in centers along the famed Silk Road and in China.

The genesis of cave sanctuaries is unclear. Their roots may lie in the long-standing Indic tradition of asceticism, whose adherents used natural structures as part of their renunciatory lifestyles. The earliest sanctuaries in India, which were excavated during the reign of Ashoka, are simple structures consisting of a rectangular outer

FACING PAGE
Bodhisattva Avalokiteshvara as Padmapani.
See page 62.

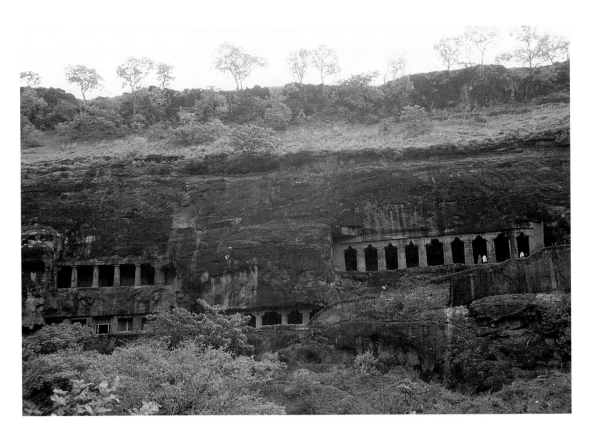

FIGURE 3.1

The cave temple complex at Ajanta.

Maharashtra Province, India, late fifth century. Ajanta is famous for the paintings that decorate the walls of many of the cave temples.

hall and an inner apsidal chamber that housed a stupa. Twenty major caves, such as those at Bhaja and Karli, and numerous minor sites patronized by individual travelers and wealthy artistic and commercial guilds were constructed in western India from 100 B.C.E. to 200 C.E. Ajanta, also created at that time, is the best-known site in the region, which includes centers such as Kanheri, Aurangabad, and Ellora. It is unclear why the building of such sanctuaries resumed after nearly three centuries of inactivity. Presumably the wealth of the region, which was under the control of the Vakataka family during the Gupta period, and the needs of travelers, merchants, and monks contributed to the reopening and development of these sites.

Cave 19 at Ajanta, commissioned by Upendragupta, the feudatory ruler of a small state within the Vakataka realm, provides a characteristic example of a relic hall (*chaitya*). It consists of a large, rectangular veranda leading to an apsidal chamber [**3.2**] that is bracketed by columns on both sides. The columns, which are decorated with floral patterns and pearl swags, define the path for the traditional

circumambulation of the stupa at the rear of the room. The wooden ribs appended to the ceilings have no structural purpose but reflect architectural prototypes in wood, bamboo, and thatch. An inscription in a nearby cave defines Cave 19 as a "perfumed chamber" (*gandhakuti*), defined in early texts as the room prepared for Shakyamuni Buddha and his disciples when they visited; in later works, this term is used for the space used to house the principal icon in a monastery. As the name implies, flowers and other scented offerings such as incense were sometimes offered to the Buddha or to the icons symbolizing his presence in the chamber; it is possible that such devotions were practiced in this cave and others at Ajanta. A passage in a liturgical text by the monk Santideva (685–763) provides a romantic description of the decoration of such caves: "beautified by columns that shine with encrusted pearls, with awnings that shine with garlanded pearls, and with floors of shining pure crystal, full of urns inlaid with fine gems, full of delicate flowers and perfumed waters."[1]

The buddha standing in an arched niche in the center of the stupa is the primary icon in Cave 19. A small buddha sits in the front of the balcony that caps the stupa, and the stone friezes beneath the wooden rafters are filled with small seated and standing buddhas, each of which occupies an individual niche. Presumably the primary icon in the stupa represents Buddha Shakyamuni, who was understood as both immanent in the monument and capable of temporary manifestation in the phenomenal world. The smaller icons may be read as either additional manifestations of the Buddha, who by this time was understood to appear simultaneously in numerous locations, or as representations of the innumerable buddhas of other worlds. The emphasis on multiple buddhas and on their ability to manifest in the world suggest the influence of Mahayana and other later traditions in the imagery of the Ajanta caves.

Most likely commissioned by Harishena, who ruled the Ajanta region from about 460 to 477, Cave 1 [3.3] is one of the most important cave sanctuaries in India and is renowned for its paintings. It is typical of caves designed with living quarters (*vihara*), in which

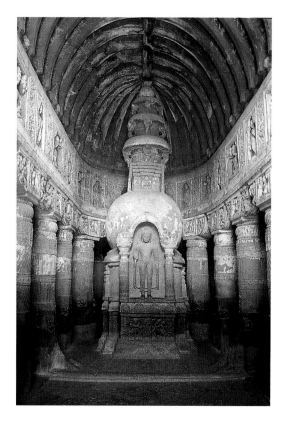

FIGURE 3.2
The interior of Cave 19 at Ajanta.
Maharashtra Province, India, late fifth century. The stupa at the back of the cave is the focus of worship and is circumambulated in the same way as a freestanding structure.

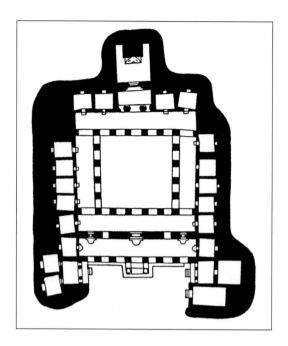

FIGURE 3.3
Plan of Cave 1 at Ajanta.
Maharashtra Province,
India, late fifth century.

small individual chambers are placed along the sides and back of a central assembly hall. A long, narrow veranda precedes the hall, and a small entry chamber and a shrine housing a Buddha image are found toward the back of the assembly space. The paintings that decorate the walls of the veranda and assembly hall were the work of a guild of professional artists, and different hands and degrees of quality are evident. These dry frescoes were painted in mineral and vegetable colorings on top of a lime wash. Two layers of plaster, the top layer more refined than the bottom, provide the substructure for the works.

The story of Siddhartha's prior life as King Janaka is depicted in a congested composition in the center of the left wall of the hall. Janaka, whose past lives were tumultuous, was eventually reborn as the ruler of a small kingdom. Despite the ardent protests of his wife, Sivali, who found his decision incomprehensible, Janaka decided to renounce the world in order to advance spiritually. After he left his pleasurable existence in the palace, Sivali followed him into the forest and attempted yet again to dissuade him. In response, Janaka snapped a piece of grass in two and handed the stalks to her, explaining that once a blade of grass is broken, each end must live alone. She relented, and he was left to his austerities.

In a detail from the painting, Janaka [3.4] is seated in a palatial chamber and wears the crown and jewelry typical of his rank. Sivali, who sits before him, lifts her hands in remonstrance during their conversation; the twisting positions of the attendants standing behind her suggest the dismay that Janaka's decision has engendered at court. In the next scene (not shown), Janaka leaves the palace, indicated by a gateway, to begin his spiritual practices; this act fore-shadows Siddhartha's Great Departure in a later life. Janaka and Sivali wear elegant clothing, including diaphanous upper garments and richly colored undergarments that appear to have been deco-rated with a complicated dying technique. Their sensuous, rounded bodies move with an easy elegance that is typical of the paintings at Ajanta and can be traced to the style developed at Sarnath. White highlights are used to emphasize the noses and other features of the primary protagonists, while subtle variations in the colors used add a sense of depth to the composition.

The large painting of Bodhisattva Avalokiteshvara holding a lotus [3.5] on the back wall of Cave 1 (to the right of the door to the antechamber) is the most famous painting at Ajanta. Also known as Padmapani ("bearer of the lotus"), Avalokiteshvara is paired with Vajrapani (to the right), who, as his name implies, is identified by the vajra, or thunderbolt, he holds. The two bodhisattvas function both as attendants of the buddha housed in the shrine at the back of the dwelling cave, and as independent icons. Avalokiteshvara as Padmapani illustrates the belief that even a simple gesture, such as offering a flower, can produce religious merit. He shares the youthful physique of King Janaka and wears a similar crown and ornaments. However, the thick strand of beads that falls from his left shoulder to his waist, a version of the sacred thread worn by members of the priestly caste in India, distinguishes him from the king who has rejected such worldly trappings. Avalokiteshvara stands in a lush landscape filled with people, monkeys, and other creatures that will presumably benefit from both his presence and his meritorious offering of a flower.

Different forms of Bodhisattva Avalokiteshvara and other iconographic innovations found at Ajanta and related sites exemplify the

FIGURE 3.4
Siddhartha's life as King Janaka (**Mahajanaka jataka**).

Detail from a painting on side wall, Cave 1, Ajanta, Maharashtra Province, India, late fifth century. In many of his previous lifetimes, Shakyamuni was often born in a royal or wealthy family.

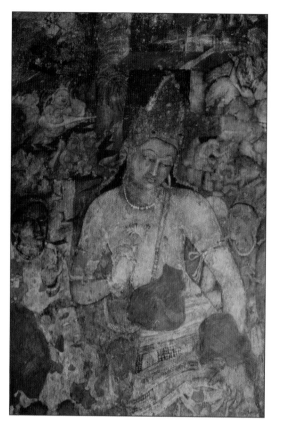

dynamic evolution of Buddhism during the late
fifth and sixth centuries; many of these innova-
tions are also found in complexes along the Silk
Road. Avalokiteshvara as the "savior from perils"
was a popular theme at Ajanta and other cave
sanctuaries in Maharashtra Province. This form
of the bodhisattva of compassion is based on a
chapter in the *Lotus Sutra* (*Saddharmapundarika-
sutra*), one of the most influential texts in the
Mahayana tradition. Most likely written some-
time in the first century B.C.E., the sutra makes
two basic points: attaining the awakened mind
of a buddha is the practitioner's primary goal,
and enlightened beings should remain in the
world to help others. According to the text, Ava-
lokiteshvara can be invoked to save the faithful,
particularly travelers, from disasters such as a
shipwreck or drowning; perils including wild
animals, brigands, and capture; and delusions
such as false beliefs and strong desires. The
emphasis on travelers may explain the popularity
of the theme in cave temples, which often served
as havens for merchants and other voyagers.

Avalokiteshvara as the savior from perils is
carved on a wall in the veranda of Cave 90 at Kanheri [3.6]. The
bodhisattva, wearing minimal clothing and with the matted locks of
an ascetic, stands in the center of the composition holding a lotus in
his left hand. A small figure kneels at his feet, and the auspicious
goddesses Tara ("star") and Brhkuti ("abundant hall") are seen to
the right and left, respectively. A seated buddha, with his hands in
one of the variants of the teaching gesture, is placed above the
bodhisattva's head. It seems likely that this figure represents
Amitabha, the head of Avalokiteshvara's spiritual lineage. However,
the teaching gesture is unusual; Amitabha is generally shown with
his hands in the meditation gesture. Two additional bodhisattvas,
wearing crowns and possibly of the same lineage as the goddesses,
are placed on either side of the seated buddha.

Avalokiteshvara's ability to save the faithful is graphically depic-
ted in the ten scenes surrounding the central group. In each scene,
smaller images of the bodhisattva, who is identified by his scanty
clothing and matted hair, are shown coming to the aid of people

facing threats such as the elephant in the upper right corner, the lion in the next scene down, or the cobra in the next: "If you are surrounded by ferocious beasts and wild animals, fearsome with their sharp teeth and claws, recall Avalokiteshvara, and they will immediately go off in all directions. If you are surrounded by malicious and terrible cobras, spitting venom at your eyes as though their heads were emitting fiery rays, recall Avalokiteshvara, and immediately they will lose their poison."[2]

The depiction of Avalokiteshvara as an ascetic, which continues the trend first seen in northwest India in the third and fourth centuries, suggests that a return to more rigorous practices was also an important aspect of Buddhism in the late fifth and sixth centuries. The addition of female deities and the geometric organization of the composition foreshadow both the inclusion of numerous additional figures as the focus of Buddhist practices and the development of structured representations of the cosmos, often called mandalas.

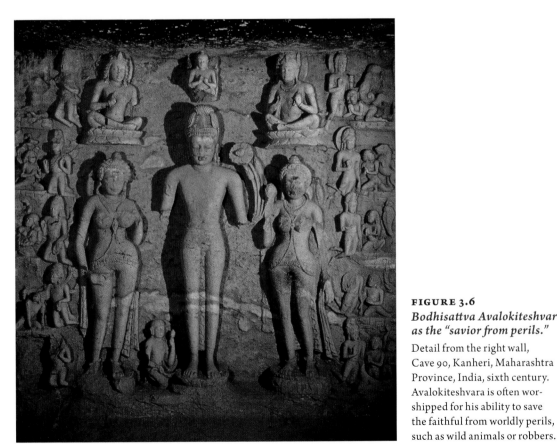

FIGURE 3.6
Bodhisattva Avalokiteshvara as the "savior from perils."
Detail from the right wall, Cave 90, Kanheri, Maharashtra Province, India, sixth century. Avalokiteshvara is often worshipped for his ability to save the faithful from worldly perils, such as wild animals or robbers.

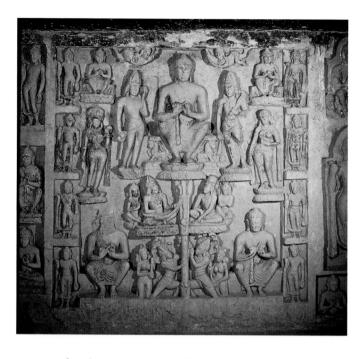

FIGURE 3.7
A mandala.

Detail from the left wall, Cave
90, Kanheri, Maharashtra
Province, India, sixth century.
The structured composition of
this group of Buddhist deities
presages the flowering of
mandalas in later Buddhist art.

A group of sculptures on the wall across the room from the Bodhi-
sattva Avalokiteshvara composition may represent an embryonic
form of mandala [3.7] because of the hierarchic placement of the
figures. An image of a buddha seated with his feet on the ground,
sometimes called the European pose, is seen in the center of the
composition. He sits on a stool decorated with lions and set above
an enormous lotus stalk. The Indic gods Indra and Brahma, with
their consorts, are placed to either side of the center of this stalk;
two *nagas*, again with their female counterparts, are shown at the
base. Two bodhisattvas with long, matted hair wear elegant sashes,
and two female divinities (possibly Tara and Bhrkuti) stand to either
side of the central buddha. Four smaller buddhas, also seated in the
European pose, are placed in the corners of the composition. They
can be seen as radiating from the central figure, thus representing
both manifestations of the powers of the primary buddha and
four individual entities. The eight buddhas standing at the right
and left sides of the composition also symbolize the wisdom and
compassion that the central buddha spreads through the cosmos
during his teaching. The organization of this group of sculptures,
with the principal icon in the center and related deities surrounding
him, is characteristic of mandalas, which are better known today in
the paintings preserved in the Himalayas.

AFGHANISTAN

NUMEROUS CAVE sanctuaries cover the sides of the mountains around the valley of Bamiyan [3.8] in Afghanistan. This region, as well as oasis states on the northern and southern branches of the Silk Road that linked the northwest of the subcontinent to China, flourished from the fourth century to the seventh. Bamiyan, which was most likely under the control of rulers of a small polity in the region, was in use before it became a major stopping point. Two Chinese monks recorded their visits to the site: Faxian (b. 350), who traveled in Central Asia, Afghanistan, and India in search of texts, images, and more updated or authentic practices, was there between 394 and 414; Xuanzang (b. 602) visited these regions for the same reasons between 629 and 645. The latter's diaries of his journeys remain crucial to the study of Central Asian and Indian history in the early seventh century.

Yuanzang also mentions the two colossal standing buddhas at either end of the Bamiyan valley, which were, until their destruction

FIGURE 3.8
The cave temple complex at Bamiyan, Afghanistan.
Sixth to early seventh century. The destruction of the cave temples at Bamiyan is one of the tragedies of the late twentieth century.

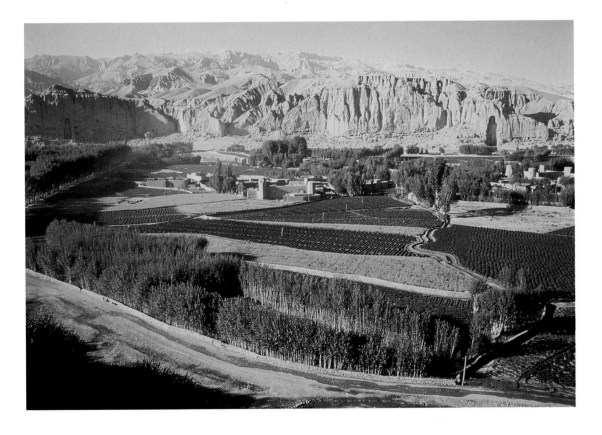

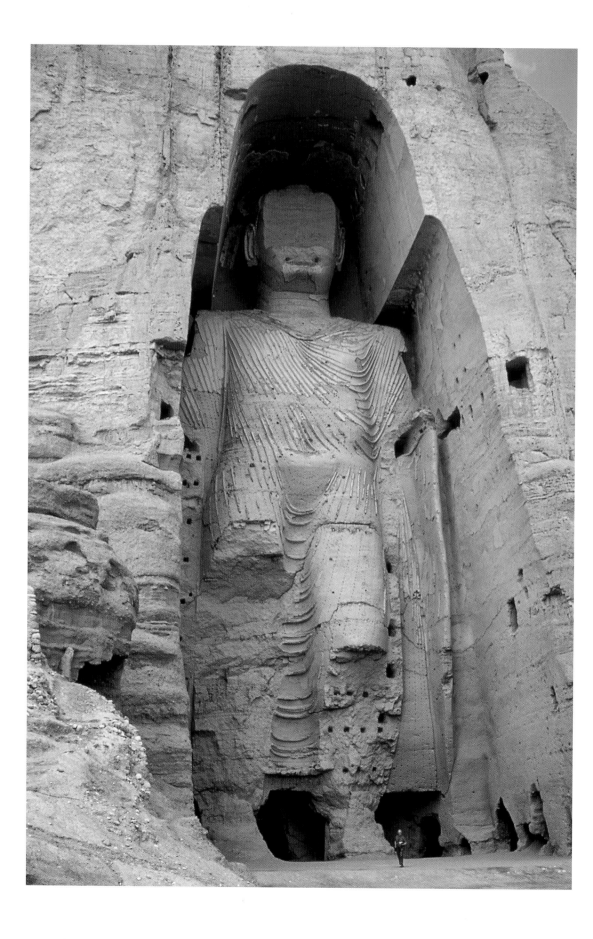

in 2001, among the wonders of the Buddhist world, as well as a gigantic sculpture of Buddha Shakyamuni reclining—a depiction of his final transcendence (*parinirvana*)—but that sculpture remains unknown in modern history and may have been either buried or irretrievably lost:

> To the northeast of the royal city there is a mountain, on the declivity of which is placed a stone figure of Buddha, erect, in height 140 or 150 feet [translation of a Chinese measurement]. Its golden hues sparkle on every side, and its precious ornaments dazzle the eyes by their brightness.
>
> To the east of this spot there is a convent, which was built by a former king of the country. To the east of the convent there is a standing figure of Sakya Buddha, made of metallic stone, in height 100 feet. It has been cast in different parts and joined together, and thus placed in a completed form as it stands.
>
> To the east of the city 12 or 13 *li* there is a convent in which there is a figure of Buddha lying in a sleeping position, as when he attained Nirvana. The figure is in length about 1000 feet or so.[3]

The larger of the two colossi at Bamiyan [3.9] was 125 feet tall, and the slightly smaller sculpture was about 120 feet. Both buddhas were painted and gilded and possibly adorned with metals and stones. The walls and ceilings of the shallow niches that housed them were filled with paintings that combined Iranian, Central Asian, and Indian elements. The buddhas were roughly carved into the surface of the hill. Ropes were attached to the sculptures and covered with plaster to create the folds of the drapery. The combination of thin folds and flat areas of cloth parallels the style of Buddha images produced at Sarnath in the first decades of the fifth century [2.13]; the sculptures dated between the mid-sixth and early seventh centuries. As mentioned earlier, Xuanzang describes the smaller of the two sculptures as Buddha Shakyamuni but does not discuss the identity of the larger image; it remains unclear whether all three sculptures represented Buddha Shakyamuni, whether one or the other of the standing figures represented another buddha such Vairocana, or whether both of the standing icons were symbols of the immanence and transcendence of celestial buddhas rather than depictions of specific deities.

FIGURE 3.9
OPPOSITE
A buddha.

Bamiyan, Afghanistan, sixth to early seventh century. It is possible that a mask, presumably of precious metal, once covered the face of the towering buddha at Bamiyan.

CENTRAL ASIA

FROM THE fourth to the eighth century, more than three hundred cave sanctuaries were constructed at sites such as Kizil (about two hundred caves, [3.10]), Kumtula (about one hundred caves), and Kizilgara (about forty-six caves) by the rulers of Kucha, a prominent state on the northern branch of the Silk Road. Like the Bamiyan complex, each center contained devotional caves as well as living and administrative quarters, and in some cases, wooden or mudbrick buildings. Most of the devotional caves in the Kucha region consist of a large front chamber linked to a smaller back chamber by two low, narrow arcades. Although this structure parallels that found in Indian complexes such as Ajanta, the thickness of the central wall between the two rooms and the narrowness of the arcades differentiates this style from those found elsewhere.

The imagery of the Kucha caves rarely varies: the center of the front chamber's ceiling is painted with auspicious motifs, while small images of seated buddhas or encapsulated representations of *jatakas* and other stories (not all of them readily identifiable) decorate the upper part of the side walls. The *jatakas* often feature ascetic practices, suggesting that, as seen in Indian cave sanctuaries, such activities were part of Buddhist practice in the area, particularly during the fourth through sixth centuries. Images of preaching buddhas surrounded by devotees are painted on the lower walls. A sculpture of a buddha sits in a niche on the front of the wall separating the front and back chambers, and a scene of the *parinirvana* combining sculpture and painting fills the back chamber.

FIGURE 3.10
The cave temple complex at Kizil.
Kucha, Xinjiang Uighur Autonomous Region. Caves at Kizil and other sites in the region are the predominant remnants of the Kucha civilization, which flourished on the northern branch of the Silk Road from the fourth to the sixth century.

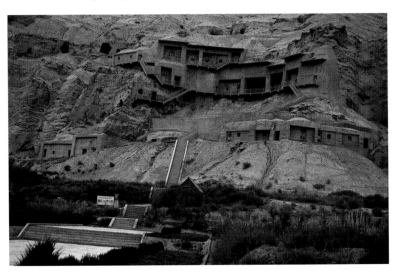

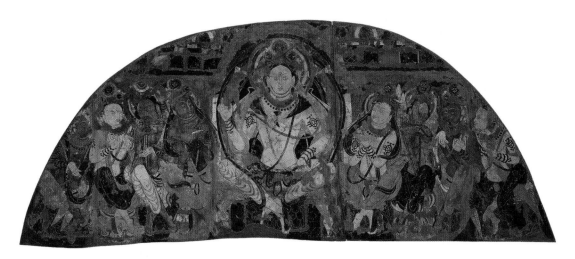

Bodhisattva Maitreya [3.11] is usually depicted in the crescent-shaped tympana over the doors to the caves. An example preserved in the Museum fur Indische Kunst, Berlin, shows Maitreya seated with his legs crossed at the ankles and attended by eight smaller bodhisattvas, four to the right and four to the left. The bodhisattvas are seated in the same pose as Maitreya, and all wear saronglike skirts derived from Indian clothing and short shawls. The clothing is depicted in the shades of malachite green and lapis lazuli blue commonly found in Kucha art. The alternating areas of deep folds and flat areas of drapery in the lower garments derived from Indian and Pakistan artistic traditions; this style was transmitted from Kucha to regions in northern China. All of the bodhisattvas also wear necklaces, earrings, armlets and bracelets, and elegant crowns topped with three large jeweled roundels. The primary bodhisattva is identified based on parallels to Chinese sculptures in similar poses, a few of which are named in inscriptions as Maitreya.

Large paintings of a distinctive type of buddha on the side walls of the front chamber or the arcades in some of the caves at Kizil and Kumtura provide some of the first visual evidence of devotion to Buddha Vairocana. As has been mentioned, Vairocana is the transcendent, unchanging form of the historical, temporary Shakyamuni. The understanding that the historical Buddha had more than one form is found in early texts and evolved into the belief that each buddha has three manifestations: an emanation in the phenomenal world (*nirmana-kaya*); another that appears in pure lands and is visible to bodhisattvas and other advanced practitioners (*sambhoga-kaya*); and a third, ultimate form (*dharmakaya*). These manifestations also parallel the division of the Buddhist universe into three

FIGURE 3.11
Bodhisattva Maitreya with attendants.

Detail from a painting over the doorway, Cave 224, Kizil Kucha area, Xinjiang Uighur Autonomous Region, fifth to sixth century. The cross-legged posture of the central figure helps to identify him as Bodhisattva Maitreya, while the postures of his attendants suggest that the group represents his pure land, known as the Tushita Heaven.

realms: the phenomenal world of desire, the realm of form, and the realm of nonform.

Buddha Vairocana is first mentioned in the fourth-century compilation of texts known as the *Sutra of the Heap of Jewels* (*Ratnakuta-sutra*) and plays a seminal role in the *Flower Garland Sutra* (*Avatamsaka-sutra*), where he is described as the source for all buddhas and bodhisattvas and for all existence in the cosmos. This concept is well illustrated in the paintings found at Kizil. Images of small buddhas fill the halo and mandorla of an example from Cave 13 [3.12], and additional images are also found on the clothing. The latter include Buddhas, Indic divinities such as Indra and Surya, praying figures, and hungry ghosts (*pretas*) shown standing between the legs of the towering buddha. Such ghosts are lost souls destined to live in hunger and thirst until they can be reborn. The earliest extant version of the *Flower Garland Sutra* was translated into Chinese in 420, and identification of the paintings at Kizil stems from parallels to similar icons created in China during the late sixth century [4.8] because one such figure is named as Buddha Vairocana. The tiny figure of a monk kneeling to the right of the buddha in the painting at Kizil, which reiterates his cosmic size, may also be an allusion to the concept of *pranidhi* in which the buddha of a past age predicts the future awakening of another buddha.

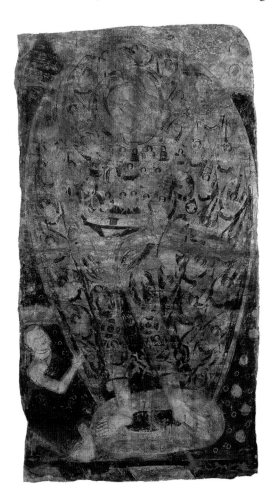

FIGURE 3.12
Buddha Vairocana.
Detail from a painting on a side wall, Cave 13, Kizil, Kucha area, Xinjiang Uighur Autonomous Region, fifth to sixth century. Vairocana, who is the transcendent manifestation of the historical Buddha Shakyamuni, is understood to embody the cosmos in his being.

CHINA

THE DIALOGUE between the established, literate culture of China and that of Indic Buddhism is one of the most long-lasting and fascinating in world history. From its introduction into China, parallels were found between Buddhist concepts and indigenous ideas. As a result, a distinctive Buddhist tradition, often known as Sinitic Buddhism, evolved in China and spread from there to Korea, Japan, and to a lesser degree northern Vietnam. Moreover, the Chinese commitment to written history, which was not shared by Indic cultures, led to biographies of monks and their patrons, as well as a history (not always

unbiased) of sectarian developments. In addition, sculptures and other artworks produced in China often carry inscriptions identifying the icons and explaining why they were produced. As a result, it is easier to identify the icons in Chinese art than those produced in India or at centers on the Silk Road, so the former can sometimes serve as the basis for studying and understanding the latter.

Both trade along the Silk Road and maritime activity contributed to the spread of Buddhism into China. The religion was most likely known there as early as the first century B.C.E. and may have been established in the first century when Emperor Mingdi (r. 57–75) dreamed of a golden man and sent envoys to bring back this person or image, presumably a sculpture of the Buddha, to the court. However, there are no known Chinese images of the Buddha from this early date. Texts, often the work of foreign monks living in designated quarters of the capital city at Luoyang in Henan Province, are preserved from the second and third centuries. During that time, Buddhism was often conflated with existing practices, such as a funerary cult focused on the construction of enormous tombs filled with necessities and luxuries. Rare examples of seated buddhas are sometimes found in the decoration of tombs and slightly later on the sides of ceramic urns.

Images carved on the cliffs at Mount Kongwang in Jiangsu, regarded as one of the three principal centers of Chinese Buddhist practice in the second and third centuries, include a standing buddha, identified by his monastic shawl and a conical form at the top of his head that represents an *ushnisha* [**3.13**]; two seated buddhas; a scene from a *jataka*; and a representation of the *parinirvana*. They are among 105 images, including Daoist figures, carved at the site and were most likely meant to be apotropaic figures, not unlike those of native traditions. Daoism, which derives from the word *dao* (usually translated as "way" or "path"), comprises teachings and practices that lead to a metaphysical understanding of the universe, which is constantly changing. It was originally based on the works of the semimythical Laozi and Zhuangzi, said to have lived during the Warring States period (403–225 B.C.E.); Daoist terms were often used in the translation of Buddhist texts. Circular depressions, possibly used to hold lamps or candles, are also found

FIGURE 3.13
A buddha and other figures.
Mount Kongwang, Jiangsu Province, China, Eastern Han Dynasty, second to third century. Early Chinese Buddhist images are often found in conjunction with those associated with Daoist practices or other local cults.

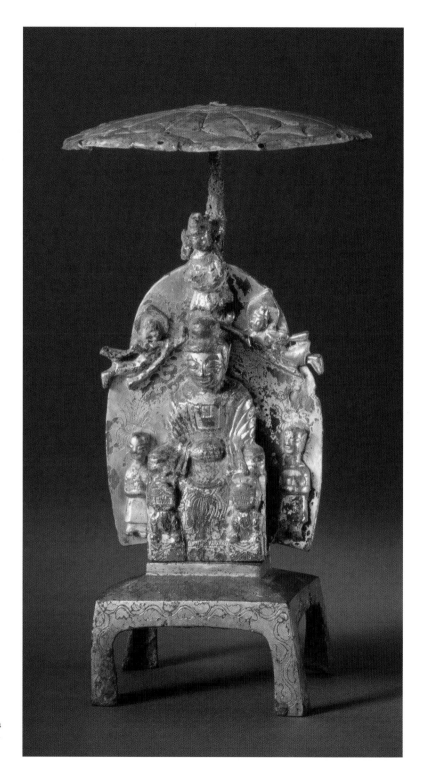

FIGURE 3.14
Buddha.

Shijiazhuang, Hebei Province, China, Sixteen Kingdoms period, third to fourth century. This is one of the few complete sculptures from third- and fourth-century China and was most likely intended for personal devotion.

at Mount Kongwang, suggesting that people living in the area used them as the focus of devotion or rituals.

Gilt bronze images produced in the northern part of China during the late third and fourth centuries, on the other hand, were independent icons rather than parts of larger amalgamations and show the development of practices specific to Buddhism. One piece excavated in Hebei Province in 1955 is a rare example of a complete sculpture from the period [3.14]. The central buddha holds his hands in a meditative gesture and is seated in a comparable posture on a high square throne with lions at the front. His elongated earlobes and *ushnisha* represent his advanced spiritual state, and he wears a long monastic shawl that covers both his shoulders, a style derived from earlier imagery in Pakistan and Afghanistan. Two small monks stand to either side of the central buddha, and two celestial figures fly overhead. Another seated buddha is placed directly above the main figure's head, and an enormous parasol, once decorated with spangles, caps the sculpture. Although this example is not inscribed, writing on contemporaneous images states that they were commissioned by individual donors to obtain merit for themselves and members of their families.

The names of many of the donors indicate that they were foreigners living in China during a time when the country was divided into various polities, many of which were under the control of non-native rulers. It is often suggested that Buddhism flourished in the third and fourth centuries because these rulers were not vested in native traditions such as Confucianism, which had previously been the primary method for unifying and governing the nation. As the name implies, Confucianism is based on the teachings of Confucius (the Western rendering of Kongzi, 551–479 B.C.E.), who emphasized morality, sincerity, and justice in government and personal behavior, as well as correctness in social relationships.

Construction of cave temples at such sites as Dunhuang in Gansu Province and Yungang in Hebei, which had begun in the early fourth century, thrived during the Northern Wei period (386–534) when northern China was reunited under the control of the Tuoba Xianbei. The Xianbei were a seminomadic, probably ethnically mixed people from the northeast. In the early fourth century, they systematically conquered or absorbed the various polities that controlled different parts of northern China and established an empire of great wealth characterized by economic and cultural ties to polities along the Silk Road, such as Kucha.

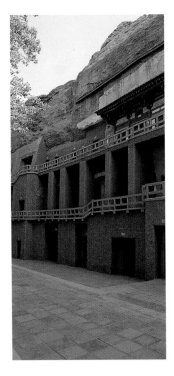

Unfortunately, internecine strife and political rivalries at court, which led to the persecution of Buddhists from 444 to 453, eradicated most of the textual and visual evidence of Buddhist practice in China prior to that time; discussions of Buddhism under the Northern Wei remain focused on material from the last part of the fifth century.

Buddhism was reinstated as the state religion in 452 and flourished during the reign of Emperor Xiaowendi (r. 471–499) and his regent, his infamous and powerful stepmother, Dowager Empress Wenming (442–490). Several of the earlier caves at Mogao [3.15], near the city of Dunhuang, were excavated during this period. Founded as a military post in 111 B.C.E., Dunhuang was an important meeting point between China and Central Asia. The earliest caves at Mogao were opened around 366 to serve as meditation chambers for monks, presumably those seeking a personal and probably austere form of practice as opposed to working at court or in an urban center. Several important worship halls were opened in the early fifth century, and construction at the site continued under the aegis of varying patrons until the fourteenth century.

Cave 254, which was opened in the late fifth century, is divided into two spaces—a rectangular veranda covered by a gabled roof, and a square inner chamber [3.16]—and shows the influence of Indian and Central Asian cave sanctuaries. A large, square pillar, based on the stupas found in Indian worship halls, dominates the inner space. The buddha on the western side of the pillar, which faces the entryway, is the most important icon in the sanctuary. He is larger than the sculpted and painted attendants that surround him and sits with his legs crossed at the ankles in the posture most commonly identified with Maitreya. This suggests that the cave sanctuary may allude to the Tushita Heaven, the pure land created and maintained by Maitreya. A large flame-shaped mandorla encircles the buddha. Asparas, angel-like beings, fly above his head, and demonic figures are painted on the base beneath. Over his upper garment, the buddha wears a long, square shawl that covers his left shoulder and falls to his ankles. A piece of the shawl covers his right shoulder in an impossible fashion, and the hems are splayed in an equally unconvincing manner behind his crossed feet. The inorganic and highly stylized folds of the drapery and the clear distinction made between these folds and the other areas of the shawl show interesting parallels to the treatment of the clothing worn by Bodhisattva Maitreya and his attendants in the cave sanctuaries at Kizil [3.11]; it

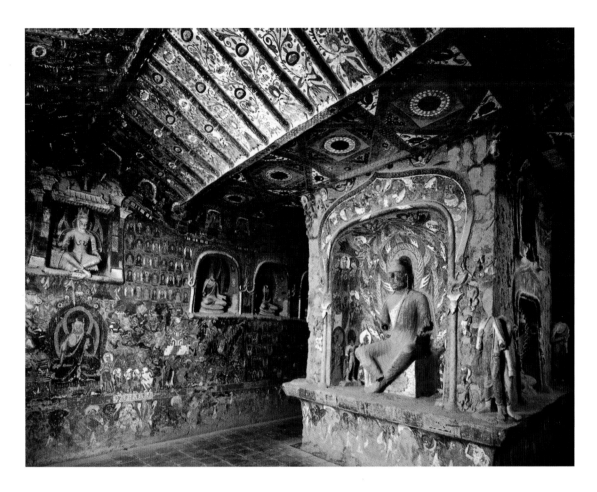

FIGURE 3.16
*The interior of
Cave 254 at Mogao.*

Dunhuang, Gansu Province,
China, Northern Wei period,
late fifth century. The large
pillar in the center of this
cave, which is decorated
with sculptures and paint-
ings on all four sides, derives
from the stupas found in
Indian cave sanctuaries.

seems likely that this Central Asian center served as one source for
the artwork at Mogao. Additional icons symbolizing the numerous
buddhas and bodhisattvas of multiple realms are found in niches on
the sides and back of the central pillar and on the side walls.

Paintings are interspersed with sculptures on the walls of the
inner chamber. A large depiction of the Buddha in his former life as
King Sibi is painted along the lower edge of the north wall. According
to the tale, which extols the virtues of generosity and selflessness,
Sibi one day saw a dove fleeing from an eagle. When he interceded
on behalf of the smaller bird, the eagle announced that he was
famished and that Sibi must replace the meat the dove would have
provided with his own flesh. Sibi, who had taken a vow never to
harm another living creature, agreed. In the lower left of the scene, a
minister is shown cutting flesh from the king's leg while the dove
hovers above [3.17]:

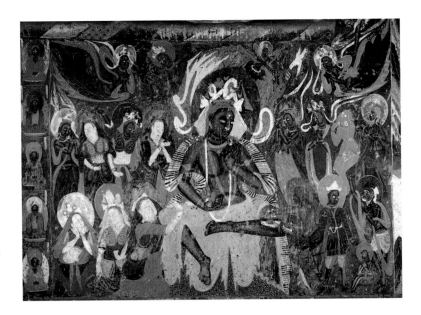

FIGURE 3.17
Siddhartha's life as King Sibi (Sibi jataka).

A painting on the north wall of Cave 254 at Mogao. Dunhuang, Gansu Province, China, Northern Wei period, late fifth century. The figure standing to the right of the seated king cuts flesh from the ruler's leg in order to feed a starving eagle and thus prevent him from killing and eating a smaller bird.

As the fearsome eagle tore at the king's flesh, the gods appeared in the sky. Some of the gods wept for the king, other praised his actions, while still others prayed to the Buddha. The king was calm and sat absolutely still. Suddenly the earth began to shake and colorful flowers fell from the heavens; the eagle and the dove disappeared. Miraculously, the king's flesh become whole again. The gods . . . had transformed themselves into the eagle and the dove to test the king's faith. The king had proved himself a pious man and the gods rejoiced with him.[4]

The composition of the scene, in which the central figure of Sibi is surrounded by smaller attendants, is reminiscent of the structure of the Maitreya painting at Kizil, as are details such as the treatment of the clothing and the tripartite crowns worn by several of the figures. Sibi's languorous pose, on the other hand, and the use of white to highlight his features can be traced to Ajanta and related sites in India. In addition to the three attendant bodhisattvas kneeling to the king's right, the painting composition also includes several standing bodhisattvas, two figures wearing armor, and a monk to the right; to the left more bodhisattvas and asparas with their hands in the gesture of respect, two emaciated ascetics, and a small standing figure whose long tunic suggests that he is Tuoba (possibly one of the donors of the painting). Like the other figures in the scene, the donor has a halo, a reference to his advanced spiritual state.

Northern Wei rulers and members of the aristocracy also supported the construction of a complex of fifty-three cave sanctuaries at Yungang near the capital of Pingcheng (present-day Datong). Historical records indicate that the first five structures excavated at this site, which are currently numbered Caves 16 through 20, were opened under the supervision of Tanyao, a cleric from northwest China who became the superintendent of monks in 460 and is known to have petitioned the court for permission to construct the sanctuaries. Each of the shallow caves, thought to have been constructed in honor of the first five emperors of the Northern Wei dynasty, contains a colossal sculpture of a buddha. Arguments continue regarding which of the caves was opened first and which cave should be with which emperor. In addition, it is unclear whether or not the colossi represent specific buddhas and, if so, which sculpture depicts which buddha.

The buddha in Cave 20 [3.18] is seated in a meditative posture and holds his hands in the corresponding gesture. His broad physique and features are comparable to works produced at Dunhuang and sites in the Kucha kingdom, as well as to artistic traditions in Afghanistan and India. He wears a a large shawl that falls over his left shoulder and also partially covers the right in a manner that is impossible with actual clothing. The stylized treatment of the clothing, in which thick, ribbonlike folds are interspersed with flat areas of drapery, is also found in contemporaneous cave temples at Mogao and reflects the transmission and amalgamation of the styles from Pakistan and India across the Silk Road. The folds are often linked to each other in unbelievable patterns and end in flamelike forms along the arms and shoulders.

Both individual and group donors, some of imperial birth, sponsored the excavation of the remaining caves at the site. Cave 10, which is a central-pillar cave fronted by a narrow veranda, is typical of the later constructions. Numerous sculptures, which were originally painted and subsequently repainted at various times, cover the walls of both the veranda [3.19] and the inner chamber. Apsaras alternate with large images of lotuses on the ceiling of the veranda, while the walls are filled with large and small images of standing and seated buddhas, many placed in individual niches. Elaborate palmette scrolls, derived from Mediterranean

FIGURE 3.18
Buddha.

Cave 20, Yungang, Shanxi Province, China, Northern Wei period, ca. 460–470. The pattern of the clothing worn by this colossal buddha derives from artistic traditions found in Pakistan and at sites, such as Kucha, along the Silk Road.

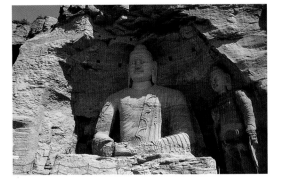

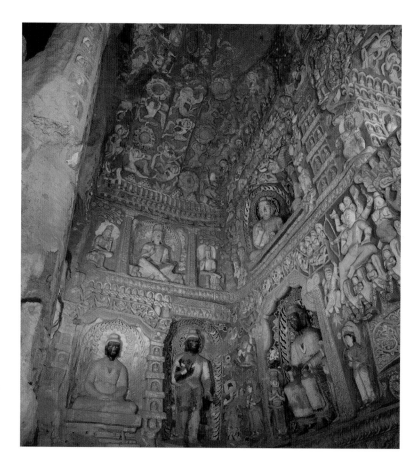

FIGURE 3.19
A view of the northeast corner of the antechamber of Cave 10.

Yungang, Shanxi Province, China, Northern Wei period, ca. 483. The profusion of figures on the side and back walls of this antechamber is characteristic of the cave sanctuaries at Yungang.

traditions that were spread by travelers along the Silk Road, further subdivide the walls. Representations of bodhisattvas seated with their legs crossed at the ankles and in the pensive pose, such as those in the upper section of the west wall, are frequently found in the cave sanctuaries at Yungang. The primary image, the figure seated with crossed legs, is on a rectangular base supported, or perhaps protected, by lions. He is encircled by a large, flaming mandorla similar to those seen at Mogao and attended by six small figures— four kneeling and two standing—whose hands make the gesture of adoration. He is separated from the two bodhisattvas on either side by large columns decorated with scrolling palmettes. The figures in the pensive pose, both seated on stools (possibly wicker) under flowering trees, are mirror images of one another; the one at the right crosses his left leg over his right knee, and the one at the left crosses his right leg over his left knee. All three figures wear long, skirtlike undergarments; thin shawls; and jewelry. The shape of the

crowns, particularly the jeweled roundels, further reflects influence from the Kucha region of Central Asia.

As mentioned previously, bodhisattvas with their ankles crossed are often identified as Maitreya and are thought to represent him seated in the Tushita Heaven; this identification seems reasonable for the primary figure in the group in Cave 10 as well. Figures in the pensive pose are also sometimes identified as Bodhisattva Maitreya; however, the secondary positions of the two figures in Cave 10 makes this unlikely. Instead, the pensive figures are probably intended to represent other beings living in the Tushita Heaven while awaiting a final rebirth during which they will become awakened. Texts such as the *Sutra of the Ten Stages* (*Dashabhumika-sutra*), which were popular in the northwest regions of the Indian subcontinent, detail a set of ten stages that each being must undergo in the quest for enlightenment. During the ninth stage, all beings, including Shakyamuni and Bodhisattva Maitreya, inhabit the Tushita Heaven while awaiting a final rebirth, and it seems likely that the two subsidiary figures in Cave 10 are intended to represent such figures as they sit in the Tushita Heaven in the presence of Bodhisattva Maitreya. In the second half of the sixth century, such pensive figures, which were often attendant figures in late-fifth-century art, became important independent icons and played an important role in the transmission of Buddhism farther east [4.6, 5.2, 5.13].

The opening of new sanctuaries at Yungang ended around 494, when the Northern Wei capital was moved southeast to the city of Luoyang. Spurred by a combination of political and economic factors, the move led to a greater appreciation of native Chinese aesthetics (as opposed to those derived from Central Asia and India), which had a dramatic impact on the style of Chinese Buddhist art in the sixth century. This seminal period marked the development of new and distinctive practice traditions within Chinese Buddhism and their dissemination to Korea and Japan.

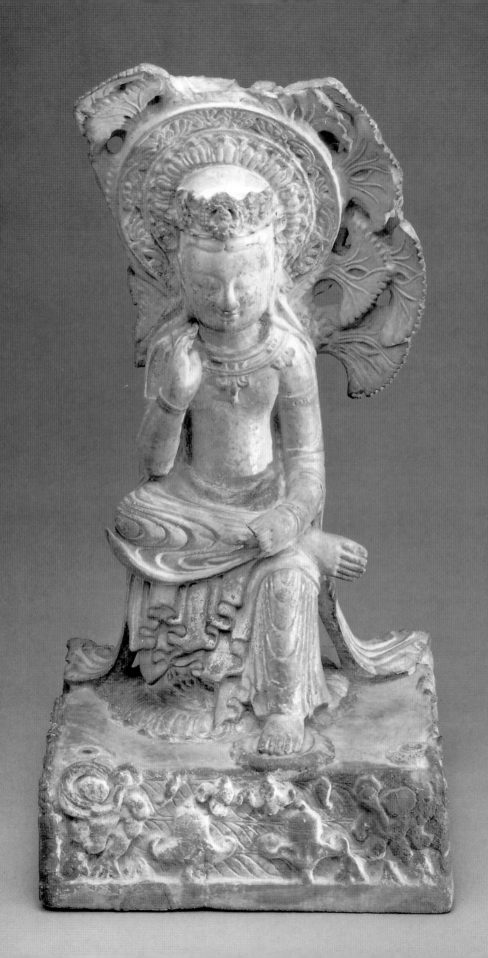

CHAPTER 4

China
A New Dimension, Sixth to Ninth Century

For a brief period, the capital established by the Northern Wei dynasty in the city of Luoyang was one of the most populous and sophisticated centers in the Asian world. Built around the remnants of earlier capitals, it contained palaces and administrative offices and was surrounded by smaller suburbs. Those to the south catered to the needs of the numerous foreigners, generally merchants or monks from various parts of Central Asia, who lived in China at the time. Historical records indicate that more than one thousand temples, some large establishments, and many smaller private dwellings were housed in the city and its environs. Known from written records and the recent excavation of its base, a towering pagoda built by Dowager Empress Hu around 516 and 519 in Yongning-si Temple ("temple of eternal peace") was famous throughout Buddhist Asia. The building's nine stories, which may have measured close to five hundred feet in total, were capped by a mast decorated with a golden vase, from which were suspended twenty-five smaller jars either made of or filled with semiprecious stones. It was burned down during a thunderstorm in 534.

Yongning-si and most of the other monasteries, as well as much of the capital, were destroyed in the fighting that led to the downfall of the Northern Wei dynasty around 534. Economic pressures and internal strife between the sinicized Tuoba Xianbei aristocracy living in the capital and their more traditional brethren stationed in the northern garrisons led first to an attack on Luoyang and ultimately to the dissolution of the dynasty. Written descriptions and a few works of art are all that remain of the innumerable sculptures, paintings, and other luxuries that once filled the temples and palaces of Luoyang.

FACING PAGE
A bodhisattva in the pensive pose.
See page 88.

FIGURE 4.1
*The cave temple
complex at Longmen.*
Henan Province, China. The
cave complex at Longmen
is the largest in Asia and
contains around twenty-three
hundred sanctuaries.

FIGURE 4.2
OPPOSITE
A buddha with attendants.
The back wall of Cave 140
(Middle Binyang Cave).
Longmen, Henan Province,
China, Northern Wei period,
ca. 523. Groups of seated buddhas
attended by two bodhisattvas and
two monks became common in
China in the early sixth century.

Some idea of the physical appearance of the sculptures and other images produced in this area during the first part of the sixth century has been preserved in the cave sanctuaries at Longmen [4.1], which were first opened then. Longmen, which also saw imperial patronage in the late seventh and eighth centuries, is one of the more extensive cave temple centers in Asia and contains nearly twenty-three hundred sanctuaries, as well as more than one hundred thousand sculptures. Unlike Yungang, the Mogao caves, or centers in Central Asia and on the subcontinent, Longmen also has more than twenty-eight thousand preserved inscriptions and serves as a major resource for the study of Buddhism in China.

Cave 140, also known as the Middle Binyang Cave, is a small, square structure. It was constructed by the Northern Wei emperor Xuanwu (r. 500–516) in honor of his father, Emperor Gaozu (d. 499), and was paired with the Northern Binyang Cave (Cave 104) intended to honor his mother, Dowager Empress Wenzhao. Unlike the profusion of figures that decorated the walls of earlier cave sanctuaries such as Mogao and Yungang, organized groups of figures, each centered around a single buddha, fill the back [4.2] and side walls of Middle Binyang Cave. The buddha on the back wall, the most important figure in the cave, is seated in meditation. He holds his left hand in the gesture of reassurance and his right in the gesture of beneficence, a combination often found in Chinese art, particularly to show buddhas and bodhisattvas who are manifest in the temporal world. Two lions guard the seated buddha, and two small monks and four bodhisattvas accompany him. Although the identity of this buddha and two others in the cave is not certain, the focus on an individual buddha rather than several such figures foreshadows the changes that were to come in Chinese Buddhism later in the century, when devotion to specific buddhas became more common. The buddha's thin torso, narrow shoulders, and thick clothing exemplify the style of Buddhist imagery that evolved in Luoyang in the early sixth century. The emphasis on thick clothing that obscures the body rather than thin drapery that reveals the underlying form illustrates the development of Chinese-style, as opposed to Indic or Central Asian, Buddhist images.

The attenuated physique and heavy, concealing drapery of the primary buddha in the center of an altarpiece dated 524 [4.3] also

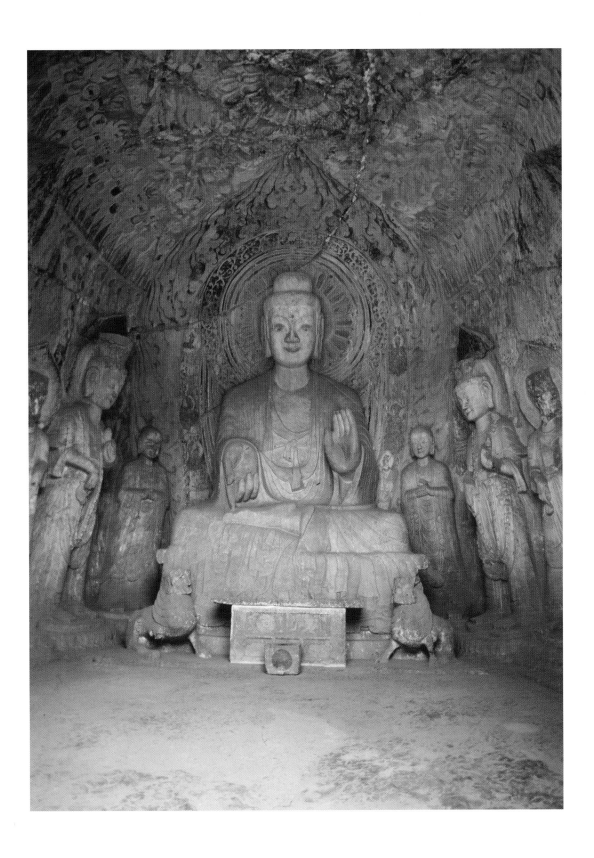

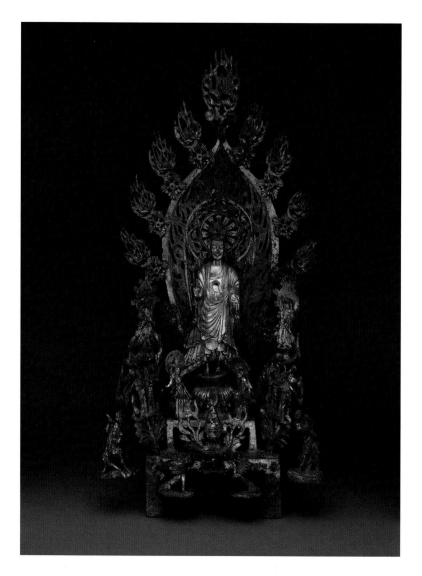

FIGURE 4.3
Buddha Maitreya (Mile).
Hebei Province, China, North-
ern Wei period, dated 524. The
position of the central figure's
hands suggests that this altar-
piece depicts Maitreya and his
entourage as they descend to
earth to guide the deceased to
rebirth in the Tushita Heaven.

show the Luoyang style of imagery. A badly abraded inscription on
the back of the base identifies the central figure as Buddha Maitreya,
gives the date, and states that a certain individual commissioned
the piece on behalf of his deceased son Gaizhi. The inscription also
expresses the hope that the son and other relatives will eventually
be united in the presence of the buddha. Buddha Maitreya has a
long, narrow face with angular features. A voluminous shawl covers
his sloping shoulders and thin torso. The folds of the clothing fall in
sweeping arcs across his torso and split into stiff edges at either side
in a pattern that resembles a fish tail. Twelve apsaras, many playing

musical instruments, encircle the flaming mandorla that surrounds Maitreya and his entourage. Four bodhisattvas, two standing and two seated in the pensive pose, attend the buddha. Two of these figures stand on lotus pedestals that emerge from the mouths of coiled dragons, a motif that became prominent in the second half of the sixth century. Four donors hold offerings, stand behind the attendant bodhisattvas, and wear Tuoba Xianbei (rather than Chinese) clothing. Two small monks stand behind these donors, and just behind them is an incense burner, which can be opened and may have been used in devotions focusing on the sculpture, nestled in the burgeoning lotus flower at the front of the altarpiece. Crouching lions and semiclad guardians yielding weapons appear at the front of the altarpiece.

The standing posture of the buddha, the combined gestures of reassurance and beneficence, and the celestial entourage that surrounds him suggest that the sculpture shows Maitreya as he is descending from the Tushita Heaven—symbolized by the figures in the pensive pose—to help devotees on earth. The two miniscule figures (one standing, one kneeling) on lotus pedestals to the right and left of the incense burner represent souls that will be reborn into that paradise. Devotion to Buddha Maitreya and the desire for rebirth in the Tushita Heaven were important aspects of Chinese Buddhism in the late fifth and early sixth centuries, when life was often uncertain due to harsh political realities and natural disasters. The barbaric battles that ended in the downfall of the Northern Wei Empire also intensified the desire for salvation and led to the development of new practices centered on Buddha Amitabha (Amitou) and the desire for rebirth in his pure land, known as Sukhavati, in the second half of the sixth century.

After the fall of the Northern Wei, northern China was divided into an eastern polity ruled by the Eastern Wei (534–550) and the Northern Qi (550–581) and a western one ruled by the Western Wei (535–557) and the Northern Zhou (557–581). In the late sixth century, the nation, including the powerful southern dynasties that still belonged to the Han Chinese, was reunified under the Sui (581–617). Many regional styles illustrate the renewed ties with India and Central Asia and exemplify Buddhist imagery at the time. The numerous iconographic innovations during this period, on the other hand, reflect the coalescence of distinctly Chinese traditions of Buddhism. Several of the more important schools of East Asian Buddhism, based on a single text or related group of texts, arose and were transmitted to Korea and Japan.

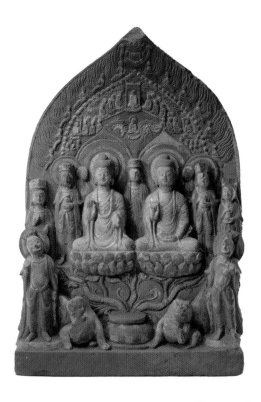

FIGURE 4.4

Buddhas Shakyamuni (Shijiamouni) and Prabhutaratna (Duobao) with attendants.

Chengdu, Sichuan Province, China, Liang dynasty, dated 545. The representations of two buddhas seated side by side illustrate a critical moment in the *Lotus Sutra* in which the buddha of the last world era appears to confirm the teachings of Siddhartha/Shakyamuni.

Two central buddhas dominate a small sculpture [4.4] produced in the southwestern province of Sichuan during the rule of the Liang dynasty (502–557), the wealthiest and most powerful of the southern dynasties. The pointed aureole and the overflowing vase (an Indian motif) at the base of the stele are characteristic of works from this province. An inscription on the back indicates that the piece was commissioned in 545 by a disciple named Zhang Yuan, who had the image made to ensure that his ancestors and relatives would be reborn in a realm where they could listen to a buddha teaching. While the robes worn by the buddhas retain the thickness typical of the early sixth century, the full faces of the central figures and the round forms of the attendants illustrate the renewed interest in volume found in the art of the time. Excavated in 1995, the sculpture retains traces of pigment, largely gold and red, that once covered the entire surface.

The two buddhas, the principal images on the sculpture, illustrate a crucial moment in the *Lotus Sutra* (*Saddharmapundarika-sutra*), which was particularly influential in East Asian Buddhism and was translated into Chinese at least six times between the third and seventh centuries. In a famous passage in the eleventh chapter, Buddha Prabhutaratna (Duobao), the buddha of the last era before this one, appears in a giant stupa in the sky while Shakyamuni is preaching, proving that he, like the historical Buddha (Shijiamouni), remains immanent. His appearance illustrates his vow to be present whenever the *Lotus Sutra* is preached. The theme of Shakyamuni and Prabhutaratna was popular in China in the late fifth and early sixth centuries. The buddhas here are attended by a large retinue, including five bodhisattvas, two monks, and two guardians, as well as small figures of donors at the sides of the sculpture. Apsaras decorate the upper edges of the piece, and an audience, who had presumably witnessed the miraculous appearance of Buddha Prabhutaratna, is depicted above the buddhas.

The *Lotus Sutra,* which is filled with miraculous happenings and dramatic metaphors, states that Buddha Shakyamuni did not become extinct after the *parinirvana* but still abides in the phenom-

enal world to guide the faithful. His lifetime as Siddhartha was an illusion designed to help devotees, who would otherwise be unable to grasp the reality of a transcendent being. This sutra is the primary text used by the Tiantai branch of Buddhism, which is noted for its classification of Buddhist teachings into certain hierarchical groups; its emphasis on meditation; and the unusual belief that the Buddha's mind, which is the cosmos, can contain impurities. Tiantai was developed in China in the late sixth and early seventh centuries and became one of the more prominent branches of East Asian practice.

First used in the early sixth century, large, two-sided stelae—often encapsulating a variety of images based on different texts—were placed in prominent locations, such as at major crossroads and in the courtyards of large temples, throughout northern China. They were based on comparable stelae that were covered with written inscriptions and placed strategically throughout the Han Empire (206 B.C.E.–220 C.E.) to help promulgate imperial decrees. The dramatic dragons placed on either side at the top of a stele now in the Henan Provincial Museum [4.5] are standard in such monuments and reflect their origins in earlier imperial imagery. A large inscription on the back states that the stele was commissioned in 559 by thirty members of a devotional society led by Zhang Dangui, Gao Hailing, and Huo Zao. Members of this group, many of whom had familial ties, are also known to have commissioned other artworks at around the same time. The small figure in the pensive pose with one leg resting on the other, seated under a tree, and accompanied by two standing attendants (top middle section of the stele) illustrates the interest in Maitreya and the desire for rebirth in the Tushita Heaven that prevailed in China during the late fifth and much of the sixth century.

In the scene below, eight monks and one woman attend a famous discussion, recorded in the *Sutra on the Discourse of Vimalakirti* (*Vimalakirti-nirdesha-sutra*), between the layman Vimalakirti (Weimo) and Bodhisattva Manjushri (Wenshu), whose name means "gentle" or "sweet glory." The learned layman seated in a palanquin to the right debates with Manjushri, the embodiment of Buddhist wisdom sitting under a large canopy at the left. Written in

FIGURE 4.5
A stele commissioned by Zhang Dangui and others.
China, Northern Qi period, dated 557. The donors of the stele, who are identified in the inscription, are also cited as patrons on other works of Buddhist art commissioned in the second half of the sixth century.

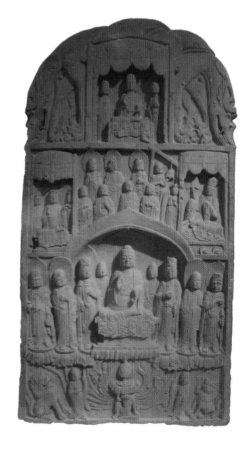

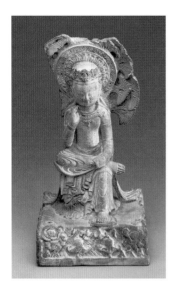

India around 150, the sutra stresses the danger of superficial judgments based on external appearance, validates lay practice, and stresses the pursuit of the perfection of wisdom. The woman at the far right of the group, identified by her clothing and the two knots in her hair, represents the monk Shariputra who, during the course of the debate, changed himself into a woman and back into a man to stress the impermanence and irrelevance of gender and other states of being. As is typical in imagery of the mid-sixth century, a large retinue that includes two figures wearing turbanlike headgear (presumably laymen), two bodhisattvas, two monks, and two guardians attend the primary buddha in the center of the stele. Guardians, lions, and two donors (one male, one female) stand to either side of the lotus, which is supported by a caryatid on the base of the stele. The juxtaposition of the heavy, concealing drapery covering the buddha and thinner, more revealing clothing worn by his attendants shows the transition from the attenuated imagery of the early sixth century to the fuller figures with thinner garb that predominated in the second half of the century.

Popular in late-fifth-century cave sanctuaries, such as Mogao and Yungang, figures in the pensive pose were not important in the early sixth century but became prevalent again in the northeast during the rule of the Northern Qi. The combination of a broad torso with thin drapery and the fuller folds of the lower garment on a sculpture [4.6] help date the work to between 550 and 560. Unlike earlier examples, this figure is not a subsidiary image but functions as the principal icon. The pensive bodhisattva sits beneath two entwined trees (now partially damaged), a motif used during the Northern Qi period to signify the auspiciousness of the rulers of that dynasty. The pond filled with large lotus blossoms and buds, which covers the base of the sculpture, illustrates the transition in the late sixth century from images of pensive figures seated in paradisiacal realms to actual representations of such pure lands; such paradises were often described as having ponds filled with lotuses.

Entwined trees and lotus ponds, particularly those with flowers bearing small figures that represent souls reborn there, are also standard motifs in depictions of Sukhavati (the "land of bliss"), the perfected realm of the Buddha Amitabha. Devotion to Amitabha and the desire for rebirth in the land of bliss may have been spurred by the turmoil that defined Chinese history in the sixth century, when constant political instability and economic chaos mitigated the value of waiting through several lifetimes of unhappiness for

Maitreya's arrival as the future buddha. The continuous friction between the two northern regimes, as well as between the north and the south, and internecine strife among the ruling elite resulted in frequent battles, assassinations, and massacres. This political uncertainty, combined with numerous crop failures, rendered life unbearable for both the aristocracy and the general populace. In Buddhist circles, the harsh reality of the period led to the belief that the second half of the century was the period of the *mofa,* an apocalyptic era when Buddhism would cease to exist. An escape into Sukhavati or some other pure land seemed the only possible way to continue the quest for self-realization or enlightenment.

Practices focusing on Buddha Amitabha, which may have originated in Central Asia, were known in China as early as the third century. The tradition, which is based on a group of three texts describing both Sukhavati and the forty-eight vows taken by Amitabha to create this pure land when he was a bodhisattva named Dharmakara, became formalized as a special branch of Buddhism in the mid-sixth century. The Indian monk Bodhiruci, who was active at both the Northern Wei and Northern Qi courts, introduced the Chinese cleric Tanluan (488–532) to the texts praising the pure land of Amitabha, thereby setting the stage for the development of the Pure Land (*Qingtu*) school of Buddhism. The texts focus on attaining rebirth in Amitabha's pure land through practices such as prostration, the calling of the buddha's name (known in Chinese as *nian fo*), reflections on and visualizations of the sacred realm, and the resolution to be reborn there.

Buddha Amitabha, whose head is surrounded by an elaborate halo, sits on a beautifully decorated throne in the center of a sculpture that is one of the earliest known images of Sukhavati [4.7]. An inscription on the back indicates that the sculpture was dedicated in 593 by eight women of the Fan clan to ensure the rebirth of their ancestors and children in the pure land. Seven small buddhas are seated in the blossoms of the trees in the background, and a single phoenix—a traditional Chinese symbol of rebirth—is also placed among the branches. Tassels filled with pearls, references to the bejeweled nature of Sukhavati, hang from the trees: "and it is beautiful and embellished with four kinds of precious materials—gold, silver, lapis lazuli, and crystal . . . and jeweled trees are growing embellished with four precious materials."[1]

Two bodhisattvas, two monks, and two donors (one male, one female) stand beside of the seated buddha. Guardians and lions are

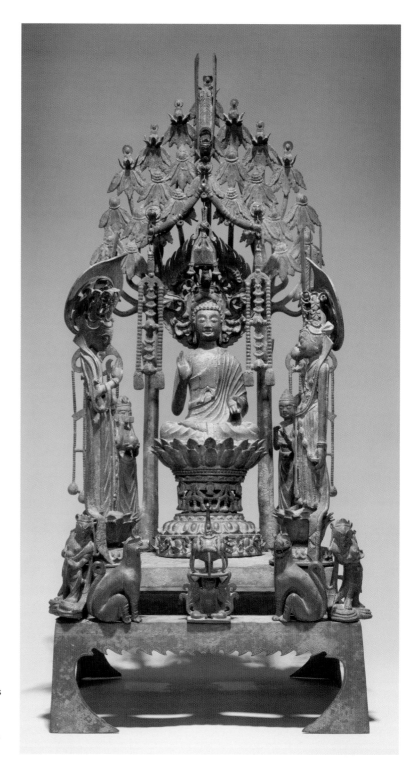

FIGURE 4.7
*Buddha Amitabha
(Amitou).*

Zhaozhou, Hebei Province,
China, Sui dynasty, dated 593.
Commissioned by seven mothers
on behalf of their families, this
altarpiece is one of the earliest
known renderings of the western
pure land of Buddha Amitabha.

situated to either side of a small caryatid that lifts a lotus bud at the front. A miniscule figure, representing a soul that has been reborn, sits in the center of the flower. Once the soul is reborn in the land of bliss, he or she will live in a perfect realm where conditions are conducive to the attainment of enlightenment. Over time, this being will become a buddha and transcend Amitabha's realm, which is a way station rather than the final goal of practice.

Representations of Buddha Vairocana (Dari or Piluzhena), which have not been identified from the late fifth century, also reappeared in China in the second half of the sixth century. The earliest known example is painted on the center of the south wall of Cave 428 at the Mogao complex [4.8], a good-sized central-pillar cave constructed during the Northern Zhou period. The buddha stands under a canopy and is attended by six bodhisattvas and four flying figures, most likely *vidyadharas*. Indian and Central Asian influences are reflected in the broad figure of the buddha, the style of clothing worn by the bodhisattvas, and the somewhat excessive use of white pigment to highlight facial features. Scenes representing different aspects of the cosmos, similar to those found in the painting at Kizil [3.12], cover Vairocana's clothing. Small buddhas, as well as a type of demigod known as an *asura* holding the sun and the moon, can be seen on the upper part of the shawl. In Buddhist cosmology, *asuras* are thought to dwell just below the gods, who reside on the slopes of Mount Meru, the center of the Indian cosmos. Human beings cover the central section of the shawl, while monkeys, birds, horses, and other representatives of the animal world are shown on the lower part. A hell in which the warden drives unfortunate inhabitants through narrow pikes is depicted on the hem of the undergarment. (Images of hell were an important theme in Eastern Asia after the tenth century [9.7, 10.9].

After a brief period of persecution at the end of the Northern Zhou dynasty, Buddhism once again flourished during the Sui and Tang dynasties. Emperor Wendi (r. 581–604), the founder of the Sui dynasty, was a Buddhist and used different practices, as well as the discovery and veneration of relics, to unite and protect his realm. Many rulers of the subsequent Tang

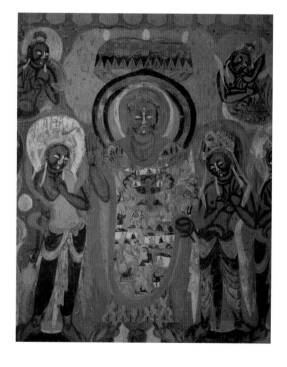

FIGURE 4.8
Buddha Vairocana (Dari or Piluzhena).
Detail of a painting on the south wall of Cave 428, Mogao complex, Dunhuang, Gansu Province, China, Northern Zhou period, 557–581. This painting, which is part of a larger group of images on the walls of a cave temple, is the earliest known image of Buddha Vairocana in China.

dynasty (617–906) were also devout; they unearthed and displayed relics, supported the establishment of temples as centers of learning and practice, and commissioned works of religious art. One of the longest lasting in Chinese history, the Tang dynasty was a period of great wealth and sophistication, with political and mercantile ties extending from the Byzantine world to Japan. Both overland and maritime trade thrived, and monks traveled throughout Asia, helping to spread new forms of Buddhist practice and related imagery. The Chinese pilgrim Xuanzang is one of the most famous. As mentioned in chapter 3, his *Record of the Western Regions,* an account written after his return to China, remains a seminal source for the history of India and Central Asia at the time.

Three intrepid Indian monks named Subhakarasimha (637–735), Vajrabodhi (669–741), and Amoghavajra (704–774), who also studied with learned masters throughout Asia, introduced a new type of Buddhism to China in the eighth century. Preserved primarily in Japan, this new form of Buddhism reiterated the importance of devotion to Buddha Vairocana; introduced additional forms of well-known deities, such as an eleven-headed Bodhisattva Avalokiteshvara [5.4]; and established the use of cosmic diagrams, or mandalas. Many of the practices that were part of this new tradition were intended to protect the nation and offer tangible benefits such as health and wealth to the ruling elite, while others included complex rituals and other forms of devotion designed for more advanced practitioners.

As discussed in chapter 3, Vairocana's role as the cosmic buddha is based on the *Flower Garland Sutra,* which was first translated into Chinese in the early fifth century. This text became important during the prosperous Tang dynasty, when two new translations were produced: one in 698 by the Indian monk Prajna, and a second in 704 that was part of a collaboration between the Shiksananda from India and Fazang (643–712), a sinicized Central Asian. Fazang is considered the third patriarch of the Huayan branch of Buddhism, which focuses on the *Flower Garland Sutra. Huayan* is also the Chinese translation of the name of this text. Fazang is famous for using metaphors—often involving light, jewels, and mirrors—to explain the interpenetrability of all aspects of the cosmos in which even the tiniest speck of dust can reveal ultimate truth. He is also noted for his systematization of the vast corpus of texts and practices found in China into five groups, with the *Flower Garland Sutra* as the highest form of knowledge. This sutra is followed by texts such as

the *Sutra of the Discourse of Vimalakirti* that accepted the possibility of a sudden awakening, those classified as later Mahayana teachings, those deemed to be earlier Mahayana teachings, and writings associated with mainstream Indian Buddhism.

Fazang, who was influential at court, served as an adviser to both Emperor Gaozong (r. 650–683) and his draconian and politically astute consort, who usurped the throne and ruled as Empress Wu Zetian (r. 690–705); devotion to Buddha Vairocana was important during both of their reigns. Under Wu Zetian, parallels between Buddha Vairocana as the ruler of an eternal, celestial realm and the empress as a just but temporary and temporal ruler were used to legitimize her control of China. As a woman, Wu Zetian could not rely on perennial Confucian themes to justify her usurpation of the throne and instead cited the apocryphal *Great Cloud Sutra* (*Dayunjing-sutra*), which extolled the just rule of a woman several centuries after the death of the Buddha.

The colossal buddha in a niche carved into the side of a cliff at Longmen near Luoyang is an embodiment of Vairocana as the generative force of the cosmos [4.9]. An inscription on the left side of the dais supporting the buddha suggests that the sculpture was begun during the reign of Emperor Gaozong and completed around 675 through the patronage of the soon-to-be empress Wu Zetian. She donated substantial funds, including some earmarked for her cosmetics. The inscription also lists the names of the monks and administrators who were responsible for the construction of the niche, which may have required about twenty years to carve. Buddha

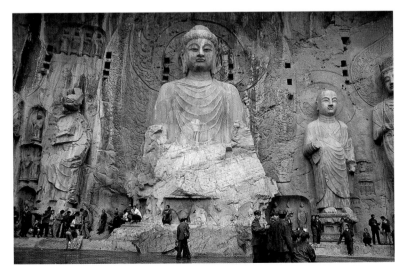

FIGURE 4.9
Buddha Vairocana (Dari or Piluzhena) and attendant bodhisattvas.

Cave 1280 (Fengxian-si), Longmen, Henan Province, China, Tang dynasty, about 675. The colossal figure of Buddha Vairocana and those of his attendants were carved under the patronage of Emperor Gaozong and his wife, Wu Zetian, who is infamous for gaining control of the Tang Empire and ruling in her own right.

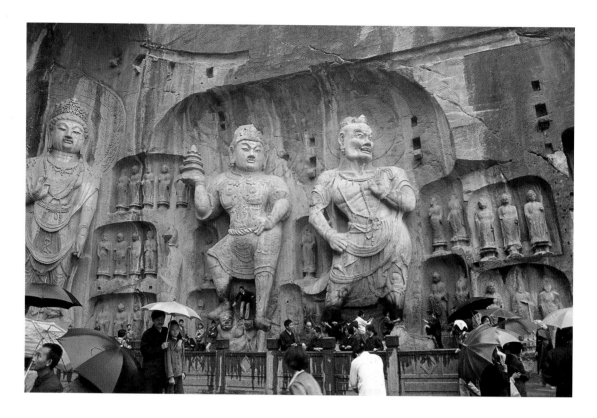

FIGURE 4.10

The guardian Vaishravana (Pishamen) and an entry guardian.

Cave 1280 (Fengxian-si), Longmen, Henan Province, China, Tang dynasty, ca. 672–675. Vaishravana, the guardian of the northern quadrant, is often identified by the pagoda he holds.

Vairocana's full shoulders and chest are covered with a thin shawl that falls in large, graceful arcs, and he has a strong face with plump cheekbones and downcast eyes. The fullness of the buddha's form and features are typical of the boldness often found in Chinese art in the late seventh and early eighth centuries, and they reflect the renewed ties with India and Central Asia at that time. Buddha Vairocana sits before a towering, flaming mandorla filled with celestial figures playing music and several small triads of a standing buddha with two attendants. The latter symbolize the manifestations of Vairocana and his powers throughout the cosmos.

Vairocana measures about fifty-six feet in height and is the center of a symbolic assemblage that includes two monks standing to either side of him, two bodhisattvas to the sides of the monks [4.10] and four guardian figures, two at each end of the group. The bodhisattvas and monks symbolize the spiritual and earthly realms, while the four guardians protect the Buddhist cosmos within. The bodhisattvas wear undergarments derived from India; long, flowing scarves; and precisely detailed jewelry that includes delicately rendered, multistoned necklaces and long chains composed of varying

strands of pearls and other jewels. Both these attributes and the dramatic armor worn by the guardians derive from imagery that developed in China in the late sixth century. The glaring, monstrous face in the lower part of the breastplates worn by the guardians and the dense scaling of the armor are also found in later representations of this type of figure throughout Eastern Asia. The outermost guardians, known as *dvarapalas,* are the protectors of entryways. The inner pair, who wear armor and stand on grotesque, demonlike creatures, are part of a set of four protectors of the cardinal directions, known as *lokapalas,* or heavenly kings (*tianwang*). Based loosely on the auspicious *yakshas* of early India, the *lokapalas* were first codified in Central Asia in the fifth or sixth century and appear in Chinese art in the middle of the sixth. Their inclusion in assemblies surrounding a buddha helps define the space as a cosmos peopled by deities (bodhisattvas), humans (monks), and demigods (various types of guardians). The figure to the right of the buddha and his attendants, identified by the pagoda he holds in his right hand, is Vaishravana (Pishamen), the protector of the north. The only one of the four guardians of the cardinal directions worshipped independently, Vaishravana was revered as a protector of the nation and of Buddhism.

The development of political and economic ties to the Kashmir region, which was one of the major centers for practice on the subcontinent in the seventh and eighth centuries, is reflected in the style of images at Tianlongshan, a smaller complex containing only twenty caves, near Taiyuan in Shanxi Province. Tianlongshan was first constructed in the mid-sixth century and reopened during the Tang dynasty. The broad shoulders, narrow waist, square face, full cheeks and lips, thin, narrow eyes, and stylized hair of a buddha from Cave 21 at the site [**4.11**], as well as the focus on depicting the body rather than the clothing that covers it, illustrate the arrival of a new wave of Kashmiri influences in the early eighth century. Also prevalent in works of art produced in the capital at Xi'an in the early eighth century, this style is often known as the "International Tang style" because of its popularity in the art of Korea and Japan at the time.

FIGURE 4.11
A buddha.
Cave 21, Tianlongshan, Shanxi Province, China, Tang dynasty, ca. 700. This elegant buddha from China shows the influence of Kashmiri traditions from the late seventh and early eighth centuries.

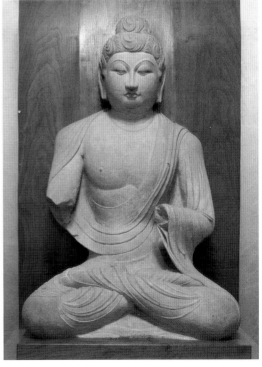

Breathtaking archaeological discoveries, many dating from 1970 on and contributing to a substantive redefinition of the development of Chinese culture, have also yielded numerous artworks that are seminal to the study of Buddhism in China in the second half of the Tang dynasty. The heavy, earthbound body of a sculpture of an unusual form of the Bodhisattva Avalokiteshvara [4.12]—excavated at Xi'an, the Tang capital in Shaanxi Province, in 1976—dates the piece to between the mid- and late eighth century. The damaged horse's head at the top of the sculpture and the small buddha seated in the front of the headdress identify the work as an image of the Bodhisattva Avalokiteshvara as Hayagriva, or "with a horse's head" (Matou Guanyin). One of six esoteric manifestations of the bodhisattva of compassion probably introduced to China in the eighth century as part of the court's sponsorship of new practices, this form has three human heads that are distinguished by their glaring eyes and grimacing mouths. The central face has fangs. The two central arms are held in an esoteric mudra known as the "horse mouth gesture," in which the palms are placed together with the second and fifth fingers raised and the nails touching, which represents resistance to evil and the spread of compassion. The remaining six hands emphasize the range of the bodhisattva's powers. The lower right is held out in the gesture of reassurance, while the two above it hold a rosary and an ax. The latter and the sword in the upper left hand are often used in Buddhist imagery to symbolize the destruction of ignorance and other delusions. The middle and lower left hands hold a vase and a lotus flower with a long stem, respectively—traditional attributes often found in representations of Avalokiteshvara.

One of the most important discoveries is a small, gilt bronze reliquary unearthed in 1987 during the excavation of an underground chamber at Famen-si Monastery near Xi'an. The casket was part of a set of four nesting reliquaries [4.13] used to hold a human finger bone thought to have belonged to Buddha Shakyamuni. The bone was wrapped in silk and placed in a small jade coffin, which was then placed in one made of rock crystal. The gilt bronze casket held the two smaller reliquaries, and was in turn enclosed in a larger iron box. The top and sides of the bronze reliquary are covered with images of buddhas and other divinities arranged in groups of five, and it provides one of the earliest known depictions of the mandala of the diamond world, or the Vajradhatu mandala, an important icon that plays a seminal role in Japanese traditions and was also influential in Java from the eighth through the eleventh centuries

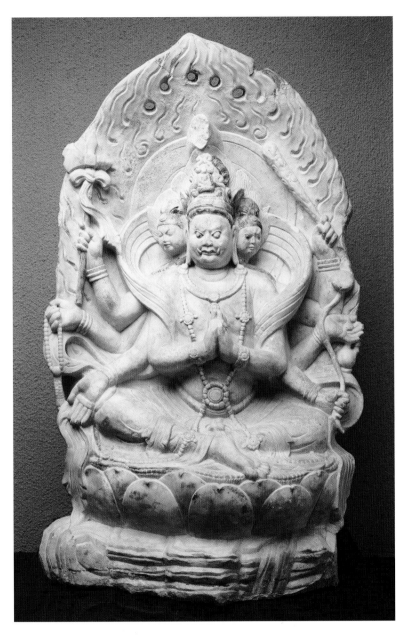

FIGURE 4.12
Bodhisattva Avalokiteshvara with a horse's head (Matou Guanyin).

Forest of Steles, Xi'an, Shaanxi Province, China, Tang dynasty, mid-eighth century. This horse-headed form is one of the more powerful manifestations of the bodhisattva of compassion.

[8.19]. Buddha Vairocana, identified by the distinctive gesture in which the left hand holds the thumb of the right, is the primary deity in this mandala. He is shown on the top of the casket accompanied by four additional buddhas and four bodhisattvas. Ancillary figures decorate the sides of the lid. Four other buddhas, each attended by a small retinue and set against a background of swirling vegetable

scrolls, are shown on the four sides of the gilt bronze reliquary: Amitabha is placed to the west (the location of Sukhavati), Buddha Amoghasiddhi ("infallible accomplishment") to the north, Aksho-bhya to the east, and Ratnasambhava ("jewel-born") to the south. Although it remains unclear when the five buddhas began to be used as a group, by the eighth century, they were understood as the heads of the five families or lineages of the innumerable deities of the expanding Buddhist pantheon.

The structure of the underground chamber at Famen-si, which resembles that of an imperial Chinese tomb, allowed access to the relics stored inside, and it is clear that the sacred remnants were removed from this site and displayed in the capital at least seven times during the Tang dynasty, presumably as an act of devotion, as well as to legitimize the rule of various emperors and to bring good luck to the nation. A finger bone housed in another set of nesting reliquaries from the site is also thought to have been the relic mentioned in a memorial written by Han Yu (768–824) to Emperor Xianzong (r. 805–820) protesting devotion to such items:

Although your servant is extremely foolish, he still knows that Your Majesty will not be deluded by the Buddha into worshipping [the relic] like this in the hope of achieving happiness and auspiciousness. This is simply a frivolous gimmick and a deceitful and exotic spectacle set up for the officials and commoners of the capital in an attempt to humor some people at the time when the harvest is good and people are happy. It cannot be true that [Your Majesty], so sage and brilliant, believes in this sort of thing . . . The Buddha was originally a man of the barbarians . . . if he were alive today. . .

[Your Majesty] would have guards escort him out of the country so that he would not be able to delude the masses . . .[2]

Han Yu's concerns were later shared by other influential courtiers in the mid-ninth century, and Buddhists suffered brutal persecution in between 842 and 845. Spurred by concern over the obvious wealth and power of the Buddhist religion and by a growing xenophobic tendency in Chinese culture that rejected the interest in foreign cultures that had marked the height of the Tang dynasty and defined Buddhism as a foreign religion, the state confiscated properties and melted down or sold artworks to raise much-needed cash. According to historical records, forty-six hundred monasteries were secularized and returned to the tax rolls, as were the monks, nuns, and other workers who resided in these establishments. At least forty thousand smaller places of worship were also closed or converted to other uses.

Monks who traveled to China seeking a more profound understanding of Buddhism and a more precise ritual practice took the International Tang style and up-to-date practices to Korea and Japan in the eighth and ninth centuries. This new style and the expanded repertoire of practices and images joined with those introduced earlier, such as devotion to Bodhisattva Maitreya and Buddha Amitabha, to create further refinements and redefinition within Sinitic Buddhism. Art found in China, Korea, and Japan illustrates traditions from the eighth and ninth centuries, such as the development of early esoteric practices centered on Buddha Vairocana, that are not well recorded and recognized in India, providing invaluable information for the study of Buddhist art and thought for this period.

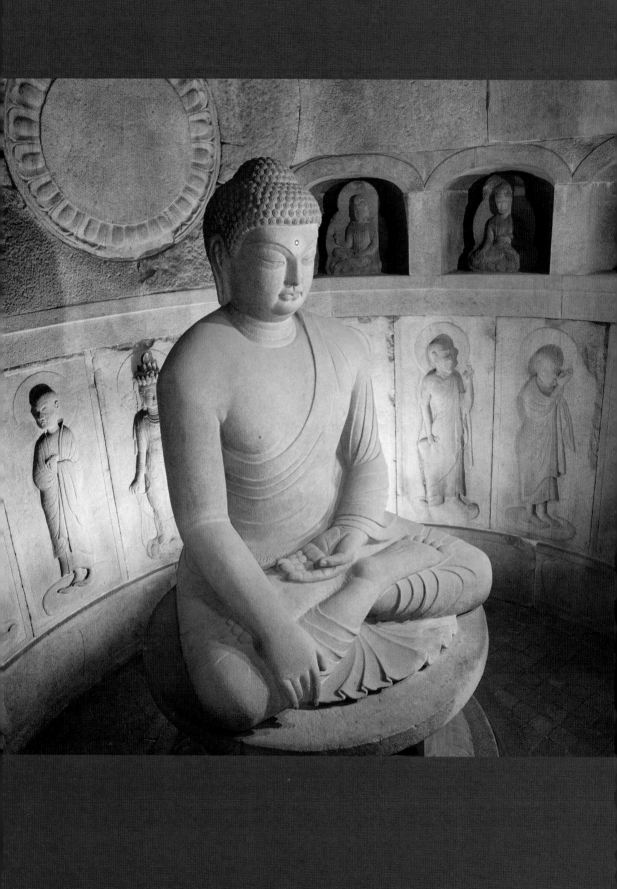

CHAPTER 5

Korea and Japan
Sixth to Ninth Century

KOREA

FROM THE first century B.C.E. to the mid-seventh century C.E., Korea was a divided nation. Four polities ruled the peninsula during the period somewhat misleadingly known as the Three Kingdoms (58 B.C.E.–668 C.E.): Goguryeo (37 B.C.E.–668 C.E.) in the north; Baekje (18 B.C.E.–668 C.E.) in the southwest; Silla (57–668 C.E.) in the southeast; and Gaya (42–562 C.E.), a small federation nestled between Baekje and Silla. Although there may have been an awareness of Buddhism earlier, it was officially transmitted to Korea by a monk sent from north China to Goguryeo in 372 C.E. and one from southern China to Baekje in 384. Due to its geographically isolated position on Korea's southeastern coast, which slowed the penetration of Chinese culture, Silla did not officially sanction the practice of Buddhism until 528. There is little written or visual evidence of Buddhism in the history of the enigmatic and less-studied Gaya federation.

Acceptance of Buddhism was spurred to some extent by the harsh political times, during which the rival Korean kingdoms vied to establish relations with powerful Chinese states. The spread of Buddhism to Korea was part of a broader adoption of Chinese culture, which also included elements of statecraft and Confucianism, as well as the use of characters for writing. Historical records indicate that temples and pagodas were built soon after the formal introduction of Buddhism, and ceremonies were held both to protect the state from invaders and to enhance the health and happiness of individuals. It seems likely that sculptures, incense burners, and other objects used in these rituals were sent from China to Korea and served as the prototypes for later Korean images and implements. The earliest extant Korean Buddhist sculpture dates to

FACING PAGE
The buddha inside Seokguram.
See page 107.

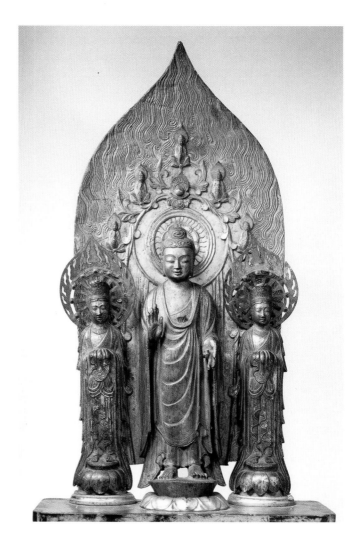

FIGURE 5.1
A buddha with attendant bodhisattvas.

Korea, Baekje period, late sixth to seventh century. The courtly clothing worn by the bodhisattvas is unusual and suggests that the sculpture was commissioned for use in an elite setting.

the fifth century. Images of the Buddha were incorporated into the decoration of tombs at that time as well.

Sculptures produced in the sixth and seventh centuries attest to the rapid assimilation of a range of Chinese styles and icons by artists on the Korean peninsula. A gilt bronze triad of a buddha accompanied by two attendants [5.1], which is attributed to Baekje and now resides in the Tokyo National Museum, shows parallels to two different Chinese prototypes. The rounded forms of the three figures reflect styles prevalent in the northeast in the mid-sixth century [4.6], while the stylized hems along the sides of their clothing derive from earlier traditions associated with the court at Luoyang [4.3]. The Buddha, who most likely represents Shakyamuni

(Seokka), is larger than his attendants and stands before a flame-shaped mandorla inhabited by seven small, seated buddhas, a standard group representing the buddhas of the past world eras. Individual halos surround the heads of the attendants whose hands are hidden beneath their garments, a gesture used to indicate respect. The robes, which differ noticeably from the Indian-style clothing generally worn by Buddhist deities, are a further indication that the attendants are courtly rather than divine. The grouping of courtiers and a buddha is unusual and, like the slight crowding of the group, typically Korean.

Pensive figures were among the most important icons produced in Korea during the Three Kingdoms period. The thin, clinging drapery covering the torso of an elegant sculpture made either in Baekje or Silla [5.2] derives from Chinese art of the mid-sixth century, while the dramatic cascade of the lower garments has prototypes in the earlier part of that century [4.6]. The bodhisattva, presumably Maitreya (Mireuk), sits with his right foot over his left knee and touches his chin with the long index finger of his right hand. As was true in China during the Northern Qi period, the Korean figures may have been used in part as imperial images to represent the just rule of the kings. A youth organization known as the "flower boys" (hwarang) was a unique feature in Silla Buddhism from the mid-sixth to the mid-seventh century. Young men from aristocratic families were chosen to lead groups of followers in an attempt to establish an ideal state, defined as Tushita Heaven, in Silla. It seems likely that the pensive images, as representatives of Maitreya and others abiding in the Tushita Heaven, played some role in this cause. The pensive figure here wears a large disc, derived from court costume, suspended from a sash on his left side, a small touch that gives the religious figure an imperial connection.

Silla defeated the Gaya federation in 562, and, with the help of Tang China, conquered Baekje in 660 and Goguryeo in 668. After the forced withdrawal of Chinese troops in 676, the peninsula was united for the first time under the newly created United Silla dynasty (668–935). Relations with Tang China, maintained through diplomatic exchanges and trade, influenced the system of government, the design of the capital city at Gyeongju, and the visual arts. Buddhism was officially sanctioned as the state religion, and the imperial family and other members of the aristocracy sponsored the building of temples and other monuments, as well as the creation of religious sculptures and paintings.

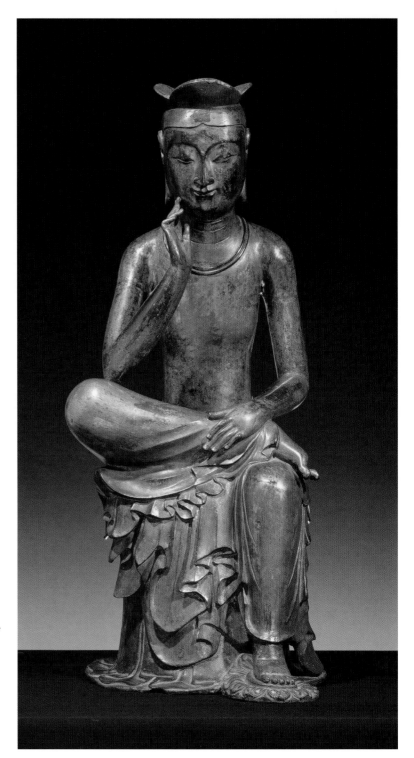

FIGURE 5.2
A pensive bodhisattva,
probably Maitreya (Mireuk).
Korea, Silla period, early seventh
century. In Korea, bodhisattvas
seated in the pensive pose
are often associated with a
youth organization known
as the "flower boys," which
strove to bring a Buddhist
paradise to earth.

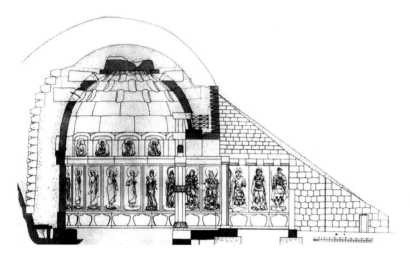

FIGURE 5.3
Elevation of Seogkuram.
North Kyongsang Province, Korea, United Silla period, second half of the eighth century.

Construction of Seokguram, which is also known as the Stone Buddha Temple, is traditionally linked to the patronage of Kim Daeseong, a member of the royal family who served at the court of King Gyeongdoek (r. 742–765). He commissioned the site to honor those who were his parents in a previous lifetime. Work at Seokguram—located near the summit of Mount Toham, east of the capital at Gyeongju—began around 740 and was finished during the reign of Hyegong (r. 765–780). Seokguram, which consists of an entryway, a rectangular antechamber, and a large domed inner chamber [5.3], is one of the most distinctive and wonderful monuments in Buddhist Asia. It was assembled from hundreds of pieces of granite in varying shapes held together by stone rivets. The overall structure alludes to the cave sanctuaries found in India, Central Asia, and China; however, the round domed chamber is more reflective of the shape of a stupa than of a temple carved into a mountain or cliff. Seokguram's scale suggests that it was intended as a private monument; it is too cozy for congregational activities.

Buddhist deities and guardians inside the monument provide a unique example of an eighth-century iconographic program. The sculptures are carved in high relief on the granite panels that cover the walls of the three rooms. In the entryway, eight demigods, four to a wall, represent Indian deities who were converted to Buddhism and became its protectors. Two seminaked guardians, comparable to the larger sculptures in the great niche at Longmen [4.10], take protective stances on either side of the doorway leading from the entryway to the antechamber. The heavenly kings that protect the four quadrants stand, two to a wall, in the narrow antechamber.

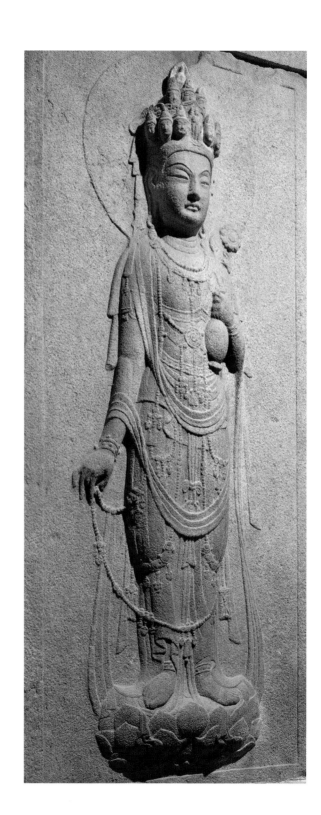

FIGURE 5.4
Bodhisattva Avaloki-teshvara (Gwaneum) with eleven heads.

Back wall, Seokguram, Korea, North Kyongsang Province, United Silla period, second half of the eighth century. Devotion to the eleven-headed form of Bodhisattva Avalokiteshvara was introduced to China in the late seventh century and spread from there to Korea and Japan.

The Indic gods Brahma and Indra stand to either side of the door to the inner chamber. Two bodhisattvas and ten figures dressed in monastic garb are shown on the rectangular panels of the lower walls of the inner chamber. The latter represent the historical disciples of Siddhartha. Seven small figures of bodhisattvas and one of the famous layman Vimalakirti are seated in the upper niches of the walls.

Bodhisattva Avalokiteshvara (Gwaneum) with eleven heads [5.4] is carved in higher relief than the figures in clerical garb and stands directly behind the seated figure of the central buddha [5.5]. The influential monk Fazang introduced this form of the bodhisattva (also found at Kanheri in India in the late fifth century) to China in the late seventh century. He constructed a ritual space for devotion to the bodhisattva and invoked the eleven-headed Avalokiteshvara to protect the Tang against the Qidan, a group from the northeast who were temporarily routed in 679. The full face, broad shoulders, indented waist, and clinging drapery of the central buddha at Seokguram belongs to the International Tang style developed in China in the late seventh and eighth centuries [4.11]. Discussions continue regarding the identity of this buddha. His right hand is held in the earth-touching gesture often used to refer to the crucial moment when Shakyamuni successfully defended his right to seek enlightenment against the forces of evil; this suggests that the Buddha is Shakyamuni. However, as mentioned in earlier chapters, seventh- and eighth-century artists also understood Shakyamuni to be the transitory manifestation of the transcendent Buddha Vairocana (Birojana). The position of the Seokguram buddha as the center of a cosmos defined and peopled by other deities argues for the sculpture representing a transcendent manifestation of Buddha such as Vairocana or Akshobhya who is identified by the earth-touching gesture.

A sculpture in Boston's Museum of Fine Arts is identified as Buddha Bhaishajyaguru (Yaksa) by the small medicine jar in his left hand [5.6]. He holds his right hand in the gesture of reassurance and stands on a beautifully cast, two-tiered lotus pedestal decorated with small rosettes. Sculptures representing Bhaishajyaguru, who is revered for his ability to cure illness and promote longevity, were

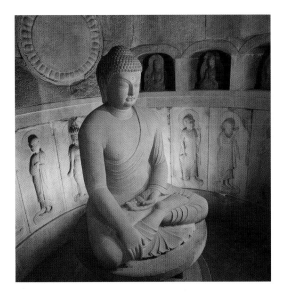

FIGURE 5.5
The buddha inside Seokguram.
North Kyongsang Province, Korea, United Silla period, second half of the eighth century. The identity of the primary buddha in the Korean sanctuary at Seokguram is still under debate. However, the gesture of the right hand suggests that he represents either Shakyamuni, or Shakyamuni/Vairochana, a fusion of the historical Buddha and one of his transcendent form.

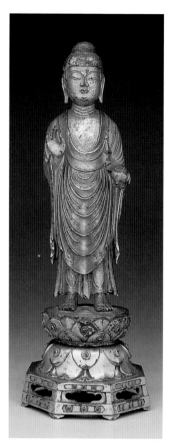

FIGURE 5.6
Buddha Bhaishajyaguru (Yaksa).

Korea, United Silla period, ninth century. Bhaishajyaguru plays an important role in early Korean and Japanese Buddhism, in part because of his link to medical practices.

widely produced and presumably immensely popular during the United Silla period. Devotion to this buddha is largely based on the *Sutra of Bhaishajyaguru,* first translated into Chinese in the fourth or fifth century. The text describes the buddha, who embodies the power of both physical and spiritual healing, as dark blue in color and holding a medicine jar. Practices involving Bhaishajyaguru, as well as the specialized medical knowledge of monks, played an important role in Japan's acceptance of Buddhism, which was introduced from Korea in the mid-sixth century; the buddha of medicine is also found in some of Japan's earliest Buddhist icons.

JAPAN

ACCORDING TO the somewhat mythologized *Chronicles of Japan,* written around 720, an envoy from the Korean kingdom of Baekje, which had long held ties to the Japanese aristocracy and members of the imperial family, brought a gilt bronze Buddha image and several Buddhist texts to Japan in 538 (or 552), possibly in an attempt to bolster alliances against Goguryeo and Silla. Despite a letter from Baekje extolling both the virtue and the supernatural power of the new religion, Japanese rulers were at first skeptical:

> This doctrine can create religious merit and retribution without measure, and so lead to a full appreciation of the highest wisdom. Imagine a man in possession of treasure to his heart's content, so that he might satisfy all his wishes in proportion as he used them. This it is with the treasure of this wonderful doctrine.[1]

As a result, the Soga, one of the more powerful clans at the time, were selected to practice the new religion to check its effectiveness. The outbreak of a plague soon after was interpreted as the anger of the native gods (*kami*) and had a negative impact on the acceptance of Buddhism, which the emperor proscribed. In 584, Baekje made a second attempt, but Buddhism was not adopted until 587 when the Soga clan and their allies, who had invoked the Four Heavenly Kings (*Shintennō*) and other deities, won a decisive victory in a civil war. Emperor Yōmei (r. 585–587), a member of the royal family with strong ties to the Soga clan, was the first ruler to practice Buddhism. He commissioned a sculpture of Bhaishajyaguru (Yakushi) when he was seriously ill but did not live to see it finished. After the brief reign of Emperor Sushun (r. 587–592), Yōmei's sister took the throne

as Empress Suiko (r. 592–628) and established Buddhism as a state religion, stressing its magical powers and ability to protect the nation. The period beginning with her reign and ending with the Taika reforms of 645 (known as the Asuka period in Japanese history) also marks the beginning of imperial patronage of monasteries and icons for use in Buddhist practices.

Records, possibly somewhat exaggerated, from the *Chronicles of Japan* list 46 religious buildings, 816 priests, and 569 nuns in the year 623. Hōryū-ji (Monastery of Flourishing Law), located just south of the city of Nara, stands on the ground once occupied by Wakakusa-dera, an earlier complex built by Empress Suiko's uncle Soga Umako and destroyed by fire in 670. The temple houses the earliest surviving examples of Japanese Buddhist architecture, which are also the oldest wooden buildings in the world. Hōryū-ji, which remains active, has undergone additions, reconstructions, and the use of existing buildings for new purposes over the centuries. The current monastery consists of two main precincts, one to the east and another to the west. The earliest structures are housed in the west precinct [5.7]. The gateway, pagoda, main image hall (also known as the "golden hall," or *kondō*), sutra repository, belfry, and roofed arcade that encloses them date to the late seventh century. The arcade is noticeably lower than the pagoda [5.8] and the main image hall [5.9], which are placed side by side toward the front of the compound. The pagoda, beneath which relics are buried, derives from the stupas of early India; as its name implies, the main image hall functions as the worship hall.

Both buildings illustrate the timber frame construction method commonly used throughout East Asia. With this method, a grid composed of stone bases supports wooden columns that, in turn, uphold bracket clusters for the ceiling and roof. The space between the columns is known as a bay, and such buildings are classified by the number of bays as well as their length and depth. Beams tie the columns together at the base and head. The brackets, which transmit the weight of the roof (or roofs) through the columns and down to the foundation, are composed of alternating horizontal and lateral arms. Fired ceramic tiles, set in a thick bed of mud, cover the roofs.

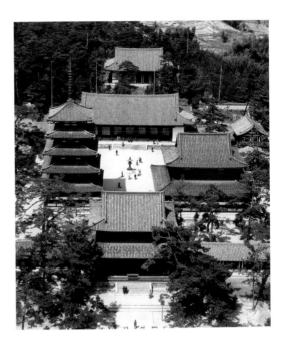

FIGURE 5.7
A view of Hōryū-ji Temple.

Nara, Japan, Asuka period, seventh century. Some of the oldest wooden buildings in the world are preserved in the Hōryū-ji complex near Nara, Japan.

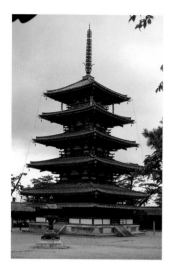

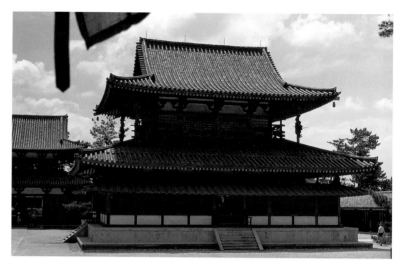

FIGURE 5.8
The five-storied pagoda at Hōryū-ji Temple.
Nara, Japan, Asuka period, seventh century. The wooden pagoda is the East Asian variant of Indian stupas.

FIGURE 5.9
TOP RIGHT
The main hall (kondō) at Hōryū-ji Temple.
Nara, Japan, Asuka period, seventh century. Post-and-lintel construction and the use of a stone base are found in timber frame buildings throughout East Asia.

The large stone foundation for both the pagoda and main image hall at Hōryū-ji are continental imports and differ from earlier Japanese architectural traditions in which columns were set directly into the ground. The slight swell of the columns from top to bottom, which is also found in early Greek architecture and known as *entasis*, adds a hint of organic growth to the buildings.

A large wooden platform is placed in the center of the main hall [5.10] to permit circumambulation of the sculptures that are the main icons of the temple. Three huge canopies painted with multi-colored lotus petals and apsaras and decorated with small wooden figures of phoenixes and musicians are suspended above the central platform. A gilt bronze triad depicting Buddha Shakyamuni (Shaka) and two attendant bodhisattvas is the principal icon in the main hall. The triad belongs to a stylistic tradition that has its roots in sixth-century China and has been found in both Korea and Japan. Seated in the lotus posture on a large square pedestal, the buddha has thin, sloping shoulders and an attenuated physique covered by thick garments with cascading folds. He holds his right hand in the gesture of reassurance and his left with the middle and index fingers pointing down, a variation on the gesture of beneficence. Flames and seven small, seated buddhas fill the towering mandorla that surrounds him. The bodhisattvas have squat physiques and wear Indian-style garments. Long, narrow scarves that cover their shoulders, cross beneath their knees, and fall over their upper arms in stylized patterns are reminiscent of the fish-tail patterning seen in early-sixth-century Chinese Buddhist sculpture [4.3].

A 196-character inscription carved in the center of the back of the mandorla links the creation of the main icon at Hōryū-ji to Prince Umayado, a member of the royal family who served as regent for his aunt, Empress Suiko. Umayado, who is better known as Shōtoku Taishi or Prince Shōtoku (574–622), is said to have written commentaries on several sutras; given lectures on others; and sponsored the buildings of monasteries, as did several members of the ruling Soga family. By the twelfth century, he had become a national icon for the introduction of Buddhism to Japan

FIGURE 5.10
Buddha Shakyamuni and attendant bodhisattvas attributed to Torii Bushi.

Interior of the main hall at Hōryū-ji Temple, Nara, Japan, Asuka period, dated 623. The platform in the center of the hall holds the primary icons of the temple and can be circumambulated in the same fashion as in an Indian stupa.

and the focus of an independent cult stressing the sanctity of his life and his understanding of Buddhism. The somewhat ambiguous and problematic inscription, which may have been added later, suggests that the sculpture was commissioned around 621 after Prince Shōtoku's consort had died and he himself had become ill. It was hoped that the sculpture would either cure him or ensure his rebirth in a Buddhist pure land. The inscription also records the prince's death and the completion of the triad in 623. Finally, it states that a certain Torii of the Shiba, a prominent guild of saddlemakers, was responsible for the creation of the sculpture. A knowledge of leather, wood, and particularly bronze and gilding, were necessary for the production of both saddles and a good-sized bronze sculpture. Although the Torii mentioned in the inscription is known today as Torii Bushi, which implies a connection with Buddhist art, it remains unclear whether or not he was actually the

FIGURE 5.11
Tamamushi shrine.
Hōryū-ji treasure house, Nara, Japan, Asuka period, ca. 650. Iridescent beetle wings that were once placed underneath the metal fittings give this small shrine its name.

artist, a member of a workshop who produced the piece, or a high-ranking individual who oversaw the production of sculptures and other luxury goods. Nonetheless, it seems likely that members of his guild or family were deeply involved in the creation of some of the earliest Japanese Buddhist icons, which are classified as examples of the Torii style.

A combination of narrow physiques and revealing drapery, also based on sixth-century Chinese prototypes, characterizes the paintings that decorate the exterior of the Tamamushi Shrine [5.11]. This miniature structure made of camphor and cypress wood is thought to replicate an early building such as the main hall of a temple complex. *Tamamushi* is the name of a type of beetle, and the structure is so named because of the iridescent wings that once underlaid the openwork metal strips found on the base and sides and between the lower and upper sections. The palmettes that decorate the metal strips are a Mediterranean design that appeared in China in the late fifth century [3.19] and then traveled to Japan as part of the complex images and ideas that accompanied the introduction of Buddhism.

The paintings were created using lacquer (the resin of the Asian sumac tree, or *Rhus verniciflua*) mixed with red and black pigments, lead oxide, and oil from the shiso plant. These include images of bodhisattvas and of the Four Heavenly Kings, as well as *jatakas*. One of the most famous, painted on the lower left wall of the shrine [5.12], depicts the story of the *Mahasattva*, or *Vyaghri jataka*, popularly known as the "tale of the hungry tigress." According to this story, Shakyamuni, reborn yet again as a young prince, met a starving tigress and her cubs while riding in a forest. Distressed by their plight, he offered his body to the animals. When he realized that they were too weak to kill and eat him, he climbed to the top of a nearby cliff and jumped off, thereby smashing his body and luring them with the smell of his blood. A classic parable for the virtue of generosity, the painting on the Tamamushi Shrine is set in a grove filled with delicate bamboo. Shakyamuni is shown three times, a narrative device that may have

FIGURE 5.12
Siddhartha as a bodhisattva feeding a hungry tigress (Mahasattva, or Vyaghri Jataka).

Detail of the Tamamushi shrine, Hōryū-ji treasure house, Nara, Japan, Asuka period, ca. 650. In this past lifetime, Shakyamuni throws himself off a cliff to feed a starving tigress and her cubs.

roots in early Indian imagery [1.9]: he stands at the top of a phantas-magoric cliff, removing his upper garment; he leaps to his death; and he is finally a broken corpse feeding the tiger and her cubs.

Sculptures of bodhisattvas in the pensive pose, many tradition-ally associated with Prince Shōtoku, were also important in early Japanese Buddhism. One of the most beautiful [5.13] is preserved at Chūgū-ji, a convent to the east of Hōryū-ji, that was once the residence of Shōtoku's mother. The thin upper and flowing lower garments derive from mid-sixth-century Chinese styles transmitted from Korea. However, the oval face and softly modeled cheeks, which parallel those of the Shakyamuni triad discussed earlier, are typically Japanese, as is the naturalism in the delicate gesture of the right hand as its touches the cheek and in the charmingly upturned toes. The two small knots of hair at the top of the head are distinctive among East Asian sculptures in the pensive pose. It is possible that unlike the majority of such icons, which represent either Maitreya (Miroku) or others residing in the Tushita Heaven, the pensive image at Chūgū-ji was intended to show Shakyamuni prior to his final rebirth. The distinctive hairstyle, which is used in representations of court figures in China and Japan, would be appropriate for Prince Siddhartha.

Adoption of Chinese-style governmental policies, begun during the reign of Empress Suiko, intensified with the Taika reforms of 645, which included both a greater centralization of the government and the nationalization of agricultural land and labor. The period between the reforms and the establishment of Japan's first permanent capital at Nara is often called the Hakuhō period (645–710), while the subsequent era is known as the Nara period (710–794). Prior to 710, a belief that defilement accompanied death meant that the seat of government was inevitably moved whenever a ruler died. Nara, which still houses a breathtaking array of early temples, was largely based on the city plan of the Tang Chinese capital at Xi'an. Latitudinal and longitudinal avenues divided the capital, and the palace was placed in the city center to the north. As was true in Tang China and presumably in Korea, a deliberate parallel was made between the emperor, the source of all earthly power, and Buddha Vairocana (Dainichi or Roshana), the creator of the cosmos. In 752, Emperor Shōmu (r. 710–756) commissioned a colossal gilt bronze sculpture of Vairocana to bring peace, prosperity, and physical and spiritual health to the people of Japan. The sculpture, once housed in Tōdai-ji ("Great Eastern") Temple, was destroyed during a period of civil war in the late twelfth century; however, historical records

FIGURE 5.13
A bodhisattva in the pensive pose.

Chūgū-ji, Japan, Asuka period, seventh century. Bodhisattvas in pensive poses were popular in Japan in the sixth and seventh centuries, and like the Chinese and Korean examples, were also often associated with members of the ruling elite.

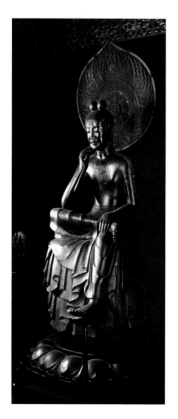

indicate that it measured about fifty-two feet in height and was backed by an enormous mandorla.

Emperor Shōmu also decreed that a state monastery and a state nunnery be constructed in every province and that a copy of the *Golden Radiant All Victorious Heavenly King Sutra* (*Survanaprabha-sauttamaraja-sutra*), chosen for its ability to protect the nation, be installed in the pagoda of each temple. As was true in Korea, prior to the development of a native, syllabic alphabet in the twelfth century, Japan's primary language was Chinese, and sutras and other texts were written and studied in that language. Ten handscrolls, now in the Nara National Museum, record the text of the *Golden Radiant All Victorious Heavenly King Sutra* in gold pigment on purple paper [5.14]. They are part of the imperial commission ordered by Emperor Shōmu in 741 and were once installed in the national temple. The text is written in an elegant example of Chinese clerical script, which was developed in the second century for use in court documents and used officially throughout East Asia for centuries. The buddha's words, preserved in writing, were awarded the same importance as corporeal remains, and particularly in Japan, texts were sometimes buried under pagodas or housed in small miniature versions of these structures.

A colossal bronze triad [5.15] representing Buddha Bhaishajya-guru and his attendant bodhisattvas, Suryaprabha (Nikkō/sun) and Chandraprabha (Gakkō/moon), is the main icon of Yakushi-ji Temple in Nara. Bhaishajyaguru sits on a lotus pedestal set on an octagonal base. He has the broad shoulders, narrow waist, and long legs found in Chinese and Korean sculptures dating to the late seventh and eighth centuries [4.11, 5.5]. His right hand is held in a

FIGURE 5.14
Detail from the Sutra of the Kings of Golden Light.
Japan, Nara period, eighth century. Written in gold ink on indigo paper, this sutra was one of several commissioned in the eighth century as an act of devotion and to protect the state.

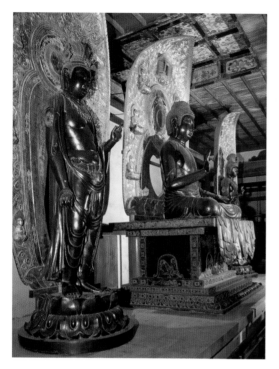

FIGURE 5.15
Buddha Bhaishajyaguru (Yakushi) with attendant bodhisattvas.

Main hall, Yakushi-ji Temple, Nara, Japan, Nara period, late seventh or early eighth century. Japan. Powerful, lush physiques of the sculptures illustrate a style that developed in China and spread throughout Korea and Japan in the late seventh and eighth century.

version of the gesture of discussion; the left, which rests on his leg, once held the medicine jar that is his traditional symbol. The bodhisattvas, also wearing clothing based on Chinese reinterpretations of Indian dress, represent the sun and the moon; they illustrate some of the astrological knowledge and practices that were incorporated into Buddhism as it traveled through Asia. (The large mandorlas behind the three deities are replacements for the originals, which became damaged over time.)

The heavy face and physique of a late-eighth-century sculpture of Buddha Vairocana [5.16] in the main hall of Tōshōdai-ji, a private temple in Nara, also parallels contemporaneous works from China and Korea. The buddha sits in a lotus posture in front of a mandorla filled with images of small, seated buddhas that are symbolic of the manifestation and dissemination of his powers. He wears a monastic shawl pulled down in the front nearly to the waistline, a device often seen in images from eighth- and ninth-century East Asia [4.11], and holds his right hand in a variation of the gesture of discussion, with the thumb touching the middle finger. The eyes were painted, presumably during an "eye-opening ceremony" when the sculpture was officially installed and brought to life, and a crystal is inlaid in the forehead to represent the *urna*. Inscriptions, discovered in 1917 during renovation, list the individuals who collaborated to make this piece, which is nearly ten feet high. They included a government administrator who controlled the craftsmen, some of whom were Korean; an artist in charge of lacquer; and a clerical supervisor.

This sculpture was made using the dry lacquer technique that originated in China, where lacquer—the resin of the Asian sumac bush—was used by at least the twelfth century B.C.E. Once processed and dried, lacquer is resistant to heat, water, and acids, and it is often used to cover vessels and other functional implements. In the dry lacquer technique, a wooden armature is covered with clay and then cloth, generally three to ten layers of hemp or linen, which has been soaked with lacquer. After the lacquer has dried, the clay is removed. The arms and legs are made of wood, and smaller parts such as fingers and earlobes are built over wires and added to the larger piece. Fine details, such as facial features or jewelry, are

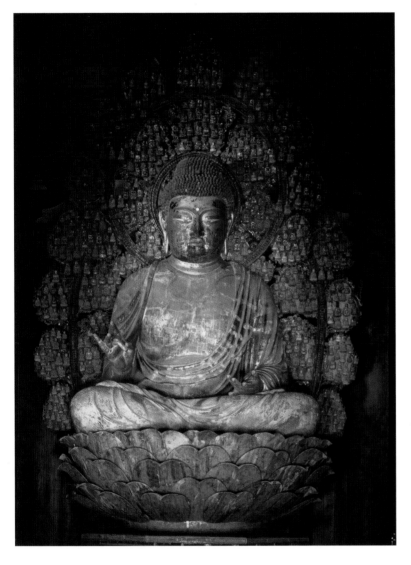

FIGURE 5.16
*Buddha Vairocana
(Dainichi or Roshana).*

Tōshōdai-ji, Nara, Japan,
Nara period, second half of
the eighth century. Numerous
small buddhas in the mandorla
illustrate Buddha Vairocana's
role as the generative force in
the cosmos.

created using a paste made of lacquer, incense powder, clay powder, and sawdust. The surface is finished either with gold leaf, as here, or with pigments of various colors.

Pigments made of minerals and animal glue are found on the famous dry lacquer portrait sculpture of the Chinese monk Jianzhen (688–763) [5.17], which is housed in the founders' hall built in his honor at Tōshōdai-ji. The delicate tones and sensitive modeling of the face suggest that this posthumous work may have captured the appearance of the cleric, who was partially blind when he reached Japan in 753 after six attempts. Although few examples prior to the twelfth century exist, portraits of monks played an important

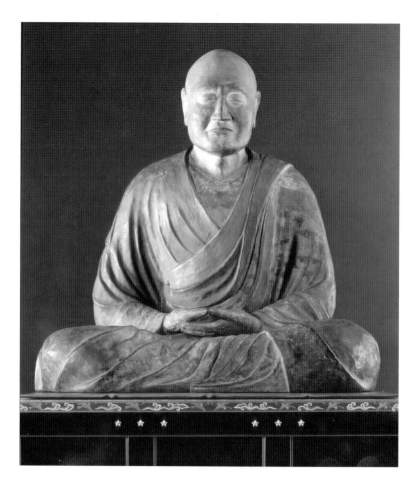

FIGURE 5.17
Jianzhen (Ganjin).
Tōshōdai-ji, Nara, Japan, Nara
period, mid-eighth century.
As shown in this sculpture,
Jianzhen was partially blind
when he reached Japan in 753.

role in Buddhist practice as early as the Tang dynasty. Monastic portraiture stems in part from the belief, influenced by Chinese Daoist practices, that an incorruptible human form is the result of advanced spiritual attainment. In Tang China, the ashes of saintly monks were sometimes incorporated into the clay used to make portraits. In other cases, corpses were covered with lacquer in an attempt to help preserve both the physical presence of the monks and their charisma. This use of lacquer may have contributed to the development of the painstaking dry lacquer technique.

Jianzhen, better known as Ganjin (Jp.), was one of many monks who traveled internationally in the seventh and eighth centuries; he brought new artistic traditions as well as up-to-date medical information to Japan. A *vinaya* (or *ritsu*) master specializing in the rules governing the life and practices of the clergy, he was invited to help refine ordination practices and built ordination platforms

at both the government-sponsored Tōdai-ji and at Tōshōdai-ji. Despite additions and renovation to the roof, the main hall [**5.18**] of the latter remains a classic example of eighth-century Japanese temple architecture. It measures seven bays wide by four bays deep and has the standard rectangular altar in the center. The building, which stands on a Chinese-style stone platform similar to that found at Hōryū-ji, uses a more compact version of the traditional bracketing system. It is characterized by an elegant horizontality; a subtle harmony, created by the use of the first bay as a porch, exists between the main hall and the surrounding area.

In addition to the *vinaya* sect, five other major schools, each founded on a text or group of related texts, dominated practice during the Nara period. Often called the "six sects of Nara Buddhism," they were all based at the imperially sponsored Tōdai-ji; monks and others who were officially ordained there served the royal family and the aristocracy, performing rites for the protection of the nation and the benefit of its rulers. Nonetheless, dissatisfaction with the rigidity of official practice and the sterility of academic study led certain monks (not all of whom were ordained by the state) in search of a more demanding and personal experience, to build hermitages and small monasteries in mountainous regions away from the bustle of the capital. Their quest led to the development of several new forms of Buddhism, some of which featured solitary austerities, while others focused on service to others. For example, in the late seventh century, the semilegendary En no Gyōja (634–?) established Shugendō, an ascetic movement with roots in mountain centers and theurgy; the monk Gyōgi (668–748), the first individual in Japanese history to be posthumously granted the title of bodhisattva (*bosatsu*), spent some time in a small hermitage before traveling through the

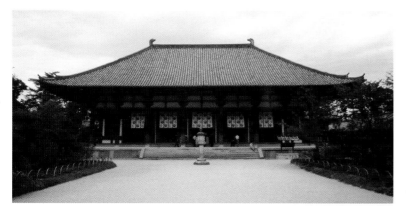

FIGURE 5.18
The main hall at Tōshōdai-ji Temple.

Nara, Japan, Nara period, ca. 759. Tōshōdai-ji is a small complex built for the use of the Chinese monk Jianzhen, who came to Japan to help regularize ordination practices.

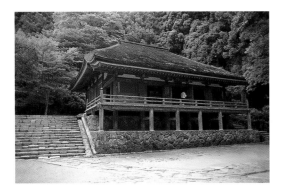

FIGURE 5.19
*The main hall
at Mūro-ji Temple.*

Japan, early Heian period, early
ninth century. Unlike state
temples, the private Mūro-ji
was established in a remote,
mountainous area, with
buildings nestled along the
sides of a mountain.

countryside preaching and performing miraculous deeds. Whether or not the Japanese interest in a more personal and intense form of Buddhism had parallels to the renewed interest in austerities found elsewhere in Asia from the late sixth to the ninth century (see discussions in chapters 2, 3, and 8) remains a challenging question.

Moving the capital from Nara to Kyoto in 794, spurred to some degree by imperial concern over the widespread power of the clergy, further bolstered the shift from academic practice in large, state monasteries to more personal forms of devotion. The ninth and tenth centuries, known as the early Heian period (794–951) after the old name for Kyoto, saw the formalization of new types of monasteries and styles of Buddhist art, many of which first flourished in remote centers. Mūro-ji, founded in the late 700s by a priest from Nara, is nestled along the side of a mountain in a region long considered sacred; it is revered for its unusual rocks and streams, and as the home of a dragon. Unlike temples in the capital that were built to fit the gridlike structure of the city, Mūro-ji is divided into three levels. Residence halls for monks are found at the base of the temple, the main hall and other buildings for worship perch midway up the mountain, and an inner precinct is located at the top. The main hall [5.19], which was probably constructed in the ninth century, stands on a masonry foundation set into a recess carved into the side of the mountain. It is noticeably smaller than comparable buildings in urban centers, measures only four bays deep, and is defined by simple wood forms and a flat bracketing system.

A seated image of Buddha Shakyamuni [5.20], now in the Maitreya Hall (Miroku-dō) at Mūro-ji, exemplifies the sculptural style of the second half of the ninth century. It was made using the single woodblock (*ichiboku zukuri*) technique, possibly brought to Japan earlier by Ganjin. In this technique, which was particularly popular in the early Heian period, the sculptor chooses a single piece of wood and carves it to produce an approximation of the desired shape. Details such as the drapery folds and facial features are added, then the surface is coated with lacquer and gold leaf or with a gessolike paste (*gofun*) and pigment. The use of a single piece of wood results in a sculpture that is fuller at the bottom than the top and is responsible for the heaviness found in the lower bodies of sculptures produced during this period. The heaviness of the sculp-

tures gives them an aura of approachability and a sense of immediacy that parallels the contemporaneous interest in more intense and personal practices, such as those associated with esoteric Buddhism.

Brought to Japan from China by monks who studied on the continent, esoteric Buddhism became important in the ninth century. Saichō (767–835), posthumously known as Dengyō Daishi, and Kūkai (774–835), posthumously known as Kōbō Daishi, are often credited with the formal introduction of this tradition to Japan. They traveled to China in 804 as part of a large diplomatic mission and returned to Japan in 805 and 806, respectively, with new texts and practices. Saichō, from a family of Chinese immigrants who were devout Buddhists, is considered the founder of the Tendai (Chinese Tiantai) sect in Japan. While practicing in a retreat on Mount Hiei, he came to the attention of the emperor, and received permission to visit China to search for material focusing on the *Lotus Sutra* and related devotional exercises and meditative practices. During his studies at the Chinese center at Mount Tiantai, he also met Shunxiao, a master of esoteric traditions trained by the famed Indian monk and translator Subhakarasimha, who initiated him into new practices. Upon his return to Japan, Saichō, who continued to stress the importance of the *Lotus Sutra* as a guide for practice and a tool for protecting the state, performed esoteric rituals for the emperor and the court.

Kūkai was a self-ordained monk rather than a state-appointed cleric. He was primarily interested in esoteric practices and also lived in the mountains, studying texts and chanting mantras, before deciding to travel to China. Upon his arrival, he went to Xi'an, where he met the re-nowned esoteric master Huiguo (764–805), who is said to have immediately recognized him as a disciple and successor. Despite having learned Sanskrit, calligraphy, and several other skills, Kūkai was briefly overshadowed by Saichō when he returned to Japan. His deeper training in esoteric practice was soon recognized, however, and in 819 Kūkai was given permission to build a monastery for the practice of Shingon (Chinese Zhenyen) Buddhism on Mount Koya, which remains a center of scholarship and practice in the tradition. Shingon (which can be

FIGURE 5.20
Buddha Shakyamuni (Shaka).

Mūro-ji Temple, Japan, early Heian period, second half of the ninth century. The heaviness in the bottom of the sculpture characterizes the quest for immediacy found in Japanese Buddhist art at the time.

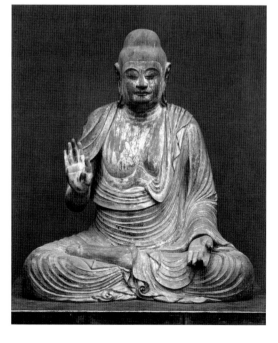

loosely translated as "true word") derives its name from the use of mantras, sacred syllables or phrases thought to be imbued with supernatural powers. Mantras, cosmic diagrams known as mandalas, and the emphasis on transmission from master to disciple were relatively new practices in in the eighth and ninth centuries, and they spread throughout Asia at that time.

Little is known about the early development of these practices in India, and the tradition brought to Japan by Kūkai is the primary source for study of both the early Chinese material and its presumed sources in South Asia. Kūkai's systemization of the material, published in the *Ten Stages of the Development of Mind* (*Jūjūshinron*) in 830, remains a primary document for the early history of esotericism in Asia. As the title implies, the study details the steps in the development of an enlightened consciousness, beginning with beings who live by impulse, moving to those who are motivated by ethical considerations as well as their desires and tastes, and ending with those whose understanding is at once more abstract and more comprehensive. Not coincidentally, the latter often follow the Shingon tradition.

A pair of mandalas known as the Womb World Mandala (Taizōkai) and the Diamond World Mandala (Kongōkai), which are also used in Japanese Tendai, are central to Shingon practices, and two icons as well as the practices associated with them were brought to Japan by Kūkai:

> Fortunately, due to the power of the grace of the Buddha and other forces hidden as well as visible, that mature beings for spiritual work, I was able to travel to Tang China in 804, whence I safely returned with the two mandalas of the Womb Realm of Great Compassion and Vajra Realm and over one hundred scrolls of Vajrayana scriptures . . . So it is that now I will promote these esoteric teachings in order to return favor the Buddhas above and to liberate beings here below, as well as to augment the dignity of various beneficent spirits . . . May all the Buddhas rejoice in, and all the heavenly beings protect, my efforts here and may all virtuous spirits please vow to help realize our wishes.[2]

The paired icons are used during public ceremonies, when they are hung to either side of the central altar with the Womb World Mandala toward the east and the Diamond World Mandala toward the west. Abbreviated versions, which are usually parts of the larger

compositions, are also used in more specialized and private rituals such as initiation ceremonies (*kanjo*). An initiate throws a flower or a twig, often anise, onto the mandala to select the buddha or bodhisattva who will become the focus of visualization and personal devotion. The Womb World Mandala symbolizes the possibility of Buddhahood in the phenomenal world, while the Diamond World Mandala is a guide to the spiritual practice that leads to enlightenment. Each is based, to some degree, on a different text. The Womb World derives from the second chapter of the *Great Vairocana Sutra*, translated into Chinese by Subhakarasimha in the eighth century; the Diamond World is based on the *Diamond Pinnacle Tantra* (*Vajrasekhara-tantra*), translated by Amoghavajra during the same period. Buddha Vairocana, shown with one face and two hands, is the primary deity of both mandalas and occupies the most important, central place in both compositions. Additional deities, divided into groups known as "courts," surround the buddha in both mandalas. Each court contains its own central figure and subsidiary deities, and each of these figures is both an independent icon and a manifestation of the powers and knowledge of Vairocana.

The Womb World Mandala [5.21] is composed of twelve courts containing 414 deities. The central court, known as the "court of eight petals," shows Vairocana sitting in the center of an open lotus, whose eight petals contain seated buddhas at the cardinal points of the compass and seated bodhisattvas at the intermediate points. The bodhisattvas represent Buddha Vairocana's vow to aid all sentient beings. The court grouped in the vertical rectangle to the right of the central scene is known as the "vajra holders' court," while that to the left is called the "lotus holders' court." The vajra holders symbolize the power of the intellect to destroy human passions, while the lotus holders illustrate the purity of all human beings. These courts and the other subdivisions of the mandala are peopled with deities who represent various stages in the search for enlightenment.

The Diamond World Mandala [5.22] is arranged in nine squares, a composition that is rarely found in later mandalas. It contains 1,461 deities. The central court, known as the "attainment of Buddhahood assembly," is divided into five small circles placed within a larger one. Vairocana, surrounded by four bodhisattvas, sits in the center circle. Buddhas Akshobhya, Ratnasambhava, Amitabha, and Amoghasiddhi (the heads of the other four major lineages or families of deities) fill the additional circles. More bodhisattvas are placed at the upper edges of this court, outside the primary circle. The three

courts, or squares, at the top of the mandala are distinctive and represent different phases in the complicated process of enlightenment, as do the other five groupings. The court at the right, known as the "assembly of four hand signs," consists of a large circle filled with images of the five primary buddhas. A large image of Buddha Vairocana holding his hands in the gesture of wisdom—in which the right hand encloses the index finger of the left, representing the union of divine wisdom with the deluded knowledge of mankind—is the only deity shown in the center court, which is known as the "assembly of one seal." The court on the left, which parallels the ninefold arrangement of the entire composition, is often called the "court of the guiding principle." Buddha Vairocana, here in the form of Vajrasattva (the "adamantine being"), is symbolic of spiritual purification and the defeat of negative habits; he is again the most important icon in the court, which also contains images of female

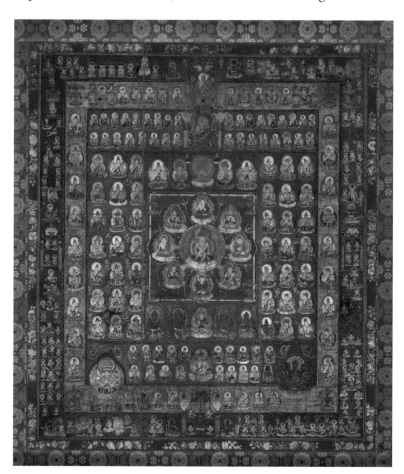

FIGURE 5.21
Womb World Mandala, or Garbhadhatu (Taizōkai).
Kyōōgokoku-ji (Tō-ji), Kyoto, Japan, early Heian period, second half of the ninth century. This is one of the earliest painted examples of a mandala known to exist.

deities symbolic of transcendence over human desires. In this court, as in all the other groupings in both mandalas, the major deities of the Buddhist pantheon are often attended by lesser-known figures who are not shown portrayed as independent deities.

The Diamond World Mandala, which was preserved in different visual forms in many parts of Asia, played a prominent role in practice during the eighth and ninth centuries, but the pairing of this mandala with that of the Womb World is found only in Japan. These early examples of Japanese mandalas and their association with early esoteric practices brought to China by Indian monks are crucial to the study of the development of Buddhism. They provide some of the first known examples of the types of images that are better preserved today in the religious traditions of Tibet, and the relationships between the mandalas of Japan and those of later esoteric traditions remains an intriguing subject.

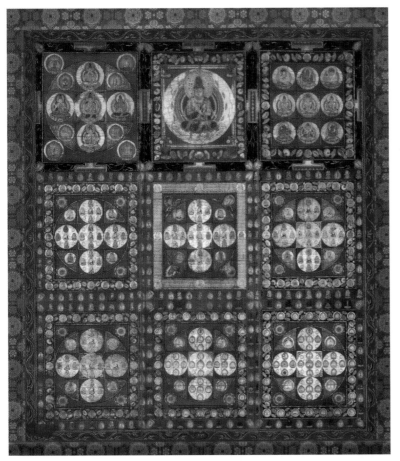

FIGURE 5.22
Diamond World Mandala,
or Vajradhatu (Kongōkai).
Kyōōgokoku-ji (Tō-ji), Kyoto, Japan, early Heian period, second half of the ninth century. Centered on Buddha Vairocana, this mandala is found in artworks from eighth- and ninth-century China, Japan, and Indonesia during the eighth and ninth centuries.

CHAPTER 6

South Asia

Regional Styles and Changes in
Religious Thought, Eighth to Twelfth Century

NORTH INDIA AND BANGLADESH

SIGNIFICANT redefinitions and changes in thought and practice, some of which led to the flowering of traditions still active in Tibet, marked the development of Buddhism in South Asia from the eighth to the twelfth century. Several factors make it difficult to trace these developments precisely. One is the inherently conservative nature of religious imagery in which the appearance of the divine is rarely altered, and types of images continue with only subtle variations. Another is a complicated political history during which varying groups controlled different parts of the subcontinent. One result of the strife was that more examples of the visual arts were preserved in peripheral areas such as the northeast and the southern tip of India, as well as Sri Lanka, than in north and central India. The existence of different styles and imagery in these regions reflects the lack of a central government and the shared visual culture of the time. Finally, Buddhism disappeared in India after the twelfth century due to both the amalgamation of Buddhism and Hinduism and the conquest of northern India by groups that adhered to Islam (which had developed in the Middle East in the seventh century).

Identified by the antelope skin, a symbol of ascetic practices, an elegant torso [6.1] that was once part of a nearly life-size sculpture of Bodhisattva Avalokiteshvara provides a rare example of the style of Buddhist imagery found in Madhya Pradesh in the ninth and tenth centuries. The taut, smooth skin of the torso, which derives from the artistic style of the earlier Gupta period, contrasts beautifully with the crisp carving of the lush, decorated torque and girdle as does the pronounced sway of the left hip that was common at the time. In 1970, a sculpture that is the mate to this torso, wearing identical clothing and jewelry but lacking the antelope skin, was discovered during an excavation at Sanchi. That piece, whose hips sway to the

FIGURE 6.1
FACING PAGE
Torso of Bodhisattva Avalokiteshvara.
Madhya Pradesh, India, ca. 900. This sculpture was once part of a triad containing a seated Buddha and another standing bodhisattva.

FIGURE 6.2

A reconstruction showing the original location of the torso of Bodhisattva Avalokiteshvara [6.1], probably along the back wall of Temple 45 at the Sanchi complex in Madhya Pradesh, India.

right, represents Bodhisattva Maitreya, and the pair once served as attendants to a seated buddha [6.2]. The triad was probably placed against the back wall in Temple 45, one of the later constructions at the famous Sanchi complex. The buddha in the center most likely held his right hand in the earth-touching gesture, a symbol identifying his defeat of Mara's forces.

Although groupings of a buddha with two attendant bodhisattvas exist in sixth-century works at sites such as Cave 90 at Kanheri [3.6], written sources citing a triad consisting of Buddha Shakyamuni and Bodhisattvas Avalokiteshvara and Maitreya are rare. However, in *Graceful Depiction* (*Lalitavistara*), a first-century biography of the historical Buddha, Siddhartha is said to have radiated compassion and friendliness, the virtues embodied by the two bodhisattvas, during his defeat of the demon Mara. A citation in the *Garland of Sadhanas* (*Sadhanamala*), written by the monk-scholar Abhayakaragupta in the late eleventh century, provides another written record for the role of Bodhisattvas Avalokiteshvara (referred to as Lokeshvara, or "lord of the world") and Maitreya as attendants to Buddha Shakyamuni. A sadhana is a type of meditation in which a practitioner identifies with a specific deity and becomes that deity. Eventually both enter a greater reality, in which distinctions such as the one between devotee and deity no longer exists.

Sadhanas, which are recorded in numerous liturgical and descriptive texts, reflect the development of tantric (derived from the word *tantra*) practices designed to provide a structured and rigorous, but more rapid, path toward enlightenment. Also known as Vajrayana ("path of the vajra"), this tradition, which stresses personal development under the guidance of a teacher, has an expanded pantheon of buddhas, bodhisattvas, and female deities, as well as a host of protective and at times terrifying deities. The development of tantric practices can be traced back as far as the seventh century. Representation of a triad consisting of Buddha Shakyamuni and Bodhisattvas Avalokiteshvara and Maitreya is one aspect of the numerous changes that occurred in Buddhism from the eighth to the twelfth century. It is possible that the addition of the two

bodhisattvas to a biographical moment was intended to stress the attainment of a compassionate emotional state during Siddhartha's triumph over Mara, as well as the triumph over death and desire that is inherent to the achievement of enlightenment.

A fabulous and densely detailed bronze sculpture of a goddess with attendants [6.3] excavated at Sirapur in Madhya Pradesh also reflects the continuation and redefinition of developments in Buddhist imagery first found in the iconography of cave temples,

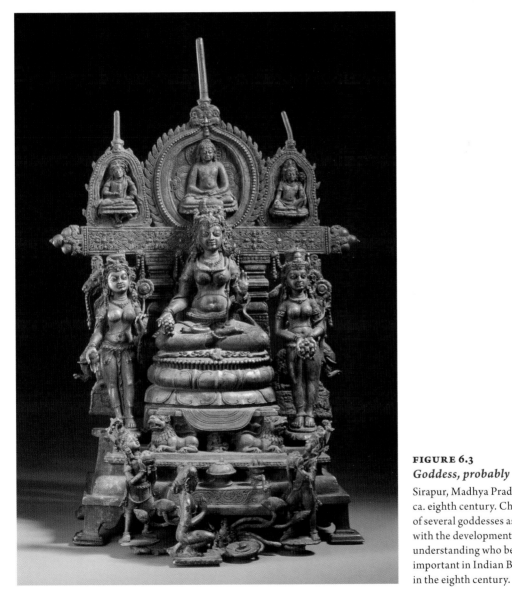

FIGURE 6.3
Goddess, probably Chundi.
Sirapur, Madhya Pradesh, India, ca. eighth century. Chundi is one of several goddesses associated with the development of spiritual understanding who became important in Indian Buddhism in the eighth century.

such as those at Kanheri in western India. Unlike earlier representations of gods and goddesses, which showed them as attendants [3.6], the deity in this sculpture functions as a buddha and is the primary icon in the triad. She is seated on a lotus pedestal set on a throne with an elaborate back composed of vertical supports, a crossbar decorated with a lush floral pattern, and lionlike figures (sardulas). The three vertical rods at the top once supported canopies, which were often found in Buddhist art [6.10] but rarely survive today. A buddha in meditation is seated with two attendant bodhisattvas—Avalokiteshvara to his right and Vajrapani to his left—at the top of the sculpture. The three smaller figures most likely represent the ultimate forms of the transitory manifestations of the three goddesses. The small female kneeling in adoration at the front of the sculpture represents the donor of the piece; the incense burner, covered dish, and conch shell suggest that the sculpture may have been used in rituals requiring these implements.

The goddess is tentatively identified as Chundi (or Chunda) by the fruit—presumably symbolic of knowledge or its seeds—that she characteristically holds in her right hand, and the male and female serpent deities (nagas) holding offerings at the front of the sculpture. Later texts link the enigmatic goddess to an incantation (dharani) of the same name, suggesting that images of Chundi are a personification of this prayer. Devotion to Chundi, who embodies a form of wisdom, appears to be part of the complex of ideas stressing the development of spiritual wisdom that was an integral to Buddhism from the eighth to the twelfth century. The goddess holding a lotus to the right is most likely Tara, also an important figure in wisdom practices. The figure to the left offering seeds is unidentified. All three wear short tops that leave the lower abdomen bare and tight-fitting lower garments. The patterns in their clothing, which is textured to suggest a brocadelike weave, are all different, attesting to the astonishing care and work required for the production of this grouping.

New or additional interpretations for images of buddhas and bodhisattvas, as well as devotion to goddesses—particularly those identified with the development of wisdom and insight—are also found in sculptures and paintings produced in the northeast, one of the most important Buddhist centers on the subcontinent at the time. During this period, the provinces of Bihar and Bengal (now West Bengal State and Bangladesh, respectively) were primarily under the control of the Pala family, although others, particularly

the Senas, ruled different sections at certain times. Monks from all over Asia traveled to the Pala realm to study Buddhism at renowned monastic universities such as Nalanda and Vikramashila. The region, in which most of the eight major sites from the lifetime of the historical Buddha are located, was also a center of pilgrimage, with devotees visiting these famous sites, particularly Bodh Gaya, where Siddhartha attained enlightenment.

Bodh Gaya remains the most sacred Buddhist site in India [6.4]. A carving on a railing pillar from the stupa at Bharhut depicts a hypaethral shrine surrounded by railings and attests to the importance of Bodh Gaya in the second century B.C.E.; it is likely that the site served as a center for devotion from that time on. A Gupta-period inscription defines a structure at Bodh Gaya, presumably Mahabodhi Temple at the site, as a perfumed hall that housed the diamond throne. The famous Chinese monk-pilgrims Faxian and Xuanzang visited Bodh Gaya in the fifth and seventh centuries, respectively; the latter wrote that there were thirty-nine monasteries at the site. The temple at Bodh Gaya has been reconstructed several times and has a large central tower and four smaller towers. Recreations of Mahabodhi, both actual buildings and miniature shrines, are found in Nepal, Tibet, Burma, and Thailand.

Sculptures showing a buddha seated in meditation with his right hand in the earth-touching gesture, which were the dominant public icons of the Pala period, are found on lower stories of the temple at Bodh Gaya, as well as on other monuments. An eleventh-century example from an unidentified building shows the buddha seated in front of a simple throne back, beneath a cluster of leaves representing the bodhi tree [6.5]. Two half-avian, half-human musicians at the left and right edges of the crossbar play a stringed instrument and cymbals, respectively. Male and female wisdom bearers hover directly above the musicians while two smaller stupas, possibly symbolizing buddhas of the past and the future, are seen at the top of the flame-shaped background. Bodhisattvas Avalokiteshvara and Maitreya, identified by the lotus and water pot held by the former

FIGURE 6.4
Mahabodhi Temple.

Bodh Gaya, Bihar Province, India. The temple at Bodh Gaya marks the location where Siddhartha achieved enlightenment and became the teaching Buddha of the current cosmic era.

FIGURE 6.5
Buddha Akshobhya
with Bodhisattvas
Avalokiteshvara
and Maitreya.

Bangladesh or West Bengal,
India, Pala period, eleventh
century. Although the gesture
of the right hand suggests
that the sculpture represents
Buddha Shakyamuni, the
elephant on the base is more
commonly associated with
Buddha Akshobhya.

and the *nagakesara* flower held by the latter, attend the seated buddha. As is typical of the period, the bodhisattvas have the long, matted hair associated with ascetic practices but wear aristocratic clothing and adornments.

The use of the earth-touching gesture suggests that the primary buddha is Shakyamuni; however, the elephant in the center of the base and the vajra carved into the front of the lotus pedestal indicate that he is Akshobhya, who rides an elephant and is the head of the

vajra family of Buddhist deities. In tantric Buddhism, Akshobhya replaces Vairocana as the primary buddha of the lineage of five transcendent buddhas, and sculptures such as this one may be read as images of Shakyamuni/Akshobhya, much as earlier images were understood to represent Shakyamuni/Vairocana [3.13, 4.8]. The earth-touching gesture, used only by Buddhas Shakyamuni and Akshobhya, may illustrate both the decision of an individual to seek enlightenment, the first step on any adherent's path, and the perception that Bodh Gaya, symbolized by this mudra, is the location where all such awakenings occur.

The crown and jewelry that appeared in the visual arts of the eighth century and are worn by the Buddha (Shakyamuni because of the lions on the base) in a twelfth-century Pala sculpture [6.6] allude to the adorning of individuals during tantric rituals. The tiny figure holding a water jug in the center of the base is the goddess of the earth, who is mentioned in many textual accounts of Siddhartha's triumph over Mara. The figures to either side of her are presumably the donors of the sculpture. The seven small buddhas surrounding the larger, primary icon represent seven of the eight most important events in the final life and teaching career of Buddha Shakyamuni and the pilgrimage sites where the events occurred. Reading clockwise from the lower left, the figures illustrate the birth of Siddhartha (at Lumbini, which is now in Nepal); his descent from the Trayasimtrasha Heaven (at Sankaysha), which he visited in order to teach the dharma to his mother; the performance of miracles (at Sravasti); his final transcendence, or *parinirvana* (at Kushinagara); the First Sermon (at Sarnath); the taming of the mad elephant Nalagiri sent by his evil cousin to kill him (at Rajagriha); and the gift of honey from a monkey (at Vaishali). The biographical moments may also symbolize the spiritual journey any devotee takes in the quest for enlightenment. For example, the taming of the mad elephant represents the conquest of internal and external obstacles, while the monkey's gift of honey illustrates the importance of conquering fear, particularly the fear of death.

FIGURE 6.6
Buddha Shakyamuni with eight great events.
Bihar Province, India, Pala period, twelfth century. The smaller figures surrounding the central icon symbolize key moments in the final life and teaching career of Siddhartha/Shakyamuni. They also allude to the locations where these events occurred.

Large-scale sculptures decorating temples and monuments, such as the two pieces just discussed, almost invariably represent Shakyamuni/Akshobhya in the earth-touching gesture. However, exquisitely carved small sculptures made of mudstone or pyrophillite rather than the more usual schist often illustrate new forms of bodhisattvas or other deities associated with esoteric practices, such as those of the *Unexcelled Yoga Tantra* (*Anuttarayoga-tantra*), that were transmitted from northeastern India to Tibet in the eleventh and twelfth centuries. The smaller scale of such sculptures suggests that devotion to these figures may have been personal rather than public during the Pala period; it seems likely that in India from the eighth to the twelfth century, practices classified today as tantric were originally restricted to advanced practitioners. This would explain why a sculpture of a buddha in the gesture of touching the earth could be a symbol of Siddhartha's defeat of Mara to one devotee and, at the same time, a reference to the celestial Akshobhya and the process of enlightenment to a tantric initiate.

A small mudstone sculpture shows Manjuvajra, the tantric form of Bodhisattva Manjushri, in a sexual embrace with the female personification of his powers and wisdom [6.7]. Manjushri, who embodies wisdom, is mentioned in early texts but not represented in the visual arts until the sixth century. The bodhisattva has three faces, six hands, and two legs, and is seated in a meditative posture that suggests that he, like a buddha, has achieved enlightenment. His upper right hand holds a sword, a traditional attribute that reflects his ability to cut through ignorance, and his sword crosses with that of his consort, who has one head and four arms. Both deities wear bejeweled crowns and other adornments, and both have the long, thin features characteristic of Pala sculpture in the eleventh and twelfth centuries. Often explained as symbolizing the union between compassion and skillful means (such as teaching or other methods to guide practitioners) as personified by the male figure and meditative insight as personified by the female, images of couples in an embrace are commonly known by the Tibetan term *yabyum* (literally "father and mother"). The iconography of this sculpture is most likely drawn from the *Hymns of the Names of Manjushri* (*Manjushri-nama-samghiti*), an early tantric text that was known throughout Asia by the tenth century.

Produced in northeast India and Nepal in the eleventh and twelfth centuries, illustrated manuscripts—which are the earliest examples of Indian paintings other than the wall paintings in cave

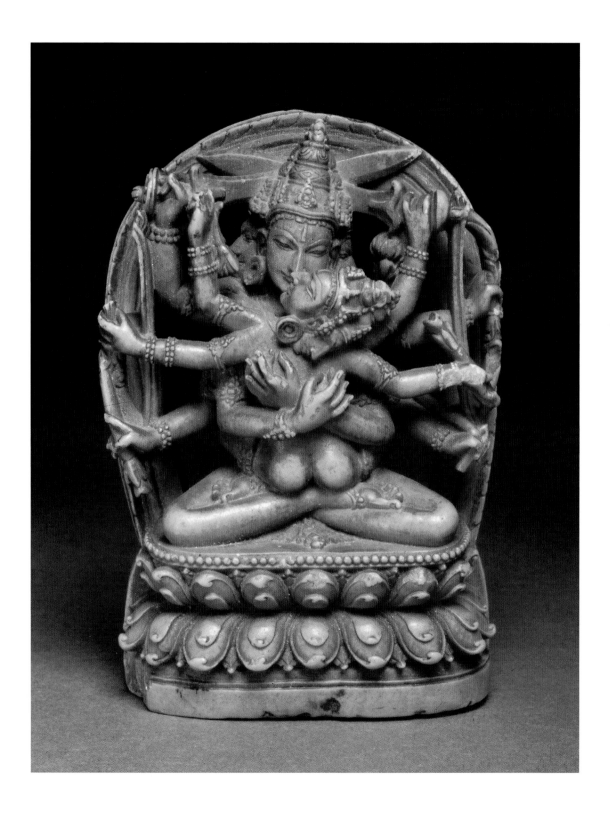

temples such as Ajanta—were made of leaves from the talipot palm strung together with cord and read by lifting one page over the other. Almost all of the manuscripts known today cite the *Sutra of the Perfection of Wisdom in Eight Thousand Lines*, one of the earliest Mahayana texts. Sections may have been formulated as early as the second century B.C.E., and the sutra was finalized by the second century. In these manuscripts, the illustrations—a combination of representations of important deities and of the eight great events in the final life of Buddha Shakyamuni—have no relationship to the text, which is primarily a philosophical treatise on the nature of wisdom and compassion and stresses the need for perfect insight (*prajna*). The *Sutra of the Perfection of Wisdom in Eight Thousand Lines*, one of several texts explaining the development of *prajna*, states that the text itself should be an object of veneration, and valued as much as, if not more than, relics, sculptures, and other icons that also allude to the presence of buddhas.

Each of the four pages from a manuscript now in the collection of The Asia Society [6.8] has three illustrations, with life scenes at each side and deities in the middle. The life scenes, reading from top to bottom and from left to right, depict the eight great events in Shakyamuni's life: the birth, the temptation by Mara, the First Sermon, the miracle at Shravasti, the descent from the heaven of the thirty-three gods, the taming of Nalagiri, the offering of honey by a monkey, and the *parinirvana*. Their placement at the edges of the pages indicates that they were not read sequentially, but were more likely meant to reiterate the quest for awakening defined in the text. The deities in the center of the page, reading from the top leaf to the lower one, are the goddess Prajnaparamita (the embodiment of perfect wisdom), Bodhisattva Manjushri, Bodhisattva Avalokiteshvara, and the goddess Tara.

Inscriptions, written in Sanskrit and Tibetan, on an additional (unillustrated) leaf of the manuscript provide a rare and fascinating history of its origin and subsequent travels. The Sanskrit colophon records the donation of the manuscript by a devotee named Nae Suta Shoha Sitna and lists the name of the scribe as Ananda of the famous Nalanda monastery. The offering of the manuscript as an act of devotion occurred in the fifteenth year of the rule of King Vigrahapala (r. 1058–1085), which would have been around 1073, thereby giving a date for its production. A second Sanskrit inscription records a rededication of the manuscript in 1151. Because such manuscripts were considered sacred objects and were used both

for teaching and as a focus of devotion or meditation, rededications and repairs were common.

The stylistic differences between the paintings on the first two leaves and those on the second two indicate that the latter were most likely added to the book when it was rededicated in the twelfth century. A comparison of the image of Manjushri on the second page and that of Avalokiteshvara on the third elucidates the different styles. Bodhisattva Manjushri is painted with a greater sense of depth and movement than Avalokiteshvara; the same is true of the attendant figures and other details in both scenes. Manjushri and the other figures in the eleventh-century leaves are painted with more delicacy and precision, and with a broader range of colors, than the paintings on the later leaves. In addition, the white background used in the twelfth-century paintings gives an unfinished appearance to these illustrations that is not present in the first two leaves.

The first of the three Tibetan inscriptions translates the information given in Sanskrit, while the second and third trace the

FIGURE 6.8
Four leaves from a dispersed Perfection of Wisdom manuscript.

Nalanda Monastery, Bihar Province, India, Pala period, dated 1073. Inscriptions in this manuscript give a fascinating history of its production in India and subsequent travel to and use in Tibet.

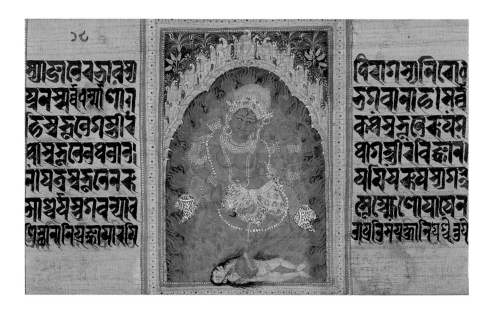

FIGURE 6.9
Goddess Kurukulla.

Detail from a page from a dispersed *Perfection of Wisdom* manuscript. Bangladesh or West Bengal, India, Pala period, early twelfth century. Kurukulla is one of the more ferocious forms of the popular goddess Tara, revered as a protector of and guide for the devout.

history of this book in Tibet. Shakyashri (1127–1225), a learned Kashmiri who served as abbot of Vikramashila Monastery in India and was active in Tibet from 1204 to 1215, owned the book. He was noted for his teaching of the *Perfection of Wisdom* sutra, and it is possible that he used the text shown here while instructing students. After passing through other hands, the manuscript became the possession of Buton (1290–1364), the compiler of the first Tibetan canon of Buddhism. The last inscription documents the use of this book and its dedication for the benefit of an otherwise unknown nobleman as part of his funeral rites.

In addition to deities associated with the wisdom cult, figures specific to highly developed tantric practices (from the *Unexcelled Yoga Tantra*) are also depicted on texts citing the *Perfection of Wisdom* sutra. An image of Kurukulla [6.9] is found on one of the twelve illustrated pages from another such manuscript containing 175 leaves. Two borders, each containing different-colored stupas one above the other, also decorate the page. Kurukulla has a full figure and tiny waist, and resembles contemporaneous sculptural representations of female deities, such as that of the goddess Chundi [6.3]. She stands beneath a golden arch set in a leafy bower, is encircled by flames, and wears extraordinary jewelry painted white, possibly to indicate that it is made of bone. Such adornments, which are often worn by the terrifying deities, symbolize the transience of human existence.

Kurukulla, whose name refers to harsh sounds, is a manifestation of the red and therefore ferocious form of the goddess Tara. Her four arms hold implements, and she stands with one leg on the body of a demon representing ignorance. Additional arms, legs, and heads, which often characterize deities worshipped in tantric practices, symbolize her power and her commitment to helping others. The bow and arrow in her two upper hands and the hook and lasso in the lower ones are made of flowers to show her ability to use natural forces to help subdue negativity. The first two implements illustrate her capacity to defeat egotism; the second, her ability to snare and control a wandering mind. Like most deities discussed in tantric texts, Kurukulla can be interpreted on multiple levels and is associated with mantras (incantations to help a deity manifest in the world) that elucidate and invoke her powers: "All becomes emptiness. From emptiness arise the eight cremation grounds, and in their midst . . . a red lotus . . . There is complete transformation, from which I emerge as glorious Kurukulle [*sic*], body red in color, the mere thought of whom brings all the three worlds under one's power."[1]

SOUTH INDIA

THE CHOLAS, who came to power in the late ninth century, ruled most of the Tamil Nadu region in southern India until the late fourteenth century, maintaining diplomatic and economic ties with polities throughout Southeast Asia as well as with southern China. Devout Hindus, the Cholas were renowned for commissioning exquisitely cast bronze sculptures of deities, such as Shiva and Parvati, and for their active patronage of literature, dance, and other performing arts. Unlike the famous bronze sculptures of Hindu gods, Chola-period representations of Buddhist deities are less known and studied. Nonetheless, more than three hundred sculptures have been excavated at the port city of Nagapattinam. This was an important Buddhist center during the Chola period and was supported by both the Cholas and rulers from Indonesia and other Southeast Asian centers with whom they maintained extensive maritime trade.

A ninth-century buddha seated on a cushion in front of a fabulous throne back is one of the earliest and more complex images found at Nagapattinam [**6.10**]. Solidly cast like all south Indian icons, the statue has survived intact, but the more fragile throne and

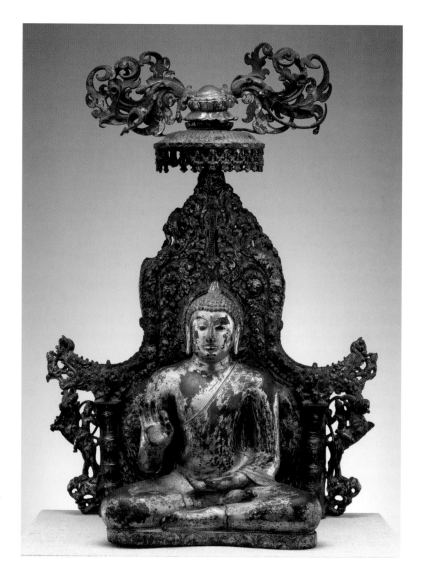

FIGURE 6.10
A buddha, presumably Shakyamuni.

Nagapattinam, Tamil Nadu Providence, India, Chola period, ca. ninth century. The fantastic creatures decorating the back of the throne also appear in later Tibetan and Chinese art.

pedestal have been damaged. The throne back consists of two pillars supporting the heads of *makaras*, whose flamboyant tails create a floral backdrop for the seated figure. Smaller beings ride on the backs of mythical *sardulas* at the sides, and the top is capped with an elaborate canopy. It is likely that two standing attendants, probably Bodhisattvas Avalokiteshvara and Maitreya, once stood behind the throne. The buddha has a full form and figure and wears his shawl over his left shoulder. He is seated in a half-lotus posture in which his right leg is placed over the left, a pose commonly seen in artworks from the southern part of India but rarely used elsewhere. The small flame rising from the *ushnisha* is also a regional characteristic and

may represent the supernal wisdom (*jnana*) of a buddha in deep meditation (*samadhi*). At least one of the biographies of the historical Buddha states that such flames appeared when he was meditating.

Many of the pieces from Nagapattinam have inscriptions, and the bottom of this buddha has two lines in Nagari characters citing the standard Sanskrit formula that states that all phenomena stem from a cause and that Buddha Shakyamuni explained such causes and their cessation. A long inscription on the base of a slightly later Chola-period sculpture of a standing buddha [6.11] indicates that it was made for use in a festival procession, providing an interesting parallel between Buddhist bronzes from the period and the far more numerous Hindu images that were also often used in such ceremonies. The inscription further links the sculpture to the construction of a chapel in a complex known as Culamanivarna-vihara. This monastery had been built in the early part of the eleventh century by a ruler from Srivijaya, a trading nation that flourished in present-day Sumatra and Indonesia (see chapter 8). The inscription also refers to a Chola ruler named Kulottunga I, or Rajendra, who patronized the addition of another chapel to the monastery around 1090. His rule lasted from 1070 to 1120, providing an approximate date for the sculpture. The figure's rigid forward-facing stance and the flame arising from his *ushnisha* are typical of Chola-period sculptures, as are the manner in which the buddha's thin drapery hugs his torso and the heaviness of the hemlines. The distinctive flaming *ushnishas* and this style of drapery were influential in the development of Buddhist art in Sri Lanka and Southeast Asia for centuries.

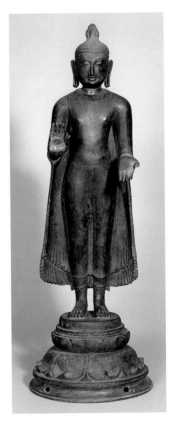

FIGURE 6.11
A buddha, presumably Shakyamuni.

Nagapattinam, Tamil Nadu Province, India, Chola period, ca. 1070–1120. The sculpture may have been carried in religious processions honoring the Buddha and his teaching.

SRI LANKA

ACCORDING to both written and oral traditions, the great Indian ruler Ashoka introduced Buddhism to Sri Lanka around 247 B.C.E., sending his son Mahinda and other missionaries to the island nation. He also sent a cutting from the bodhi tree that was enshrined at Mahavihara, the first Sri Lankan monastery built in the capital city. Mahinda's conversion of the ruler and others is recorded in early historical chronicles such as the fifth-century *Dipavamsa* and the sixth-century *Mahavamsa*. According to the latter, "the great Thera [monk] Mahinda, of immense miraculous powers and wisdom . . . Himself, unshakeable, he caused the earth to quake at eight spots . . . caused one-thousand people there to attain the Path and the Fruit."[2]

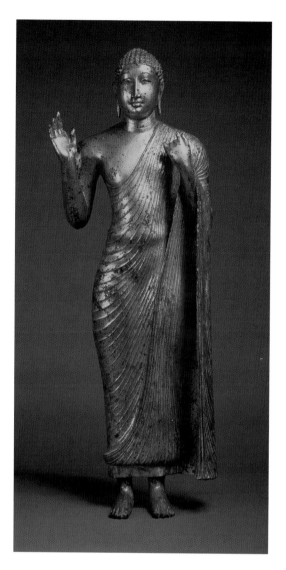

FIGURE 6.12
A buddha, presumably
Shakyamuni.

Sri Lanka, late Anuradhapura
period, ca. 750–850. Details in
the treatment of the drapery,
such as the heaviness of the
shawl's hem, illustrate the long-
standing ties between Sri Lankan
art and Buddhist imagery in
southern India.

Although Sinhalese monks are known to
have visited Bodh Gaya and other centers in north
and northeast India, sculptures produced in Sri
Lanka show long and continuing ties to artistic
traditions from south India centers. A gilt bronze
sculpture [6.12] dating from about 850 to 950
illustrates the seminal role played by Indian
sculptures from Andhra Pradesh in Sri Lankan
art, particularly during the late Anuradhapura
period (ca. 300–1000), named after the the
island's capital city. The sculpture shows a stand-
ing buddha wearing a shawl thrown over his left
shoulder with the thick hem that is characteristic
of early Indian traditions [1.16]. He has broad
shoulders and long legs, and a hint of a waistline
is visible beneath his clothing. His rounded face
has full features, and his snail-shell hair is care-
fully cropped to hug his head in a manner that
also reflects prototypes from the subcontinent.

A magnificent Sri Lankan sculpture of Bodhi-
sattva Avalokiteshvara [6.13] shows the deity
seated with one foot hanging down and the other
knee bent, an easy posture that is often assumed
by bodhisattvas and reflects their accessibility in
the phenomenal world. His left hand supports
his weight, while his right is held in the *kataka*
mudra, a gesture in which the thumb and index
finger touch and the remaining fingers are bent,
indicative of holding a lotus. Bodhisattva Avalo-
kiteshvara shares the broad shoulders and long
legs of the Sri Lankan buddha and also has a
slightly modeled abdomen. He wears an elegantly cast saronglike
garment that flows softly over his legs and is supported with two
knotted sashes and an inlaid belt. Avalokiteshvara's dramatic head-
dress, which was once inlaid with semiprecious jewels, is charac-
teristic of Sri Lankan bodhisattvas from the period. The open cavity
in the center of the headdress, which most likely once held an image
of Buddha Amitabha, is also typical.

No evidence exists of the production of Buddhist images after
993, when the powerful Hindu Cholas of southern India conquered
Sri Lanka and established a new capital at Polonnurava, the city that

gives the next period (993–1235) its name. State patronage of monuments and monasteries began again after 1070, when a new tradition of ordination was launched with the help of monks from Burma, whose ruler also helped repel the Indian invaders. In addition to freestanding works in stone, bronze, and gold, rock-cut complexes, such as that at Gal Vihara [**6.14**], were constructed at that time. Built by Parakramabahu I (1153–1186), Gal Vihara contains three cave sanctuaries housing four colossal stone sculptures: two seated images, a standing figure with his arms folded across his chest, and a recumbent buddha. Only one sanctuary, the central chamber, has been completely preserved. The unprotected seated buddha [**6.15**], which measures fifteen and a half feet in height, has the broad shoulders and long legs characteristic of Sri Lankan icons but lacks the delicate modeling of the torso found in earlier pieces. His flat face and masklike features further distinguish him from works produced during the Anuradhapura period, as do the stylized double folds of his garments.

The buddha sits in a meditative posture on a square throne decorated with lions and vajras. The exuberant back of the throne consists of pilasters decorated with floral designs and three crossbars that terminate in *makara* heads. Four shrines containing images of buddhas whose postures and gestures are identical to those of the primary buddha (possibly a reference to the five buddha families) are found at the top of the throne back; attendant bodhisattvas (not visible here) are on either side of the central icon. The triad of a buddha with two attendant bodhisattvas parallels contemporaneous thought and imagery in India and shows that Mahayana and possibly tantric practices were also found in Sri Lanka from the eighth to the twelfth century.

Ironically, any study of the imagery at Gal Vihara is complicated by the fact that such newer practices, associated with the lineage of monks from Abhayagiri Monastery established in the first century B.C.E., were officially proscribed during the reign of Parakramabahu I in favor of the more conservative practices long preserved at

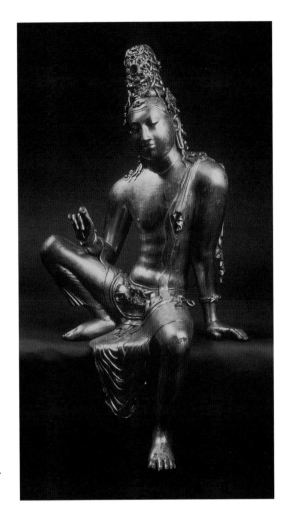

FIGURE 6.13
Bodhisattva Avalokiteshvara.

Sri Lanka, late Anuradhapura period, ca. 750–850. Relaxed postures help show the continuing presence of bodhisattvas such as Avalokiteshvara in the phenomenal world.

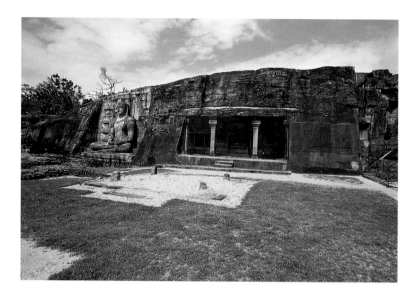

FIGURE 6.14
A view of Gal Vihara.
Pollonnaruva, Sri Lanka,
Pollonnaruva period, 1153–1186.
The monumental figures at Gal
Vihara were constructed in the
twelfth century after Sri Lanka
had successfully repelled the
Indian Cholas from the island.

Mahavihara and related centers: "so that the unification of the sangha which he had achieved with great effort should endure unbroken for five thousand years, and so that members of the community should be endowed with the virtue of having few desires and be diligent in the pursuit of the two vocations of books and meditation, he requested those monks to help protect the Order by giving sermons and instructions, and proclaimed . . . observances."[3]

As mentioned earlier, Mahavihara was the first monastery built in Sri Lanka and traces its lineage to one of the earliest branches of mainstream Buddhism, known as the Sthaviravada ("school of the elders"). This branch of Buddhism was later dominated by a Pali-language tradition known as the Theravada, which was thought to represent the earliest and purest teachings of the historical Buddha. The Theravada tradition can be traced to monks working at Mahavihara, who in the first century B.C.E.—worried about the impact of changes in India, imperial patronage of the new Abhayagiri tradition, and an invasion from Tamil Nadu rulers—sent a group of monks to a cave to transcribe their oral traditions into Sinhalese. By the fourth and fifth centuries, Indian monks were coming to Sri Lanka to study the material preserved there. One, a monk from Kancipuram named Buddhaghosa, requested permission to translate the texts from Sinhalese into Pali, which remains the liturgical language in Sri Lanka and mainland Southeast Asia. To prove his understanding of Buddhist thought and practice, and his ability to adequately translate the canon, Buddhaghosa was asked to write a

treatise known as *The Path of Purity* (*Visuddhimagga*). This volume and the Pali-language version of the Buddhist canon that he helped to translate serve as the basis for the Theravada tradition chosen by Paramakrabahu I as the proper type of Buddhism in the mid-twelfth century. Because of the disappearance of Buddhism in India after the twelfth century, rulers in Burma, Thailand, and Vietnam, relying on Sri Lanka as a primary source for an orthodox lineage of thought and practice, also adopted Theravada as their state form of Buddhism around this time (see chapter 13).

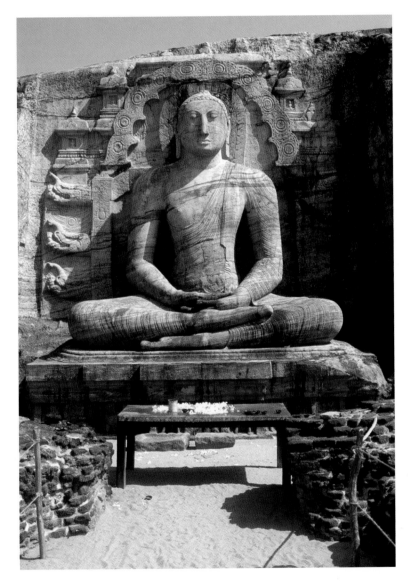

FIGURE 6.15
A buddha.

Gal Vihara, Pollonnaruva, Sri Lanka, Pollonnaruva period, 1153–1186. Four smaller buddhas in identical positions are found in the niches decorating the back of the main figure's throne.

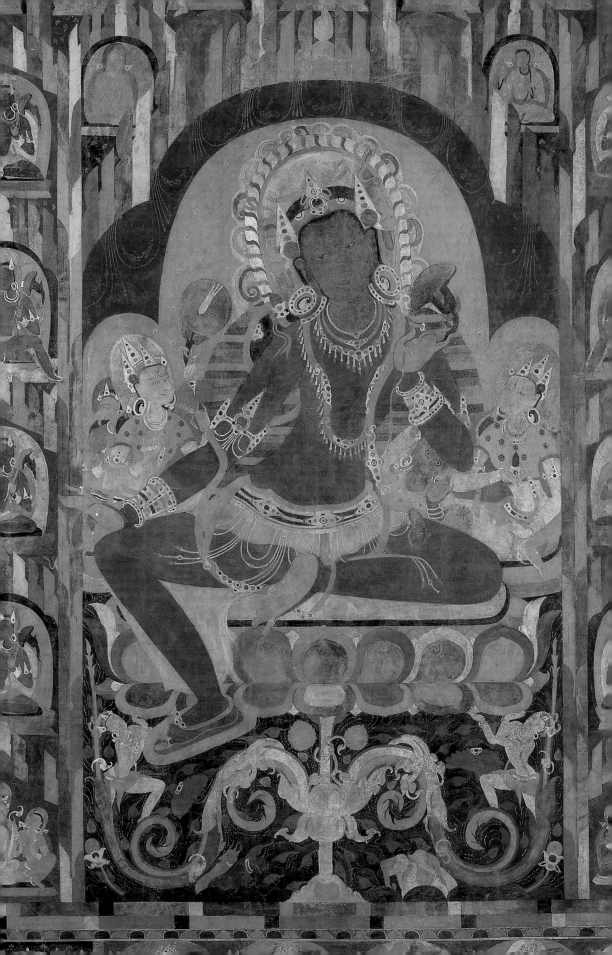

CHAPTER 7

The Himalayan Region
Nepal, Kashmir, Ladakh, and Tibet,
Eighth to Twelfth Century

NEPAL

IN ADDITION to the art and practices from India, those from Nepal and the Kashmir region of the subcontinent also played a significant role in the development and dissemination of Buddhist traditions from the tenth to the fourteenth century. Until the eighteenth century, Nepal, which included the Kathmandu valley and a few outlying regions, encompassed a smaller area than the modern nation. Sculptures and paintings from this limited geographic zone are the work of artists of Newari descent, often members of the same family or workshop, and the material is noted for its strong craftsmanship and iconographic conservatism. The crucial location of the Kathmandu valley, which served as a link between the north and east of India and the other nations of the Himalayas, helped to spread Nepalese artistic traditions and their Indian prototypes to Tibet and, ultimately, to China (see chapter 11).

Identified by the small image of Buddha Amitabha seated in his crown, a gilt bronze sculpture of Bodhisattva Avalokiteshvara [7.1] is an example of a Nepalese type popular from the sixth through the nineteenth century. The bodhisattva stands with his right hand in the gesture of reassurance; his left once held a large lotus stalk, which is now missing. He wears a saronglike garment decorated with delicately incised floral patterns and split to hug his legs, as well as several pieces of elaborate jewelry. A decorated belt is tied at his waist, and a thick sash falls over his hips. Prototypes for the use of this type of sash and the slight sway of the posture are found in representations of bodhisattvas from the Gupta period [2.16]; this style spread to Nepal during the Licchavi period (ca. 300–879) when a daughter of the ruling house married the Indian emperor and the region was under Gupta control.

FACING PAGE
The goddess Tara in her green manifestation.
See page 159.

FIGURE 7.1
*Bodhisattva
Avalokiteshvara.*

Nepal, Transitional period,
late tenth to early eleventh
century. This sculpture is
one of the earliest known
examples of the use of
semiprecious stones for
inlay decoration.

The smooth torso, broad shoulders, and long legs of the bodhisattva also derive from fifth- and sixth-century Indian prototypes, but the broad face, full cheekbones, and elegant features reflect Nepalese taste. Unlike the small, full features seen in Indian sculptures, these are larger and thinner, the eyes and eyebrows have an elegant curve, and the nose is long and thin. The subtle modeling of the body and the dense detailing of the jewelry and clothing—seen, for example, in the layered folds of the sash—help date the bodhisattva to the late tenth or early eleventh century. This is one of the earliest extant examples of the use of semiprecious stone inlays to decorate a sculpture. Originally all the circular depressions in the jewelry would have been filled with multicolored stones; few remain today. The use of inlays spread from Nepal to Tibet and remains a distinctive feature of Himalayan sculpture.

A rare and early rendering of a palace-architecture mandala, the most common variant of this icon in the Himalayan world, was painted in Nepal around 1100 [7.2]. Such mandalas show a principal deity (or deities) in the center of a multilevel, square, palacelike structure with gateways at the four cardinal directions. The structure is placed within a larger circle. In this example, the circle consists of three tiers containing lotus petals, one ring of vajras, and one of flames. All three symbolize purity and help mark the transition from the sacred realm at the core of the mandala to the mundane world beyond the gateways.

The complicated imagery of Nepalese (and Tibetan) mandalas is detailed in texts such as the *Garland of Sadhanas,* which contains chapters devoted to the arrangement of different types of mandalas, the symbolism used, and visualizations and other practices that focus on these icons. Such texts also describe the spiritual and mundane benefits obtained by creating, looking at, praying to, or meditating on mandalas. Fundamentally, mandalas represent manifestations of a specific deity in the cosmos and as the cosmos. As such, they are sacred places, which by their presence in the world remind the viewer of the immanence of Buddha-nature in the universe and of its potential in him or her.

Each figure in a mandala has several purposes, functioning as a specific deity, as a manifestation of the central deity's powers, as a focus of visualization and meditation, and as a signpost for a spiritual process. The process presumes a constant dialogue between the deity at the center of the mandala (and its various manifestations) and the practitioner who moves, at least metaphorically, from the

FIGURE 7.2
Mandala of Paramasukha-Chakrasamvara, and Vajravarahi.

Nepal, Transitional period, ca. 1100. A rare early Nepalese painting, this work is also one of the first examples of the palace-architecture type of mandala commonly found in later Tibetan art.

outer reaches of the mandala to its core. On this journey, the practitioner encounters different forms of divinity from inside out, identifies with each of the deity's manifestations as parts of a single whole, and moves closer to the goal of perfect understanding or enlightenment.

The central deity in this painting is the father-mother pairing of the female Vajravarahi, called "sow-headed" because she is sometimes shown with a pig's head, and the male Chakrasamvara, also known as Paramasukha-Chakrasamvara. The couple illustrates the union of wisdom and compassion that is at the heart of all practice.

(On a deeper level, visualizations of the imagery in this mandala help develop a mind that is filled with clear light.) There are hundreds of forms of this mandala because it is considered a primary part of the *Unexcelled Yoga Tantra,* and because the deities at the center are among the first introduced to initiates. In this version, Paramasukha-Chakrasamvara has four heads, three of which are shown: the central face is blue, the left is green, and the right one is white. Both he and the one-headed goddess have four arms and trample on the backs of two figures, one with red skin and one with white. Both wear adornments and carry ritual implements used to destroy obstacles to awakening; the garland of human skulls is symbolic of the destruction of egotism. Six additional four-armed goddesses fill the petals of the large lotus in the center of the mandala palace. These figures and the main couple all hold what appears to be flayed skin, possibly human because of its white color (most icons of this type have a tiger's skin). The goddesses are protective figures, as are the five female deities seated in individual niches at the bottom of the painting. Eight initiation vases set against backgrounds of red, green, white, and yellow—symbolic of the four directions—fill the area between the central lotus flower and the square walls of the palace. The vases, which are filled with pure water and medicinal and nutritious substances, are often used in rituals and symbolize the nature of the adherent and the internal bounds that must be shattered during practice.

Figures, presumably practitioners and others associated with the mandala, its teachings, and its visualizations, stand and sit in the second tier of the palace wall. Comparable but larger representations of adepts, practioners, and semidivinities are also found in the eight death grounds that fill the upper and lower edges of the painting and are associated with the eight cardinal points of the Buddhist cosmos; they include figures teaching, dancing (at times with snakes or other animals), riding and coupling on the backs of animals, and practicing austerities and various types of meditations and offerings. In the lower left border of the painting, a naked adept performs a ritual using a conch shell, flowers, and other offerings. This figure is most likely Kanhapa, who had a vision in which Vajravarahi's left leg rests against Chakrasamvara's limb rather than encircling his waist as is more common in such icons. Kanhapa is identified by the posture of Vajravahari in this painting. He is one of a group of eighty-four great adepts, or mahasiddhas, who lived and practiced in India from the sixth to the tenth century and attained enlightenment in their

ordinary bodies. They are noted for their unusual or heterodox lifestyles and methods, and they developed great magical powers as part of their spiritual development. Adepts are an important theme in later Tibetan painting and sculpture, and like buddhas and bodhisattvas, they can sometimes be identified by certain physical characteristics or by the implements they hold. The two women at the lower right of the painting, probably the donors who commissioned it, are performing a ritual that requires several different types of offerings.

The rich palette of this painting, dominated by red and yellow, and the elongated proportions and animation of the figures are characteristic of illustrated manuscripts from Nepal and India. The broad faces are typical of early Nepalese works, as is the careful treatment of details such as the jewelry and other decorations. The placement of the eight graveyards on the outer edges of the painting, as opposed to within the set of circles surrounding the inner palace, as well as the humor and attention to detail in these scenes are characteristic of early variants of mandalas.

KASHMIR

THE REGION encompassing present-day Kashmir and nearby sites in northeast Pakistan was also influential in the practice and development of Buddhism from the eighth to the twelfth century. Buddhism was practiced in this region under the rule of the Kushans, and by the fourth century, the area had become a major center for study and innovations in practice. Kashmir is noted for both ivory carving and bronze casting and served as a conduit for Buddhism's transmission to China and Tibet.

A wonderful ivory plaque [7.3] was once part of a small, portable altar used for personal devotions. The deep carving attests to the skill of the craftsmen, as do the density of the composition and the range of figural and facial types. The emaciated buddha in the center shows ties to earlier traditions that flourished in Pakistan and Afghanistan under Kushan rule [2.11]. The emaciated figure seated in a cross-legged pose to the left also appears to be an ascetic, whereas the one to the right wears the long undergarment and shawl of a Buddhist monk. Presumably the former represents Siddhartha practicing austerities and the latter shows the Buddha after he had achieved enlightenment. Both are receiving offerings from smaller figures standing before them. The figure at the left may represent the

moment when Sujita offered milk to Shakyamuni and he chose to take nourishment, thereby moving away from his arduous practice. The women and cows depicted on the base probably represent Sujita and others preparing offerings of milk and food for the emaciated Siddhartha/Shakymuni. The figure on the right may illustrate a scene from the Buddha's teaching career. Many of the smaller figures at the top of the plaque have unkempt hair and beards, suggesting that they also are undergoing deprivations.

A long Sanskrit inscription on the base of a complex gilt bronze sculpture [7.4]—showing a buddha, two stupas, and several other figures set above a rock base—states that a treasurer named Samkaresena and his wife Princess Devashri dedicated the icon and gives a date in the year 3 or 8 of a certain period. An inscription on another sculpture of the same style and date helps to identify Devashri as the daughter of a king who ruled the Gilgit area, now part of northern Pakistan, around 700 and dates the sculpture to around 714. It is not clear whether Samkaresena worked for his father-in-law or for a ruler in some other part of the Kashmir region. The main buddha is seated on a two-tiered lotus pedestal that rises from a base inhabited by serpent deities and supporting two stupas with staircases and numerous parasols. The small buddhas seated in the domes of the two stupas may represent the Buddhas of the past and future cosmic eras. The small male figure standing at the left side of the base is Samkarasena, while the female figure holding a censer at the right side is Princess Devashri. Samkarasena's beard, his belted tunic, long boots, and headdress reflect the clothing worn by the rulers of Kashmir and related centers. The other small figures kneeling at the edges of the base are most likely attendants to the two donors.

The deeply cut and stylized folds of the Buddha's garments, his three-pointed cape, and the distinctive crown with beaded decoration characterize sculptures produced in Kashmir and parts of Pakistan during the eighth and ninth centuries. Most of the sculptures are made of brass (copper and zinc, as opposed to bronze with copper and tin) and inlaid with silver and sometimes copper. The two deer and the wheel

FIGURE 7.3
OPPOSITE
Buddha Shakyamuni as an ascetic with attendants.

Kashmir region, India, eighth century. Small but beautifully carved, this ivory plaque may once have been used in a traveling shrine.

FIGURE 7.4
Crowned Buddha Shakyamuni or Vairocana.

Kashmir region, India, or Gilgit region, Pakistan, early eighth century. A princess and her husband, who were the donors of this striking altarpiece, are shown standing at the right and left of the base.

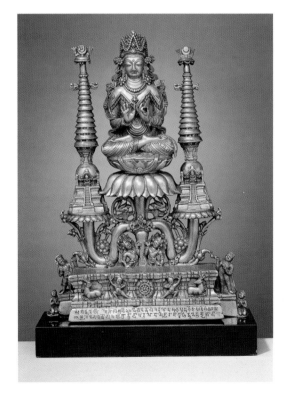

on the base indicate that the sculpture represents Buddha Shakyamuni preaching the First Sermon. Features such as the crown and cape, however, show that other imagery has been added to this biographical moment. Crowned buddhas are found in northeast India; the cape is specific to Kashmir and related centers in Pakistan and Afghanistan. Like the crown, the cape may also parallel the use of such adornments in ceremonies for initiating adherents into specific practices. Regal adornments and the sun and moon at the top of the stupas indicate that the primary buddha may be a fusion of the historic Shakyamuni and the transcendent Vairocana, both of whom are often shown making the gesture of turning the wheel of the law. This variant of the gesture, in which the thumb and forefinger of the proper right hand touch the fourth or fifth finger of the left, is sometimes thought to identify representations of Buddha Vairocana.

LADAKH AND TIBET

BY THE seventh century, both Indian and Chinese forms of Buddhism were known and practiced in Tibet; by the eighth century, when Tibet ruled a vast empire that controlled much of Central Asia and parts of northwest China, it was the state religion. Buddhist influence waned, however, during the persecutions that occurred between 840 and 842. Like those in China at approximately the same time, infighting at court and a widespread concern about the wealth and influence of the clergy contributed to the purge. In the late tenth and eleventh centuries, new rulers once again chose to practice and patronize Buddhism. Monks from renowned centers, such as the Pala kingdom of northeast India and Kashmir, were invited to Tibet to teach and lead a resurgence of Buddhism (often called the "second diffusion"). In addition to texts, monks brought paintings, sculptures, implements, and other paraphernalia to Ladakh and to western and central Tibet, stimulating the creation of new artistic traditions there.

A sculpture of a standing bodhisattva [7.5] is distinguished by the detailed rendering of the exuberant floral patterns on his lower garment, which hugs his legs in a manner reminiscent of the clothing worn by the Nepalese bodhisattva discussed earlier. However, the interest in musculature evident in the powerful articulation of the torso, the exaggerated waistline, the triangular shape of the face, and the strong features shows a Kashmiri influence. The pose of the

FIGURE 7.5
A bodhisattva.

Western regions, Tibet, 1000–1050. The Kashmiri influence is seen in the shape of the face and the strong features of this wonderful brass sculpture produced in the western part of Tibet.

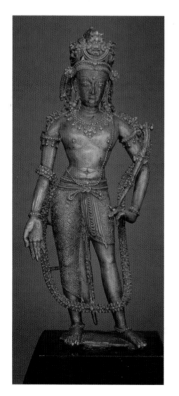

FIGURE 7.6
Alchi Monastery at Ladakh.
India, tenth to thirteenth
century. Some of these buildings
are filled with magnificent
paintings and sculptures.

figure and the long garland of flowers encircling his neck and lower legs are characteristic of works from Ladakh and parts of western Tibet. The bodhisattva holds a partially damaged lotus stalk in his left hand; an attribute placed on the lotus flower at the time it was carved would have served to identify the figure more precisely.

Kashmir's importance as a source of Buddhism during the second diffusion is paralleled by its artistic influence; it is possible that a Kashmiri working in Tibet made this magnificent sculpture. Several Kashmiri artists are known to have traveled to western Tibet with the monk-scholar Rinchen Zangpo (958–1055). Zangpo went to Kashmir in search of texts and images at the behest of the king Yeshe O, who wished to reform and revitalize Buddhism in his small kingdom of Ngari in western Tibet. Rinchen Zangpo and his Kashmiri collaborators, who are credited with establishing several monasteries in western Tibet, also helped to found the Kadma tradition, one of the four main lineages in Tibetan Buddhism; it is noted for an emphasis on elaborate ritual, propitiation of deities, and scholarship.

Kashmiri influence also predominates in the paintings found in several buildings in the monastic complex at Alchi [7.6] in Ladakh,

built between the tenth and thirteenth centuries. As is typical of Buddhist monasteries, the complex, which is also known as the *choskor* ("jewel refuge"), is enclosed by walls and contains several buildings. The walls of the Sumstek ("three-storied building"), the tallest of the five buildings in the enclosure, were made using a combination of rocks and mud plaster common to the region and wooden architectural elements and decorations that derive from Kashmiri traditions. Paintings based on Kashmiri textile patterns decorate the ceiling of the Sumstek, which was constructed in the late twelfth and early thirteenth centuries.

Three colossal clay sculptures of Bodhisattvas Avalokiteshvara, Manjushri [7.7], and Maitreya dominate the first and second floors of the Sumstek. Each of the bodhisattvas parallels the style seen in the gilt bronze sculpture discussed earlier; they wear long, sarong-like garments that are divided to hug the legs and are covered with painted images. Scenes of temples and selected deities are seen in the garment worn by Avalokiteshvara; representations of the lifetimes of Shakyamuni are shown in the clothing worn by Maitreya; and images of the mahasiddhas decorate Manjushri's attire. A dedicatory inscription found to the left of Maitreya's feet explains that the donor, a member of the powerful Dro clan, set up the bodhisattvas as receptacles for the powers of the body, speech, and mind. Practices involving an understanding of the basic tenets of Buddhism through the mastery of these three elements were integral to later branches of Buddhism. The sculpture of Manjushri was created to remove bodily impurities and to help obtain a human buddha body, that of Avalokiteshvara was intended to remove vocal impurities and obtain a glorious body, and that of Maitreya was to help in obtaining the absolute buddha body.

A series of mandalas based on the *Compendium on the Essence of All Buddhas* (*Sarvatathagatatattvasamgraha*) is found on the walls of the upper stories of the Sumstek. The *Compendium on the Essence of All Buddhas* is a longer version of the *Diamond Pinnacle Sutra* that played an important role in early esoteric traditions in China and Japan. Rinchen Zangpo translated both the sutra and an influential commentary on it known as *Spreading Light on True Reality* (*Tattvalokakari*). A representation of the Diamond World Mandala (Vajradhatu) [7.8], found on the east wall of the upper story, has a nine-court structure similar to that observed in earlier Japanese traditions [5.22]. The principal deity, seated in the center of the palace precinct, is the four-faced form of Buddha Vairocana, known

FIGURE 7.7
OPPOSITE

Bodhisattva Manjushri.
Right wall of the Sumstek, Alchi Monastery, Ladakh, India, twelfth to thirteenth century. The unkempt figures depicted on the bodhisattva's garment are early representations of the mahasiddhas, semihistorical Indian adepts who contributed to the development of Tibetan Buddhist practices.

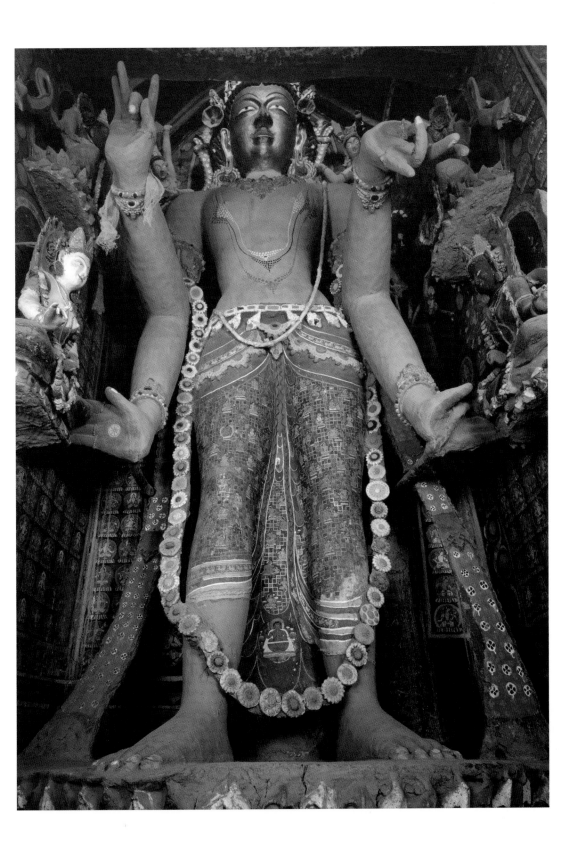

FIGURE 7.8
The Diamond World Mandala (Vajradhatu).
Second upper story of the Sumstek, Alchi Monastery, Ladakh, India, twelfth to thirteenth century. This is one of several variations of the Diamond World Mandala found among the ten paintings that decorate the Sumstek's upper floor.

as the Sarvavid ("universal knowledge") Vairocana. The heads of the four other buddha families accompany the main icon: Amitabha is directly above him, Akshobhya below him, Ratnasambhava to his right, and Amoghasiddhi to his left. Bodhisattvas are seated in the four other courts inside the palace, which has two sets of walls. Goddesses, each in her own circle, which signify the inner and outer offerings of the rituals and practices associated with this mandala, fill the space between the outer walls of the palace and the inner complex. The gateways at the four cardinal directions are detailed with jewels and capped with images of paired deer and a *kirtimukha*

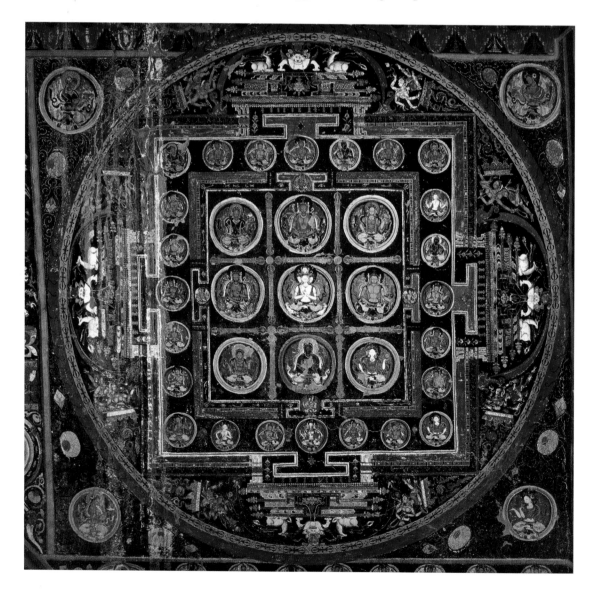

("face of glory"), an auspicious Indian image often found in Buddhist art. Vibrant color is used in this mandala and all the paintings on the walls of the Sumstek; the figural style of the many deities reflects a combination of elements from Kashmir, Nepal, and northeast India.

In a painting (*tangka*) dating to the second half of the eleventh century, the goddess Tara [7.9] and her retinue sit on a lotus pedestal that rises from an elaborate stem similar to that found on the gilt bronze sculpture from the Kashmir region [7.4]. Tara, who was depicted in Indian art as early as the sixth century, became a major deity in later Tibetan traditions, where she was seen as a savior and took multiple and, at times, ferocious manifestations. Marichi, often known as the goddess of the dawn, is to the left of Tara holding a vajra and the branch of a tree, and Pratisara, who protects against evil, is to the right holding a jewel and possibly a lotus. A pig-faced goddess sits behind Marichi, and a manifestation of the goddess Bhrkuti, shown black with a wrathful expression, and holding a skull cup (*kapala*) and ritual chopper (*kartrika*), is behind Tara's left arm. Tara sits with a slight sway, wearing a diaphanous shawl decorated with an elegant circle motif and a gauze orange undergarment. She is adorned with a diadem, large earrings, two necklaces, armlets, bracelets, a jeweled belt, and additional jewelry on her ankles and toes.

Tara and her attendants sit beneath a trilobite arch in front of a background of vertical staves representing a crystalline mountain landscape. The mountains are filled with small figures frolicking with lions and elephants, and reference to a form of Tara known as Khadiravani ("dweller in the magical Khadira forest"). Bodhisattvas with devotees are shown in the two lowest of the ten small niches found at either side of the painting. The eight small images of the goddess in the remaining niches identify this painting as a manifestation of Tara who protects from the eight perils (*ashtamahabhaya*). Like those of Bodhisattva Avalokiteshvara, the perils include physical dangers such as attacks by demons or bandits, poisonous snakes, fires, floods, and false imprisonment in foreign countries. The painting is based on the *Sadhana of Arya Tara, Called Protectress from the*

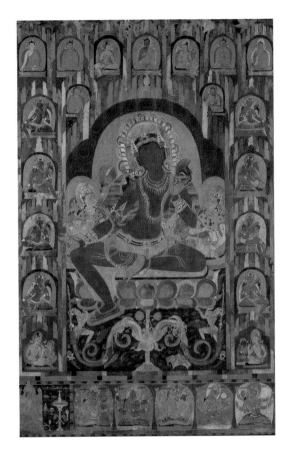

FIGURE 7.9
The goddess Tara in her green manifestation.
Tibet or India, late eleventh to twelfth century. Arguments continue regarding whether this beautiful painting was produced in India or Tibet.

Eight Perils (*Arya Tara Ashtabhaya Trata Nama Sadhana*), a Sanskrit text that was translated into Tibetan by the Indian monk-scholar Atisha (982–1054) and his Tibetan disciple Naktsho: "I bow to her, to this one whom we need only remember to be free from all the eight great perils . . . having bowed to her, I will describe her. Listen, then, my child to her sadhana . . . on her right [side] she [displays the gesture of] a deity that grants all wishes, at the same time her left hand holds a lotus . . . She has a single face, a beautiful countenance, and the appearance of fresh youth . . . She sits in the half-lotus position [and from this seat] will protect the three worlds."[1]

The renowned Atisha, who was invited to Tibet in the mid-eleventh century, played a critical role in the second diffusion of Buddhism and is regarded as one of the seminal figures Tibetan religious history. He is also noted for introducing Tibet to devotion to Tara, for his understanding of the *Perfection of Wisdom* sutras, and for his emphasis on proper monastic behavior:

> Do not say, "I am a [monk]," so long as you care for material wealth and livelihood . . . You may be living in a monastery, but do not say, "I am a [monk], I live in a monastery . . . This . . . is not the time for smiling; it is the time to have courage. It is not the time for holding high positions; it is the time to hold a humble position. It is not the time to live in a crowd; it is the time to take shelter in solitude. It is not the time to guide students; it is time to guide oneself. It is not the time to follow mere words: it is time to meditate on their true significance. It is not the time to be drifting; it is time to remain firm in one place.[2]

It seems likely that the two small figures just above and to each side of Tara's head represent Atisha on the viewer's left, dressed in the clothing of an Indian monk, and his disciple Dromton, on the right in Tibetan clothing. Buddha Amoghasiddhi, who is associated with Tara in the text just mentioned, is the central figure among the small images at the top of the painting, which also include the heads of the four other buddha families, as well as two bodhisattvas. Five six-armed goddesses and a Tibetan monk kneeling before an altar filled with offerings are depicted in the lower section of the painting.

Sanskrit and Tibetan inscriptions on the back of the painting, uncovered during a 1995 restoration, provide invaluable information regarding its history and include mantras and other consecratory

formulas. One states, "The Reting God[dess] . . . The personal meditation images of Chason Dru-o. Consecrated by Sechilpuwa of Chekhawa. Placed [opposite] the Protector Deity at Chilbu [monastery]."[3]

Dromton (Atisha's disciple) founded the Reting Monastery in 1057. Chason Dru-o—who was a prominent disciple of Sharwapa (1070–1141), the abbot at Reting—founded Chekhawa Monastery. Another Sharwapa disciple, Sechilpuwa, later established a monastery at Chilbu. It seems likely that these monks shared a religious lineage and moved the painting, which was deeply revered for both its imagery and its ties to Atisha, from monastery to monastery. Painted and sculpted icons, as well as objects such as robes and ritual implements used by venerated monks, were often passed from master to disciple as part of the transmission of the charisma and spiritual understanding of the teacher.

The extraordinary quality of the painting and its ties to Atisha raise questions regarding where it was made. The languid pose of the goddess, her oval face, and her elongated but lush form are comparable to those of the goddesses Prajnaparamita and Tara in the Indian manuscript discussed in chapter 6, which was made in Nalanda and preserved in Tibet [6.8]. The figures in both works have tilted heads; rounded abdomens; and fluid, gently tapering arms. All have their hair gathered in a topknot and falling over one shoulder, and their attendants and adornments—particularly the diadems and wide armlets—are comparable. Moreover, the toe rings worn by Tara and the deities in the Indian manuscript were more common in India than in Tibet.

It is not impossible that Atisha, who spent several years at the famous Vikramashila monastery, commissioned the painting there and took it with him to Tibet, where it was passed from one of his disciples to another, eventually entering the possession of Chilbu Monastery. It is also possible that an artist trained in an Indian center either painted the work in Tibet or taught a Tibetan artist to paint in a similar style. In either case, the painting remains a visual testimony to the vibrancy of Buddhism in northeast India and the Himalayas from the eighth to the twelfth century, as well as to the seminal role played by these centers in developing practices still preserved in Tibet and to a lesser extent in later Chinese traditions.

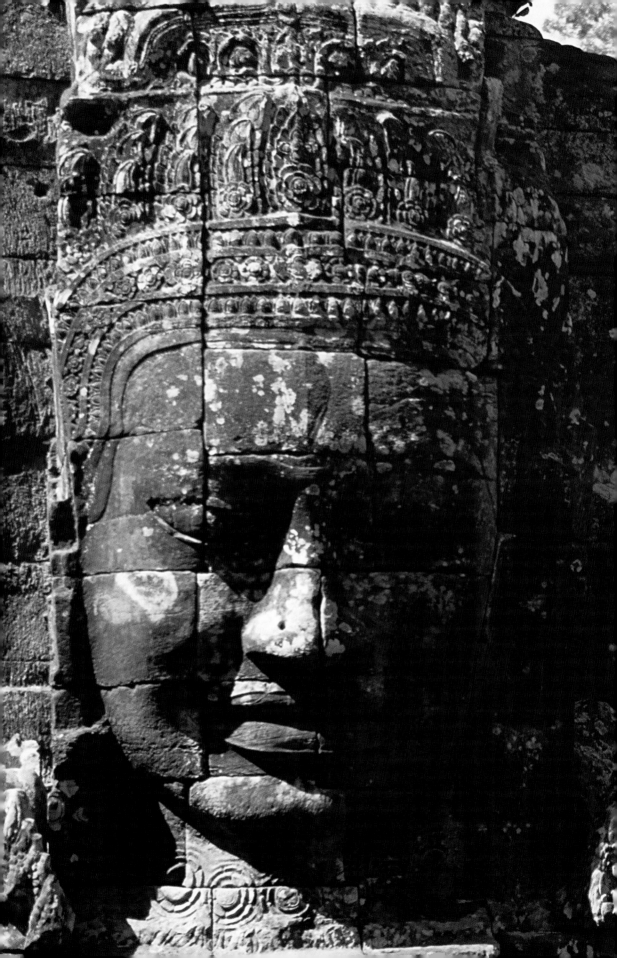

CHAPTER 8

Southeast Asia
Diffusion and Divergence

BUDDHISM SPREAD throughout mainland and island Southeast Asia along well-established maritime and riverine routes that linked various domains with each other and with places as distant as Rome and China. Although Buddhist traditions indicate missionaries from the Indian emperor Ashoka reached parts of Myanmar (Burma) in the third century B.C.E., little evidence of practice there or elsewhere in Southeast Asia before the sixth century has been preserved. Visual arts indicate that patronage of religious sculptures became widespread from the seventh to the ninth century; this growth is linked to the rise of prosperous and cosmopolitan centers and to the thriving trade at the time. Ties with India, which intensified during this period, are reflected in the spread of Hinduism and Buddhism, which coexisted in an intriguing synthesis in Southeast Asia for centuries. Many rulers appear to have practiced or at least supported both religions simultaneously, relying on Hindu traditions for ceremonies, particularly those of royal investiture, and on Buddhism for physical and spiritual salvation.

Study of the history of Southeast Asia is severely hampered by the lack of written evidence. Material discussing the earliest polities is found primarily in Chinese writings, including records from courts that had trade relations with Southeast Asia and from monk-pilgrims who traveled through the region on their way to and from India. Inscriptions on stelae and other markers, in both Sanskrit and in native languages, provide information such as the names of rulers and sometimes the geographic extent of their kingdoms. The geographical relationship between the numerous early polities and present-day nations is not necessarily precise. As a result, the language spoken by the predominant group in any given area, rather than geographical boundaries, is often used to classify different

FACING PAGE
Detail from Towers at Bayon Temple.
See page 175.

centers. Art and culture associated with three contemporary areas—Myanmar and Thailand, Vietnam and Cambodia, and Sumatra and Java—are most often studied. However, it is likely that further research and new archaeological discoveries will someday provide a fuller picture of the fascinating development of thought and imagery in this part of the world.

MAINLAND SOUTHEAST ASIA: MYANMAR AND THAILAND

PEOPLE SPEAKING Pyu, a member of the Tibeto-Burman language family, and those speaking Mon, from the Mon-Khmer family, were dominant in present-day Myanmar from the second to the ninth century. Second-century Chinese sources note the rich lifestyles and artistic traditions, including metalworking in gold and silver, of the Pyu, who established a kingdom or city-state that lasted until the ninth century. A number of Buddhist ruins, including stupas, have been found at the site of the city Sri Kshetra (near present-day Prome), a walled enclosure that most likely served as a capital.

A silver reliquary [8.1], probably used to hold the remains of a monk or accomplished devotee, provides a rare example of the style of early Buddhist sculpture in Myanmar. The round base originally supported a tree, presumably the bodhi tree, that was decorated with silver branches and leaves found scattered on the ground during an excavation in 1927. Four seated buddhas, each accompanied by a smaller standing figure dressed in monastic garb, encircle the base of the reliquary. Each buddha has an articulated halo and sits in front of an awkwardly rendered throne back capped with upward-facing *makaras* derived from Indian traditions. Their broad shoulders, delicately modeled torsos, and long, powerful legs illustrate an awareness of Indian Gupta traditions, as does the thin, clinging drapery. However, the buddhas are shown with their feet lying on their legs rather than crossed, reflecting influences from the southern part of India, where this treatment was common [6.10]. An inscription written in Pali at the top of the reliquary identifies the four buddhas, but only one name—Gotama (Pali for Gautama)—is readily recognizable. A second inscription on the base, written in both Pali and Pyu, identifies the two donors as Sri Prabhuvarman and Sri Prabhudevi, presumably a ruler and his wife since the Sanskrit word *varman* is often used in a royal context, particularly in southern India. Both the style of the buddhas on the reliquary and the inscription indicate a date in the fifth to sixth century.

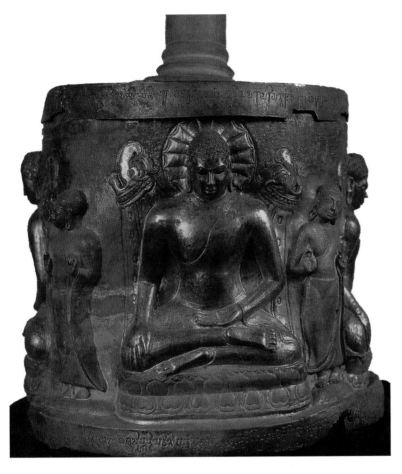

FIGURE 8.1
A reliquary decorated with buddhas and attendants.
Myanmar (Burma), fifth to sixth century. Influence from contemporary Indian artistic traditions is seen in the proportions of the four buddhas on the sides of this Burmese reliquary.

Around 835, the rulers of Nanchao (literally, "Southern dynasty"; ca. 649–957), an independent kingdom in Yunnan Province in southwest China, briefly overran Pyu. By the late ninth century, Chinese control had been broken, and a new kingdom centered on a capital at Pagan and ruled by Burmese speakers had been established. Unlike Sri Kshetra, the walled city of Pagan contained only royal residences and administrative offices, with most of the populace living outside the city gates. Control of overland and river routes linking the region to China, the southern reaches of mainland Southeast Asia, and India contributed to the prosperity of Pagan, particularly during the eleventh and twelfth centuries. In 1060, King Anawratha (r. 1044–1077) captured the port city of Thaton in present-day Thailand, expanding Pagan's contacts and influence on the Malay Peninsula. He also maintained strong economic and diplomatic ties with rulers in Pala India and Sri Lanka, and he helped Vijayabahu I of Sri Lanka defeat the Indian Cholas who had briefly

conquered that island nation. In addition, monks and religious scholars from Sri Lanka and India traveled to the Buddhist court at Pagan, a major center of practice and thought in Asia at the time. More than two thousand monuments [8.2], including numerous brick temples and stupas, in varying states of preservation, remain at Pagan.

The posture and proportions found in a bronze image of Buddha Shakyamuni [8.3] from Pagan illustrates the continuing importance of Indian traditions in the art of neighboring Myanmar. The buddha has the broad, relatively unarticulated physique often found in contemporanious works from northeast India and holds his right hand in the earth-touching gesture that was ubiquitous during the Pala period. However, the broad forehead, slight downward tilt of the head, and short neck distinguish the Burmese piece from works produced in India, as does the use of a small stone (now missing) at the top of the *ushnisha*.

Small settlements supported by trade existed along the southern and western coasts of present-day Thailand as early as the second or third century, such as Panpan, mentioned in Chinese records dating from the fifth to the eighth century. Archaeological and historical accounts indicate that this polity—located in the vicinity of present-day Surat Thani Province—flourished during the late sixth and seventh centuries, a period also noted for its concomitant patronage

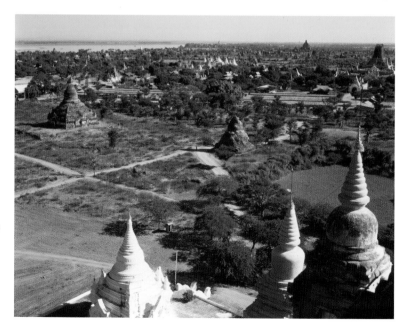

FIGURE 8.2
A view of the temples at Pagan.

Myanmar (Burma), Pagan period, eleventh to thirteenth century. Pagan, the eponymous capital of a Burmese kingdom, was a major center of Buddhist practice from the eleventh to the thirteenth century.

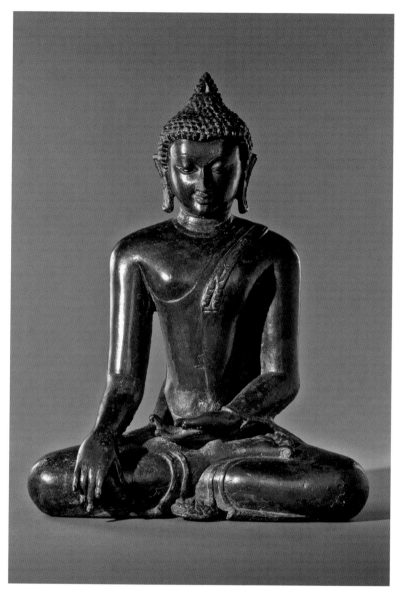

FIGURE 8.3
Buddha Shakyamuni.
Pagan, Myanmar (Burma), Pagan period, ca. 1100. The narrowness of the figure's chin and the slight downward tilt of his head help to distinguish this Burmese sculpture from works produced in India during the same period.

of architecture and art. Both Buddhist and Hindu gods are found at sites in the area around Panpan. A sculpture of Avalokiteshvara [8.4] is one of the earliest known Thai images of this bodhisattva, who was particularly important in Southeast Asia due to his traditional role as a protector of merchants and other travelers, a function that was no doubt valued by the maritime-based cultures in the region.

The figure's stance, compact physique, and understated drapery, which echo Indian Gupta artistic traditions, date the sculpture to

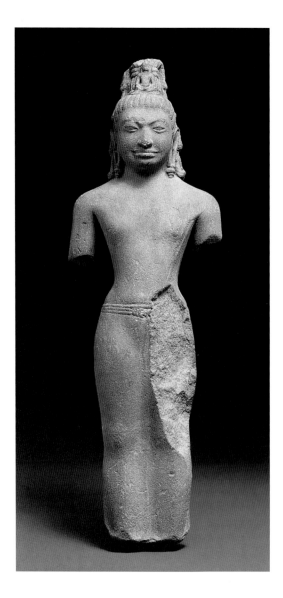

FIGURE 8.4
*Bodhisattva
Avalokiteshvara.*

Thailand, possibly Banban
culture, late sixth to seventh
century. The antelope draped
over the bodhisattva's left
shoulder is a reference to
ascetic practices.

the late sixth or early seventh century. The face is large and flat, while the nose and lips are broad and fleshy. Avalokiteshvara wears coiled earrings and a long garment secured by a double-strand cloth belt. His hair is arranged in the *jatamukuta,* in which the hair is drawn into a chignon on top of the head and held together by braids. The unkempt hair and the antelope skin that covers his left shoulder add an element of asceticism to this sculpture, which parallels other images of bodhisattvas produced in Sri Lanka and throughout Southeast Asia. As discussed in earlier chapters, bodhisattvas first appeared in western Indian art under the guise of ascetics in the sixth century [3.6], and the importance of ascetic imagery in the representation of bodhisattvas in Southeast Asia, particularly from the seventh to the ninth century, reflects the widespread interest in a more rigorous practice found throughout Asia at that time.

In addition to Panpan and other small polities, the larger kingdom of Dvaravati, ruled by Mon speakers, flourished in the central part of present-day Thailand from the sixth through the eleventh century. The name of the kingdom derives from the Sanskrit inscription *Sri Dvaravatisvara punya* ("foundation work of merit of the King of Dvaravati") found on three silver metal medals excavated at sites in central Thailand. The Chinese word *Duoheluo* is also understood as a reference to this kingdom. Art associated with Dvaravati, including brick temples, stone sculptures, and stucco reliefs, has been found throughout central Thailand and in parts of lower Myanmar, and the style continued around Haripunya (present-day Lamphun) until the thirteenth century.

Sculptures produced in Dvaravati, such as a bronze icon dating to the ninth century [8.5], are predominantly representations of buddhas. This standing buddha, presumably Shakyamuni, wears traditional Indian monastic clothing. The lack of folds in the garment and the hint of a waistline reflect the persistence of influences from

Gupta-period India, as does the figure's smooth physique. The slight elongation of the body, the U-shaped hem of the shawl, and the conical shape of the *ushnisha* distinguish the sculpture from its Indian prototypes. Both hands are held at chest height in the gesture of discussion (*vitarka mudra*), in which the thumb and index finger are joined. In Indian art, this same gesture for both hands symbolizes the moment when Shakyamuni descended from the heaven of the thirty-three gods after visiting with his deceased mother. In the art of Dvaravati, the gesture is used by almost all Buddha images. It seems unlikely that only this specific biographical moment would play such a prominent role in early Thai Buddhist sculpture; rather, the use of the identical gesture for both hands probably reflects an appropriation of an Indian prototype that was frequently copied without concern for any hagiographical reference.

MAINLAND SOUTHEAST ASIA: VIETNAM AND CAMBODIA

ADAPTATIONS OF Indian conventions are also found in the art of Vietnam and Cambodia, both of which developed distinctive variations of Buddhist imagery from the seventh to the ninth century. A large, powerful sculpture of a female deity [8.6], excavated at Dong Duong in 1978, exemplifies the style of the Champa kingdom that was based in the central and southern regions of coastal Vietnam. The Chams, who spoke a Malayo-Polynesian language, ruled this region from the third to the thirteenth century. The deity stands erect with her feet fairly close together. She wears one sarong over another in a manner commonly seen in Cham art; the longer undergarment falls to her ankles and has thick, full pleats, while the second top garment falls to mid-calf and has thin, deep folds. Inlays once filled the diamond-shaped cavity in the forehead and single long eyebrow; glass and black stone inlays remain to show her eyes.

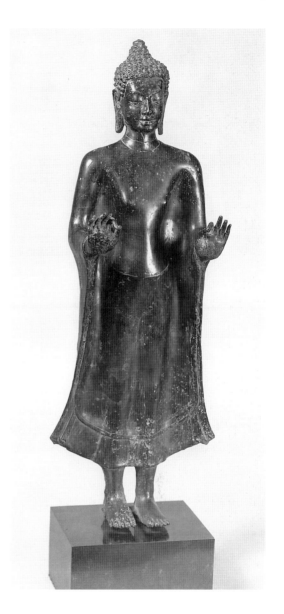

FIGURE 8.5
A buddha, presumably Shakyamuni.

Thailand, Mon style, ninth century. Buddhas with both hands raised in the gesture of discussion predominated in early Thai art.

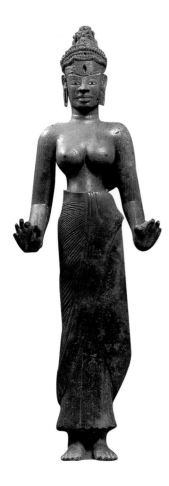

FIGURE 8.6
A goddess, possibly
Lakshmindralokeshvara.

Dong Duong, Vietnam, Champa
style, ca. 875–910. Most likely
the primary icon at the now-
destroyed monastery of Dong
Duong, this sculpture combines
deities worshipped by the ruler
of the region.

A tiny buddha protected by a seven-headed cobra is set into the front of her high headdress in a fashion reminiscent of contemporary Sri Lankan pieces. Buddhas with cobras, which predominated in Cambodian sculptures of the late twelfth and early thirteenth centuries, represent an event in the last life of the historical Buddha, when the serpent Muchilinda sheltered him from a storm during the meditation that led to his ultimate awakening. The use of such an icon in the headdress of a female divinity has no known parallels elsewhere in Buddhist Asia and contributes to discussions regarding the identity of this figure.

The position of her hands, which are held down with the forefingers and thumbs touching, suggests that she once held something, and as a result, she was initially identified as the goddess Tara, who is often shown holding two lotuses. The subsequent discovery of the lotus that she originally held in her right hand and the conch shell from her left suggest that the sculpture may represent a different goddess. One possibility is Lakshmindralokeshvara, a deity revered by King Jaya Indravarman II (r. 875–899), the patron of the Dong Duong complex. One of the stelae excavated at the site indicates that the king commissioned the complex in honor of Lakshmindra-lokeshvara, a combination of the Hindu goddess of good fortune, Lakshmi (who sometimes carries a lotus); the deity Indra (who sometimes carries a conch); and Bodhisattva Avalokiteshvara (who also holds a lotus and is sometimes known as Lokeshvara or Lokesha, "lord of the world"). Lakshmindra was part of the king's personal name before his accession, and the joining of his name to that of his patron deity (Avalokiteshvara) was a fairly common practice in Southeast Asia: "and in making this supreme and eminent Lokeshvara, born from a succession of Buddhas, I shall contribute to the deliverance of [the beings] of the world . . . Desiring to learn what Dharma is, the king thus in his heart, and being skillful in finding out the essence of supreme truth, he made this Lokesha by his own hands [i.e., commissioned it]."[1]

Although it is now mostly in ruins, Dong Duong Monastery, which originally measured 4,265 feet on its east-west axis, was one of the largest in the Champa kingdom. The main precinct of the complex [8.7] contained three groups of brick buildings with stone door frames: a monastery, a pillared hall used for rituals that may have included dance performances, and a main sanctuary with a central shrine tower encircled by eight smaller buildings. As was usually the case, the rear of the compound was the most sacred part

and may have been used for state ceremonies. Based on information from the stele inscription cited earlier, it has been suggested that the bronze sculpture of Lakshmindralokeshvara was the primary icon at the site and was once installed on a large altar in the central shrine. This shrine was dedicated to the ruler or some member of his immediate family, while the nine smaller shrines were used to honor other members of the royal line and their ancestors.

Like the Chams, with whom they had complicated and not always friendly relations, the Khmer-speaking people based farther south in present-day Cambodia derived their wealth from a flourishing maritime trade. Information about the early history of Cambodia is, once again, found primarily in Chinese writings. Such documents record the existence of a powerful mercantile polity known as Funan (first to seventh century), which had trading ties linking the greater Roman world to India and southern China. (Funan is generally understood as the Chinese transcription of the word *bnam*, which later evolved into the Khmer *phnom*, or "mountain.") Funan most likely developed by incorporating smaller city-states throughout the Mekong Delta, as well as those such as Panpan on the Malay Peninsula, and linking them in a communication and trade network. According to the Chinese envoys who visited in the third century, Funan benefited from an agricultural productivity that allowed the housing and feeding of foreign sailors from many lands, who were often forced to wait for up to five months for the monsoon winds to shift so they could continue their journeys. The capital, located near present-day Ba Phnom, had several palaces and grand houses, as well as repositories for books and other treasures. Excavations of the coastal site of Oc Eo, linked to the interior by canals, have revealed a rectangular city measuring 1 by 1.9 miles. Chinese mirrors, Roman coins, and fragments of early wooden sculptures have been found at this site.

FIGURE 8.7
A reconstructed plan of the Dong Duong complex.
Vietnam, ca. 875–910.

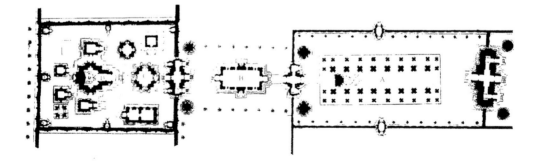

Chinese records also indicate that at some point in the seventh century another state known as Zhenla overtook Funan. Zhenla, which also consisted of several smaller polities unified in some fashion, was later divided into Zhenla of the Land and Zhenla of the Sea; the meaning of this distinction remains unclear. Inscriptions in both Sanskrit and Khmer, which record the names of various rulers, suggest that by the eighth century Cambodia had been further divided into smaller rival kingdoms, and the history of this period remains murky. As a result, Hindu and Buddhist sculptures produced in the region from the sixth to the ninth century are frequently classified as pre-Angkor, the time before the powerful Angkor or Khmer Empire (802–1432) that arose in the ninth century.

Several bronze sculptures, ranging in height from a few inches to nearly five feet and excavated from the underground burial chamber of a temple precinct at Prakon Chai (now in Buriram Province, Thailand), display stylistic features associated with many pre-Angkorian works. Most of the icons associated with Prakon Chai are representations of bodhisattvas, either Avalokiteshvara or Maitreya, but a few buddhas and smaller images of ascetics have also been found in the area.

A large image of Bodhisattva Maitreya, identified by the stupa in his headdress [8.8], provides a beautiful example of the style of images at Prakon Chai. The sculpture was cast in the lost wax method (described in chapter 2), using an alloy with a high tin and low lead content that gives a silvery sheen to the surface. Maitreya stands in a relaxed pose with his feet slightly apart. He has a lithe, slightly muscled figure; a youthful face; a serene, introspective gaze; and four arms. He wears a short hip wrap that ties at the right and is further supported by two simple knotted cords. The simple clothing and lack of adornments indicate that he belongs to the tradition of ascetic bodhisattvas that was widespread in Southeast Asia from the seventh to the ninth century.

The rise of the Angkor Empire is thought to date from around 802, when King Jayavarman II (802–850) established Khmer rule. The period from the late ninth to the mid-fifteenth century is often known as the Angkor period, named for the capital that was established at the end of the ninth century by King Yashorvarman I (r. ca 889–910). Angkor, one of the most remarkable capital cities in world history, is noted for its complicated hydraulics system and the vast number of breathtaking monuments that were constructed in and around its boundaries. These structures, inevitably dedicated to

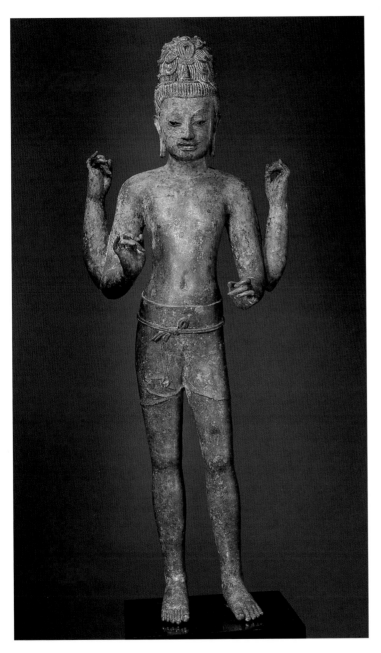

FIGURE 8.8
Bodhisattva Maitreya.
Prakhon Chai, Buriram
Province, Thailand, Pre-Angkor
period, eighth century. The 1964
discovery of a hoard at Prakon
Chai, on the border between
Cambodia and Thailand,
had a profound impact on the
study of sculpture in mainland
Southeast Asia prior to the
rise of the Khmer Empire.

Hindu gods, ranged from relatively small temples dating to the
earlier years of the period to gigantic temple mountains profusely
decorated with sculptures; examples are the Baphuon and Angkor
Wat, which were built during the eleventh and twelfth centuries.
Beginning with Jayavarman II, the Khmer kings ruled by divine

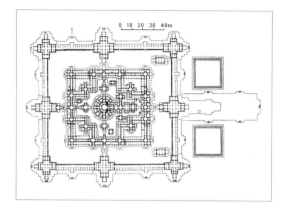

FIGURE 8.9
A plan of Bayon Temple.
Cambodia, Angkor period,
late twelfth to early
thirteenth century.

right as *devarajas* (god-kings), an Indian concept possibly transmitted from Java where Jayavarman spent some time in exile before establishing control over Cambodia. Sculptures of Hindu deities created during this period served two functions: each was regarded as both the image of a god, such as Shiva or Vishnu, and the symbol of a given ruler. Images were often given personal names, such as Lakshmindralokeshvara, thereby linking a ruler (or some other person) directly to the deity.

Jayavarman VII (r. 1181–ca. 1218) was the only Khmer emperor to practice Buddhism rather than Hinduism. Noted for his extensive public works, including hospitals, way stations, and a network of roads, Jayavarman VII sought to govern as the embodiment of a compassionate bodhisattva in the same way his predecessors had established a parallel between their right to rule and the powers of Hindu gods. He established Angkor Thom (meaning "great capital") to celebrate his victory over a Cham king in 1181 after four years of fighting. The city is built around the Bayon temple [8.9], which symbolized Mount Meru, the mythical center of the Buddhist cosmos. The temple, which underwent several renovations, some possibly during its original construction, has not survived as well as other Khmer monuments due to the shabbiness of the construction methods and materials used. It extends along an east-west axis from a large platform bordered by two pools. The square enclosure, which measures about 525 by 426 feet, contains numerous smaller shrines linked by narrow passageways, as well as two libraries at the north-east and southeast. Forty-nine towers decorated with large faces [8.10] are scattered among the various sanctuaries of the inner gallery and central block. The faces on the towers show Avalokiteshvara as Lokeshvara, the patron deity of the emperor and his realm.

A sculpture representing Bodhisattva Avalokiteshvara [8.11] as the generator of the cosmos, a variant of the Lokeshvara manifestation, is a striking example of the innovation often found in Buddhist imagery during the reign of Jayavarman VII. Identified by the seated Buddha Amitabha in his headdress, the bodhisattva has eight arms, which once held implements indicative of his power and compassion. Numerous small images of seated buddhas, representing both the many worlds he embodies as the cosmos and the spread of the dharma therein, fill his torso. The eight somewhat larger

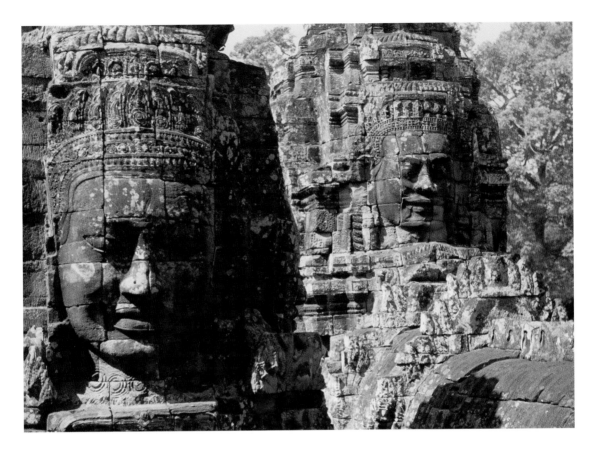

buddhas that encircle his waist symbolize his dominion over the
four cardinal and four intercardinal directions. The meaning of a
ninth buddha placed in the center of his chest is unclear; it may
reflect either his dominion of an apex above the cosmos, his great
compassion, or both. The forward-facing position and square face
are typical of works produced during the reign of Jayavarman VII,
as are the looping curls of the headdress. The rendering of the waist-
band as higher at the back than at the front and the floral decoration
on the large belt are also characteristic of the period.

The heaviness of the legs of a wonderful bronze sculpture that
shows Hevajra dancing [8.12] is also typical of the art produced during
the reign of Jayavarman VII. Hevajra (the "Laughing Vajra") belongs
to a group of fierce protectors, often known as wrathful deities. Unlike
earlier protectors such as the guardians of the four cardinal directions,
Hevajra and the other figures in this category function as both protec-
tive and defensive figures, and they are actively involved in spiritual
development. The acceptance that such ferocious and terrifying
figures embody a great spiritual understanding is part of the shift in

FIGURE 8.10
Towers at Bayon Temple.

Cambodia, Angkor period, late
twelfth to early thirteenth
century. Powerful faces carved at
the top of many of Bayon's towers
are thought to symbolize the
immanence of Avalokiteshvara,
the bodhisattva of compassion.

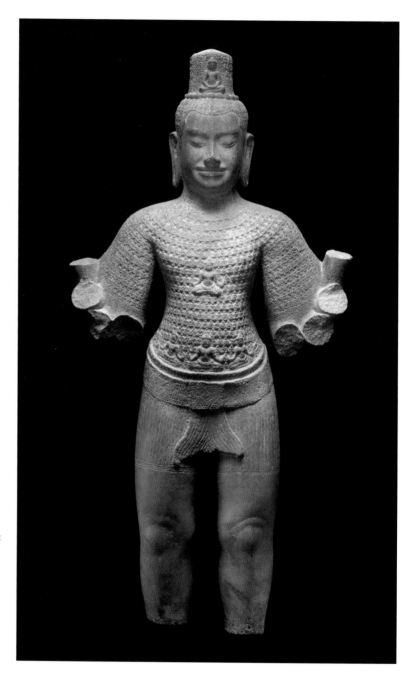

FIGURE 8.11
*Bodhisattva Avalokiteshvara
as Lokeshvara.*

Bayon, Cambodia, Ankgor
period, late twelfth to early
thirteenth century. Images
depicting Avalokiteshvara as
the source of the cosmos are
unique to Cambodia during
the Ankgor period.

perceptions that leads to a deeper awakening. Devotion to them
includes visualization and identification, and wrathful deities play an
important role in later esoteric traditions. The depiction of the deity
parallels descriptions found in texts, such as the *Hevajra-tantra,* first
recorded in India at the beginning of the eighth century:

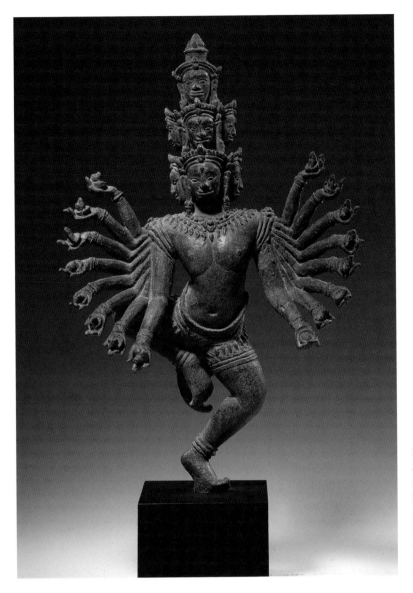

FIGURE 8.12
Hevajra.

Cambodia, Angkor period,
late twelfth to early thirteenth
century. Implements held
in Hevajra's sixteen hands
symbolize his mastery
of elements and beings in
the cosmos.

[Hevajra's] eyes are red from compassion: his body is black to
indicate his sentiments of friendliness: . . . his eight faces [sym-
bolize] the eight releases, and his sixteen arms, the sixteen voids . . .
The skulls in his right hands contain these things in this order: an
elephant, a horse, an ass, an ox, a camel, a man, a lion, and a cat.
Those in the left are: Earth, Water, Air, Fire, Moon, Sun, Yama
[Death], and Vaishravana. They symbolize his universal mastery
over all matter and beings: alive and dead, on earth, in the under-
world, on the planets, and in the heavens.[2]

This sculpture once danced on the back of a prone figure symbolic of the delusions that Hevajra destroys. The eight heads of the guardian are arranged in three rows. The five heads in the top two rows may represent the five heads of the major families of deities. The three heads on the bottom symbolize a triad consisting of Buddha Shakyamuni, Lokeshvara, and Vajrapani (another protective figure), an unusual combination that was also popular during Jayavarman VII reign. The interest in esoteric imagery found in art produced during this time, however, did not continue in mainland Southeast Asia after the thirteenth century. The Thais and other groups in the area, whose desire for independence contributed to the dissolution of the Khmer empire, chose to practice the more austere traditions known today as Theravada that were followed in Sri Lanka (see chapter 13).

ISLAND SOUTHEAST ASIA: SUMATRA AND JAVA

LITTLE EVIDENCE of the practice of Buddhism (or Hinduism) in island Southeast Asia exists before the rise of Srivijaya, an enigmatic polity thought to have controlled the Straits of Malacca from the seventh to the eleventh century. Excavations around Palembang in Sumatra indicate that it served as the capital for the Srivijayan confederation, a wide-ranging maritime trade network with ties to China and many regions to the west. The first record of Srivijaya is found in the writings of the Chinese monk Yijing (635–713), who visited the kingdom in 671 on his way to India and again from 685–689 when he returned to China after studying in Nalanda for several years. According to him, Palembang: "[has] more than a thousand Buddhist priests whose minds are turned to study and good works. They examine and study every possible subject, just as in [India] . . . If a Chinese priest wishes to go to the West to hear and read [original Buddhist texts], he would do better to stay in Palembang for a year or two."[3]

Amoghavajra, one of the three great patriarchs of early East Asian esoteric thought, also studied there, as did the famed Atisha of Indo-Tibetan tradition, who wrote: "From among all these gurus, the one unencompassable by thought, absolutely matchless, without rival was Guru Suvarnadvipa, 'the Golden Islander.' His name was Dharmakirti, 'Dharma fame.' Although he lived on the Golden Island [Sumatra], his fame pervaded the entire [Buddhist] world and

he was like the crown jewel of all Buddhists. It was said the he was the foremost teacher [of training in kindness and compassion]."[4]

Srivijaya's importance in the dissemination of imagery associated with early esoteric doctrine parallels its dominance of the trade between India and China. This ended around 1025 when the Cholas of southern India, who had conquered Sri Lanka, also attacked Sumatra in an attempt to extend their power in the region.

Srivijaya encompassed the southern areas of the Malay Peninsula as well as parts of Java and Borneo, and items produced in the realm have been found throughout Southeast Asia. As a result, it remains difficult to label any individual works of Buddhist sculpture as typical of Srivijayan style. However, the softness of the physique and face in a sculpture of Bodhisattva Avalokiteshvara [8.13], as well as the lush and beautifully detailed jewelry, distinguish this piece from works made in other polities in the region (such as Dvaravati) and from contemporaneous works made in Cambodia. It seems likely that the combination of soft, rounded forms and fantastic, richly crafted jewelry reflects the taste of the Srivijayan rulers. Such regal adornments also suggest identification of this powerful, multi-armed form of Avalokiteshvara with a ruler, similar to practices in other Southeast Asia regions. It is difficult to identify the bodhisattva precisely because the lower part of his eight arms and the implements he would have held are missing. It is worth noting, however, that Amoghapasha [9.3], one of the two eight-armed manifestations of Bodhisattva Avalokiteshvara, was popular in both India and China from the eighth to the tenth century, providing a possible identity for this sculpture.

The depiction of the hair as a series of diagonal, ribbonlike lines and the corkscrew curls running along the sides of the topknot and falling over the shoulder indicate that a sculpture of an eight-armed goddess was made in Sumatra [8.14]. These details parallel those on ninth-century bronze sculptures discovered in the Komering River at Palembang in 1930. The crafting of the diadem as a thin

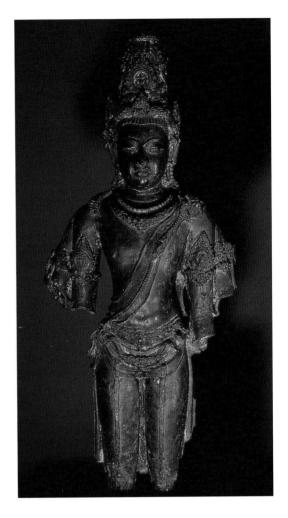

FIGURE 8.13
Bodhisattva Avalokiteshvara.

Thailand, Srivijaya style, eighth to ninth century. The beautiful physique and abundant jewelry worn by this representation of the bodhisattva of compassion characterize sculptures produced under the aegis of Srivijaya, a maritime polity based in Sumatra.

band with triangular shapes, the three-dimensional quality of the armlets, and the high and extremely thin waist are also comparable to those of sculptures excavated in Sumatra. With the exception of the vajra in the goddess's upper right hand, the implements she holds are too damaged to recognize, and her identity remains unclear. Nonetheless, like the multiple-armed figure of Bodhisattva Avalokiteshvara discussed earlier, the sculpture of a goddess with multiple arms can be linked to the early esoteric doctrines taught and practiced in Sumatra and found throughout Southeast Asia in the eighth and ninth centuries.

Inscriptions found on commemorative stones in Sumatra indicate that the Sailendra family, which ruled the Kedu Plain in central Java, also controlled Srivijaya from the ninth to the early eleventh century. Monuments built in central Java, such as the magnificent Borobudur and nearby Hindu temples attest to the wealth of the region at that time. The Borobudur, which measures 360 square

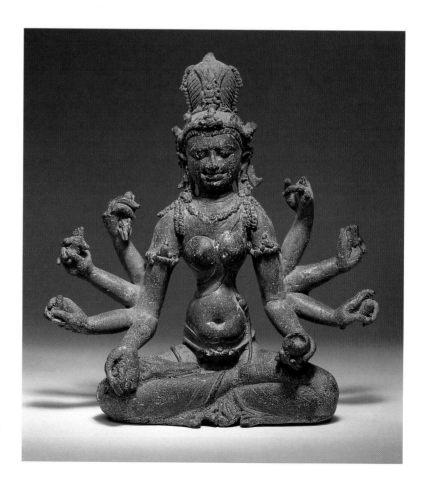

FIGURE 8.14
A Buddhist goddess.
Sumatra, Indonesia, Srivijaya style, early ninth century. Although she cannot be positively identified, features such as the treatment of her hair indicate that this goddess was made in Sumatra.

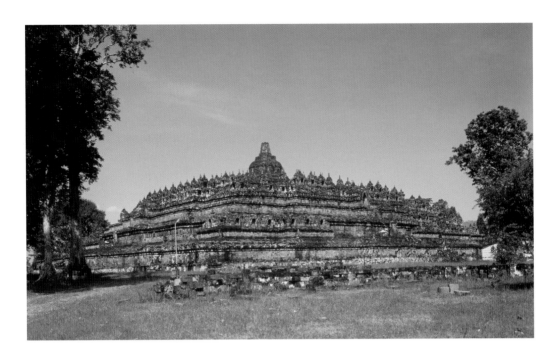

feet, has no interior space. It consists of a series of stepped terraces joined together with staircases. The base and four lower terraces are square [8.15], while the top three are round. The walls of the base and four lower terraces are filled with rectangular panels carved with narrative scenes. Those on the base emphasize the Buddhist law of causality, while the images on the first terrace and some of those on the second present an amazingly detailed history of the lives of Buddha Shakyamuni. Other narratives on the second terrace and most of the images on the third and fourth [8.16] show scenes from the *Structure of the World Compared to a Bubble* (*Gandavyuha-sutra*), part of the *Flower Garland Sutra*, which details the journey of a young pilgrim named Sudhana who travels the cosmos in search of enlightenment:

FIGURE 8.15
Borobudur.

Central Java, Indonesia, early ninth century. One of the more dramatic monuments in Asia, the Borobudur incorporates elements of the stupa and the mandala.

> [Sudhana] explored one Buddha field for an aeon. He explored another for as many aeons as there are atoms in countless Buddha fields, without ever leaving that field. In each and every moment of thought, he entered quadrillions of Buddha fields and brought beings there to the maturity that is unsurpassed complete enlightenment . . . and gradually, he came to equal all the [Buddhas] . . . in the purity of knowledge; he came to equal them in voice and speaking; he came to equal them in great love, in great compassion, and in the inconceivable liberation of bodhisattvas.[5]

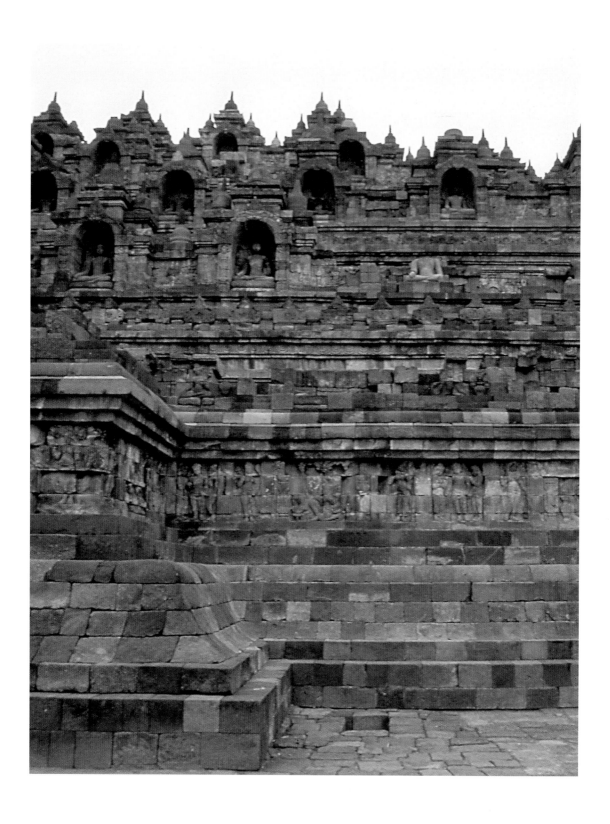

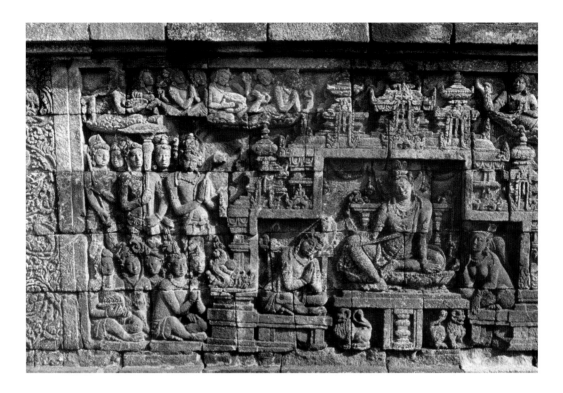

Sudhana encountered monks, kings and queens, gods, and bodhisattvas during his quest. In a scene from the third terrace, he meets with Bodhisattva Manjushri [8.17] to request instruction. The bodhisattva, the young pilgrim, and a female attendant are shown in an elegant three-tiered building that reflects the style of imperial architecture during the period. The bodhisattva is seated with one foot hanging down and the other resting on a cushion, while Sudhana (to the left) kneels and holds his hands in the gesture of respect. Flying figures, indicative of the paradisiacal nature of Manjushri's realm, fill the upper part of the scene. Members of Sudhana's retinue, who also make the gesture of respect, are seated and standing outside the structure. Both the bodhisattva and the young pilgrim wear a conical, or mountain-shaped, crown and detailed jewelry and belts.

One hundred and eight buddhas sit in niches or at the edges along the outer walls of the square terraces. Each side of the monument houses twenty-seven, and they are distinguished from one another by their placement to the north, south, east, or west, and by their hand gestures. A buddha originally from the west side of the monument [8.18] is identified as Buddha Amitabha by both

FIGURE 8.16
OPPOSITE
A side view of Borobudur.

Central Java, Indonesia, ninth century. The narrative scenes on the sides of the terraces help guide visitors through different stages of Buddhist thought and practice.

FIGURE 8.17
ABOVE
Sudhana visits Bodhisattva Manjushri.

Detail from the third terrace, Borobudur, central Java, Indonesia, early ninth century. Sudhana, the young protagonist of an important sutra, visited many teachers during his pilgrimage to find a greater awareness. Here he is seen requesting instruction from Manjushri.

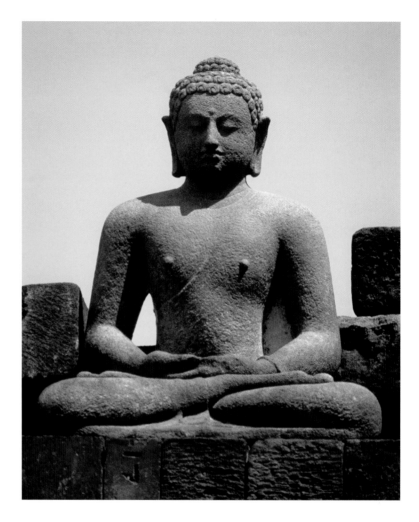

FIGURE 8.18
Buddha Amitabha.
Borobudur, central Java,
Indonesia, early ninth century.
The meditative gesture of
the buddha's hands identifies
him as Amitabha, who presides
over the western quadrant of
the monument.

his placement on the monument and his meditative gesture. The buddhas on the other three sides are Amoghasiddhi (facing north, making the gesture of reassurance), Ratnasambhava (facing south, making the gesture of bestowing), and Akshobhya (facing east, making the earth-touching gesture). Each buddha wears a thin shawl that covers his left shoulder and a long undergarment. The latter is shown as a series of impossible horizontal pleats between the crossed legs.

Seventy-two stupas with reticulated domes are found on the three round terraces, and a larger, unopened stupa dominates the top and center of the monument. All of the stupas contain images of seated buddhas, and the combination of visible buddhas on the square terraces and the partially hidden figures in the stupas contributes

to the inevitable and unending debate about the meaning of this enigmatic monument. The structure of the Borobudur resembles that of contemporaneous imperial funerary monuments, and it is possible that it is a stupa marking the remains of one of the rulers of the Shailendra dynasty. However, the multiple stupas and buddhas on the monument and the clear divisions between the four cardinal directions resemble the structures of painted mandalas, as does the ability of the devotee to physically and spiritually move from the outer precincts (or base) to the inner realms (or summit). The Borobudur may have functioned as a mandala, presumably one in the Diamond World (Vajradhatu) tradition that was popular throughout Asia in the eighth and ninth centuries. It may also be read as a combination of stupa and mandala. In addition, its imagery presents a visual rendering of the Buddhist cosmos leading from the realm of desire (symbolized by the historical manifestations of Buddha Shakyamuni) to that of form (represented by the tale of Sudhana) to that of formlessness (symbolized by the stupas at the top). It also embodies the progression implied in these stages as a part of the practitioner's spiritual development.

No monuments or inscriptions dated after the tenth century have been found in central Java. In the early eleventh century, Airlangga (r. 1019–1042), a member of the Kadiri lineage and one of many rival claimants from the eastern part of Indonesia, overthrew the Sailendra family. Like the Sailendras, the Kadiri practiced Buddhism and Hinduism, and imagery associated with both traditions is found in the art produced during their rule. A group of four small sculptures [8.19], which were once part of a large three-dimensional mandala, illustrates the continuation of practices associated with the Diamond World Mandala in the late tenth and

FIGURE 8.19
Four deities from a Diamond World Mandala (Vajradhatu).

Nganjuk, east Java, Indonesia, Kadiri period, late tenth to early eleventh century. Small sculptures such as these were once part of larger groupings assembled into mandala formations.

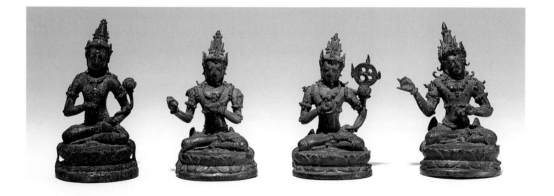

early eleven centuries. Two complete sets of figures were discovered in Indonesia—one in the village of Chandi Reja in 1913, and the other more recently at Surocolo. They suggest that comparable small figures found in Indonesia and elsewhere in Southeast Asia may also have been part of larger groups of deities. The sculptures represent bodhisattvas functioning as attendants or retinue deities, and they would have been placed in the outer areas of the mandala. Their long, thin bodies and strong faces typify works from east Java; however, the conical crowns and jewelry parallel the adornments worn by figures in the reliefs at Borobudur. The slight differences in the adornments of the attendant bodhisattvas and the implements they hold in their hands distinguish them from one another, but they have yet to be identified with certainty.

In 1222, the Kadiri lineage was overthrown by the Singasari dynasty ruling from the present-day city of Malang. An invasion by the Mongols (based in China) in 1292 marked the end of the brief Singasari rule, and a new kingdom known as Majapahit was established. It controlled Java until the early sixteenth century. Art produced under the Majapahit rulers was often courtly or secular and included dramatic jewelry and textiles as well as small terracotta sculptures showing scenes from daily life. A magnificent sculpture representing the Buddhist goddess Prajnaparamita [8.20] is one of the more important works of religious art from that period. The sculpture is also thought to be a posthumous portrait of Queen Rajapati, the consort of King Ketarajasa (r. 1293–1309), the founder of the dynasty. The figure, who sits on a simple throne in a posture of meditation, is also identified as Prajnaparamita, the personification of spiritual insight, by the book that sits on top of the lotus to her left side. She holds her hands in a variation of the gesture of turning the wheel of the law, a combination of a buddha who teaches the perfection of spiritual wisdom and a ruler who promotes such knowledge. Her long physique and strong face show the influence of eastern Javanese sculptures such as the small bodhisattvas discussed previously. The elaborate jewelry, particularly the astonishing armlets and belt, belong to the tradition of regal jewelry in Southeast Asia; the lush wrap, with its dense floral patterns, may parallel court costumes from the twelfth and thirteenth centuries. The depiction of a queen in the posthumous guise of a Buddhist deity promotes the notion of divine rule, and is another example of the identification of a ruler with a Buddhist or Hindu divinity characteristic of Southeast Asia, particularly from the ninth to the fourteenth century.

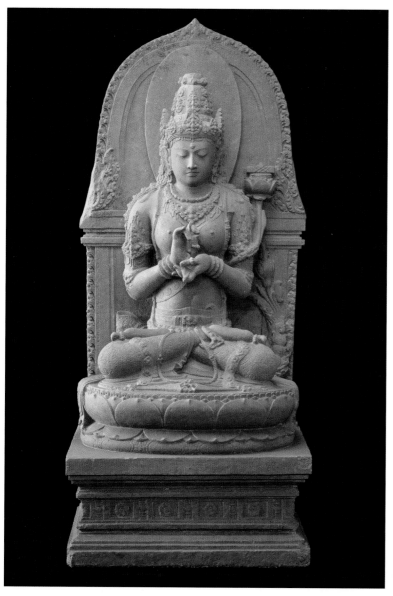

FIGURE 8.20
Goddess Prajnaparamita.
Candi Singasari, Malang, east
Java, Indonesia, Singasari period,
thirteenth century. Sculptures
that combine a Buddhist deity
and a portrait of a ruler were
a long-standing tradition
blending the divine and the
royal in Southeast Asian art.

Buddhist sculptures created for the Majapahit kingdom are
among the last such icons preserved from Java and other parts of
Indonesia. By the twelfth century, the Arab merchants who had
played an active role in the maritime trade that contributed to the
wealth of the region had established settlements in the northern
part of Sumatra and other areas; over time the inhabitants of island
Southeast Asia converted to Islam, which remains dominant there
today.

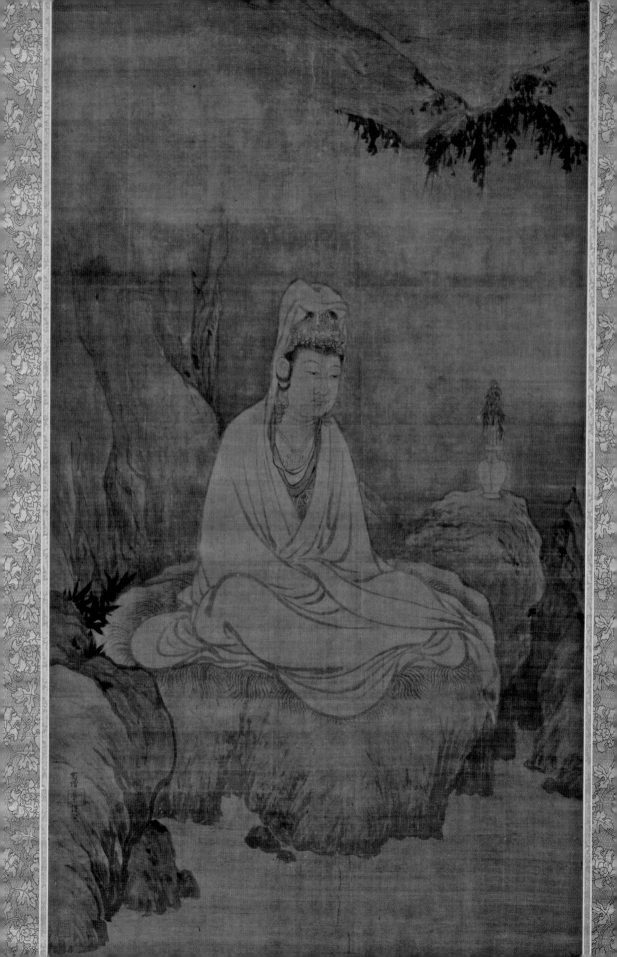

CHAPTER 9

China Under Foreign Rule
Tenth to Fourteenth Century

THE DISSOLUTION of the powerful Tang Empire in the early tenth century was followed by the rise of regional centers and an influx of foreign peoples to China. Both factors contributed to the vitality of Chinese Buddhism from the tenth to the fourteenth century, a period characterized by an emphasis on new themes and different manifestations of major deities, such as Bodhisattva Avalokiteshvara. In 907, the Qidan from Mongolia conquered much of northeastern China and ruled as the Liao dynasty (907–1125). At the same time, a smaller region was under the control of the native Northern Song dynasty (960–1127) based in Kaifeng in Henan Province. In 1115, the Jurchen (or Ruzhen) confederation from Mongolia conquered the Liao territories and ruled as the Jin dynasty (1115–1234). The Jin also overcame the Northern Song, forcing them to move south of the Yangzi River, where they established a new capital at Hangzhou as the Southern Song (1127–1278). Both the Jin and the Southern Song were eventually incorporated into the vast empire created by Kublai Khan (1215–1294), which ruled China as the Yuan dynasty (1272–1368) from the capital at Dadu (now Beijing). One of the largest empires in world history, the Mongol Yuan dynasty also included Tibet and parts of Korea, linking much of Eurasia in a vast trade and cultural network that had a strong impact on the visual arts. (The development of Sino-Tibetan Buddhist imagery during this period is discussed in chapter 11.)

The lush but not particularly muscular physiques and plump faces of carved figures produced in Liao and other centers in northern China reflect the continuing impact of the artistic traditions of the Tang dynasty. However, the thin, narrow torso of a small, gilt bronze sculpture representing Bodhisattva Manjushri (Wenshu) [9.1] typifies Liao style, as do the heavy jewelry, full sleeves, and ropelike sash above the waist. Youthful features are common in

FACING PAGE
Detail from a set of paintings showing a crane, Bodhisattva Avalokiteshvara, and monkeys.

See page 201.

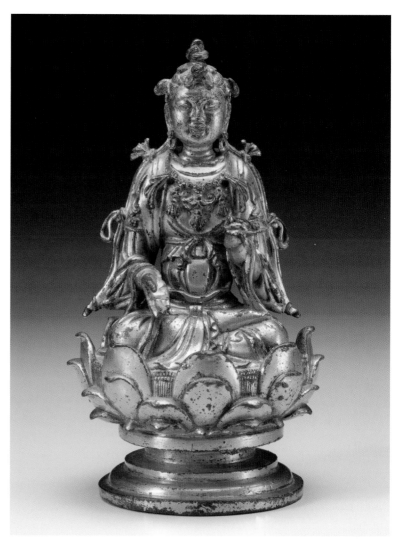

FIGURE 9.1
Bodhisattva Manjushri
(Wenshu) with five
knots of hair.

China, Liao dynasty, tenth
to eleventh century. The five
knots in the bodhisattva's hair
represent the five syllables in an
invocation dedicated to him.

images of Manjushri, who is frequently shown as a boy in artworks.
The five tufts of hair on his head symbolize the syllables in the
Sanskrit mantra A-RA-PA-CA-NA, one of the primary invocations
associated with this bodhisattva. Each tuft represents a syllable, and
each syllable has religious meaning. For examples, five recitations of
the syllable PA ensure a meditative vision of Manjushri, while five
recitations of the final NA can lead to a realized awakening. The tufts
also allude to the five peaks of Mount Wutai, an important center
in Shanxi Province, which by the eighth century was considered
the earthly abode of Manjushri. Stories detailing his appearance
to worthy pilgrims, including monks from India, are recorded in

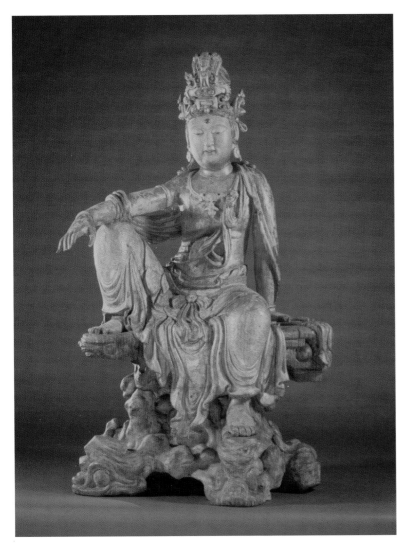

FIGURE 9.2
Bodhisattva Avalokiteshvara
(Guanyin).
China, Jin dynasty, ca. 1200.
Sixteen blocks of wood were
used to make this sculpture of
the bodhisattva of compassion.

Chinese texts. Devotion to Manjushri can be traced to the work of
the monk Amoghavajra, one of the three founders of early esoteric
practice in China, and the iconography of this sculpture attests to
the continuing importance of such practices under the Liao.

The fleshy face and lush form of a wooden sculpture depicting
Bodhisattva Avalokiteshvara [9.2] characterize works produced in
northern China during the Jin period. After the twelfth century,
wood replaced stone as the primary medium for Buddhist sculptures,
which were often housed in monasteries and sometimes in buildings
dedicated to a particular divinity. The thickness of the garment and
the careful rendering of the knots used to tie the scarf and the sash

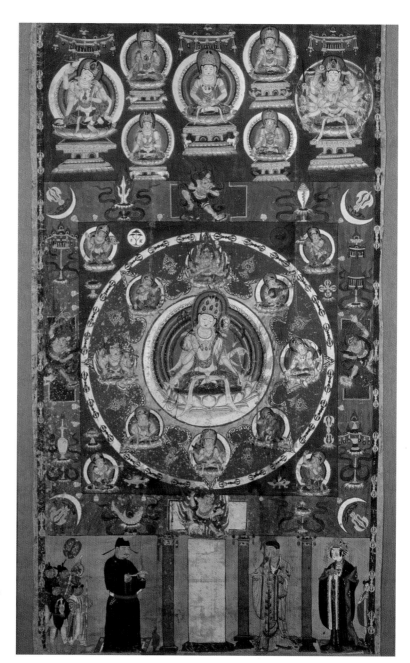

FIGURE 9.3
Mandala of Avalokiteshvara as Amoghapasha (Amojia Guanyin).
Dunhuang, Gansu Province, China, Five Dynasties period, tenth century. The lasso held by the primary deity is one of the primary implements attributed to this form of Avalokiteshvara. It is used to ensnare the devout and help them perceive the world and themselves more clearly.

at the waist are typical of Jin sculpture, as is the somewhat flamboyant treatment of the crown and hair. An image of Buddha Amitabha standing at the front of the coronet helps to identify the figure as Avalokiteshvara. The standing posture of the buddha is

unusual and reflects the importance of Amitabha as a savior who descends to earth to bring the souls of the devout to his pure land. The sculpture was created using twelve different blocks of wood; an additional four pieces were used to make the dramatic, rocky base. Crystals are inlaid for the eyes and the *urna*, and the image was originally brightly painted with flesh tones for the skin and blue, red, green, and gold pigments for the clothing and jewelry.

The combination of the rock base and the figure's posture indicate that the sculpture represents Avalokiteshvara seated in his personal pure land known as Mount Potalaka. In China, the mythical Mount Potalaka became identified with Mount Putuo, an island off the coast of Zhejiang Province, an important destination for pilgrims. Devotion to Avalokiteshvara in his pure land is typical of the changes in Buddhist thought from the tenth to the fourteenth century: interest in this bodhisattva became increasingly important, and icons such as this one were prominent in Chinese Buddhist imagery.

Bodhisattva Avalokiteshvara with the unerring lasso (Amoghapasha, or Bukongjuansuo Guanyin), who sits in an eight-pointed star in the center of the painting, is the primary deity in a mandala [9.3] found in one of the Mogao caves near Dunhuang, which was ruled by powerful families in the tenth century. (This area was later incorporated into the Xixia kingdom [1038–1220] of the Tanguts, a Tibetan people based in Gansu and Qinghai Provinces.) In this mandala, Avalokiteshvara is surrounded by a circle of vajras and placed within a square foundation with protective deities at the four cardinal directions. He wears a crown and jewelry and holds a lasso, the traditional lotus, and a rosary in three of his four arms. The lasso, which is the identifying implement of this form of the bodhisattva, allows him to snare the faithful and help them free themselves from the delusions that impede enlightenment. Additional forms of Avalokiteshvara alternate with attendant deities in the eight peaks of the stars.

The four-armed wish-granting Avalokiteshvara (Monibao Guanyin) and the powerful thousand-armed manifestation (Qianshou Guanyin) appear at either side of five buddhas in the upper portion of the painting. The buddhas, who are echoed by the smaller images in their crowns and in that of the principal icon, represent the five lineages of Buddhism. Buddha Vairocana, identified by his white color, is the central and largest of the five. The smaller buddhas, also identified by color, are Akshobhya (blue), Ratnasambhava (yellow),

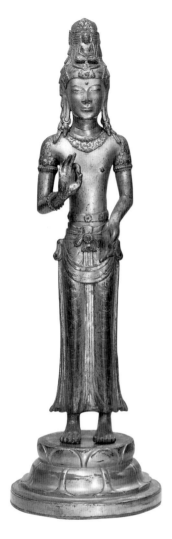

Amitabha (red), and Amoghasiddhi (green). Donors, presumably husband and wife, stand in the lower part of the painting, and the monk who consecrated the image is shown with his entourage.

An interesting regional image of Bodhisattva Avalokiteshvara was produced in Yunnan Province in southwest China between the ninth and the twelfth century. Identified by the relatively large image of Buddha Amitabha in his headdress [9.4], the bodhisattva stands in a forward-facing position with his right hand in the gesture of exposition and his left in that of bestowing. He wears a saronglike lower garment gathered at the waist with a bejeweled sash and has an additional sash over his hips. The unusual belt at his waistline derives from Indian sculpture, as does the long hair gathered into a topknot. The torque at the neck, the earrings, and the large armlets are typical of Yunnanese representations of Avalokiteshvara. This type of bodhisattva is thought to have been brought to Yunnan by an Indian monk in the seventh century and to have served as the cult image of the rulers of the Nanzhao and Dali (937–1253) kingdoms. As mentioned in chapter 8, Nanzhao occupied parts of Burma from the early ninth to the early tenth century, and both kingdoms maintained cultural and economic ties with various polities in Southeast Asia to whom they were connected by overland and river routes. The forward-facing position, clothing, jewelry, and hairstyle of the Yunnanese-type Avalokiteshvara parallels those of many Southeast Asia works, as does the use of the bodhisattva as the patron and protector of a ruling family.

Regional variations of themes are also found in cave temple complexes in Sichuan Province, just north of Yunnan. Iconic images and narrative sculptures found at the Dafo Wan on Mount Baoding near Dazu illustrate thirty-one different themes, including forms of Bodhisattva Avalokiteshvara and scenes from the lives of the historical Buddha and famous local monks. The eclectic nature of the imagery at Baoding is attributed to the sponsorship of a monk named Zhao Zhifeng (1159–ca. 1240), who supervised the production of the sculptures. One of the narratives, commissioned by a magistrate named Yang, is a series of carvings illustrating a cycle of parables commonly known as the Ten Oxherding Songs [9.5], which was popular in China after the early eleventh century.

The oxherding parable is often linked to the Chan sect of Buddhism. The Chinese word *chan* is a transliteration of *dhayana*, the Sanskrit word for "meditation." Contemplation, various types of visualizations, and different forms of meditation are perennial prac-

tices in Buddhism, but Chan is distinguished from other traditions by its emphasis on mindfulness while performing the tasks of daily life and on meditation as the principal method for achieving enlightenment. Like other Chinese practices, however, Chan presumes that each individual has an immutable Buddha-nature that can be awakened during spiritual development. Scattered documents found at sites such as the Mogao caves suggest that an emphasis on meditative practices was found in centers in north China as early as the sixth century; practices based on the works of specific masters began in the seventh century. Monks following Chan traditions lived in dedicated complexes as well as in monasteries dedicated to other branches of Buddhism, particularly the Lu (Vinaya), noted for its emphasis on rules of conduct.

The ox (*niu* is the Chinese translation for both "ox" and "water buffalo") and herdsman as a metaphor for practice (the ox is the unenlightened mind that the herdsman is trying to control) can be traced back to an early Indian text describing the eleven ways of tending oxen and comparing them with the responsibilities of a monk. A similar tradition is found in Tibet, where the same word is used for both "cow" and "elephant," and the parable refers to a mahout and his mount. There were once at least a dozen Chinese versions of the oxherding cycle, but those recorded by Dabai Puming and Kuoan Shiyuan are the best known. Each of the ten "songs" is a step on the path to enlightenment, beginning with looking for, sighting, and herding the ox, moving to the ox alone, then the herdsman, and then a great void symbolizing enlightenment.

The narrative at Mount Baoding, which runs about eighty-five feet in length and is read from left to right, is filled with overtones of daily life and pastoral scenes. Both are typical of the site, as is the interest in dramatic and engaging facial features. The monumental scale of the scenes—the herdsmen are about four and a half feet

FIGURE 9.5
Detail from a relief illustrating the Ten Oxherding Songs.
Mount Baoding, Sichuan Province, China, Southern Song dynasty, twelfth century. Herding, chasing, and catching an ox are metaphors for the pursuit of enlightenment.

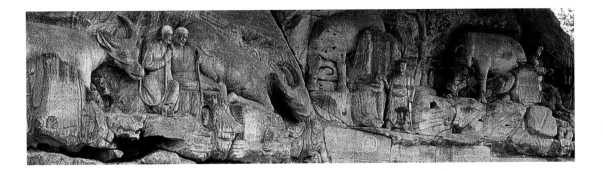

high—is also characteristic. In the fifth of the ten scenes, two deeply relaxed and amused hersdmen are shown seated with their arms around one another. Each has a loose hold on the reins of the ox standing next to them. The animal at the right is bending down to take a drink of water. In the next scene, a younger man stands at ease and no longer clings to the ox's leash, an image that represents the stage of releasing the ox (delusions). The youth points to a text inscribed on the rock to his right that reads as follows:

> Having harnessed the ox by the nose,
> It will obey [even if] the nose has no cord.
> The water and grass . . .
> He will follow you on his own account.
> As the stream below the mountain's shade,
> There is no need to keep him restrained.
> Morning or evening he does not escape . . .[1]

FIGURE 9.6

OPPOSITE

An arhat manifesting himself as the eleven-headed Avalokiteshvara (Guanyin).

China, Southern Song dynasty, ca. 1178. Artist: Zhou Jichang. The figure in the center of the painting holding a mask with the face of the eleven-headed form of the bodhisattva of compassion may represent a famous priest who manifested himself in that form.

In the next scene, the ox roams free while an unconcerned herdsman stands beside him.

Arhats (*luohan*) were another theme that flourished in China from the tenth to the fourteenth century. Like *bodhisattva,* the term *arhat* has many interpretations. It is found in early texts as a reference to Buddha Shakyamuni and his disciples. In Mahayana texts, such as the *Lotus Sutra,* arhats serve as exemplars, helping others in their spiritual journeys. Devotion to a specific group of sixteen arhats, which began in Tang China, was based on a text titled *A Record of the Abiding Dharma Spoken by the Great Arhat Nandimitra* that was brought to China by Xuanzang, and first translated in the mid-seventh century. This text endows the arhats with magical powers and describes the paradisiacal realms they inhabit. It also explains that the arhats remain in the phenomenal world to protect Buddhism during the tenebrous period between the lifetime of Buddha Shakyamuni and the advent of Buddha Maitreya. After the eighth century, devotion to the arhats was a predominant component of Chinese practices, and paintings and sculptures representing groups of sixteen, eighteen, or five hundred arhats were produced for use in temples and other settings.

An elegant painting showing five arhats in a garden [9.6] is one of a hundred (each showing five arhats) painted by Zhou Jichang and Lin Tinggui between 1178 and 1180 for a temple in the vicinity of Hangzhou in Zhejiang Province. Zhou and Lin were professional

painters who supplied Buddhist images to local patrons and to others in Japan via the port city of Ningbo. A good number of paintings of arhats and other themes common in the Ningbo region still exist in Japan. Research indicates that the set in question was deposited in Jufuku-ji Temple in Kamakura in the thirteenth century and was presented to the Hōkō-ji in Kyoto in the late sixteenth century, before ultimately entering the collection of the Daitoku-ji. In 1894, several paintings from the set were exhibited at the Museum of Fine Arts in Boston, and their unexpected beauty caused a small furor and contributed to a growing interest in Chinese and Japanese art in the United States. Bernard Berenson (1865–1959), a renowned critic, wrote the following description of his first view of the paintings: "They had a composition of figures and groups as perfect and simple as the best we Europeans have ever done . . . I was prostrate. Fenollosa [a curator] shivered as he looked. I thought I should die, and even Denman Ross [a patron] who looked dumpy and Anglo-Saxon was jumping up and down. We had to poke and pinch each other's necks and wept. No, decidedly I never had such an art experience."[2]

Four of the arhats are shown standing, while a fifth is seated on a large, thronelike chair in the center of the composition. The latter has a halo and wears a mask or otherwise transforms himself into a manifestation of Bodhisattva Avalokiteshvara with eleven heads. This miraculous change is sometimes explained as a reference to one of two revered monks—either Baozhi (425–514) or Sengqie (617–710). Both were known for their miraculous powers, and both transformed themselves into the eleven-headed Avalokiteshvara. Sengqie is also considered a mani-festation of Baozhi, and it is possible that both monks are conflated in the unique imagery of this painting. The swirling clouds near the high balcony overlooking a bamboo grove add an otherworldly element to the painting and also suggest the forces that are at work during the transformation.

Two of the other four arhats have darker skin and somewhat unprepossessing features, suggesting that they represent foreign— presumably Indian or Central Asian—figures, while the other two appear to be Chinese. Two laymen, a monk, a devotee holding an incense burner, and a young male servant holding a tray are shown in the foreground. The gentleman holding a brush may be Zhou Jichang, who created the painting, while his companion, holding a sketch, may be the patron. The monk, dressed in black, is most likely Yishao, an abbot of the Huian-yuan Temple in Ningbo. Yishao wrote dedicatory inscriptions on several paintings from the same set as the piece in question, which was commissioned by a group of laymen as an act of devotion and to acquire religious merit.

Paintings representing the ten kings of hell were also produced for domestic use and for export, particularly in the Ningbo area. The broad, even outlines used to define the figures, desk, screen, and blossoming flowers in a painting depicting Yama, the fifth king [9.7], and the precise use of color are typical of works by Jin Chushi (Jin the Recluse), an artist working in Ningbo. Yama, the only king to be worshipped independently of the others, is seated at a desk placed before a screen and is attended by a clerk. A demon forces a deceased soul dressed in white to gaze into a karmic mirror, which shows the murder of a man in a boat. Two small souls flee from another demon holding two swords in the lower part of the painting. The setting is based on a judicial court in the late twelfth century, while details such as the flower garden in the background illustrate the elegant lifestyles found around Hangzhou at the time.

Scenes of beings in hell were first observed in sixth-century Central Asian paintings, and those of the ten kings, some of whom are derived from Indic traditions and others from Chinese imagery, became popular after the tenth century. According to the tenth-century Chinese text titled *Sutra of the Ten Kings of Hell*, after death,

each individual appears before all ten kings to have his or her life judged, and their next incarnation, in a pure land, as a human or an animal, or in a hell is decided. Family can sometimes change a person's fate by commissioning rituals, and paying the clergy who perform them, every seven days during the first forty-nine days, in one hundred days, and in three years and one day after death.

The landscape on the screen behind the seated king was painted using black ink, modulated into different strokes or shades of wash, a technique with strong ties to Chinese calligraphy from the seventh and eighth centuries that had become popular by the tenth century. Paintings created using this method were often the work of well-educated individuals, many of whom served at court in varying capacities. Chinese scholarship has traditionally ranked such literati paintings, which are thought to express the character and personality of the artist, above those crafted by professional artists such as Zhao Jichang, Lin Tinggui, and Jin Chushi. This technique is also often, but not always, found in the works of artists or monk-artists affiliated with the Chan tradition of Buddhism. During the Northern Song dynasty, noted Chan monks developed ties with influential members of the intelligentsia; the long-standing link between the monochrome ink technique and Chan imagery may be due in part to these interactions.

Hagiographical literature detailing the actions and words of Chan masters thrived in the tenth and eleventh centuries. A history of Chan that traced its roots through the enigmatic figure of Bodhidharma (Damo), a south Indian prince said to have arrived in south China in the sixth century, to Kashyapa, one Buddha Shakyamuni's disciples, was codified at that time. Such literature also recorded disputes that led to the creation of varying branches within Chan and extolled the lives and awakenings of legendary or semilegendary early masters, many said to have lived during the Tang dynasty. Some early Chan masters experimented with teaching methods that included beating, shouting, eccentric behavior, and the posing of provocative and to some degree unanswerable questions. These questions and related aphorisms, often known as *gongan* (the Japanese koan), were recorded in anthologies such as the *Record of Linji* (*Linjilu*) and the *Patriarchs' Hall Anthology* (*Zutangji*). The importance of Chan during the Southern Song period may reflect the transfer of the court to the Hangzhou region, where important monasteries were dominated by Chan practices. Chan, its arts, and its literature were transmitted to Korea (where it is called Seon) and Japan (where it became Zen) at that time.

FIGURE 9.7
OPPOSITE
Yama, the fifth king of hell.
China, Southern Song dynasty, late twelfth century. Artist: Jin Chushi. Yama is one of a group of ten kings of hell who judge the faithful as they transition to another realm.

FIGURE 9.8
The Sixth Patriarch cutting bamboo.

China, Southern Song period, thirteenth century. Artist: Liang Kai. It is generally believed that the Sixth Patriarch of Chan/Zen Buddhism achieved enlightenment while he was chopping bamboo.

Liang Kai (active first half of the thirteenth century) and Fachang Muqi (active thirteenth century), two of the most revered painters of Chan imagery, worked during the Southern Song period. From 1201 to 1204, Liang Kai served as a painter at the imperial court academy. For reasons that remain unknown, he refused the offer of the Golden Belt award and left the court to spend the rest of his life wandering among the monasteries in Hangzhou. Paintings, such as one showing the Sixth Patriarch chopping bamboo [9.8], illustrate his ties to these centers. The Sixth Patriarch, Huineng (638–716), is considered the founder of the "southern tradition" of Chan Buddhism, which is noted for its definition of enlightenment as an immediate and intuitive understanding that is possible at any point in time, can occur during any activity, and does not require either textual study or practices such as chanting. As is often typical of Chan imagery, Huineng is shown as an ordinary fellow squatting as he cuts the plant. The contrast between the choppiness of the brushstrokes that define the figure and clothing of the patriarch and the smoother, softer lines used to show the vines wrapping around the trunk of the tree in the background illustrate Liang Kai's mastery of the calligraphic techniques from the ink painting tradition. This painting is paired with another, now in a private collection in Japan, that shows Huineng tearing up a sutra.

The monk Fachang Muqi also employed a range of brushstrokes and ink washes in creating the image of the white-robed Avalokiteshvara (Baiyi Guanyin) that is now part of a group of three paintings [9.9] in the Daitoku-ji in Kyoto. Strokes of varying shapes, painted with more or less ink, are used to define the robe worn by the bodhisattva, his jewelry and hair, and the rocky ledge on which he sits, as well as details such as the crane's feathers and the monkeys' hair in the two accompanying paintings. Muqi was born in Sichuan Province but spent much of his life in Zhejiang, where he restored Liudong-si Temple near scenic West Lake. Although no Chinese sources describe him as a

Buddhist, Japanese records indicate that he was a disciple of the master Wuzhun Shifan (d. 1249).

The white-robed Avalokiteshvara is another of the new forms of the bodhisattva that were popular in China during the tenth to the fourteenth century. A sixth-century translation of a *dharani* is assumed to be the source for this image. In the painting, the bodhisattva is seated on a grass mat (suggestive of ascetic practices) on a boulder overlooking the water. The remoteness of the setting is reminiscent of Mount Putou (the Chinese Potalaka), while the vase with willow branches at the right ties this icon to another new manifestation, the bodhisattva of compassion holding a willow branch. The white-robed Avalokiteshvara is sometimes depicted as female and is invoked to help women conceive.

It seems likely that the paintings of the crane walking in a bamboo grove and the monkey mother and child seated on an evergreen branch were grouped with that of Avalokiteshvara in Japan, where such arrangements of independent works were common in the fourteenth and fifteenth centuries. The crane is a long-standing Chinese symbol for immortality. Monkeys often serve as a metaphor for the undisciplined mind in Buddhist writings. Both illustrate the belief that daily life provides a foundation for religious practices, which underlies much of the Chan Buddhist doctrine.

Japanese monks often traveled to China to study with learned masters at centers near Hangzhou; as a result, works by artists such

FIGURE 9.9
A set of paintings showing a crane, Bodhisattva Avalokiteshvara, and monkeys.

China, Southern Song dynasty, late thirteenth century. Artist: Fachang Muqi. The artist who painted this wonderful group was one of the most famous monk-artists of the thirteenth century.

as Liang Kai and Fazhang Muqi are now often found in Japan. Both the triptych attributed to Muqi and the paintings by Liang Kai discussed earlier have seals that identify them as works once in the collection of the shogun Ashikaga Yoshimitsu (1358–1408), a major patron and collector of Chinese art. Both Japanese museums and temples often have Chinese portraits of famous masters such as Zhongfeng Mingben (1263–1323) [9.10] in their collections. One example, now in the Senbutsu-ji in Kyoto, shows the portly monk gazing off into the distance. The composition of the painting—in which a high-ranking monk is seated in a meditative posture in an abbot's chair, holds a fly whisk, and has a staff symbolic of his office—and the addition of an inscription at the top of the painting are typical of formal portraits. Zhongfeng Mingben's long hair is unusual and may reflect the influence of his teacher Gaofeng Yuanmiao (ca. 1289–1362), who also contravened monastic conventions by letting his hair grow. The painting also shows the monk's mutilated left hand; he burned the little finger to present it as a sacrifice to the Buddha during his youth.

Zhongfeng Mingben was one of the more influential Chan monks of the Yuan dynasty. He studied Buddhism seriously as a young man and received the tonsure at Shizi-yuan Monastery on Mount Tienmu in 1287. After the death of his mentor in 1295, he declined the position of abbot of the Dajue-si and, despite repeated offers from elite clergy and members of the court, repeatedly refused important appointments, temporarily choosing a life of wandering and solitary meditation:

> Surrounded by a thousand peaks—a room of half the
> normal size.
> Made leisurely by the experience of myriad realms—one
> monk alone,
> Aside from this ready-made *koan*
> There is no Dharma to be passed from lamp to lamp.[3]

Despite his peripatetic lifestyle and lack of interest in official titles, he taught students from Korea and Japan, as well as monks from Tibet. Zhongfeng Mingben argued against the sectarianism often found within Chan lineages and advocated mutual understanding and acceptance among different forms of Buddhism and other teachings, arguing that all practices led to spiritual development:

FIGURE 9.10
A portrait of Chan Master Zhongfeng Mingben (1263–1323).

China, Yuan dynasty, ca. 1318–1323. One of the more important monks of his day, Zhongfeng Mingben taught students from Japan, Korea, and Tibet, as well as China.

There is Buddha everywhere,
There is Buddha in movement, there is Buddha in
 quiescence
There is Buddha in the midst of busy affairs, there is
 Buddha during the time of leisure,
There is Buddha when you lie down, there is Buddha
 when you stand up,
There is Buddha in the good, there is Buddha in the bad,
There is Buddha in life, there is Buddha in death.[4]

Portraits such as this were shown in image halls dedicated to the lineage of a temple or tradition of practice, and sometimes they were given to disciples or other devotees. The inscriptions found on paintings can include biographical information, as well as exhortations from the subject to one of his disciples. However, the one on this painting was partially destroyed during a fire and is missing the top lines, so it is indecipherable. The work was housed in Nanzen-ji in Kyoto where Mu'in Genkai (around 1310–1358), who studied with Zhongfeng Mingben, was appointed abbot in 1349; it is possible that Mu'in Genkai took the painting with him when he returned to Japan in 1326.

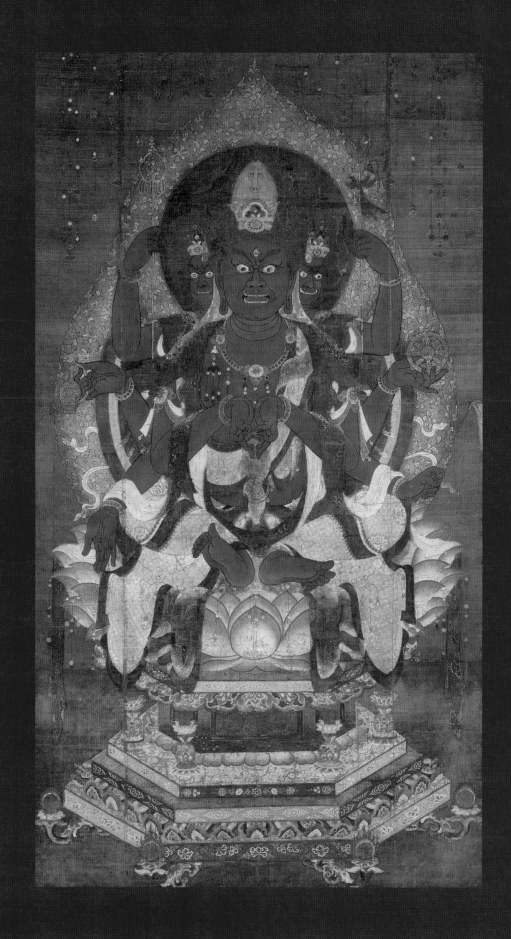

CHAPTER 10

Aristocrats and Warriors in Korea and Japan
Tenth to Fourteenth Century

KOREA

IN 918, General Wang Geon (877–943) consolidated the Korean peninsula after several decades of unrest during which aristocratic warlords had challenged and ultimately broken United Silla control. Wang Geon established the Goryeo dynasty (918–1392) and built a capital in his hometown of Gaegyeong (now Gaeseong). Threatened on its northwestern borders by the Qidan Liao, who attempted to invade the peninsula on several occasions between 993 and 1018, the Goryeo government maintained diplomatic relations with the contemporaneous Northern Song in China, as well as with the subsequent Jin dynasty. The Mongol founders of the Chinese Yuan dynasty also attacked Korea, first in 1231 and repeatedly between 1232 and 1259, forcing the government to move the capital to the small island of Ganghwa in the Yellow Sea. After the establishment of diplomatic relations with Goryeo, the Mongols used the peninsula as a base for attacks against Japan in 1274 and 1281, which were repulsed by the divine winds known as kamikaze. By the mid-fourteenth century, however, relations between the Mongol Yuan dynasty and Goryeo Korea were cordial, and the Koreans at first sided with the Mongols against the Chinese, who ultimately defeated them and founded the Ming dynasty (1368–1644).

Buddhism was important in Goryeo. Deities were invoked to protect and guard the nation, and many of the clergy held court rank and were supported by the government. Reception of a Chinese-language, woodblock-printed edition of the Buddhist canon, produced between 971 and 981, was one of the first attempts to make this literature widely available and stimulated the creation of two such compendia during the Goryeo dynasty: the first (around 1010) to help repel the Liao invaders, and the second (between 1238 and

FACING PAGE
Detail of Bodhisattva Avalokiteshvara with a horse's head (Batō Kannon).

See page 211.

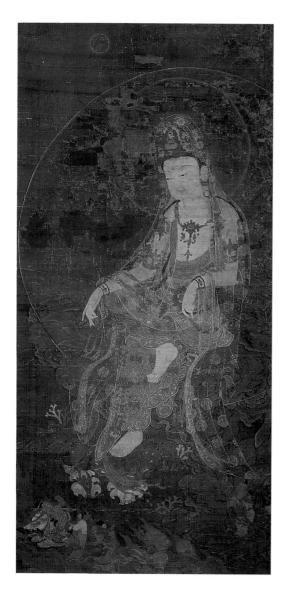

FIGURE 10.1

The water-moon form of Bodhisattva Avalokiteshvara (Suwol Gwaneum).

Korea, Goryeo period, early fourteenth century. An interest in exquisite forms and details characterized Korean Buddhist painting in the thirteenth and fourteenth centuries.

1247) to resist the Mongol Yuan attacks. The latter served as the basis for an early-twentieth-century Japanese reprint of the *tripitaka*, which remains a primary source for the study of Buddhist texts in Chinese.

Much artistic material from the Goryeo dynasty is preserved in Japan thanks to religious interchanges between the two countries and as a result of the Japanese invasion of Korea in the late sixteenth century. An early-fourteenth-century painting of Bodhisattva Avalokiteshvara (Gwaneum) [10.1], which illustrates the adoption of new forms of this bodhisattva developed earlier in China, shows the delicacy and elegance that characterize Korean art during this period. The bodhisattva wears a carefully depicted red garment, an array of jewelry, and a transparent gauze shawl that also covers his head. The delicate gold roundels that decorate the shawl were often used in fourteenth-century painting. The ethereal designs, the careful outlining of the edges of the drapery, and the shades of red, green, white, and gold in the painting are typical of the courtly taste of the period.

His posture with one leg resting on the knee of the other, the paradisiacal setting, mountainous background, and coral beneath his feet identify the image as one of Avalokiteshvara in Potalaka. The large, moon-shaped halo surrounding his head and the willow branch in the vase to his right link the painting to forms such as the water-moon Avalokiteshvara or Avalokiteshvara with the willow branch, which were also developed in China in the tenth to the fourteenth century. Like those showing Avalokiteshvara in his pure land, these icons stress the bodhisattva's salvific powers and ability to grant wishes. The small image of a rabbit standing in the moon at the top of the painting illustrates a traditional Chinese legend of a hare creating the elixir of immortality in the moon. The boy at the lower left of the painting is the young pilgrim Sudhana (Sonjae), the protagonist of the *Flower Garland Sutra*, who visited Avalokiteshvara in Potalaka and many other teachers during his

search for a greater awareness. Images of Bodhi-
sattva Avalokiteshvara were commissioned as
objects of devotion and to ensure salvation and
other benefits, such as children.

Similar concerns underlie the popularity of
Bodhisattva Kshitigarbha (Jijang) in the art of
the period. Kshitigarbha, the bodhisattva of the
earth womb, played a minor role in India, where
from the sixth to the twelfth century he was
shown as one of a group of eight great bodhi-
sattvas but not as an independent deity. Devotion
to this bodhisattva, which began in Central Asia,
can be traced back to the *Sutra of the Ten Wheels*
(*Dasachakrakshitigarbha-sutra*), first translated
into Chinese in the fifth century. This text
de-scribes Kshitigarbha as a bodhisattva who
guides souls through the torturous Buddhist
hells, often in the guise of a monk, which explains
why he is the only bodhisattva shown wearing
monastic robes. He also plays an important role
in devo-tions designed to avoid or mitigate
punishments assigned by the ten kings of hell
and is sometimes thought to control these
figures. Worship of Kshitigarbha flourished in
Tang-period China when the *Sutra of the Ten
Wheels* and related texts were translated.

The hood worn by the bodhisattva in a paint-
ing showing him [10.2] with an additional twenty
figures is derived from a Chinese text known as
the *Record of the Returned Soul* (*Huanhun-ji*) in
which Kshitigarbha is described as wearing this headgear as he
rescues souls from hell. An olive-green shawl held together by an
elaborate ring over his left shoulder covers a red undergarment with
a blue hem. The monk with the shaved head and dark skin standing
to Kshitigarbha's left may be Daoming, an eighth-century Chinese
figure, who was mistakenly sent to a hell and rescued by the bodhi-
sattva. Two attendant bodhisattvas, the Four Heavenly Kings wear-
ing armor, and the ten kings of hell in Chinese court costume stand
on either side of Kshitigarbha. A growling lion, an unidentified
guardian, another figure, and one dressed in black are shown at the
bottom of the painting.

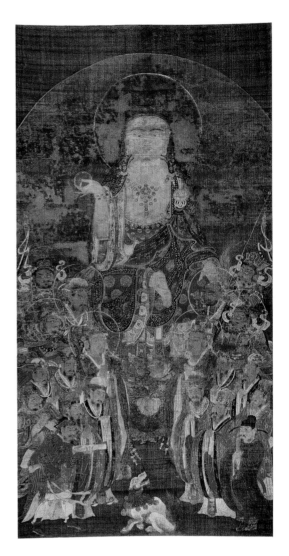

FIGURE 10.2
*Bodhisattva Kshitigarbha
(Jijang).*
Korea, Goryeo period, four-
teenth century. Kshitigarbha
is the only bodhisattva who
is shown dressed like a monk
rather than in secular garb.

FIGURE 10.3
Phoenix Hall (Byōdō-in).

Kyoto Prefecture, Uji, Japan, Heian period, eleventh century. The main building in this temple has long been known as the Phoenix Hall because it resembles a bird in flight, particularly when viewed from above.

JAPAN

Around 898, the powerful Fujiwara clan gained control of Japan, in part by arranging marriages between their daughters and members of the imperial family. After such a wedding, the Fujiwara father would encourage his son-in-law to abdicate and appoint family members as regents or civil dictators, depending on the age of the putative emperor. The Fujiwara and other aristocratic clans built tax-exempt estates; amassed great wealth; and helped to support the flowering of the arts—including literature, poetry, music, and the conduct of religious services—that characterized the late Heian or Fujiwara period (951–1185). The emphasis on beauty and an awareness of the ephemeral nature of life that informs the early eleventh-century *Tale of Genji* (one of the first novels ever written) by Lady Murasaki Shikibu reflect the pervasiveness of Buddhist thought during the period and typifies the aesthetic tastes of the time. The construction of lavish temple complexes endowed with

sculptures, paintings, and ritual paraphernalia was characterized by exquisite workmanship and sumptuous surfaces; it may have been intended to reiterate the transitory reality of human existence by briefly capturing an elusive beauty that would soon fade.

Phoenix Hall [10.3], the main building of Byōdō-in Temple in Uji just south of Kyoto, was constructed by Fujiwara Yorimichi (992–1074) on a site first purchased in 998 by his father, Fujiwara Michinaga (966–1027), for use as a summer retreat. The building, which stands in the middle of a man-made lake in the shape of a Sanskrit *A,* was constructed using the stone bases, wooden pillars and posts, and tiled roofs seen in earlier Japanese temples. There is, however, an elegance and lightness to Phoenix Hall that was not evident in earlier architecture. Covered walkways link the central chamber to the two structures at either side, and the placement of the latter at right angles to the main space gives the building the appearance of a bird in flight, particularly when viewed from above, and explains the name.

A large sculpture of Buddha Amitabha (Amida) [10.4] dominates the interior of the central chamber of the hall, which was designed to represent Sukhavati. The sculpture is seated on an elaborate lotus pedestal placed before an openwork mandorla and set beneath a canopy. Amitabha's hands are in a variation of the gesture of meditation, with the thumb and fingers curled up to touch each other. Apsaras playing musical instruments decorate the mandorla and are also attached to the upper parts of the side and back wall of the room. The lower parts of the wall were originally painted with images of landscapes with gently rolling hills, which are also thought to illustrate the different levels of rebirth possible in Sukhavati.

The sculpture was carved by Jōchō (d. 1057), one of the most famous artists of the period, who often worked for members of the Fujiwara family. During his career, Jōchō was awarded the titles Master of the Dharma Bridge (*Hōkkyō*) and Master of the Dharma Eye (*Hōgen*), prestigious Buddhist appellations that were rarely given to artists. The image of Buddha Amitabha, which was made from fifty-three pieces of wood, was constructed using a multiple woodblock tech-

FIGURE 10.4
Buddha Amitabha
(Amida).

Byōdō-in, Uji, Japan, Heian period, ca. 1053. Artist: Jōchō. Paintings on the walls surrounding this sculpture indicate that it represents Buddha Amitabha seated in his western pure land.

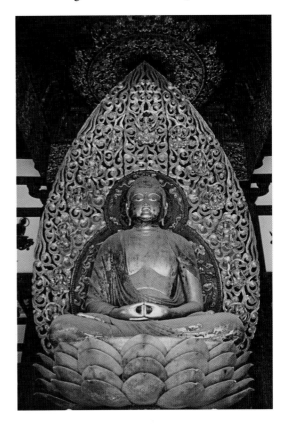

nique (*yosegi zukuri*) that became popular in Japan in the eleventh century. The use of many blocks of wood allows for the manipulation of proportions, such as the buddha's long legs, which was not possible in the single woodblock technique. The length of the legs, the broad and simple features of the face and chest, and the soft folds of the drapery give the statue a calm stability typical of the period and were made possible by the multiple blocks.

Similar proportions are found in an extraordinary painting representing Bodhisattva Avalokiteshvara with a horse's head (Batō Kannon) [10.5] produced in a workshop in Kyoto in the mid-twelfth century. The horse-headed manifestation of the bodhisattva was founded in China in the eighth century [4.12] and spread to Korea and Japan with the early variants of esoteric Buddhism. This form of the bodhisattva is one of the six manifestations of Avalokiteshvara that are associated with different levels of rebirth and presides over the fate of animals, one of the six realms of existence into which all sentient beings can be reborn. In the late twelfth century, elaborate rituals were developed for worshipping Avalokiteshvara with a horse's head, and by the thirteenth century, he was also revered as the protector of warriors and horses. In the painting, the bodhisattva has a red body, eight arms, and four heads, and he sits on a pink lotus that rests on an extravagant multitiered throne beneath a delicate floral canopy. His front two hands are in the horse-mouth mudra; five of the remaining six hold (reading counterclockwise) a fly whisk, a wheel, a combined hatchet and ax symbolic of compassion and the resistance of evil, a monastic staff, and a bird-headed vase that derives its shape from the metalwork of Tang-period China. The sixth is in the posture of beneficence. In addition to the sump-tuous color, the painting was decorated with pieces of silver leaf—for example, in the garlands in the canopy—that have darkened over time. Pieces of cut gold leaf help to define the hair, while smaller fragments compose the decorative motifs of the mandorla, clothing, jewelry, and throne.

The luxurious and courtly aesthetic that imbues this painting of the paradoxically ferocious bodhisattva was replaced by a taste for realism and immediacy that marked the military rule of the Kamakura period (1185–1333). Rivalries between different branches of the Fujiwara clan, various members of the imperial family, and their respective supporters resulted in continuing battles that ultimately led to the rise of two military clans, the Minamoto and the Taira. The devastating Genpei War, which lasted from 1180 to 1185, ended

when Minamoto Yoritomo (1147–1199) defeated his Taira rivals and established a new military government based in Kamakura (1185–1333), the city that gave the era its name and was the center of his power. In 1336, another military dynasty, the Ashikaga, supplanted the already weakened Kamakura rulers and established a capital at Kyoto. The rule of the Ashikaga family is often termed the Muromachi period (1392–1573) after the district in Kyoto where they located their headquarters. The Ashikaga, some of whom were famed collectors of Chinese art, did not control as wide an area as their Kamakura predecessors, and strife among provincial warlords (*daimyo*) caused increasing instability. The Ōnin War of 1467–1477, which saw the destruction of Kyoto and the collapse of shogunal power, plunged the country into a century of warfare and social change that only ended when Oba Nobunaga (1534–1582) seized control (see chapter 15).

Reconstruction of the monasteries destroyed and damaged during the battles that took place in the second half of the twelfth century helped spur the development of a new aesthetic during the rule of the Kamakura shoguns. Inspired to some degree by access to works dating to the Nara period (often from temples in the eponymous city), the Kei family created a style of sculpture characterized by convincing naturalism in the treatment of forms, faces, and clothing. The school traced its lineage to a sculptor named Raijo (1044–1119), a second-generation student of the famed eleventh-century artist Jōchō [10.4]. Kōkei (active 1175–1200) is credited with establishing the Kei atelier, which through its work on the reconstruction of temples such as Kōfuku-ji and Tōdai-ji became one of the more dominant schools of sculpture in the thirteenth and fourteenth centuries.

Around 1213, Unkei (1151–1223), one of Kokei's sons, sculpted imaginary portraits of the Indian masters Asanga (Muchaku) [10.6] and Vasubandhu (Seishin) [10.7] for the Kōfuku-ji. The sculptures, which were created using the multiple woodblock technique, origin-

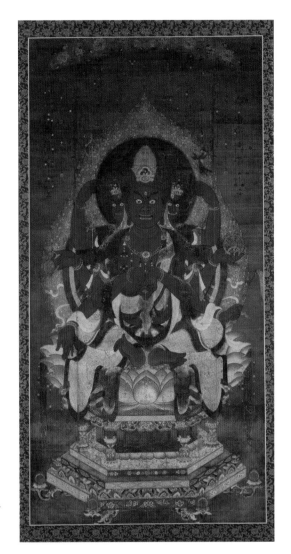

FIGURE 10.5
Bodhisattva Avalokiteshvara with a horse's head (Batō Kannon).

Kyoto, Japan, Heian period, twelfth century. In Japan, this form of the bodhisattva of compassion is revered as a protector of warriors, horses, and cattle.

ally flanked an image representing Buddha Maitreya. The two nearly life-size figures stand in relaxed poses. Both wear the clothing of high-ranking monks with undergarments covered by large, square shawls held together by clasps (different for each sculpture) on the left shoulder. The undergarments and shawls are rendered in a series of large, irregular folds that convincingly mimic the fall of real drapery. The older Asanga has craggy face and holds a cylindrical

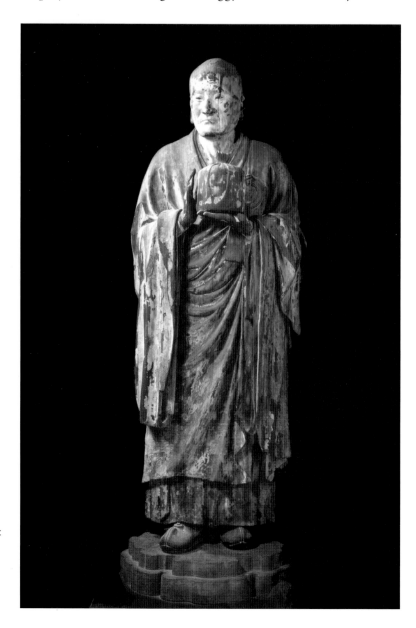

FIGURE 10.6
The monk Asanga (Muchaku).

Kōfuku-ji, Nara, Japan, Kamakura period, 1212. Artist: Unkei. This powerful sculpture is an imaginary Japanese portrait of a famous Indian monk, one of the patriarchs of the branch of practice introduced to China by the famous monk-pilgrim Xuanzang.

object covered in cloth. The slightly younger Vasubandhu has a plump face and gesticulates to indicate that he is teaching.

Asanga and his half-brother Vasubandhu lived in India in the fourth century and are generally credited as patriarchs of the Yoga-cara (Hossō) tradition, which stresses the role of consciousness in spiritual practice and is noted for its categorization of the essential nature of all phenomenal manifestations. Shilabhadra (529–645)

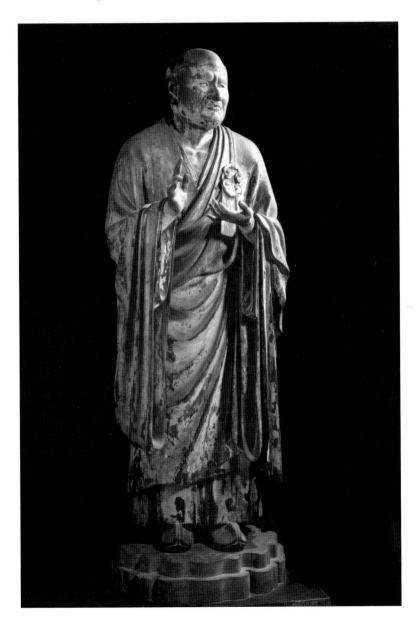

FIGURE 10.7
The monk Vasubandhu (Seishin).

Kōfuku-ji, Nara, Japan, Kamakura period, 1212. Artist: Unkei. This imaginary portrait sculpture, as well as the one of Asanga, were created in Japan almost a thousand years after the brothers worked in India.

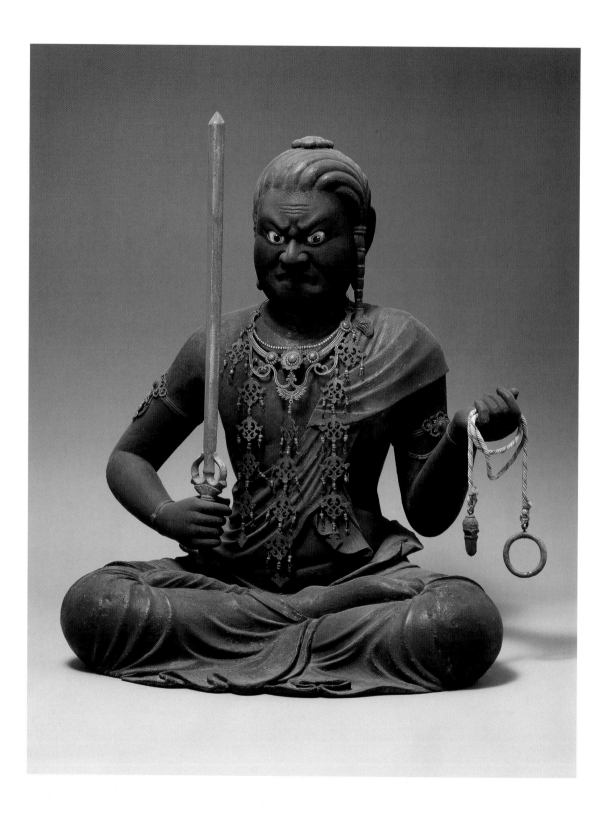

taught the tradition to the famous monk-pilgrim Xuanzang at Nalanda in the early seventh century, and it was ultimately transmitted from China to Japan, where it became one of the six major sects of the Nara period. Kōfuku-ji was a major center of Yogacara practice, which explains why these engaging portraits of the Indian masters were commissioned.

Devotion to a group of five powerful protective figures known as the Wisdom Kings or Vidyaraja (Godai Myōō) reached Japan from China in the ninth century, and images of these deities were also produced in the Kamakura period. In addition to serving a protective function, the Wisdom Kings embody the righteous and benevolent wrath of Buddha Vairocana. Achala (Fudo Myōō), whose name is often translated as "immovable," was the focus of a ritual brought to Japan by Kūkai. Produced by an artist closely affiliated with Kakei (active, 1183–1223), another master of the Kei school, a sculpture of this powerful entity [10.8] follows the description given in the *Vairocana-sutra,* which was translated into Chinese around 725. The king has a dark body, a terrifying visage in which one eye is slightly smaller than the other, and a fang. He wears Indian clothing, including a precisely defined lower garment and a scarf tied across his chest. His extravagant necklace is comparable to the jewelry in the painting of the horse-headed Avalokiteshvara [10.5], who is also sometimes understood as one of the Wisdom Kings. The lasso and sword, which represent his respective abilities to snare souls and bring them to salvation and to cut through obstacles, are recent replacements.

The brutal wars and natural calamities that marked Japanese history in the second half of the twelfth century, and their consequently negative impact on daily life, are also reflected in the production of graphic images of Buddhist hells at that time. A horrifying scene of the hell of dissections [10.9], painted in the late twelfth century, shows the gruesome hell reserved for monks who have committed homicide. The five tiny, naked figures cowering at the lower left of the scene represent monks who are awaiting their turn on the nearby dissection tables. Those who have already been dismembered are shown boiling in a cauldron that is stirred by one of the warders. The painting was part of a horizontal scroll or hand scroll, which was unrolled from right to left for viewing and interspersed sections of text with images. The text that pertains to this painting indicates that when one of the wardens says the word *alive,* the monks are immediately reassembled only to begin their horrible

FIGURE 10.8
OPPOSITE
Achala (Fudo Myōō).
Japan, Kamakura period, early thirteenth century. Artist: Circle of Kaikei. Achala's stocky body and black (or dark blue) complexion symbolize his role as a subjugator of enemies.

punishments all over again. In this and all other Buddhist hells, there is no respite for the wicked, particularly monks and nuns who have broken their vows.

One source for such hell scenes is the first chapter of the *Essentials of Salvation* (*Ōjōyōshū*), which provides a detailed description of the hells and lists the sins that lead transgressors to their dooms. Like many of his contemporaries, Genshin (942–1017), the author of this text, originally trained in the Tendai tradition but also advocated practices devoted to Buddha Amitabha and the desire for rebirth in Sukhavati. The remaining chapters of his influential book detail the beauty of this pure land and the pleasures that await one upon birth there. This work provided one of the foundations for the development of Buddhist practices focused exclusively on the desire for rebirth in Sukhavati that flourished during the Kamakura

FIGURE 10.9
The hell of Dissections.

Detail from the *Jigoku zōshi* (*Hell Scroll*), Japan, Kamakura period, late twelfth century. A terrifying hell is one of the possible realms of rebirth in the Buddhist cosmos. This one, where individuals are dismembered, reassembled, and then cut again, is reserved for monks and nuns who have broken their vows.

period. Another was the widespread belief that, as in the late sixth century in China, the later part of the Kamakura period marked the last degenerate age of the Buddhist aeon, during which conditions were so desperate that spiritual development through individual effort was impossible.

Hōnen (1133–1212) and his disciple Shinran (1173–1263) were seminal figures in the development of Japanese Pure Land Buddhism, which stresses the calling of the name of Buddha Amitabha as the primary practice. Hōnen founded the Pure Land tradition (*Jōdoshu*), and Shinran established the True Pure Land tradition (*Shin Jōdoshu*). Both based their work to some degree on the *Essentials of Salvation* and on the *Sutra on the Meditation of the Buddha of Infinite Life* (*Amitabhadhayani-sutra*) and a commentary on this text by the sixth-century Chinese monk Shandao. As Hōnen notes: "If we wish

早且可被比事う

FIGURE 10.10

Detail from a scroll illustrating the life of Hōnen.

Japan, Kamakura period, early fourteenth century. Hōnen is one of the more important figures in the development of the Japanese tradition of Pure Land Buddhism, which focuses on devotion to Buddha Amitabha and the desire for a rebirth in his western paradise.

to free ourselves from the round of birth and earth, we should lay aside for now one of the two excellent teachings, the holy path, and select and enter the way of the Pure Land. If we wish to enter the way of the Pure Land, which advocates two methods of teaching . . . we should select the true one . . . which . . . consists of invoking the Buddha's name. This certainly results in rebirth in the Pure Land, for it accords with the Buddha's Original Vow."[1]

A painting, once part of a larger hand scroll produced between 1307 and 1317 that illustrates the life of Hōnen, shows the monk [10.10] seated in a room defined by sliding panels with landscape decoration. Also the subject of the portrait hanging in the center of the room, Hōnen is seated at the left, writing his name at the top of a painting that he will give to Shinran, who is seated before him. The scene reflects the transmission of Pure Land practices from one monk to the other, and their mutual commitment to spreading Buddhism to all segments of Japanese society: "I well recall how the venerable Hōnen would often smile pleasantly in his undiscriminating and simple way when he saw humble people, saying, 'They are assured of rebirth in the Pure Land.' In contrast, when he met people who

were proud of their learning he would say, 'What sort of thing will this man's Pure Land rebirth amount to?' Though a long time has passed since then and I am nearly ninety years of age, I remember those things vividly."[2]

Development of the Pure Land traditions was reflected in the popularity of representations of Buddha Amitabha seated in Sukhavati during the second half of the Kamakura period. Variations in which Sukhavati is bordered with narrative scenes on the sides and at the bottom are known as Taima mandalas because the first icon of this type was a cloth or textile image, probably made in China in the eighth or ninth century and preserved in Taimadera Temple, south of Nara. An example of this popular icon [10.11], now in the collection of the Cleveland Museum of Art, depicts Buddha Amitabha attended by the bodhisattvas Avalokiteshvara and Mahasthamaprapta (Seishi); they are seated on magnificent thrones set on a platform in the middle of a golden lotus pond. A large retinue encircles the triad, and similar entourages accompany the four buddhas, two standing and two seated, in the foreground of the painting. The souls of the faithful that are reborn in Sukhavati sit or kneel on the calyxes of lotus flowers or float on boats in the golden pond, while musicians and dancers fill the center stage. Elegant pavilions filled with people can be seen in the background, and additional figures ride on clouds at the top of the painting. The beings, architecture, and other elements are delicately outlined with black ink, filled with colors, and often highlighted in gold.

The narrative scenes along three borders, which are based on the *Sutra on the Meditation of the Buddha of Infinite Light,* illustrate a way to reach the pure land at the painting's core. Reading from bottom to top, the scenes to the left tell the story of the Indian queen Vaidehi and king Bimbasara who were imprisoned and almost murdered by their son Ajatashatru. Heartbroken, the queen prayed to Buddha Shakyamuni, who responded by granting her a vision of the pure lands of the ten directions. Queen Vaidehi chose to focus her devotion on Sukhavati, and Shakyamuni gave her a series of sixteen meditations to help her attain rebirth there. Thirteen of the meditations are represented from top to bottom at the right of the painting. The remaining three, subdivided into the nine possible degrees of rebirth, are shown in the lower border to either side of a long standardized inscription explaining the rediscovery of the original Taima Mandala in Japan and its importance to Pure Land practice. The nine degrees of rebirth possible for sentient beings are

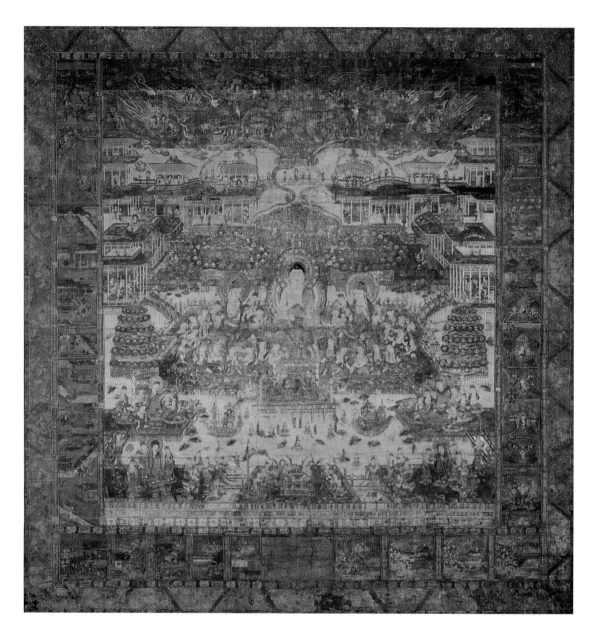

divided into three major groups: those who have accumulated merit by various types of bodhisattva practices; those who follow earlier Buddhist practices or have lived virtuously without the benefit of Buddhism; and those who are ignorant or have committed crimes. Although rebirth in Sukhavati is possible for all three groups, some—presumably with less-than-blameless lives—may have to wait for a while between death and rebirth. The closed lotus flowers

in the painting, thought to contain the souls of those who have not yet actually been reborn, illustrate this belief.

The descent of Buddha Amitabha from Sukhavati to earth to escort the soul of a recently deceased person to the perfect realm, which is one of the smaller scenes in the Taima Mandala, was also an important, independent subject in Japanese Buddhist art. In a nearly five-foot painting [10.12], now in Chion-in Temple in Kyoto, Amitabha rushes to earth standing on clouds to succor the soul of a recently deceased priest. The cleric, who holds his hands in a gesture of prayer and grasps a rosary, is seated in a building before a table that holds several sutras written in gold ink on blue paper, probably Pure Land texts. A large retinue of bodhisattvas, many playing musical instruments, including various types of drums, a lute, and a zither accompany the buddha. Bodhisattva Avalokiteshvara, identified by the standing image of Amitabha in his headdress, leads the procession and holds a lotus pedestal that will be used to take the soul of the dead priest to Sukhavati. The miniscule figures in the sky above the priest's chamber are emanations of Amitabha's power and compassion. The tiny pavilion in the upper right corner represents Sukhavati. The gently rolling hills with waterfalls, flowering cherry trees, and various species of evergreen place the scene of Amitabha's descent in the Japanese countryside and reflect the Kamakura-period belief that deities from various traditions occupied the island nation.

Interest in sacred sites and parallels between the native deities (*kami*) and the imported Buddhist deities flourished with the growth of the "way of mystical practice" (*shugendō*) during the Heian period (794–1185). Adherents of this practice generally retreated to isolated mountains to meditate and practice austerities and, in their openness to multiple beliefs, helped to solidify both an appreciation of nature as a manifestation of divinity and an understanding of the parallels between divinities of different traditions. By the tenth century, the belief that Buddhist deities and native gods were manifestations of one another (*honji-suijaku*) had been codified; by the Kamakura period, this system was an integral part of Japanese Buddhism. Images of both Buddhist deities and Shinto gods were often incorporated into representations of famous sites, such as the Kasuga Shrine in Nara, the Sanno Shrine on Mount Hiei (northeast of Kyoto), or the Kumano region at the southern tip of the Kii Peninsula, graphically illustrating the presence of these divinities on the Japanese islands.

FIGURE 10.11
OPPOSITE
The pure land of Buddha Amitabha (Amida), or Taima Mandala.

Japan, Kamakura period, fourteenth century. The smaller scenes surrounding the central image are steps guiding the devout to the pure land in the center.

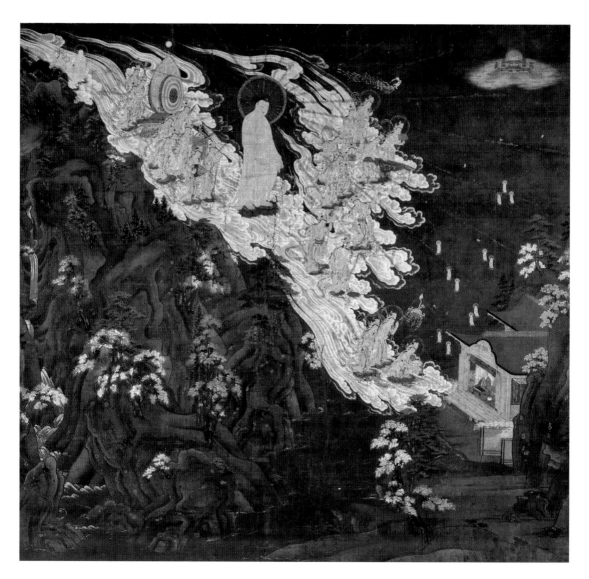

FIGURE 10.12
The descent of Buddha Amitabha (Amida Raigō).

Chion-in, Kyoto, Japan, Kamakura period, early thirteenth century. In this towering painting, the buddha and his entourage descend to earth to bring the soul of a recently deceased monk to the western paradise.

A luminous painting dated to around 1300 [10.13] illustrates a composition representing the Kasuga Shrine that developed in the late twelfth century. The "bird's-eye" view, which is often used in paintings dedicated to Kasuga, distinguishes Japanese painting traditions from those imported from China. Rolling hills with delicately painted cedars serve as the background to a depiction of both the Buddhist Kōfuku-ji, the tutelary shrine of the Fujiwara family, and the nearby Kasuga Shrine, the locus of their (native) family gods. The gate at the bottom of the painting leads to Kōfuku-ji, constructed around 720, while a gold-colored path winds from the

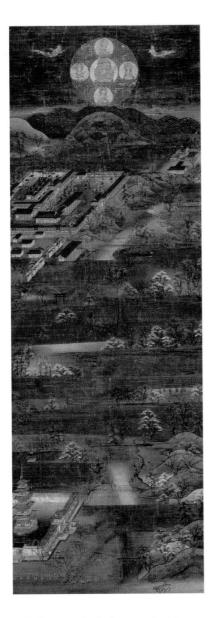

FIGURE 10.13
Mandala of the Kasuga Shrine.

Japan, Kamakura period, early fourteenth century. The Kasuga area of Nara is home to both Buddhist and Shinto shrines, as well as deer that are considered sacred to the sites.

Buddhist site through the wooded plain to the Kasuga Shrine, which was established in 768. Deer, sacred to the Kasuga cult, frolic in the woods. The subtle moonlight in the painting, the conical Mount Mikasa, and the heavily wooded Mount Kasuga in the background are traditionally found in illustrations of the site.

The Kasuga Shrine is dedicated to the God of the Heavenly Roof (*Ame no Koyane no Mikoto*), the guardian deity of the Fujiwara family, who is enshrined in the third of four buildings decorated

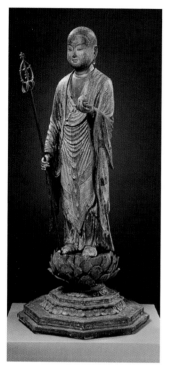

FIGURE 10.14
*Bodhisattva
Kshitigarbha (Jizō).*

Japan, Kamakura period, 1223–1226. Kshitigarbha, who protects women and children and leads souls from hell, is also revered in the Japanese Shinto tradition.

with horn-shaped finials on the roofs and placed together in the center of the complex. This god is identified with Bodhisattva Kshitigarbha (Jizō), who appears to the right in the gold-rimmed disc that hovers at the top of the painting and contains images of the five Buddhist forms of the deities of the Kasuga Shrine. The consort of the principal Shinto deity (Himegami), who is housed in the fourth shrine, is a manifestation of the eleven-headed Avalokiteshvara (seen at the right side of the disc). Two additional deities—the God of the Sword (*Futsunushi no mikoto*), a form of the Buddha Shakyamuni (center), and the God of Relentless Thunder (*Takemikazuchi no mikoto*), the manifestation of Buddha Bhaishajyaguru (top)—inhabit the first and second shrines, respectively. A newer structure built in a separate complex at the site houses the Young Prince (Wakamiya), a form of Bodhisattva Manjushri (bottom). Paintings of the Kasuga Shrine were displayed in a special ceremony held there each year on the twenty-first day of the fifth month. Historical records indicate that they were also used as the focus of worship in aristocratic homes, where they may have served as substitutes for a visit to the site.

Parallels between the style and size of a sculpture of Bodhisattva Kshitigarbha [10.14] in the collection of The Asia Society in New York, one of Bodhisattva Avalokiteshvara in the Nara National Museum, and another of Bodhisattva Manjushri in the Tokyo National Museum suggest that all three were once part of a pentad embodying the Buddhist manifestations of the five deities of the Kasuga Shrine. When the sculpture of Kshitigarbha was repaired in the early 1960s, inscriptions—primarily the names of donors or pious wishes written in black ink—were found throughout the hollow interior of the body and head. Among them is the name of the sculptor, Zen'en, a member of the En school, whose life and work is recorded almost exclusively in such inscriptions. The gently swelling, youthful physique and face of Bodhisattva Kshitigarbha, his long, narrow eyes and fleshy mouth, and the full, flowing garments enhanced by deep folds are characteristic of the Zen'en style of the 1120s and are also found on Japanese sculptures.

The names of two prominent monks at the Kōfuku-ji are also inscribed on the interior of the sculpture of Kshitigarbha. Jisson is referred to as the abbot of this temple and Han'en as the former abbot. Temple records indicate that the monks held these positions from 1223 to 1226, providing a date for the sculpture. The inscriptions inside the two sculptures in Japan provide additional information. For example, Han'en, the monk mentioned in the inscription inside

Kshitigarbha, is also recorded in that of the eleven-headed Avalo-kiteshvara. This monk is known to have officiated at a ceremony in 1215 in which images of the five Buddhist deities of the Kasuga Shrine were installed in a pagoda at nearby Kōfuku-ji. Further information found in the sculptures in Japan suggests that they and the piece in New York were most likely part of a second set of images of five Buddhist manifestations at the Kasuga Shrine, made slightly later, and housed in the Hokke-dō at Kōfuku-ji.

Although meditative practices of various types were known in Japan as early as the seventh century, Zen (Chan) Buddhism was not prominent there until the Kamakura period. The introduction and acceptance of Zen reflects the high level of travel between China and Japan at that time. About one hundred Japanese monks are known to have visited China during the Southern Song period and approximately fifty during the Yuan dynasty. Two are generally credited with the establishment of Zen in Japan: Eisai (1141–1215) visited China in 1168 and again in 1187 during an unsuccessful attempt to travel to India; Dōgen was in China in 1223. Eisai introduced the Rinzai (Linji) tradition, with its stress on the study of koans and other practical applications of practice. Dōgen (1200–1253) promulgated the Sōtō (Caodong) tradition, which emphasized the relationship between meditative practice, such as sitting (zazen), and the acceptance of one's innate Buddha-nature. The study of koans and the physical discipline found in Rinzai Zen were particularly attractive to the military leaders of the Kamakura and Muromachi periods, and this form of the religion thrived in urban centers such as Kamakura and Kyoto, while Sōtō Zen received greater support in rural areas.

In the late fourteenth century, the newly powerful Ashikaga shogunate began a system of ranking urban temples affiliated with the Zen tradition into a hierarchy known as the "five mountains (gozan) and the ten important temples," which was based on a system used in Southern Song China. Temples in the provinces were classified as "under the forest," or rinka, centers. The ranking of the temples varied according to the patronage of certain shoguns. For example, Ashikaga Yoshimitsu, previously mentioned as an important collector of Chinese paintings, established Shōkoku-ji Temple around 1392, which led to a rearrangement of the hierarchy of the gozan temples, in which Shōkoku-ji became the second most important center in Kyoto. Monks living and working in gozan temples often played a critical role in Muromachi Japan, advising shoguns on political, economic, and cultural issues, while serving as

FIGURE 10.15
The Four Sleepers.

Japan, Kamakura period, early fourteenth century. Artist: Moku'an Reien. The fourth sleeper is the tiger that served as a companion to one of the three eighth-century Chinese monks depicted in this painting.

FIGURE 10.16
OPPOSITE
Orchids and Rocks.

Japan, Muromachi period, mid-fourteenth to early fifteenth century. Artist: Gyokuen Bonpō. The pairing of the painting and poem works on many levels. It is a reference to a famous Chinese minister, and it also shows an awareness of Chinese painting techniques.

links to China. *Gozan* monasteries, which also functioned as centers of scholarship and art, introduced new aspects of Chinese literature, including the Confucian classics, and the Chinese tradition of monochrome ink painting to Japan.

Moku'an Reien, a monk-artist who painted in the early fourteenth century, was ordained at Kamakura in 1323 before traveling to China in 1327, where he remained for the rest of his life; the abbot of the Liudong-si, the monastery that Fachang Muqi helped to restore, recognized Moku'an Reien as a reincarnation of that famous Chinese artist. Moku'an's painting of the *Four Sleepers* [10.15] depicts three quasilegendary masters of the Tang period, a theme that was developed in the early eleventh century. Hanshan (Kanzan), Shide (Jittoku), and Fenggan (Bukan) and his tiger are huddled together as they sleep beneath the shelter of a cliff. *Poems on Cold Mountain* (*Hanshanshi*), an eighth- or ninth-century record, is the primary source for their history. According to these writings, Hanshan ("cold mountain") was a solitary practitioner who lived on Mount Tiantai in Zhejiang Province. He would often visit Shide, a foundling who worked in the kitchen of Guoqing-si Temple. Noted for often inexplicable behavior and maniacal laughter, which was symbolic of their ability to see beyond the obvious, Hanshan and Shide are often shown with Fenggan. The latter, who astounded his colleagues by riding a tiger, was the abbot of Guoqing-si who had rescued the young Shide.

In the painting, Hanshan, identified by the two knots in his hair, rests against Fenggan, who leans on the sleeping tiger, as does Shide. The knots, which indicate that Hanshan is a young man here, may refer to the perception that he was a manifestation of Bodhisattva Manjushri. Fenggan, recognized by his corpulence and balding head, is sometimes identified as a buddha, while the disheveled Shide is a manifestation of Bodhisattva Samantabhadhra (Fugen). The sense of spontaneity in the painting and the modulated brushstrokes—some light, some dark, some soft, some bold—show a proficiency that helps to explain Moku'an's identification with the famous Muqi. A little-known monk named Xiangfu Shaomi wrote the inscription at the top, which describes the figures and their "big dream." Refer-

ences to dreams and dreaming, an allusion to an altered and presumably advanced state of consciousness, are often used metaphorically in Buddhist writings.

Poems and prose that alluded to and expanded on the theme of a painting were frequently written on works produced by members of the Chinese literati tradition, and the practice was also adopted in *gozan* temples. For example, a poem at the top of a graceful painting of rocks and orchids [10.16] by the monk-artist Gyokuen Bonpō reiterates the understanding of orchids as symbols of purity of heart and loyalty by referring to a famous Chinese minister named Qu Yuan (ca. 343–247 B.C.E.), who embodied those qualities:

> Bedecked in garlands, the dancing pair
> Combines their rival fragrances.
> Who could fashion anew these deep red tassels?
> ... dashed off in remembrance of the Minister of Chu.[3]

Sent to study Zen at the age of ten, Bonpō worked in temples in Kyoto and Kamakura throughout his career. His poems and signature are frequently found on early-fifteenth-century landscape paintings produced in Kyoto, some of the earliest Japanese examples of this genre. He created more than twenty paintings of rocks and orchids, and it has been suggested that the emphasis on a single theme was intended as a type of religious practice. A familiarity with Chinese style is evident in the elegant rendering of the long stems of the orchids and the use of the flying white technique—in which the paper shows through the spread bristles of the brush—for rendering the base of the plants. The painting shows a three-point perspective also derived from China: the rock in the foreground is viewed from above, while the leaves, stems, and blossoms are seen in a straight-on view or from below.

Sesshū Tōyō (1420–1506), the most renowned monk-painter of the Ashikaga period, also adopted the three-point perspective in his spectacular painting using the "flung ink" (*haboku*) technique. As the name implies, this method gives an impression of spontaneity and speed in the use of the brush and the resulting abstract rendering of a landscape [10.17]. Sesshū's genius is seen in his ability to portray a small boat with two figures and a hut—probably a sake restaurant because of its flag—nestled on the bank of a towering mountain. His long inscription explains that he painted the landscape as a farewell gift for one of his pupils, a monk-painter named Josui Sōen (active

1495–1499), who was affiliated with the Engaku-ji in Kamakura. The six additional inscriptions at the top of the painting were made by important and high-ranking monks in Kyoto, which Sōen visited on his return to Kamakura.

Sesshū, which translates as "snow boat," is a sobriquet the artist adopted when he was forty-three. He left Kyoto in 1464, possibly because of the political unrest that eventually led to the Ōnin War, and moved to Yamaguchi Prefecture in western Japan, where he established a painting studio known as the Unkoku-an. He traveled to China in 1467 and 1468, visiting Mount Tiantai and other important Buddhist centers in the South; after returning to Japan, he moved back to his studio in Yamaguchi. Sesshū's work served as an inspiration to many later painters, including those who defined themselves as the Unkoku school after the name of his studio.

As already discussed, the long-standing cultural, religious, and economic exchanges between Japan and China are reflected in the use of the monochromatic landscape traditions in Japan and in the inclusion of Chinese paintings (as well as ceramics and lacquers) in Japanese art collections. Traditions such as the tea ceremony, flower arranging, and the construction of dry landscape gardens (*karesansui*), which continue to be practiced today, were also influenced by interchanges between China and Japan. As the name implies, dry landscape gardens are composed of gravel, rocks, and moss but do not contain shrubbery, plants, or flowers. That at Ryōan-ji [10.18], which was built around 1488 or 1489 as part of the reconstruction after the Ōnin War, is one of the most austere: it consists of fifteen rocks and gravel raked into patterns suggestive of swirling water. Gardens like this are intended for viewing rather than visiting, and they may often have served as the focus of meditation in Zen monasteries such as Ryōan-ji. However, like ink painting, the tea ceremony, and other activities that were introduced to Japan with Zen Buddhism in the late Kamakura and Muromachi periods, an interest in rocks and the creation of dry gardens have become part of Japanese culture, and neither Buddhism nor any other practice inevitably underlies their construction.

FIGURE 10.17
OPPOSITE
Haboku Landscape.

Japan, Muromachi period, 1495. Artist: Sesshū Tōyō. Chinese-style ink painting and landscape compositions were first introduced to Japan together with practices affiliated with the Chan (Zen) tradition. Sesshū created this evocative landscape with quick, abstract brushstrokes that appear to have been thrown onto the paper.

FIGURE 10.18
ABOVE
A view of a dry landscape garden (karesansui).

Ryōan-ji, Myoshin-ji, Kyoto, Japan, Muromachi period, late fifteenth century. Gardens without plants are also associated with Zen practices and are often, but not exclusively, used as the focus of meditation.

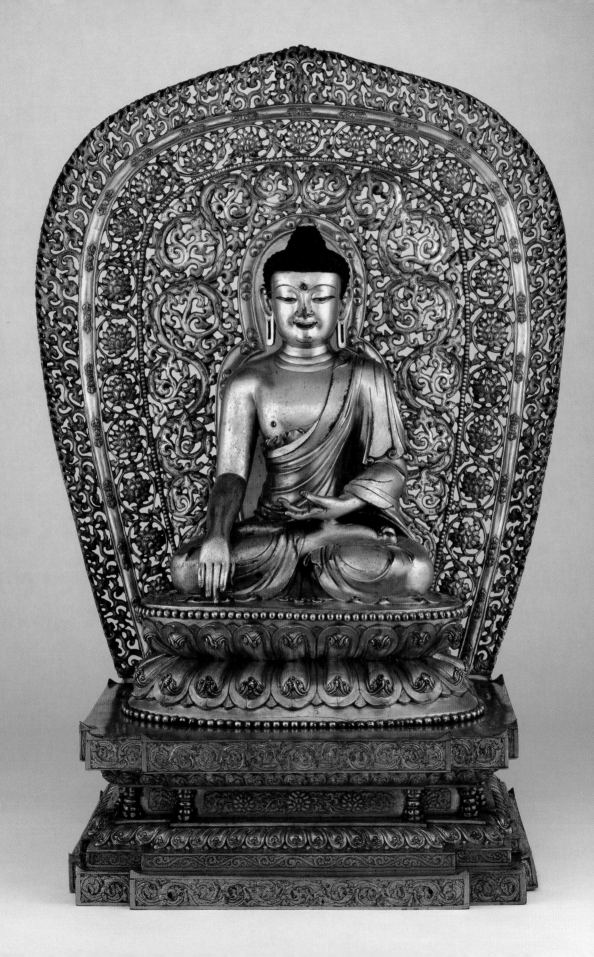

CHAPTER 11

Early Sino-Tibetan Traditions
Twelfth to Fifteenth Century

THE FORMATION of the Mongol Empire in the mid-thirteenth century had a profound impact on the development of a style of Buddhist art known as either Sino-Tibetan or Tibeto-Chinese. This empire, which encompassed the largest contiguous landmass in history, was founded in 1206 when Temujin (ca. 1162–1227) was named Genghis Khan (Chinggis Khan), or "universal sovereign" of the various tribes in the eastern steppes. (The steppes are large, grassy belts linking Northeast Asia, parts of Russia, and southeastern Europe). By the mid-thirteenth century, Mongols controlled present-day Afghanistan and Kashmir, much of northern China (including the Xinjiang Uighur Autonomous Region), Tibet, Manchuria, and parts of Korea and northern Vietnam. The northeastern part of this vast realm was administered from China where Kublai Khan (1215–1294) and his successors ruled as the emperors of the Yuan dynasty (1272–1368). The Venetian Marco Polo (1254–1324), who lived at the Yuan capital at Dadu (Beijing) for some time in the middle of the century, provided one of the first Western accounts of Tibetan-style Buddhism practiced at the Mongol court. He was impressed by the powerful sorcery of some of the monks and their reverence for someone named "Shakyamuni Burkhan," whom Polo equated with Moses, Jesus Christ, and Muhammad.

As mentioned in earlier chapters, Buddhism disappeared in India after the twelfth century, while centers of thought and practice burgeoned in Kashmir, Nepal, and elsewhere in the Himalayas. Artists in the Kathmandu valley, who had a long tradition of painting and metalwork, were among the most renowned at the time; the style they developed in the twelfth and thirteenth centuries served as a primary source for Buddhist art in Tibet and China in the thirteenth and fourteenth centuries, as well as for later traditions shared

FACING PAGE
Buddha Akshobhya.
See page 240.

by these two cultures and Mongolia until the nineteenth century. The broad form and face of a gilt bronze image of an unidentified bodhisattva [11.1] epitomize Nepalese art in the thirteenth century. The bodhisattva sits with a slight sway at his waist and wears only a thin undergarment that helps to define his idealized body. His square face has long, almond-shaped eyebrows and eyes, which are downcast and indicate his meditative state. His braided hair is pulled into a topknot, and he wears a five-piece diadem, fantastic earrings, a necklace, armlets, bracelets, and additional adornments at his ankles. The antelope skin wrapped around the lower part of his left arm is a reminder of the ascetic practices often found in certain Buddhist practices.

Very similar jewelry, as well as body and facial type, are found in a painting of Buddha Amoghasiddhi [11.2] that is part of a set of five buddhas (representing the heads of the five buddha lineages)

FIGURE 11.1
A bodhisattva, possibly Avalokiteshvara.

Nepal, thirteenth century. This is one of the earliest existing sculptures decorated with inlays of semiprecious stones, a technique common throughout the Himalayas.

FIGURE 11.2
OPPOSITE
Buddha Amoghasiddhi.

Central regions, Tibet, first half of the thirteenth century. One of a larger set, presumably of the five buddhas who head the primary lineages, this painting of Amoghasiddhi includes a portrait of the monk who consecrated the group in the lower right corner.

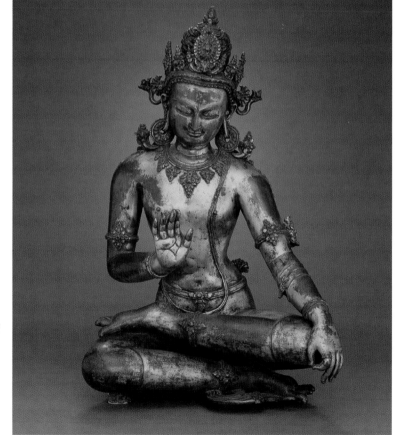

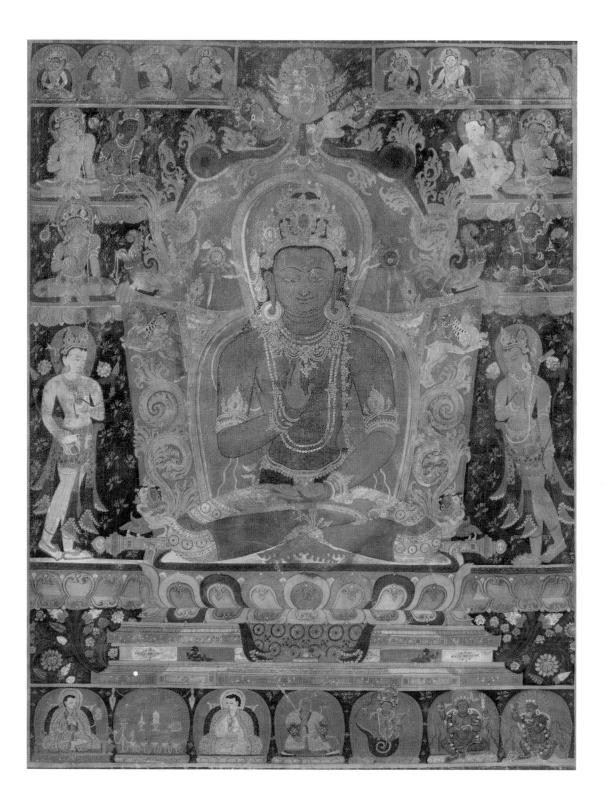

produced in the central part of Tibet in the first half of the thirteenth century. The exquisite rendering of the jewelry, the way in which the decorated lower garment hugs his legs, and the use of scattered flowers in the background all show a Nepalese influence. It is likely that either artists from Nepal or Tibetans trained in that style painted the icon. Amoghasiddhi, who is green and sits on an amazing throne, is associated with the north, heads the action family, and symbolizes an all-encompassing awareness. The back of his throne is covered with scrolling vines and figures, including the entwined couples at the base and those riding the astonishingly lifelike *sardulas.*

Eight bejeweled and crowned bodhisattvas attend the buddha: two stand to the sides, and six are seated above. The bodhisattvas allude to the Mandala of the Eight Great Bodhisattvas, one of the earliest mandalas that was popular throughout Asia from the sixth through the tenth century. Lists of the eight great bodhisattvas are found in texts such as the *Sutra of the Eight Buddhas,* in which they are described as protectors of the faithful and providers of mundane blessings; they also greet the souls of the newly deceased when they arrive in a pure land such as Sukhavati. Additional figures, many of them protective, are painted in the upper and lower borders of the painting. A lay donor, identified by the white robe under his cloak, sits at the upper left, and another such figure, seated to one side of a table with ritual offerings and holding a bell and a vajra, is in the lower border. The latter and the monk holding an incense burner illustrate the consecration of the image of Buddha Amoghasiddhi. The Nepalese influence in the painting indicates that it was produced at a monastery associated with the Sakya lineage of Tibetan Buddhism. Established in the late eleventh century, Sakya, which is one of the four principal Tibetan lineages, is also noted for its rigorous scholarship. The donors of the painting of Buddha Amoghasiddhi were most likely members of the Khon clan, who often served as abbots of Sakya establishments and were among the most powerful groups in a fragmented thirteenth-century Tibet.

The refined palette with an emphasis on reds and blues, figural types, clothing, and jewelry, as well as the astonishing amount of detail and the use of a dense scroll background in a painted mandala [11.3] featuring Jnanadakini (the personification of intuitive wisdom), illustrates the continuation of Nepalese artistic traditions in central Tibet in the fourteenth century. Dakinis are celestial beings (at times protective, at times erotic) who appear to practitioners to

FIGURE 11.3
OPPOSITE
A thirteen-deity
Jnanadakini mandala.
Central regions, Tibet, ca. 1375. Flat colors, elegant figures, and beautifully drawn details are characteristic of paintings produced at monasteries in central Tibet in the fourteenth and fifteenth centuries.

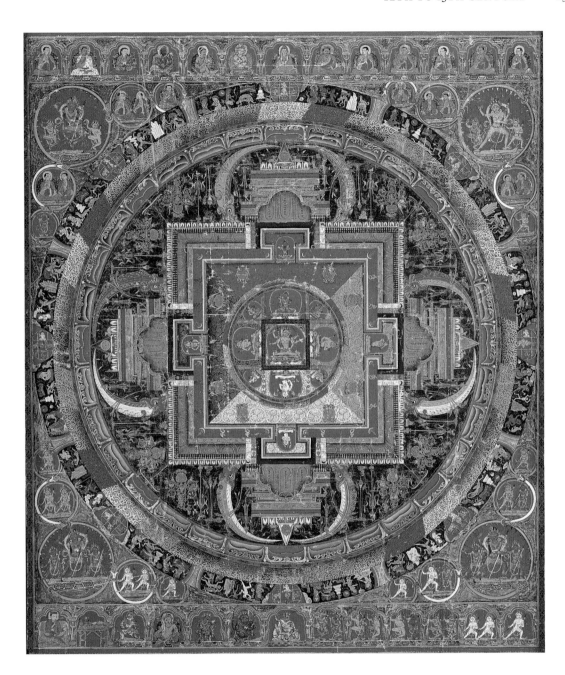

assist them in their spiritual development. In the painting, Jnana-dakini is seated on a lion throne in the center of a lotus inhabited by eight additional goddesses that fills the circular inner precinct of the palace-architecture-type mandala; the structure has fabulous gate-ways at the four cardinal directions guarded by protective figures.

The eight cremation grounds, often found in mandalas of fierce protectors, are shown in the outermost of the three circles that define the inner precincts of the mandala. Four additional dakinis and numerous small figures, including several pairs of monks, presumably teachers and students, often appear in small circles and inhabit the areas on the outer edges of the mandala. The unidentified figure at the lower left of the painting, shown wearing a Tibetan-style robe and a Nepalese hat, may be the donor who commissioned it.

The Jnanadakini mandala is one of a set of paintings illustrating a series of ritual texts known collectively as the *Garland of Vajras* (*Vajravali* or *Vajramala*) composed by the Indian monk-scholar Abhayakaragupta in the late eleventh or early twelfth century and translated into Tibetan soon after. Different versions of the texts, some listing twenty-eight mandalas and others forty-two or fifty-five, have been preserved; the basic text played an important role in the transmission of later Buddhist traditions from India to the Himalayan region. The Kashmiri monk Shakyashri brought a thirteenth-century recension of this text to Tibet, where he taught at a Sakya monastery from 1204 to 1215. The *Garland of Vajras* is also mentioned in the work of the Tibetan Buton (1290–1364), the famous fourteenth-century monk-scholar who is sometimes believed to be a reincarnation of the Kashmiri Shakyashri. Buton is noted for his study of different religious lineages and for his 1345 compilation of an important version of the *Tanjur*, the Tibetan-language version of the Buddhist canon.

Thirteen monks and teachers depicted in the arcade at the upper border of the Jnanadakini mandala link this painting (and others in the set) to Buton and his work in the mid-fourteenth century. The monk in the center of the arcade is Sonam Gyaltsen Pel Zangpo (1312–1375), also known as Lama Dampa, an aristocratic monk-teacher, who worked with and supported Buton. Lama Dampa served as the abbot of Sakya Monastery from 1345 to 1349 and was a powerful political figure in the mid-fourteenth century. The commissioning of such an extensive cycle of paintings based on the work of Buton and dedicated to Lama Dampa was most likely intended to commemorate the funeral of the latter, who is always depicted in a central location in the lineages at the upper borders of all the paintings in the set.

Lama Dampa also had strong ties to the Phagmodrupa clan that ultimately freed Tibet from the domination of the Mongols, which began around 1240 when Koden, a grandson of Genghis Khan, led a

small force into the central regions and gained control of the area. Koden also forced the renowned Kunga Gyaltsen, honorifically known as Sakya Pandita (1182–1251) and a member of the Sakya family and religious lineage, to come to his capital at Liangzhou in Gansu Province, ostensibly to help deepen the people's understanding of tantric Buddhism, which was adopted as a state religion by Kublai Khan in 1268.

Chogyal Phagpa (1235–1280), who created a script for the Mongol language based on the Tibetan one, and his younger brother accompanied their uncle, Sakya Pandita, to China and quickly rose to prominence at the Mongol court. In 1260, Kublai Khan was named the ruler of the empire and Phagpa, who served as his principal link to Tibet, became the national preceptor of the Mongol Yuan Empire. Although the relationship between Phagpa and Kublai Khan is often described as that of a monk and his patron and implies a teacher-to-student dynamic, it is unclear whether or not Phagpa had any influence at court beyond his roles as a religious teacher and a monk who performed rituals and other ceremonies on behalf of the state.

He was, however, responsible for bringing the young Nepalese artist Anige (1244–1306) to the court at Beijing in 1262. According to Chinese sources, Anige was the leader of a group of artists brought to central Tibet, the stronghold of the Sakya sect, in 1261 to construct a "golden pagoda." Although he was only seventeen at the time, Anige was already an accomplished artist, noted for his casting of metal sculptures and also trained in painting and weaving. In China, Anige quickly gained fame and was named director of all artisan classes in 1273 and controller of imperial manufactories in 1278. Chinese records indicate that Anige, who supervised craftsmen brought to Beijing from throughout the vast Mongol realm, was involved in numerous projects, including the creation of religious paintings and sculptures. Acenge, one of his sons, and the Chinese Li Yuan are said to have worked in Anige's style, and it seems likely that other artists from diverse backgrounds were also familiar with Nepalese traditions.

A sculpture of a bodhisattva [11.4] made using the dry lacquer technique, which was produced by an unknown artist in China, illustrates a skillful blending of this technique and the Indo-Nepalese style. The body and face of the Chinese bodhisattva are remarkably similar to those seen in the gilt bronze sculpture from Nepal [11.1], as are the braided topknot and jewelry. In addition, both figures sit in a cross-legged position and have a subtle bend at

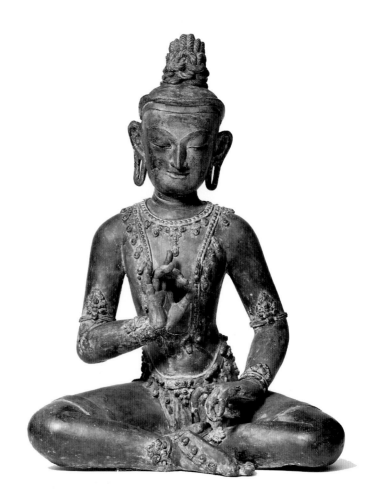

FIGURE 11.4
A bodhisattva.

China, Yuan dynasty, mid-fourteenth century. Although the use of dry lacquer is a Chinese technique, the style of this bodhisattva derives from Nepalese traditions introduced to China during the rule of the Mongol Yuan dynasty.

FIGURE 11.5
OPPOSITE
The Mandala of Yamantaka (Yemandejia) *with imperial portraits.*

China, Yuan dynasty, ca. 1330–1332. The Mongols valued woven icons such as this mandala more highly than painted images.

the waist. The Chinese figure lacks the crown worn by the earlier Nepalese deity, but this adornment was probably made of metal such as silver or gold and lost over time.

The scrolling background of a magnificent silk tapestry (*kesi*) palace-architecture mandala [11.5] exhibits parallels to that found on the throne back of the painting of Buddha Amoghasiddhi [11.2]. Produced either in Beijing or Hangzhou, the tapestry shows the primary deity, Yamantaka-Vajrabhairava, standing in a circle in the center of a multileveled square palace with elaborate gateways at the four cardinal directions. Yamantaka conquers Yama, the Indian lord of death, and by extension transcends death. In some manifestations, he also embodies the powers of Vajrabhairava, who has the ability to cause destruction and thereby renewal. A large circle surrounds the palace compound, while additional figures—including manifestations of the principal deity, monks, others representing a practice

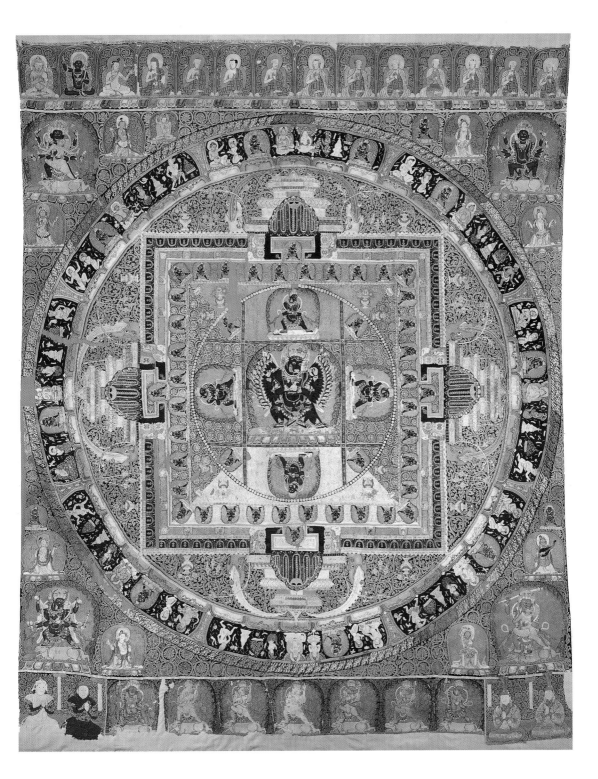

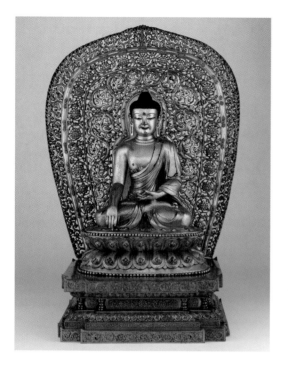

FIGURE 11.6
Buddha Akshobhya.

China, Ming dynasty,
Yongle period, 1403–1424.
The buddha is identified by
the earth-touching gesture,
which was used only by the
historical Buddha Shakyamuni
and the transcendent Buddha
Akshobhya.

lineage, and donors—are shown at the top and bottom of the tapestry. Those at the lower left and right are identified by Tibetan inscriptions as Tugh Temur (in Chinese writings, Emperor Wenzong), who reigned briefly and intermittently from 1328 to 1332; his elder brother, Khoshila (Mingzong), who was emperor in 1329; and their respective spouses, Budashri and Bubashu. The combination of the four helps date the tapestry to between 1330 and 1332. It was probably commissioned for use in an initiation ceremony at the Chinese court around that time.

As mentioned previously, Tibet overthrew Mongol rule around 1358, when members of the Phagmodrupa revolted against the faltering Yuan dynasty and gained control of much of the geographical area encompassed by present-day Tibet. Native control of China was reasserted in 1368, when a rebellion toppled the remnants of the tottering Yuan dynasty and established the long-lasting Ming dynasty (1368–1644). Relations between the newly liberated China and Tibet, which had weakened in the second half of the fourteenth century, due in part to the turmoil in both realms, were reinstated during the early fifteenth century, particularly during the reign of the Yongle emperor (1403–1424), who was a follower of Tibetan Buddhist traditions. A spectacular gilt bronze sculpture of a seated buddha [11.6] shows the elegant forms and lush gilding that typifies art made at court during his reign. The buddha sits on a double-tiered lotus pedestal placed on an articulated throne profusely decorated with flowing botanical scrolls, which are based on those found earlier in Nepalese and Tibetan painting. Similar scrolls of various types fill the interior of the mandorla that encircles the buddha, most likely Akshobhya because of the earth-touching gesture of his right hand. His full shoulders, long legs, and quiet articulation ultimately derive from the Indo-Nepalese techniques introduced by Anige during the Mongol Empire. The soft folds of the clothing that flows over the legs and the left side of the chest, however, exemplify Chinese taste, as does the extremely careful casting of the bronze sculpture. An inscription on the lotus pedestal, which reads "Bestowed During the Reign of the Yongle Emperor" (*Da Ming nian shi*), indicates that the piece was produced in an imperial workshop.

At least thirteen official delegations between China and Tibet are recorded during the reign of Yongle, including substantive visits by three of the more important Tibetan clerics of the time: Deshin Shegpa (1385–1415) of the Karma sect, who is often known by the Chinese name Helima; Kunga Tashi Gyalsten (1349–1425) of the Sakyas; and Sakya Yeshe (1352–1425), who served as a representative of the famed Tsongkapa (1357–1419), the founder of the Geluk branch. The activities surrounding Helima's visit to the court are typical of the fanfare that accompanied such delegations. He arrived at Nanjing (still the capital until the court moved to Beijing in 1420) and was greeted by a thousand monks and thirty adorned elephants. The emperor, guards in gold armor, and other spectacularly arrayed officials welcomed him to the palace. During his stay in China, Helima performed funerary rites for the emperor's parents, supervised the creation of mandalas, and initiated the emperor and others into their practices. Sculptures, ritual implements, and other goods such as the famed Chinese blue-and-white porcelains were given to Tibetan visitors and sent as gifts to important clerics, and numerous examples are preserved today in Tibet. These gifts, as well as works sent earlier from the Yuan court in Beijing, had a strong and long-lasting influence on Tibetan artistic traditions, which often show an awareness of Chinese art and imagery after the fourteenth century.

The paintings and sculptures that decorate the chapels of the Great Stupa in the Palcho monastery at Gyantse [11.7], constructed under the patronage of the rulers of the principality of Gyantse between 1427 and 1440, provide a good example of the admixture of

FIGURE 11.7
The Great Stupa at Palcho Monastery, Gyanste.
Tibet, ca. 1427–1440. Built in the fifteenth century, the so-called stupa at Gyantse contains 108 chapels and more than 10,000 murals.

Nepalese and Chinese styles that developed in Tibet at the time and also flourished in the mid-fifteenth century, a period noted for a flowering in the visual arts. The stupa (*chorten*) at Gyantse, also known as a *kumbum* ("house of a thousand buddhas"), has eight stories divided into seventy-five chapels. The two lower stories contain imagery based on texts classified as *kriya-tantra,* or devoted to Buddha Amitayus, and *charya-tantra,* meaning focused on the one-faced Buddha Vairocana. The third and fourth stories follow texts in the *yoga-tantra* classification in which the four-faced Sarvaravid manifestation of Vairocana predominates and in the *Unexcelled Yoga Tantra (Anuttarayoga-tantra)* featuring Buddha Akshobhya. Adepts and teachers who transmitted the teachings

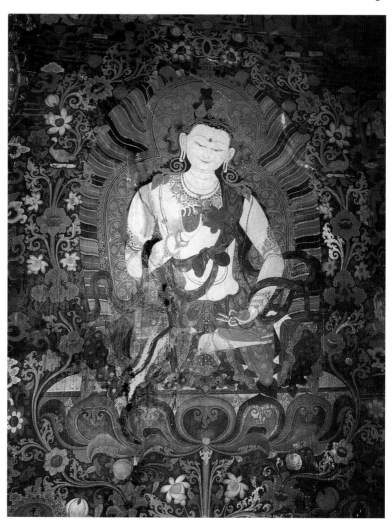

FIGURE 11.8
Bodhisattva Avalokiteshvara as Lokeshvara.

Chapel S3, Palcho Monastery, Gyantse, Tibet, ca. 1427–1440. The treatment of the lush foliage in this painting and its sense of space reflect an awareness of Chinese artistic traditions.

illustrated in the lower stories are depicted in the uppermost levels of the Gyantse stupa.

Each chapel contains sculptures and murals, and the placement of the icons in these rooms is based on specific texts. For example, all of the icons on the south side of the third story are taken from the *Paramadi-tantra*, a commentary on the *Compendium of the Essence of all Buddhas*. A sculpture of Buddha Amitayus, a form of Buddha Amitabha thought to bestow longevity, is the primary icon in Chapel S3 and is attended on one side by a painting of Vajrasattva and on the other by one of Bodhisattva Avalokiteshvara in the form of Lokeshvara [11.8]. The bodhisattva sits, swaying slightly, on a large lotus and has a powerful physique, elegant features, and exquisite adornments that continue Nepalese-Tibetan artistic style. However, he occupies a space that has a sense of depth that is uncommon in Tibetan art and derives from Chinese traditions. The careful knotting of the bodhisattva's sash and the thick, naturalistic folds of the scarf and lower garments reflect a Chinese understanding of clothing that is also seen in the Yongle-period sculpture of a buddha [11.6]; the botanical scrolls and individual blossoms that surround the seated bodhisattva parallel the exuberance often found in Chinese textiles and decorative arts from the early fifteenth century.

Paintings of arhats produced in China at that time [11.9] and those created in Tibet slightly later [11.10] dramatically illustrate the Tibetan use of Chinese styles and imagery. The cult of arhats, important in East Asia, was introduced to Tibet from China as early as the fourteenth century, and Tibetan paintings of these figures usually follow Chinese models. Both the Chinese and Tibetan works show a solitary figure wearing monastic clothing, seated in a remote and somewhat idyllic landscape, and accompanied by a strolling lion and a youth holding a red lacquer stand and a green (possibly celadon or jade) bowl. The towering mountains in the backgrounds are rendered in shades of blue and green with touches of gold, and they follow a tradition of blue-and-green landscape painting that was popular in China in the late seventh and eighth centuries. The

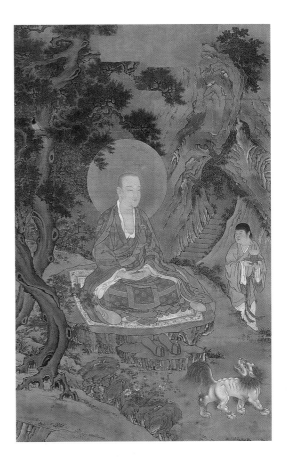

FIGURE 11.9
An arhat (Luohan).

China, Ming dynasty, Yongle period, 1403–1424. Although they are mentioned in Indian-language texts, arhats appear primarily in East Asian and, to a lesser degree, Tibetan Buddhist art.

FIGURE 11.10
An arhat.

Central regions, Tibet, mid-
to late fifteenth century. This
Tibetan painting derives both
its imagery and its style from
Chinese works.

seated figure of a meditating buddha, probably Amitayus, in the
upper right corner of the Tibetan work is the only iconographic
difference in the two paintings. Stylistically, the Tibetan works lacks
the spatial depth of the Chinese piece, and the greater detailing in

the tree bark and mountainsides further distinguishes the Tibetan painting from the Chinese example, as does the flatter and more schematic rendering of the leaves. Those in the Tibetan painting are shown as undifferentiated clumps, whereas in the Chinese work the leaves are carefully distinguished from one another. The use of opaque pigments rather than watercolor, and cloth as opposed to silk, also indicate Tibetan workmanship.

Shared styles and techniques are also evident in ritual implements such as axes, choppers, vajras, and bells produced in the two countries. Such implements were often made of iron overlaid with patterns in silver and gold, a technique sometimes known as damascening that may have been introduced to both China and Tibet from the Middle East during Mongol Yuan rule. Protective and other ferocious deities in Tibetan Buddhism often hold such implements, which were also used by high-ranking lamas in rituals and other practices. The implements embody a host of protective and symbolic functions and help users (and viewers) advance in their spiritual practices. The scrolling geometric patterns and three-dimensional snakes found on the handle of an ax [11.11] are common to works produced in the fifteenth century, as are the knotted forms at the top of the handle. An inscription on the handle of the ax suggests that it was manufactured in Tibet. With the exception of the two characters *Da Ming* (Great Ming) at the beginning, the inscription is illegible, making it unlikely that the piece was made in Beijing or some other Chinese center, where literacy and the ability to properly record a date can be assumed. Moreover, the snakes curling along the handle lack the sense of movement and depth found in contemporaneous Chinese implements. It seems likely that the ax, thought to be part of a set that includes the mace and flying knife here, was made in Tibet in the mid- to late-fifteenth century, a period characterized by Chinese influence in the visual arts. Chinese-style dragons decorate the sides of the mace, while the head of a *makara*—a crocodile-like creature from India with an upturned snout, long whiskers, a curling mane, and protruding teeth—joins the blades to the handles of both the ax and the chopper.

FIGURE 11.11
A ritual ax, mace, and chopper.

Tibet, mid- to late fifteenth century. Monks and other practitioners used ritual implements such as those often held by deities in the visual arts.

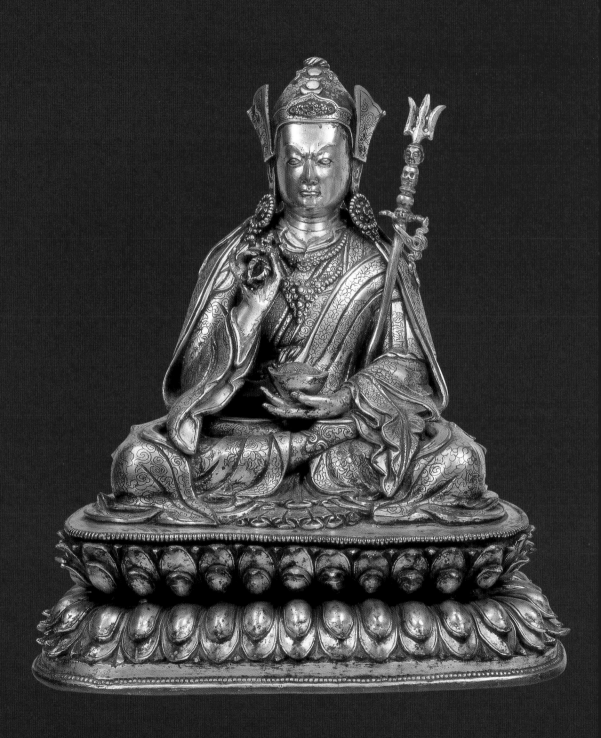

CHAPTER 12

The Dalai Lamas in Tibet

Sixteenth to Nineteenth Century

THE PRESERVATION and refinement of spiritual lineages and prac-
tice traditions defines Tibetan Buddhism even today. From the
sixteenth to the early twentieth century, Tibet was the heart of a
religious culture shared with the Mongols, and the politically and
economically powerful court of the Manchu Qing dynasty (1644–
1911) in China (see chapter 14). Despite the influence of the Dalai
Lamas and other important monks, however, relations between the
three cultures were not equitable, and Tibet was often threatened
or controlled by either the Mongols or the Manchus. Moreover, the
Manchus, who had helped repel a confederation of Mongols that
attempted to invade Tibet in 1717, took advantage of the situation to
appoint a residential governor and assumed control of Tibet in 1721.

The Geluk, one of the major traditions of Tibetan Buddhism that
is headed by the Dalai and Panchen Lamas, was the most powerful
order during this period. The establishment of the Dalai Lamas, the
principal hierarchs of this lineage, as the temporal rulers of Tibet
from 1642 to 1951 can be traced in part to the struggles between
alliances of aristocratic families and monastic centers that charac-
terized Tibetan history from the mid-fifteenth to the mid-sixteenth
century and again briefly in the mid-seventeenth. The placing of
figures such as the Dalai Lamas as the heads of religious lineages
developed in the fifteenth and sixteenth centuries, replacing an
earlier system of hereditary and family-based appointments, such as
that found in the Sakya order in the thirteenth and fourteenth
centuries.

The founder of the Geluk, Tsongkapa (1357–1419), also known as
Jey Rinpoche ("precious master"), was one of the more important
theologians in the fourteenth and fifteenth centuries. He established
several monasteries—including Ganden, the primary center of the
lineage, in 1409; Drepung in 1316; and Sera in 1419—and sent an

FIGURE 12.1
FACING PAGE
Padmasambhava.
Tibet, late sixteenth to
seventeenth century.
Padmasambhava is credited
with establishing the first
Buddhist monastery in Tibet.

emissary to visit the Yongle emperor in China. The word *Geluk* can be translated as "virtuous," and Tsongkapa's movement was reformist, stressing the importance of the monastic code, celibacy, and purity in leadership and politics. He also established a curriculum that led to an advanced degree in theology. The Geluk and earlier Nyingma, Kagyu, and Sakya orders are distinguished from one another by their links to different adepts and monks, as well as by the teachings emphasized at different points in the path of spiritual development. After the rise of the Geluk, noted for their eclecticism in practice, an extraordinarily complicated visual imagery developed in Tibet that was shared by all the lineages and often combined imagery based on earlier traditions. In addition, beliefs that certain monks were incarnations of both Buddhist deities and other historical figures added another layer to the meaning of Tibetan Buddhist art: a sculpture or a painting of a famous teacher can be understood as a portrait of that historical figure, as a reference to an earlier teacher or a deity, and as an image of a buddha. Such icons also serve as records of the transmission of teachings from one master to another.

A lama or teacher is a necessity for the study and practice of all traditions, and portraits of monks and adepts are common in Tibetan art. Like buddhas and other divinities, teachers are identified by clothing, gestures, and other attributes. Padmasambhava, also known as Guru Rinpoche or "precious teacher," is considered one of the founders of Nyingma ("old") Tibetan Buddhism and also played an important role in Geluk practices, particularly after the seventeenth century. (Nyingma traditions are based on early translations of texts, some of which—such as the *Tibetan Book of the Dead*—were hidden, presumably during the tenth and early eleventh centuries when Buddhism was proscribed, and found later by practitioners.) Probably born in India in the eighth century, Padmasambhava was a gifted adept who used his miraculous powers to banish demons from Tibet and established Samye, the first monastery in Tibet. In a beautiful cast-bronze sculpture [12.1], Padmasambhava, who takes eight different manifestations in the visual arts, is seated and wears the decorated clothing and rich jewelry of an aristocrat. He holds a vajra in his right hand and a skull cup in his left, and a ritual staff (*khatvanga*) is tucked into his left side. The distinctive hat, decorated with the sun and moon, identify him, as does the long Tibetan inscription incised on the back of the base: "As soon as you set foot in Tibet you established the Buddha's teachings which wash away all sins. May [Padmasambhava] the Great Master of Uddiyana, conqueror of the hordes of demons,

obtain the unalterable Buddha body. May he overpower with
virtuous weapons all illusions . . . May the sweet melody of the conch
which spirals to the right, its color unrivalled by moonlight, resound
until the end of the world."[1]

An inscription at the bottom of a painting [12.2], which is part
of a set of portraits of Buddhist masters, identifies the subject as the
"lion of philosophers," most likely Mawai Senge (1367–1449). The

FIGURE 12.2
The monk Mawai Senge.

Central regions, Tibet, sixteenth
century. Portraits of monks often
include other practitioners of the
same traditions along the borders.

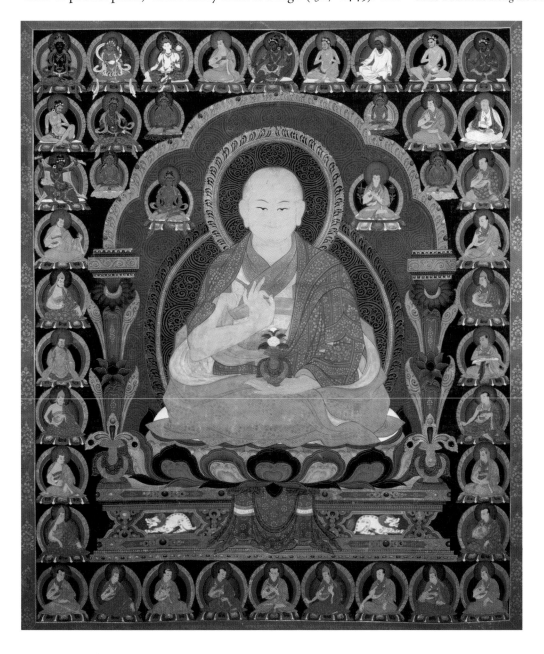

master has a round, friendly face and is seated on a lotus pedestal set on a throne in a manner comparable to depictions of buddhas. He wears monastic garb and a full Tibetan-style cloak, and he holds his right hand in the gesture of teaching; the vase topped with a sprig of white flowers in his left hand is an initiation vase. A small figure of the famed thirteenth-century master Sakya Pandita and another of Buddha Amitayus are seated to the right and left of the monk's head. Mawai Senge was affiliated with the Sakya; the painting's dense, scrolling background and the precise depiction of details, such as the jewels decorating the throne and the patterns of the robes, reflect the long-standing importance of Nepalese aesthetics in centers associated with that order.

Inscriptions identify the celestial buddhas and bodhisattvas, monks, and mahasiddhas seated in the borders of the painting; they identify the painting as a record of the teachers who transmitted the *Supreme Bliss Daka Ocean Tantra* (*Samvara Dakarnava-tantra*). This tradition can be linked to the mahasiddha Naropa, the third figure from the top on the left border, who holds a flayed human skin. Naropa, who lived in India in the tenth or eleventh century, played a fundamental role in the development of the Kagyu order, noted for its oral teachings and visionary practices. He received the teachings from Tilopa, another mahasiddha, who is seated above him in the painting. Tilopa received them from Buddha Vajradhara, who is shown above Tilopa. Shavaripa, identified by his dark skin and his bow and arrow, in the center of the top row, is another of the great adepts or mahasiddhas associated with the lineage depicted in the painting. His central position suggests that he may have been important to Mawai Senge's personal practices.

Shavaripa is also one of the subjects in a painting [12.3] depicting two adepts in a remote and somewhat mountainous landscape. The use of blue and green pigments to shade mountains, the bamboo clump behind a large rock, and the sense of space in the painting derive from Chinese styles first introduced to Tibet in the fourteenth century and reinforced during the seventeenth and eighteenth centuries. Shavaripa began practicing after Bodhisattva Avalokiteshvara appeared while he was working as a hunter and showed him the ghastly consequences of this lifestyle. Shavaripa, shown here with minimal clothing and matted hair, appears to be dancing as he watches his prey, a running antelope, flee. He is shown again in the background holding a bow and wearing a cloak made of peacock feathers, a reference to an epithet that calls him a wearer

FIGURE 12.3
*Adepts Shavaripa
and Dharikapa.*

Eastern region, Tibet, ca. 1600.
Their clothing, gestures, and the
figures that accompany them can
often identify adepts.

of these adornments. His two wives, one holding a quiver and the
other a boar, are shown in the center of the painting. Dharikapa, the
other mahasiddha in this piece, is seated on a levitating throne in
the foreground. The elegant clothing he wears and the two vessels to
his right allude to his birth as a king. Converted by the mahasiddha
Lupiya, Dharikapa abdicated and spent twelve years as the lowly
servant of a temple dancer, who released him from his position when
she discovered his knowledge and abilities. The woman standing
behind the throne and holding a skull cup filled with offerings
most likely represents the dancer, who eventually became one of
Dharikapa's disciples.

An inscription written on the back identifies a sculpture [12.4] as a portrait of Ngawang Lobsang Gyatso (1617–1682), the renowned "Great Fifth" Dalai Lama, a seminal figure in Tibetan history, and one of the more astute political figures in seventeenth-century Asia. The round head and pointed chin of the figure parallel other portraits of the Great Fifth, and the somewhat mannered treatment of the folds of his clothing and the loose, decorative patterns suggest that this sculpture dates slightly later than that of Padmasambhava [12.1]. *Lama* is a Tibetan word used to describe a spiritual guide or teacher (Sanskrit, *guru*). *Dalai Lama*, which can be translated as "ocean of compassion," was coined in 1578 by Altan Khan (1507–1582), the leader of a confederation of Mongols centered on Hohhot, when he accepted the Geluk teaching from Sonam Gyatso (1543–1588). Sonam Gyatso, who was later identified as the third holder of that title, is understood as an incarnation (*tulku*) of one of Tsongkapa's disciples, as is the current Dalai Lama.

After his assumption of the title of Dalai Lama, Ngawang Lobsang Gyatso identified the abbot of Tashilunpo Monastery

FIGURE 12.4
Ngawang Lobsang Gyatso,
the Great Fifth Dalai Lama.

Central regions, Tibet, late seventeenth century. In addition to his importance as a monk and theologian, the Great Fifth Dalai Lama was one of the most astute politicians in seventeenth-century Asia.

and one of his teachers as the first Panchen Lama, an emanation of another of Tsongkapa's disciples, and ultimately a manifestation of Buddha Amitabha. In 1650, the Great Fifth recognized Zanabazar (1635–1723), a renowned Mongolian monk and artist [14.6], as an incarnation of the influential monk-theologian Taranatha (1575–1634) and ultimately as a manifestation of Buddha Shakyamuni; he named Zanabazar the first Jebtsundamba Khutuku (Bogdo Gegen), the Mongolian equivalent of the Dalai and Panchen Lamas. The Dalai and Panchen Lamas jointly identified Huang Taiji (1592–1643), one of the founders of the Manchu Qing dynasty, as a manifestation of Bodhisattva Manjushri, and in 1652, the Great Fifth traveled to China to meet the Shunzi emperor (r. 1644–1661), the first emperor of the dynasty. Building on the earlier relationship with Huang Taiji, the Dalai Lama and the emperor met as preceptor and protector, or teacher and student—a relationship between Tibetan religious traditions and Chinese temporal power that had its roots in the earlier pairing of Kublai Khan and Phagpa.

The Great Fifth was well versed in Nyingma teachings as well as other practices, including Dzogchen meditation, which can be traced in part to the work of Padmasambhava. His synthesis of different types of practice and his desire to help beings at all stages in their spiritual development is central to the Geluk. He was a mystic and a poet, and he often recorded and analyzed his visions and dreams. According to a manuscript known as the *Sealed and Sacred Biography*, Ngawang Lobsang Gyatso had a vision in which he became Bodhisattva Avalokiteshvara, and the perception that all Dalai Lamas are also incarnations of this deity is often traced to this moment: "I took the form of Avalokiteshvara, transforming myself into all his [other] manifestations. In this fashion, I received the five initiations into knowledge. As the master [of the mandala], and in concentrating on the union of *yabyum*, I experience a great joy as well as receiving initiation into wisdom-knowledge."[2]

Around 1645, the Fifth Dalai Lama began the construction of the Potala Palace [12.5] in Lhasa on the site of a structure built by Songsten Gampo (r. ca. 627–649), the eighth-century king credited with bringing Buddhism to Tibet, who is also thought to be a manifestation of Avalokiteshvara. As the name implies, the center represents Avalokiteshvara's pure land. The Potala Palace, which measures about 1,180 feet long, is nestled against the side of the Red Mountain and constructed in a traditional Tibetan method that uses massive stone walls with small windows and flat wooden roofs. In addition

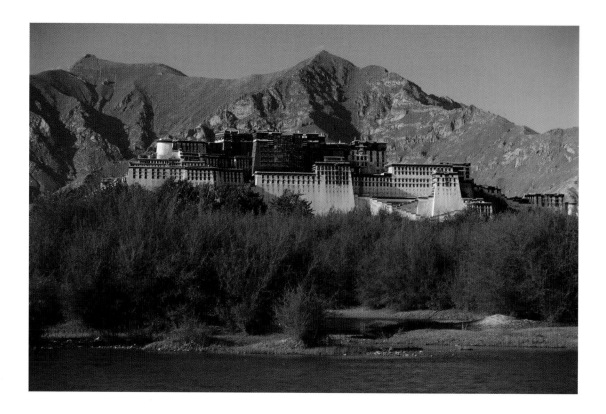

FIGURE 12.5
The Potala Palace.

Lhasa, Tibet, first constructed 1645. The primary residence of the Dalai Lama, the Potala Palace is also understood as a reference to the pure land of Bodhisattva Avalokiteshvara. The Dalai Lamas are manifestations of this deity.

FIGURE 12.6
OPPOSITE
Kalachakra Mandala.

Central regions, Tibet, seventeenth century. Composed in India around the tenth century, the text that served as the basis for this painting has an apocalyptic message in which the cosmos is destroyed due to the lack of dharma and then rescued by warriors from the mythical realm of Shambhala.

to serving as the religious and administrative center for Tibet until 1951, the palace has several chambers decorated with murals and remains an important repository for paintings, sculptures, ritual implements, texts, and secular luxuries such as textiles and ceramics imported from China.

A figure seated on a throne wearing a blue cloak and bone jewelry to one side of an offering table in the lower border of a painting most likely represents the Great Fifth [12.7, no. 19] and helps link the production of a painting of the Kalachakra Mandala [12.6] to him. Donors identified as Mongolian by their clothing are seated to the right of the offering table, while the smaller figure wearing red to the right of the Great Fifth Dalai Lama is most likely Desi Sanggye Gyatso (1653–1705), an important monk-scholar who also served as the Great Fifth's regent. The mandala follows the palace-architecture tradition but has three inner palaces rather than one. These structures represent mind [12.7, no. 22], speech [12.7, no. 23], and body [12.7, no. 24] and fill the center of the complicated painting. The Kalachakra deity and his consort stand in an eight-petaled lotus in the center of the inner palace and are attended by eight female personifications of their powers [12.7, no. 6]. Twelve animals, each

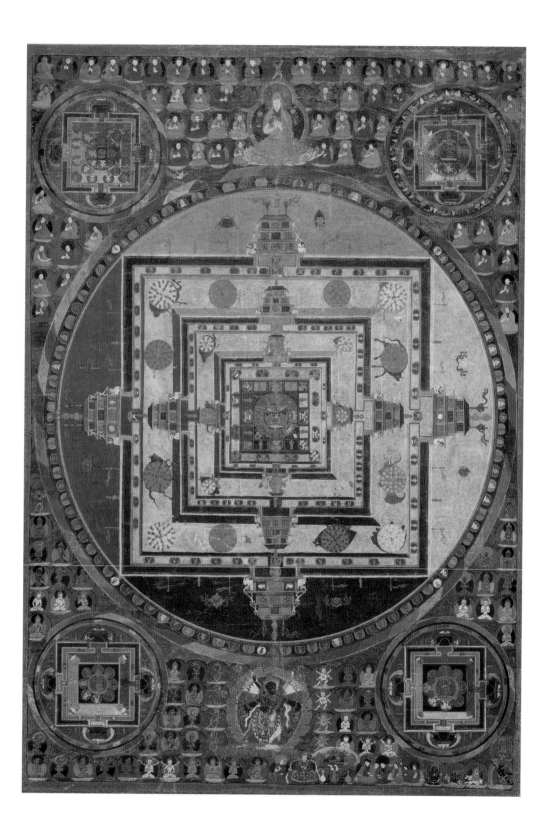

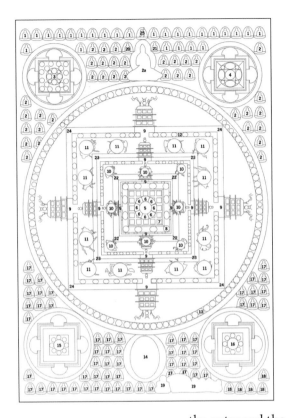

FIGURE 12.7

A line drawing of the same mandala [12.6] identifying various figures within the composition.

carrying a wheel filled with small deities, symbolize the 360 days in a traditional Tibetan year and are shown in the courtyard between the second and third palaces. Smaller mandalas dedicated to additional deities of the Kalachakra cycle are painted in the four corners. The Kalachakra couple [12.7, no. 25] is also placed at the top of the painting in the border containing several of the religious kings who ruled a mythic land known as Shambhala [12.7, no. 1], which plays an important role in the Kalachakra tradition. Tsongkapa [12.7, no. 2a] in the center of the upper border is the most prominent and largest of the numerous of the masters [12.7, no. 2] who transmitted the teaching.

Mandalas of this type are based on the *Kalachakra-tantra* composed in India around the tenth century, and preserved in several recensions in Tibet. The *Kalachakra-tantra* contains outer teachings regarding mundane realities, inner teachings pertaining to spiritual practices, and secret teachings that lead to the union of the outer and the inner doctrines. It also has a complicated cosmology, and an apocalyptic prophecy that the world will be destroyed due to the lack of dharma (Buddhism) and then restored when Rudracharkin, the last of the kings of Shambhala, saves the cosmos and thereby establishes a golden age of practice. The original text was given to Sucandra, the first of the religious kings of Shambhala (the prototype for the Western Shangri-la), by Buddha Shakyamuni after Sucandra asked for a teaching that would allow him to retain his worldly pleasures and responsibilities. Sucandra's practice caused Shambhala to become a perfect world or paradise, and this hidden realm has been ruled by seven religious kings and twenty-five later rulers, often known as the Kulika kings. The Dalai Lamas are also understood as incarnations of the second Kulika king, Pundarika, who is thought to have written a commentary on the Kalachakra titled *Stainless Light* (*Vimalaprabha*). The green and blue mountains in the background of a painting convey the otherworldly nature of the realm inhabited by the kings of Shambhala [12.8]. An unidentified king, one of a set of paintings depicting several such figures, holds a bow and arrow, wears lush clothing, and is seated on a throne

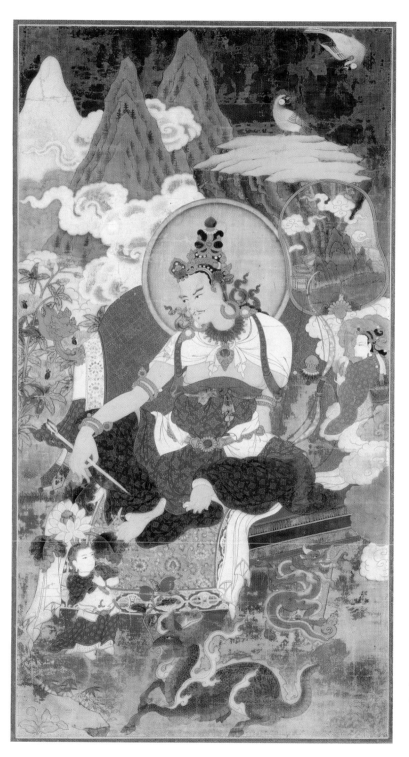

FIGURE 12.8
King of Shambhala.

Eastern regions, Tibet, eighteenth century. The Tibetan Shambhala is the origin of Shangri-la in Western literature.

covered with an elegant cloth or carpet. Both he and his two attendants wear crowns and jewels. The perfect realm they inhabit is filled with flowers, birds, and animals, both real and mythical, including the dragon coiling around one of the legs of the throne and the composite creature in the foreground.

Tsongkapa is also depicted at the top of a painting of enlightened protector Yama Dharmaraja ("death king of the law of cause and effect") [12.9]. He wrote a poem recording his vision of one of the forms of this deity, one of several fierce guardians invoked by Geluk practitioners:

> The slightest stamp of your extended and drawn-back feet
> destroys the world with its four elements.
> Your intensely fierce buffalo face blazes
> Extremely and your great roar fills the three realms
> ·
> Great masses of fierce flames embraced by
> Blackening smoke like lighting flashing in a
> Thunderhead.
> · · · · · · · · · · · · · ·
> Your hair flaming up earthly yellow
> adorned with five skull diadem, crown adorned
> with fierce vajra,
> Your neck hung with blood-smeared fresh-
> Severed head garlands, your three eyes flash
> And bulge and dart about.[3]

The buffalo-headed Yama, who is the ancient Indian ruler of death, was converted to Buddhism by Bodhisattva Manjushri, and the importance of this deity in Geluk practices—the Great Fifth saw him in a vision in 1654—derives in part from the belief that Tsongkapa was an incarnation of Manjushri. The black-bodied Yama embraces his consort, Chamundi, and stands on the back of a bull, which in turn tramples a human figure. Yama wears a garland of severed human skulls; Chamundi sports the skin of a flayed antelope. Both deities have two arms and three eyes, and thick, lush flames surround them. Twelve of Yama's minions, each holding a different implement and wearing the skin of a wild animal, can be seen in the upper half of the painting. Two protective figures are shown riding donkeys at the bottom, while two others drag small, naked beings—a possible reference to Yama's role as one who judges

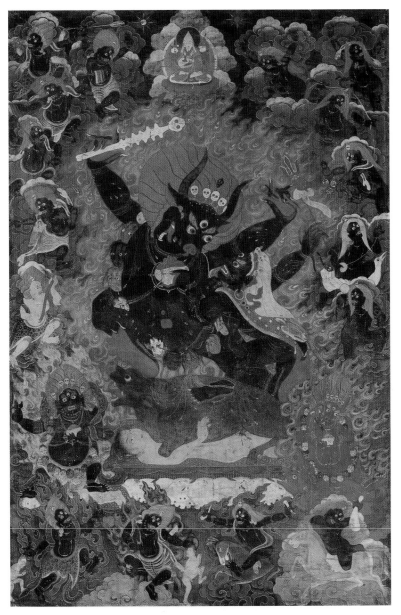

FIGURE 12.9
Yama Dharmaraja.

Central regions, Tibet, mid-seventeenth century. Flames often surround representations of fierce, active deities such as Yama, who in this manifestation protects practitioners from droughts, bandits, and other misfortunes.

souls at the gateway to hell. The black-bodied, buffalo-headed form of Yama shown in this painting is an outer manifestation of the protector that confronts worldly obstacles and guards against drought, bandits, and other troubles. The small figure with a demonic face standing to the right of the central couple represents an inner manifestation of Yama that destroys spiritual obstacles such as fear, hate, and pride. The red, buffalo-headed Yama to the

FIGURE 12.10
Protector Mahakala.

Central regions, Tibet, eighteenth century. The skull in the left hand and the chopper in the right are the most standard of the many implements held by Mahakala.

left is a secret manifestation that works with an individual's deeper and more spiritual aspects and can also ensure longevity. There is also an ultimate manifestation of Yama (not shown) that represents the benefits of encountering death.

A portrait of Padmasambhava [compare 12.1] in the upper border of a painting of the enlightened protector Mahakala [12.10] links this work to Nyingma and Geluk traditions, but the figure to Padmasambhava's left wears a hat typical of the Kagyu order. Mahakala wears a black cloak and is shown carrying a vajra-chopper and a white skull bowl in his arms. Eight additional figures, including Vaishravana, the guardian of the northern quadrant (second from the top left), surround him. A gruesome offering of a huge, red heart and five sense offerings are placed in the foreground of the painting, which is executed with calligraphic gold lines on a black background. This type of painting is sometimes known as a "black thanka" and was popular from the seventeenth to the nineteenth century; however, its origins are obscure.

Early manuscripts in which blue and black backgrounds were used for the written word are preserved in Japan from the eighth century [5.14] and later in Nepal, and they may have provided sources for the development of paintings with black backgrounds.

Some of the earliest-known Tibetan examples are preserved in an illustrated manuscript of the *Sealed and Sacred Biography* written by the Fifth Dalai Lama; the popularity of this style may also be another reflection of the prominence of the Geluk order. There is, however, another theory that suggests that the so-called black thankas derive from the practice of using the ashes of an important teacher to color a piece of cloth before using it as a canvas. Such a practice would have rendered the painting a relic of the teacher and imbued it with his mastery and understanding.

The composition of the painting of Mahakala, in which a larger central figure is surrounded by smaller images, was widely used from the seventeenth to the nineteenth century. In a nineteenth-century work representing a minor deity known as Sinpoi Tsomo Jigje Mar ("red zombie-riding protectress") [12.11], the central icon

has become larger in proportion to the other images in the painting, and details such as the flames are more loosely rendered and less realistic. The protectress rides on the back of a nine-headed zombie and wears a flayed human skin and jewelry made of bones. She has long hair, three eyes, and four astounding fangs; wears a diadem with a skull and the head of a wolf in her hair; and holds a ritual staff and a sword. A skull filled with severed organs and two other bones tied together are placed in the foreground on the bank of a flowing blue stream. The protectress is one of a group of secondary guardians, often derived from spirits associated with a natural formation such as a mountain or lake, who can help practitioners with narrow, generally mundane, problems. They are somewhat unreliable and are therefore dangerous as well as beneficent. This painting is part of a larger set that centers on a form of Mahakala and features protectors of four important medical texts. Gesi Sanggye Gyatso, also shown in the Kalachakra Mandala discussed earlier [12.6, 12.7], is portrayed at the top of the painting. This monk-theologian, who served as the regent for the Fifth Dalai Lama, also supervised the scholars who produced the *Blue Beryl,* a commentary on the medical texts that were an important component of monastic training in Tibet.

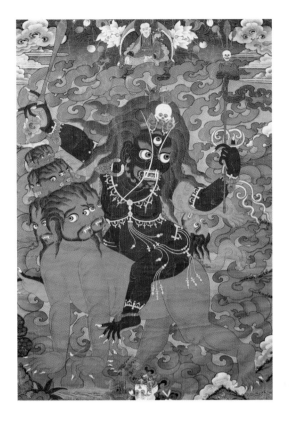

FIGURE 12.11
Sinpoi Tsomo Jigje Mar, or the "red zombie-riding protectress."
Tibet, mid-nineteenth century. This ogrelike divinity is associated with healing, particularly with the importance of spiritual wisdom, symbolized by the sword and staff, to the medicinal arts.

CHAPTER 13

Sri Lanka, Myanmar, and Thailand
Fifteenth to Nineteenth Century

AFTER THE twelfth century, rulers in Sri Lanka, Myanmar, and Thailand supported a conservative and somewhat rigorous practice known as Theravada (or Hinayana). This tradition traces its development to texts preserved in Sri Lanka as early as the second century B.C.E. and to *The Path of Purity*, written by the Indian monk Buddhagosa in Sri Lanka in the fifth or sixth century. Theravada emphasizes the preeminence of the monk over the layman, the importance of purity defined as closeness to the life and teachings of Buddha Shakyamuni, and the maintenance of unbroken and proper ordination lineages that can ultimately be traced to disciples of the historical Buddha. Monks either worked and practiced in large monasteries or chose a more solitary path, living in forests or other isolated environments. Clergy benefited from substantive royal patronage, and Buddhism in this part of Asia was characterized by the perception that royalty was sacred and that rulers should embody the qualities of a buddha—or at least, like the famed King Ashoka of India, rule according to Buddhist virtues and support the clergy and their activities. As a result, rulers and other laity often spent some time living as monks and taking partial vows toward ordination.

Due to a pivotal position in the maritime trade between east and west, the Sri Lankan coasts, controlled by Muslim traders after the twelfth century, were also captured by the Portuguese in the sixteenth century and the Dutch in the seventeenth. Some of the earliest records regarding the practice of Buddhism are found in Western sources from this period. "The religion of the country is idolatry . . . There are many both Gods and Devils, which they worship, known by particular names, which they call them by . . . There is another great God, whom they call Buddou, unto whom the salvation of all souls belongs . . . The Places where he is commemorated are two, not temples but the one is a mountain, and the other a tree."[1]

FACING PAGE
Phra Sankachai.
See page 274.

The Theravada tradition preserved in Sri Lanka and Myanmar was first seriously studied in the West during the period of the British rule in India (1858–1947), when regions in both nations also fell under English control. Scholarly and casual descriptions of practice and art played a seminal role in nineteenth-century Western discovery and understanding of Buddhism.

Not surprisingly, the expanded pantheon of deities preserved in Tibetan traditions and, to a lesser extent, in East Asia is not found in Sri Lanka or mainland Southeast Asia. Images of Buddha Shakyamuni, which dominate the art of Sri Lanka, Myanmar, and Thailand, follow well-established traditions, at times displaying interesting redefinitions of earlier styles. It seems likely that the conservative nature of Buddhist sculpture in Sri Lanka and Southeast Asia derives from a desire to maintain ties to the historical Buddha, because sculptures and other representations were thought to contain his physical manifestation and spiritual charisma.

SRI LANKA

THE FLAT face and physique of a seated Sri Lankan buddha [13.1] reflect the style found at the twelfth-century Gal Vihara [6.15], as do the broad, powerful shoulders. The disproportionately long hands

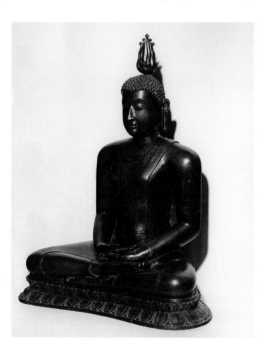

FIGURE 13.1
Buddha Shakyamuni.
Kandy, Sri Lanka, ca. fourteenth century. Elements such as the proportions of this seated buddha and his flaming *usnisha* are shared by Sri Lankan sculptures and those produced in Myanmar (Burma) and Thailand.

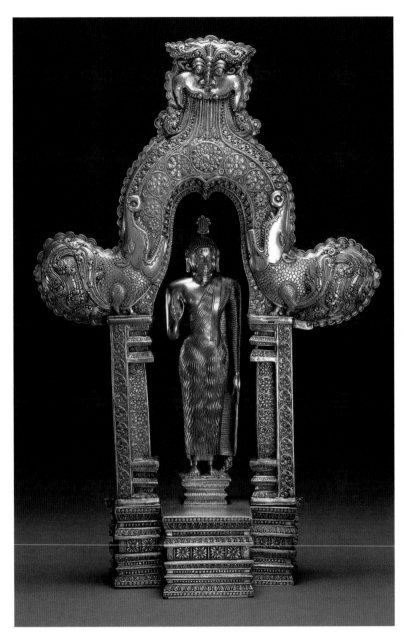

FIGURE 13.2
Buddha Shakyamuni.

Sri Lanka, eighteenth century.
Elaborate arches such as that
surrounding this sculpture of
Buddha Shakyamuni are found
in later Indian works as well
as in Sri Lanka.

and feet typify sculptures produced in the fourteenth and fifteenth
centuries. The buddha, who has downcast eyes, wears an under-
garment covered by a surplice, which falls over his left shoulder. The
flame-shaped *ushnisha* was popular in southern India from the ninth
to the twelfth century [**6.10, 6.11**] and was preserved in Sri Lanka
and mainland Southeast Asia for centuries. A silver sculpture of a

buddha dating to the eighteenth century [13.2] shares the elaborate *ushnisha* and wide shoulders of the fourteenth-century example. In both, a thin piece of cloth, probably the edge of a shawl, falls over the left shoulder. The stylized rendering of the folds of the garments of the eighteenth-century sculpture, however, can be traced to traditions found in Sri Lanka during the eighth and ninth centuries [6.12]; this continued the artistic styles found in the Amaravati region of India in the third and fourth centuries [1.16]. Buddha Shakyamuni stands on a tiered pedestal in a fabulous gilt silver archway, a device often found in later Indian and Sri Lankan art. The plinth and jambs are covered with floral scrolls, and the top of the equally lush arch has a leonine head known in Sanskrit as a *kirtti-mukha*. This motif and the *makaras* at the ends of the archway are ubiquitous Indic symbols for protection and good luck.

MYANMAR

EXCHANGES OF monks and texts between Sri Lanka and Myanmar began in the twelfth century when the latter helped the former overthrow the Indian Cholas. Ties intensified after the fifteenth century when King Kammazedi (r. 1472–1492) sent monks to Sri Lanka to find a more authentic ordination ceremony and practice, reflecting Sri Lanka's long-standing role as the source for authoritative texts and practices, as well as for traditional and presumably accurate imagery. The broad shoulders and long hands and feet of a seated buddha dating to the fourteenth or fifteenth century [13.3] are comparable to Sri Lankan sculptures of the same period, as is the representation of the thin edge of the shawl over the left shoulder. The slim waist, the long fingers and toes each of equal length, the casting of the lotus pedestal in two parts, and the dense geometric decoration also exhibit parallels to Sri Lankan imagery. The pointed chin, short neck, and slight downward tilt of the head, however, are Burmese characteristics.

Buddha Shakyamuni sits in a lotus posture and holds his right hand in the earth-touching gesture that was popular in Myanmar [8.3] and eastern India in the eleventh and twelfth centuries [6.5, 6.6]. Two lions and an image of the earth goddess wringing her hair to wash away Mara's hordes appear on the base. Two monks are also attached to the lotus pedestal; each of them holds a piece of cloth between folded hands, illustrating the widespread tradition of offering cloth to images of buddhas. They most likely portray

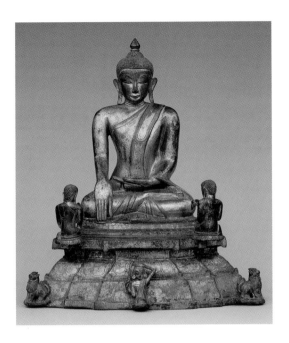

FIGURE 13.3
*Buddha Shakyamuni
with attendants.*

Myanmar (Burma), fourteenth
to fifteenth century. Small
monks kneeling on either side
of the altarpiece represent
two of the historical Buddha's
more important disciples.

Maudgalyana and Shariputra, two of Buddha Shakyamuni's most
important disciples, who symbolized the importance of using skillful
means and knowledge, respectively, in the search for enlightenment.
Skillful means allude to practices such as teaching or using parables
to help others in their quest for understanding. Disciples such as
Maudgalyana and Shariputra are more important in Theravada than
in other branches of Buddhism and are often represented in later
Myanmarese and Thai art.

Burmese manuscripts made both of palm leaves, a traditional
material found earlier in India [6.8], and of paper folded into
concertina-like books are preserved from the eighteenth and nine-
teenth centuries. While such books include texts on cosmology as
well as more secular themes such as courtly rituals, the majority
record, and often illustrate, the lifetimes of Shakyamuni. The monk
Ditiya Medi Hsayadaw translated one version of the sacred biog-
raphy into Burmese in 1798, and it is possible that the prevalence of
manuscripts recording and illustrating the hagiography after that
time stems from its accessibility to laymen and to those monks
(likely the majority) who were not fluent in the canonical Pali.

Crowded compositions, overlapping scenes, secular details, and
a bright palette characterize two pages from an illustrated biography
of the Buddha dating to the nineteenth century [13.4]. The figures in
the foreground illustrate Siddhartha's discovery of the unpleasant

realities of life and his subsequent departure from his home in search of greater understanding: Siddhartha, accompanied by attendants, leaves the palace in a gilded carriage; he points to the figures of a monk, an old man, an invalid, and a corpse that he sees during his rare excursion outside the palace gates. To the right, he is shown wearing royal clothing and adornments and seated in a courtyard with several of his attendants and a princess who announces the birth of his son. Struck by the realization that even such a wonderful event is a fleeting illusion laden with attachment and delusion, he resolves to seek the calm of enlightenment, and at the far left, he presents a pearl necklace to a maiden. The courtly setting dramatically illustrates the pleasurable and worldly exis-tence that he is about to renounce, which is also symbolized by the necklace. In the next scene, set in another chamber of the palace, the elegantly dressed Siddhartha lifts a curtain and bids a silent farewell to his sleeping wife and a group of palace musicians: "Forsake not these resplendent sleeping ladies, with eyes beautiful as the petals of a full-blown lotus; these decorated with magnificent necklaces and jewels and precious stones; these [beings] brilliant as the lightning detached from the clouds of the sky."[2] His faithful

horse is already saddled and standing near the gates to the palace complex, and in the scene at the upper right, Siddhartha and his groom and friend, Chandaka (shown holding the horse's tail), leave the palace attended by several figures, most likely minor divinities, holding lights. The flowers in the background represent the fabulous blossoms that, according to several texts, filled the skies and fell to earth in celebration of Siddhartha's decision to become a buddha. Mara, standing at the far right with one hand lifted and the other holding a sword, is present to foreshadow his attempt to stop Siddhartha/Shakyamuni from attaining enlightenment.

THAILAND

REPRESENTATIONS OF the historical Buddha and records of his lifetimes also predominate in the art of Thailand, the only major Theravada center that was never controlled by Western powers. As mentioned earlier, Buddhism reemerged as the state religion in different parts of Thailand after the dissolution of the powerful and largely Hindu Khmer Empire, which ruled mainland Southeast Asia from the early ninth to the mid-fifteenth century. Different styles of sculptures are associated with various principalities that arose in Thailand after the eleventh century, such as that of Lan Na (late eleventh to early twentieth century), which centered around the cities of Chiang Mai and Chieng Sien in the north and Sukothai (ca. 1240–1348) farther south.

Both of these principalities relied on Sri Lankan traditions as the basis for ordination and practice, as did the later kingdom of Ayudhya (1352–1767), which replaced Sukothai in the mid-fifteenth century. Lan Na, which remains relatively unstudied, fell briefly under Burmese rule in the mid-sixteenth century and was also periodically conquered by Ayudhya, with whom it had an uneasy relationship. The establishment of the current Thai capital of Bangkok is a result of the 1767 Burmese destruction of Ayudhya. Ayudhya, which maintained diplomatic and economic ties with nations to the east and west, was the major political and cultural center of mainland Southeast Asia. It is also Siam in Western historical writings.

The softness of the face and body of a seated image of Buddha Shakyamuni [13.5] are typical of sculptures produced in Lan Na in the fifteenth and sixteenth centuries. The Buddha is seated in a meditative posture and holds his hand in the ubiquitous earth-touching gesture. He wears an extraordinary parure, which is comparable to the adornments worn by rulers in mainland Southeast Asia for state

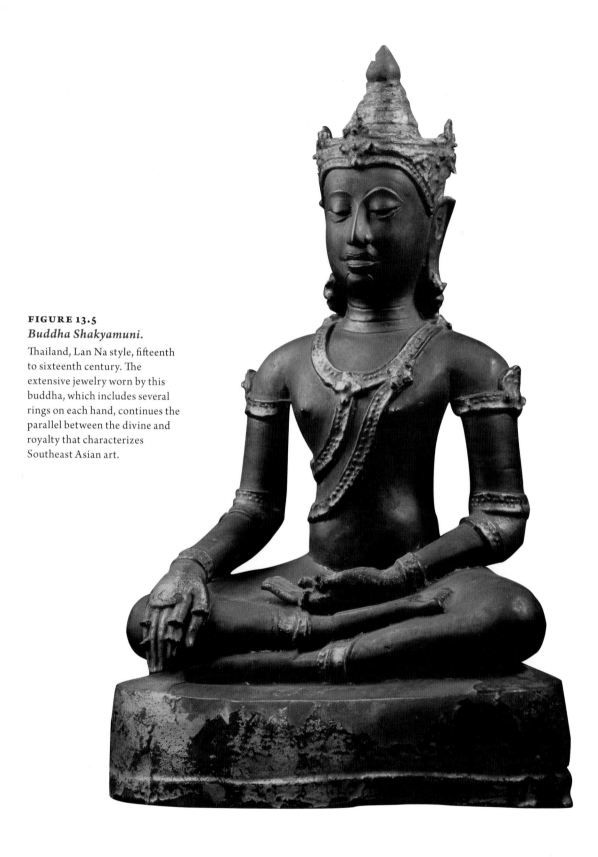

FIGURE 13.5
Buddha Shakyamuni.
Thailand, Lan Na style, fifteenth
to sixteenth century. The
extensive jewelry worn by this
buddha, which includes several
rings on each hand, continues the
parallel between the divine and
royalty that characterizes
Southeast Asian art.

and other festivities, and includes a crown, earrings, a breast orna-
ment, six armlets, two bracelets, several rings, and thick anklets.
Thai buddhas with crowns and jewelry, which were also popular in
the eighteenth and nineteenth centuries, provide another example
of the concept of sacred kingship, a link between a ruler and a deity
that pervades Southeast Asian history. The production of such
images is sometimes linked to a passage in the *Jambudvipa-sutra*, a
later recension of the biography of Shakyamuni. According to this
source, the Buddha appeared as a crowned and bejeweled king in the
center of a magically created city to help his patron, King Bimbasara,
defeat the challenge posed by another ruler who had magical powers.
The magnificence of the Buddha's appearance caused the magician-
king to become a monk and seek enlightenment.

Unlike crowned and bejeweled buddhas, sculptures showing a
buddha walking have few parallels elsewhere in Asia. A nearly life-
size gilt bronze example [13.6] has the soft, oval face; elegant body
lines; long nose; and sweeping eyebrow curves that characterize
sculptures produced in the Sukothai kingdom in the fourteenth and
fifteenth centuries. Buddha Shakyamuni stands with his left foot
forward and his right slightly lifted as if in movement, and he holds
his left hand in the gesture of reassurance. Although the biographies
of Shakyamuni indicate that he walked tirelessly, images of buddhas
are usually shown either standing or seated in meditation, postures
that illustrate the timelessness of the Buddha's enlightenment rather
than his earthly existence. The importance of walking buddhas in
Thai sculpture reiterates the humanity that both underlies his final
reincarnation and serves as a paradigm for the lives of clergy and
laity who also walk and sit during their daily activities: "When a
monk is walking, he knows 'I am walking,' and when he is standing,
knows 'I am standing,' . . . Whatever posture his body may take,
he now that he is taking it . . . Thus, O monks, a monk practices
mindfully contemplating the body."[3]

A sculpture of a buddha walking (facing south) was one of four
images displayed in separate buildings in the western (inner) pre-
cinct of the Wat Phra Si Sanphet temple built in the capital city of
Ayudhya around 1472. A seated buddha (facing west), a standing
buddha (facing north), and a reclining icon (facing east) were
housed in the other three buildings [13.7]. The different postures
of the four sculptures may illustrate the four attitudes or modes of
deportment that are common to all monastic traditions and are
discussed in various texts.

FIGURE 13.6
Buddha Shakyamuni.
Thailand, Sukothai period,
fourteenth to fifteenth century.
While not unique to Thailand,
the depiction of a buddha
walking is more common
there than elsewhere in Asia.

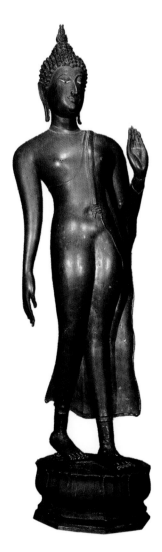

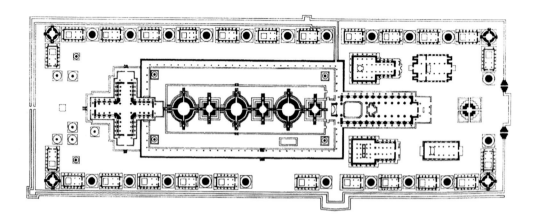

FIGURE 13.7
*A plan of Wat
Phra Si Sanphet.*
Ayudhya, Thailand, founded
fifteenth century.

FIGURE 13.8
OPPOSITE
*A view showing three
stupas (chedi) at
Wat Phra Si Sanphet.*
Ayudhya, Thailand, founded
fifteenth century. The three
stupas in the center of the
compound mark the remains
of members of the royal family
who supported the construction
of the monastery.

Wat Phra Si Sanphet, which never housed a community of monks, was founded by King Borommaracha (r. 1370–1388) of Ayudhya to serve as an ordination center for members of the royal family and was originally attached to a palace. The rectangular complex, surrounded by a cloister of smaller buildings, includes an ordination hall (*ubosot*) to the east and numerous stupas (*chedi*), image halls, and other structures. The three large stupas in the center of the compound [13.8] mark the remains of the king and his two sons. As is typical of temples in Thailand, which range from enormous university-like complexes to humble village structures, the buildings at Wat Phra Si Sanphet were constructed largely of brick. Many of the original materials were transferred to Bangkok in the late eighteenth century after the Burmese destruction of Ayudhya and were used to build temples there.

In addition to sculptures of the historical Buddha, "portraits" of his disciples are important in Thailand and other Southeast Asian centers. One of the most popular is a portly figure, generally identified as Phra Sankachai, who is a manifestation (of some sort) of Gavampati, one of the Buddha's twenty-four historical disciples listed in *The Path of Purity*. As can be seen in the squat neck and ungainly proportions of a seventeenth-century sculpture [13.9], Phra Sankachai used his magical powers, derived from his advanced spiritual state, to change his handsome form to that of a dwarf and a hunchback. The snail-shell curls of his hair are one of the traditional marks of a buddha. Here, the curls allude to the monk's spiritual advancement and to the belief that Buddha Shakyamuni granted his final transcendence (nirvana) after Phra Sankachai showed his deep understanding by rejecting the illusion of physical beauty.

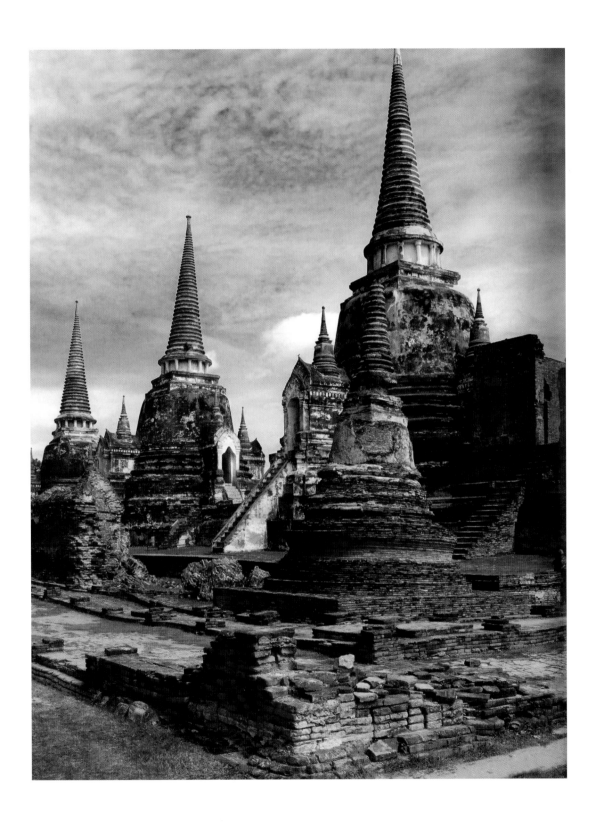

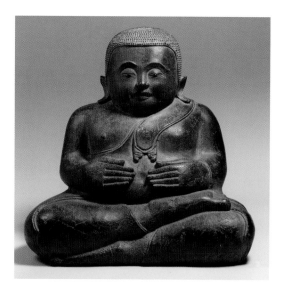

Images of Phra Sankachai, which are also found in Burma and Laos, are placed near those of Buddha Shakyamuni on altars in monasteries or in separate chapels dedicated to him, showing the importance of this figure in Thai practice. Representations of the divine monk, who is thought to help with mundane challenges such as sickness as well as offering spiritual salvation, are also found in small roadside stands and distributed as amulets. Today, Phra Sankachai is sometimes conflated with Buddha Maitreya as Budai [14.3], a Chinese monk noted for his large potbelly, possibly because numerous individuals of Chinese descent have immigrated to Thailand over the centuries.

Devotion to Phra Malai is also founded on *The Path of Purity.* Tales of Phrai Malai, who is based to some degree on a Sinhalese monk named Maleyya or Malayya (second century B.C.E.) and was noted for his preaching and skill in meditation, are among the most widely illustrated themes in Thai books and palm-leaf manuscripts. The oldest Phra Malai texts, which are characterized by their extensive use of Pali words and can be traced to the Lan Na kingdom, stress the importance of generosity or giving as a means of generating merit. This group of texts is read or recited during the Vessantara Jataka Festival, an evening-long celebration of Shakyamuni's penultimate life that includes offerings of large numbers of candles, incense, flowers, and foods.

In later texts, written primarily in Thai with few Pali words and often characterized by lively and amusing imagery, Phra Malai acquired magical abilities, including flight. He often visited other realms, such as the Heaven of the Thirty-Three Gods, where he met Buddha Maitreya, who taught him how to avoid hell and how to attain a better rebirth when Maitreya becomes the teaching Buddha of a new historical aeon. Later texts also focus on descriptions of the horrors of the various hells visited by Phra Malai and on the sainted monk's ability to help save beings from these tortures. They are often read, chanted, or performed during funerary rites to help the newly deceased escape from the heinous hell realms. In an illustrated page from a manuscript dated 1844 [13.10], the monk, identified by his red robe, flies above three different hells: one in which adulterers climb thorny trees while being attacked by animals and guardians;

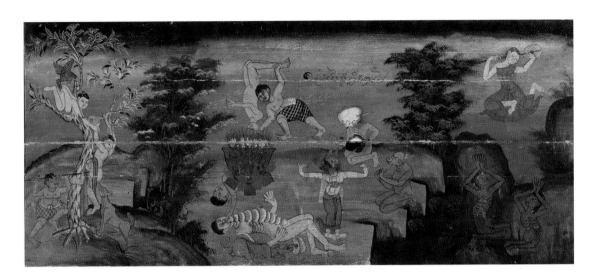

another where sinners are burned in fires fueled by corpses; and a third in which a dog devours a body. The two living skeletons in the painting lift their hands in the gesture of respect and ask the monk to take messages to their descendants, helping them avoid such ghastly fates:

> Then the demon-bodied *preta* [or hungry ghosts] and
> every one of the hell beings,
> Of various sorts, all raised their hands in reverence to
> Phra Malai [saying]
> "We're in deep trouble. We beg you Phra Malai,
> to go and tell our relatives."[4]

FIGURE 13.10
Phra Malai visiting hell.

Detail from a larger manuscript, Thailand, dated 1844. Intense practice helped Phra Malai acquire unusual abilities, including flying and saving beings from the Buddhist hells.

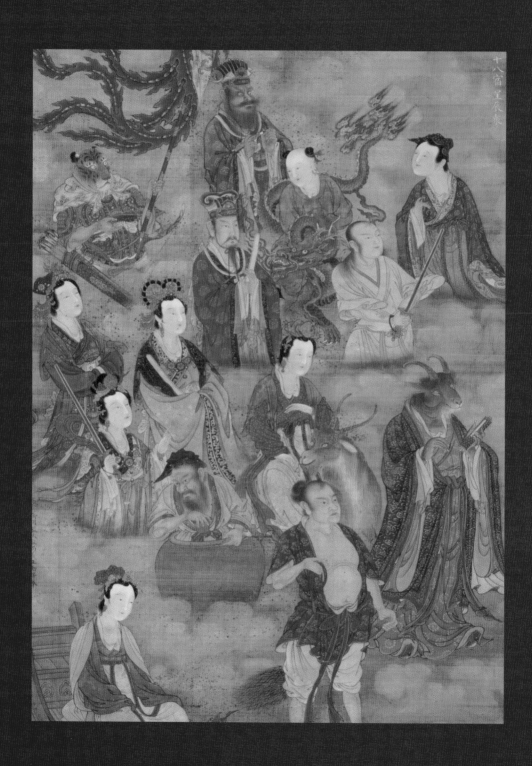

CHAPTER 14

Ming, Manchu, and Mongol in China
Fifteenth to Eighteenth Century

CHINESE IMAGERY that developed from the tenth to the fourteenth century, particularly themes created in Chan circles or those introduced from Tibet during the Mongol Yuan dynasty, is found in Buddhist art produced throughout the native Ming dynasty (1368–1644) and the subsequent Manchu Qing dynasty (1644–1911). Members of the imperial family, court officials, and laity from many walks of life practiced Buddhism, patronized monastic establishments, and commissioned art objects and elaborate rituals designed for the welfare of ancestors and other sentient beings. Ties between the court and Buddhist monks were reflected in the advisory role of certain Buddhist clerics and in rituals and other devotions performed in honor of the members of the imperial family and to protect the nation. Fostered to some degree by the wealth and stability of the second half of the Ming dynasty, wider literacy led to the printing of large numbers of books, including Buddhist texts and new genres such as morality tales, which helped spread practices as well as images and ideas to a wider audience. Lay Buddhist movements often emphasized the philosophical closeness rather than the differences between Buddhism, Daoism, and Confucianism. Imagery associated with all three religious traditions, as well as that derived from popular culture, was broadly shared by artists working for the court, those in other professional environments, members of the literati, and monks and others who painted as an act of spiritual or personal development.

Public monasteries, particularly those with official support, were classified into three broad categories during the Ming and Qing periods: centers belonging to the Chan tradition, those that were discipline-based (*lu*), and those that housed ritual specialists (*jiao*). However, such categories were not rigidly observed; some form of

FACING PAGE
Detail from gods of the twenty-eight lunar mansions.

See page 279.

meditation and study was found in large urban complexes and in the numerous smaller monasteries in the countryside. Moreover, despite their official affiliations, the majority of the clergy served the ritual needs of the laity, officiating at important events, particularly funerals, and any number of related rituals designed to ensure a final rebirth in Sukhavati or some other nonsamsaric realm.

The projecting eaves of the roofs, covered walkways, and post-and-lintel construction of Zhihua-si Monastery in Beijing [14.1], which was classified as a Chan establishment, are typical of the wooden architectural traditions that predominated in China, Korea, and Japan; one common characteristic is the south-north orientation of the complex that includes several gateways, towers for a bell and a drum, and multiple halls. The Buddha Hall that once housed sculptures of buddhas and other divinities is found in the third court-yard. Residence halls for monks, a kitchen, and other functional rooms that were once located in the northernmost parts of the mon-astery have been destroyed or converted to other uses, including exhibition spaces for some of the temple's holdings.

FIGURE 14.1
The Buddha Hall
in Zhihua Monastery.

Beijing, Hebei Province, China, Ming dynasty, fifteenth century. Zhihua Monastery was an important musical center that supported a troupe noted for its combination of liturgical, royal, and folk music traditions.

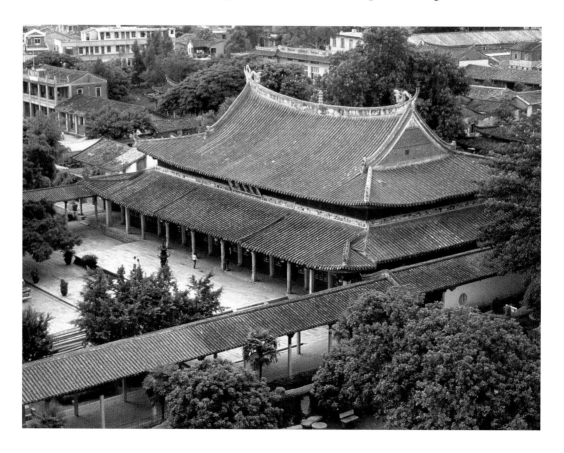

According to an inscription carved on a stele in the temple, Wang Zhen, a powerful eunuch at the Ming court, established Zhihua Monastery around 1440, possibly by converting an existing structure. Wang Zhen served as tutor to Zhu Qizhen (1427–1468), the heir apparent to the Ming throne, who ruled first as the Zhengtong emperor (1436–1449) and again as the Tianshun emperor (1457–1464) after a brief interruption due to a disastrous campaign against the Mongols. Wang Zhen's ties to the emperor and his ability to found and support a Buddhist establishment attest to the growing influence of eunuchs in the mid-fifteenth century. In addition to the clergy who lived and worked at the monastery, Wang Zhen also supported a troupe of musicians, who became famous for the development of a style of music that combined Song-period liturgical music, Ming palace music, and folk songs.

An inscription in gold at the top right dates a painting showing fourteen of the twenty-eight star deities [14.2] to the second day in the eighth month of 1454. The one at the lower right states that it was produced by imperial order under the direction of the director of the directorate of imperial accoutrements, Shang Yi, Wang Qin, and others. The painting is part of a large set commissioned for use in the Water-Land ritual held to benefit all sentient beings that had died either on land or on water. The ritual, which dates to the late Tang period, remained one of the more spectacular funerary rites in Chinese culture until the early twentieth century. It consists of weeklong celebrations; includes numerous officiants and participants and, at times, a substantial audience; and involves complicated cycles of purification and confession, recitations, offerings, and vegetarian feasting. While larger temples had halls dedicated to this ceremony, others converted existing spaces by hanging paintings of the deities invoked during the ritual in a public hall, which was otherwise used for a variety of purposes. On the second day of the ritual, the paintings were hung in a specific arrangement that placed the more important deities, such as buddhas and bodhisattvas, in the primary location, called the "inner altar." Gods of the celestial

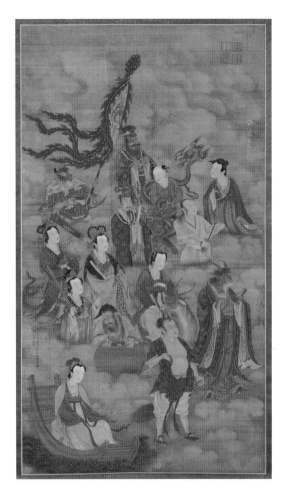

FIGURE 14.2
Gods of the twenty-eight lunar mansions.

China, Ming dynasty, Jingtai period, dated 1454. Stellar deities of various sorts—some Indian, some Central Asian, and some Chinese—were incorporated into the Buddhist pantheon as early as the eighth century.

bureaucracy, the ten kings of hell, bureaucrats, monks and nuns of past ages, and beings in the six realms of existence were placed in secondary stations known as the "outer altar." Tables holding incense burners, flower vases, and other implements were set before the various paintings. During the course of the ritual, all of the beings depicted were invoked and brought into the ritual space. The more advanced beings freed the others, particularly the ancestors and relatives of those who had commissioned the ceremony, from their karmic impediments; nourished them with ambrosial delicacies; and sent them to rebirth in Sukhavati.

Mentioned in early Chinese writings, the twenty-eight star deities represent the lunar mansions through which the moon passes as it circles the earth. By the Tang period, these figures had become linked with various Central Asian and Indian astrological phenomena and incorporated into Buddhist (and Daoist) practices designed to help ensure mundane benefits such as prosperity or health. The fourteen figures in this painting [14.2] are carefully outlined and shown floating against a background of swirling clouds. Gold and other expensive pigments depict the sumptuous clothing, much of which is derived from Chinese court costumes. Some of the divinities are male and some female, and they are differentiated by standing and seated postures and by features such as the goat's head of one of the figures or the dragon encircling another. These divinities are often difficult to identify specifically; however, the woman in the small boat in the foreground of the painting most likely corresponds to the lunar mansion *shi* (house), while the bearded man in a jar can be equated with *xu* (emptiness), corresponding to the Western zodiac sign Aquarius.

The seal at the lower right on a painting of the monk Budai [14.3] is that of Empress Xiaosu (1487–1504), the mother of the Hongzhi emperor (r. 1488–1505), and indicates that, like the work discussed earlier, the piece was also painted at court. The inscription at the upper right of the painting states that it was dedicated in the year 1504. The careful depiction of the corpulent Budai and his young attendants, the sharp outlines used to define the figures, the rich colors, and the overall composition of the painting show the continuation of Southern Song traditions often found in paintings produced at court during the Ming dynasty. Budai, who lived in the late ninth or early tenth century, is identified as a Chan master and noted for his cryptic utterances and strange behavior. Like many of his contemporaries, he wandered throughout southern China rather

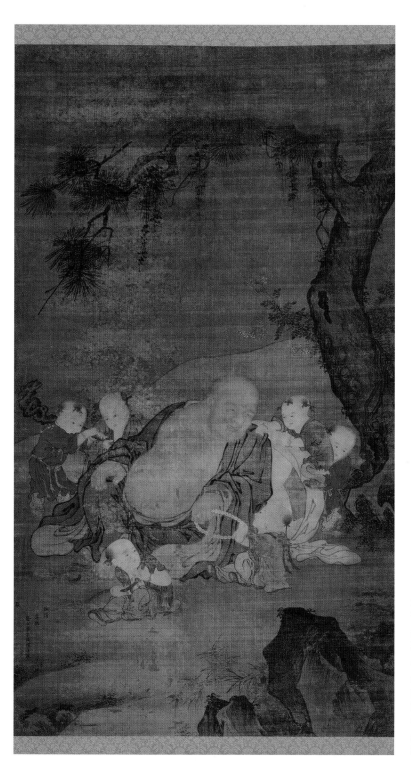

FIGURE 14.3
The monk Budai as Bodhisattva Maitreya (Mile).

China, Ming dynasty, dated 1504. Often thought to be a portrait of the Buddha, this pot-bellied figure is really that of a Chinese monk who was a manifestation of the future buddha, Maitreya.

than settling in one monastic center. The name Budai refers to the cloth bag he carried and to his rounded belly, one of his more notable physical features, which is also mentioned in his biography from the eleventh-century *Jingde Record of the Transmission of the Lamp*:

> He was so fat that he looked like a bag. His forehead was narrow [or possibly, he had a habit of wrinkling his brows] and his stomach big. His speech was very unexpected. He used to lie down and sleep wherever he happened to be. He always carried a bag in which he kept all his necessaries . . . he took up his seat, cross-legged, on a flat stone below the eastern veranda, and spoke the following verse: "Maitreya, the veritable Maitreya, divided his body into ten thousand million parts. From time to time [appearing among men] he proclaims [the Truth] to the men of that era, but they naturally do not recognize him." When he had finished reciting this verse, he quietly passed away . . . Now in the Yuelin temple, in the eastern part of the Great Hall, is preserved his body [embalmed], and people in many places speak of his re-apparition as a proven fact.[1]

In the painting, Budai rests against his white bag, holding a rosary and accompanied by six children. The latter refer to legends in which Budai pulls alms bowls, sandals, and other items from his bag in order to amuse the children, who were also drawn by his storytelling skills. In Buddhist circles, particularly Chan, Budai's bag is sometimes interpreted as symbolizing man's attachments to things, while the children are thought to represent the six stages of human knowledge. (Children were also a popular theme in Chinese painting and decorative art to symbolize material comforts such as the blessings inherent in male progeny.) The ubiquitous images of a full-bellied Laughing Buddha found in later East Asian representations of Budai are based on the understanding of Budai as a reincarnation of Maitreya that derives from the poem he wrote before dying, in which he revealed his true identity as this buddha. In Japan, where he is known as Hotei, Budai is also one of the seven gods of good luck, a group that also plays a role in popular culture.

The exaggerated treatment of the bark of the tree trunks and the detailing of the large flowers and foliage in a painting of Buddha Shakyamuni resting in a mountainous landscape [14.4] date the work to the first half of the seventeenth century and link it to painting styles associated with independent artists who were active in the Yangzhou area of Jiangsu Province. The repetition of a small

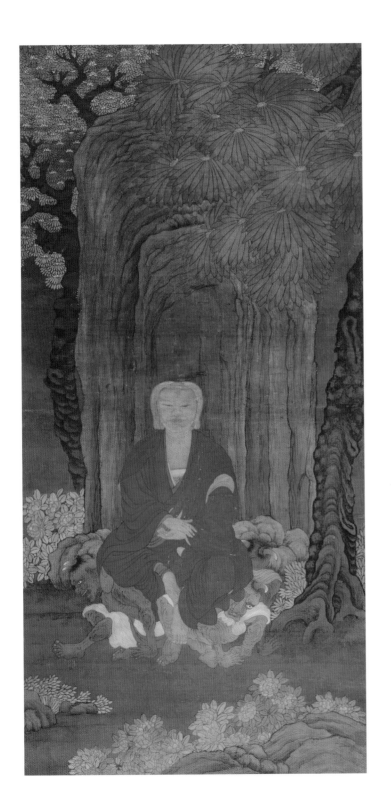

FIGURE 14.4
*Buddha Shakyamuni
(Shijiamouni) in
a landscape.*

China, Ming dynasty, first half
of seventeenth century. It is
unusual to find a painting
showing the historical Buddha
seated on the backs of squirming
demons. This painting reflects
the eclecticism found in Chinese
Buddhist art and practice in
the late sixteenth and early
seventeenth centuries.

number of brushstrokes to create a lush surface is typical of the works of such artists; however, the vibrant coloring of the painting suggests an awareness of religious styles found at court and in monasteries. Images of Buddha Shakyamuni in a remote setting with long, unkempt hair are often identified as representations of Shakyamuni practicing austerities in the mountains, an unusual biographical scene that appeared in the art of Pakistan in the third and fourth centuries [2.11] and in later Kashmiri imagery [7.3] but is not found again until the thirteenth century in China. The reappearance of this variant image of Buddha Shakyamuni is often attributed to the growth of the Chan sect, which led to a renewed emphasis on personal discipline. In the painting, Shakyamuni wears an unusual red garment and holds his hands in nontraditional gestures. He sits in a relaxed, and therefore unusual, position on the backs of snarling, horned demons, a motif that is typical of protective deities but not usually associated with buddhas and is linked to esoteric imagery rather than Chan. The painting exemplifies the blending of Chan, esoteric Buddhism, and other traditions that characterize Buddhist thought and imagery in China after the fifteenth century.

Also known as Bada Shanren, Zhu Da (1626–ca. 1705), who practiced as a monk of the Chan Caodong tradition, is recognized as one of the more important masters of seventeenth-century literati painting. He spent most of his life in or near Jiangxi Province; it is possible that he saw paintings by earlier Chan masters preserved in the region during his lifetime and was influenced to some degree by these works. For example, the mynah birds and rocks that are the subjects of two hanging scrolls [14.5] are also found in the works of Muqi and other Song artists, and they were probably standard in the art of Chan monks since the twelfth century. They illustrate the ephemeral nature of reality and typify the Chinese use of nature as a metaphor for the spiritual process.

Heroic in size, the paintings are part of a group of eight and were executed on satin, an unusual material that responds differently to the application of ink than do the silk and paper normally used in China. Ducks and sparrowlike birds are the subjects of the remaining paintings in the group. One of the birds is perched on a branch, while the other three rest on rocks that float in an unspecified space. The eccentric use of space (neither the trunk nor the rocks are shown completely), the ragged areas of white in the birds' bodies, and their idiosyncratic personalities are often found in Bada Shanren's oeuvre from the 1690s, as are the dramatic areas of wet, black ink used to highlight the surface of the rocks or the shape of the mynah birds.

FIGURE 14.5
Mynah Birds, Old Tree, and Rock.

China, Qing dynasty, seventeenth century. Artist: Bada Shanren (Zhu Da). Birds, flowers, and other natural phenomena are often found in paintings associated with Zen Buddhist practices in east Asia.

Zhu Da was a minor member of the ruling Zhu family of the Ming dynasty that was displaced in the mid-seventeenth century by the Manchu takeover of China and the founding of the Qing dynasty. It is possible that his ordination and lifestyle were intended to shelter him from the consequences of his ties to this family, which was under constant threat from the Manchus as they solidified their

FIGURE 14.6
Bodhisattva Maitreya.

Mongolia or China, seventeenth century. Artist: Attributed to Zanabazar. The artist-monk Zanabazar is also revered as the first Bogdo Gegen, the Mongolian equivalent of the Tibetan Dalai Lama.

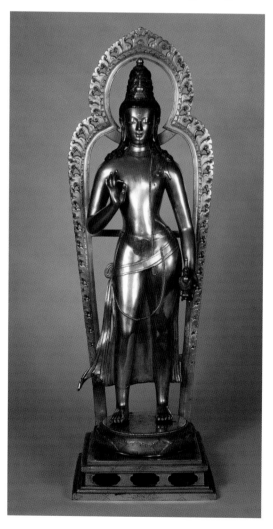

hold on China. Around 1670, he left the monastery where he served as abbot and lived a somewhat uncomfortable existence in Jiangxi Province, where he was noted for his eccentricity—including the loss of speech for some time—and where he eked out a living as a painter. Around 1684, Zhu Da took the name Bada Shanren, possibly as a result of the final consolidation of Manchu control of China in 1683. The sense of imminent danger that pervades the paintings of the mynah birds and rocks can be interpreted as a lament for both the political realities of the period and the precariousness of Bada Shanren's existence at the time.

Manchu was the name given in the sixteenth century to the Jurchen (or Ruzhen) peoples who lived in Manchuria and adjacent regions (present-day Liaoning and Heilongjiang Provinces) and had previously conquered parts of northern China as the Jin dynasty. In the early seventeenth century, the Manchus, who had been pushed north and east by the Mongols four centuries earlier, established a new state that included part of Mongolia and Korea, with a capital at Mukden (now Shenyang). They used a Chinese-style administration, and in 1636, took the dynastic name Qing, which means "bright" or "pure." In 1644, the Manchus, taking advantage of a rebellion in Ming China, captured Beijing, and by 1680, they controlled the entire country.

Nurhachi (1559–1622), the founder of the Manchu state, as well as his sons and descendants, were devoted followers of the Geluk branch of Tibetan Buddhism and maintained ties with Mongolian clerics who practiced the same tradition. The Mongolians gave a famous statue of the protective deity Mahakala, thought to have been cast under the direction of Phagpa to en-sure Kublai Khan's victory over the Chinese Song dynasty, to Huangtaiji (1592–1643), one of Nurhachi's sons. Huangtaiji installed this figure at Mukden, and his grandson, the Kangxi emperor (r. 1661–1722), later moved it to Beijing. Religious leaders from both Mongolia and Tibet were frequent and respected visitors to the Qing court in China, often traveling to Beijing or the summer capital at Chengde. For example, the

Fifth Dalai Lama (Ngawang Lobsang Gyatso) visited the Shunzhi emperor (1644–1690) in 1652; Zanabazar (1635–1723), the first Bogdo Gegen, who had close political ties to the Kangxi emperor (1662–1722), visited Beijing on numerous occasions and died there in 1723.

Zanabazar, whose birth was heralded with numerous miracles and apparitions, was recognized as a spiritually advanced entity early in his youth and sent to Tibet at age fourteen to meet both the Great Fifth and the Panchen Lama, the leaders of the Geluk order; he was responsible for the introduction of Geluk scholarship and practices to Mongolia. Zanabazar was also a noted sculptor, establishing a workshop for the production of images, reliquaries, and most likely ritual implements and other ceremonial accoutrements. A sculpture [14.6], which can be identified as an image of Bodhisattva Maitreya because of the stupa in the headdress and the water jar in his hands, has the youthful mien and sleek physique found in pieces produced by Zanabazar and his disciples. Maitreya has the long, matted locks of an ascetic and wears an antelope skin over his right shoulder. The style of the thin, lower garment worn by the bodhisattva ultimately derives from Nepalese traditions that were transmitted through Tibet; the large sash that falls diagonally from the right hip can be traced to the art of Gupta-period India [2.16].

Found in Tibet but not previously in China, the use of stone as a building material in temples constructed for the Manchu Qing emperors provides another example of the sharing of religious traditions between these two cultures. The Diamond Throne Pagoda, which consists of a square platform covered with stupas/pagodas [14.7], is the northernmost building in the large Biyun-si complex in the western part of Beijing. Buildings of this type show the importance of Indian and Tibetan Buddhist traditions during the Manchu Qing dynasty. The square base is made of brick covered with mottled stone, while the upper stories are made of polished white marble. Auspicious emblems such as the lotus and the wheel are carved on the sides of the first story. Images of seated buddhas, reminiscent of the imagery found on the temples at Bodh Gaya in India [6.4], fill the remaining four stories of the square base. The seven pagodas, symbols of the immanence of the Buddha and other advanced beings, which can be seen on the upper part of the structure, illustrate the diverse

FIGURE 14.7
The Diamond Throne Pagoda at Biyun Monastery.
Beijing, Hebei Province, China, Qing dynasty, Qianlong period, founded ca. 1748. The structures at the top of this pagoda derive from Indian and Tibetan architectural traditions.

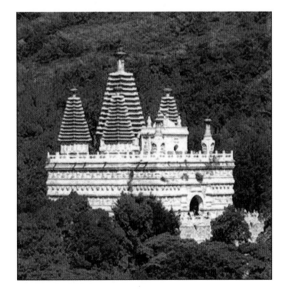

Buddhist traditions that coexisted in China during the Qing dynasty. Two of the stupas/pagodas have the round shape commonly found in Tibet, one is square, and the remaining five resemble the taller wooden structures of East Asia. The square base and arched doorways of the Diamond Throne Pagoda most likely derive from the famous Cloud Platform at Juyongguan to the northeast of Beijing, constructed between 1343 and 1345 at the order of one of the Mongol Yuan emperors to bring happiness to others. The use of this structural type in Qing monasteries may have been intended to create a visual link to their Mongol precursors and explains the existence of comparable structures in Mongolia.

The Qianlong emperor (1736–1795) added the Diamond Throne Pagoda to Biyun-si Monastery in 1748. An avid patron and collector of the arts, he also commissioned a reproduction of the Potala Palace (Putuozongsheng) in Chengde in 1767 to serve as a residence for the Dalai Lama and one of Tashilunpo (Xumifushou) in the same city between 1779 and 1780 for the Panchen Lama. Both monasteries were filled with textiles, paintings, sculptures, and all the other necessities for the personal and ritual lives of the two high-ranking Geluk lamas, their disciples, and attendants. Several of the paintings commissioned for the Xumifushou are still extant today, including one depicting Bodhisattva Samantabhadra (Puxian) [14.8], who symbolizes virtue and can extend life. The bodhisattva is seated on a white moon disc set on a complicated pedestal in a landscape painted in the shades of blue and green often associated with paradises or otherworldly realms in Chinese and Tibetan art. The shape of the bodhisattva's face and features and the smooth physique are stylistically comparable to the image of Maitreya by Zanabazar discussed earlier, as is the stylized treatment of the flames encircling the mandorla; both parallel Tibetan art from the same period [12.9, 12.10]. Bodhisattva Samantabhadra holds two lotus blossoms supporting a vajra and a disc symbolizing the moon. Five offerings to peaceful deities, which differ from those offered to more terrifying deities, are placed on lotuses rising from a pond at the front of the painting. The offerings are intended to invoke the five senses: sight (mirror), sound (cymbals), smell (curds in a conch), taste (fruit), and touch (a peace of silk). Two forms of Tara, one white and one green, sit in the foreground; an image of Buddha Amitayus (Wu-liangshou), the life-extending manifestation of Buddha Amitabha, is found at the top attended by a heavenly retinue.

The Sino-Tibetan imagery seen in this painting, in the sculpture attributed to Zanabazar, and in many later Tibetan paintings and

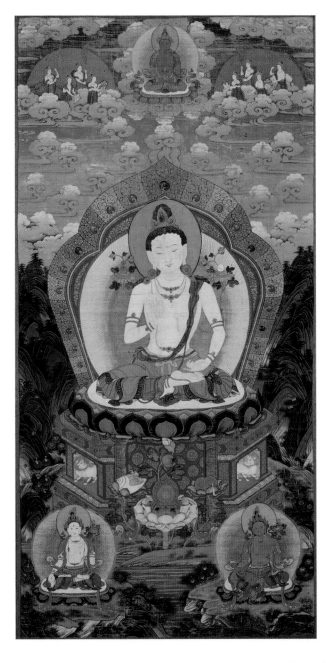

FIGURE 14.8
*Bodhisattva
Samantabhadra (Puxian).*
China, Qing dynasty, Qianlong
period, ca. 1779–1780. The style of
this painting, particularly the
physique of the bodhisattva, was
common to Tibet, China, and
Mongolia in the seventeenth
and eighteenth centuries.

sculptures coexisted with native artistic traditions affiliated with
Pure Land or Chan Buddhism into the early twentieth century. One
of the more interesting and unresolved questions in the history of
Buddhist art is why no parallels to the former are found (or were
preserved) in either Korea or Japan, both of which shared other
Buddhist traditions with China during this period.

CHAPTER 15

Revivals in Korea and Japan
Sixteenth to Nineteenth Century

KOREA

GENERAL YI Seonggye's (1335–1408) choice of the Chinese tradition of Neo-Confucianism rather than Buddhism as Korea's state religion was part of a series of changes, including the establishment of a new capital at Seoul and significant land reforms, that marked the formation of the long-lived Joseon dynasty (1392–1910) in Korea. The use of Neo-Confucianism as a means of organizing and governing a state can be traced to Chinese thinkers such as the ninth-century Han Yu (see chapter 4) and to the work of synthesizers such as Zhu Xi (1130–1200), who blended the long-standing Confucian emphasis on proper behavior and self-discipline with metaphysical premises based to some degree on Daoist and Buddhist writings. The reemergence of Confucianism as the state-sponsored system of thought in twelfth-century had a profound impact in China: after the fifteenth century, a thorough grounding in the classics, particularly in the *Four Books* chosen and annotated by Zhu Xi, was mandatory for the training of bureaucrats-scholars who managed all aspects of government. In Joseon-period Korea, such literati-bureaucrats were known as *yangban*. This group gained significant political power and had a negative impact on the Buddhist establishment, which no longer received substantive support from the state. In addition, restrictions were placed on monasteries and monks, some temples were demolished, and others were resettled in secluded areas. Despite government prohibitions, however, some members of the ruling elite and others in Korea continued to practice Buddhism privately while publicly supporting Confucian-based state policies.

Revival of official support for Buddhism in the mid-sixteenth century was due to the powerful and perspicacious Queen Dowager Munjeong (1501–1565), who, between 1545 and 1565, ruled first as the

FACING PAGE
Detail of a calligraphy.
See page 302.

official regent for her young, sickly son and later as the unofficial regent for her son and stepson. As was true of other women in East Asia who gained significant power, Munjeong may have chosen Buddhism to counteract the traditional Confucian strictures against the use of political power by women, as well as an act of personal devotion. In 1549, she abolished the state's anti-Buddhist policy, and in 1551, she reinstated the state examinations for Buddhist priests and ordained twenty-six hundred new priests. She also revitalized religious art by commissioning series of paintings depicting traditional imagery, such as Buddhist triads or the arhats (*nahan*). An inscription written in gold on a painting of an elderly arhat [15.1] sitting in a remote landscape reading a text gives a date of 1562 and states that it is the one hundred and fifty-third of a group of two hundred commissioned by the dowager queen. The rich hues of red, white, and green in the painting are typical of works produced during her regency, as is the use of gold pigment. The opaqueness of the arhat's clothing helps to distinguish early Joseon-period painting from the translucent garments found in icons produced in the earlier Goryeo period, as does the smaller, less elaborate pattern of the clothing [10.1]. The use of ink to depict rock, pine tree, and other landscape elements, which illustrates the continuation of monochromatic paintings traditions introduced earlier from China, reflects renewed ties between Ming China and Korea in the fifteenth and sixteenth century.

The heroism of monks who assembled an army and battled the invaders during the Japanese invasion of Korea between 1592 and 1597 furthered the revitalization of Buddhism, as did the reconstruction of monasteries decimated during the fighting. By the sixteenth century, Korean Buddhism focused on two branches, the meditative Chan tradition (Seon), and one devoted to the study of texts (Gyeojeong). As was true in China, however, monks, regardless of their affiliations, performed funeral and other rituals for practitioners. Such ceremonies, which were designed to ensure a favorable rebirth, were elaborate performances that included dramatic music and dance presentations, as well as feasting and the offering of gifts.

Paintings and other goods were often produced for use in ceremonies of various types, and some, such as the Nectar Ritual paintings, also act as a visual record of such activities. The Nectar Ritual is intended to guide the souls to Sukhavati, and paintings depicting this rite were hung in temples as part of funerary ceremonies. As is the case with paintings used in the Water-Land ritual, those depicting the Nectar Ritual were placed in the "lowest" of the three spaces

used in the ritual, below (or to the right) of buddhas, bodhisattvas, and other deities. Seven buddhas, including Amitabha, the only one who looks directly at the viewer, fill the top part of a Nectar Ritual painting dated to 1759 [15.2]. The buddhas stand on flowing clouds and are attended by the white-robed Avalokiteshvara (Gwaneum), Bodhisattva Kshitigarbha (Jijang), and another deity who leads the soul to Sukhavati. Monks performing rituals and figures in formal processions are seen to either side of the large altar filled with fruits, flowers, and other offerings, which dominates the center of the painting. Two large figures of hungry ghosts writhing before the altar represent the souls in need of guidance, while the numerous smaller vignettes in the foreground of the painting, some of which illustrate calamities, record the realities of the phenomenal world. (The presence of such genre scenes in Buddhist imagery parallels the development of paintings that feature the daily activities of Koreans as well as famous scenery.) The large size of the Nectar Ritual painting suggests that it could have been hung both inside a monastery building or on the outside of the structure where it would be accessible to a larger number of viewers. Large-scale banners are also hung on the exterior of monasteries and on the sides of mountains in Tibet; it is possible that such banners were also used in China in the seventeenth and eighteenth centuries, when the ruling Manchus adhered to the practices of the Tibetan Geluk order.

FIGURE 15.2
OPPOSITE
A Nectar Ritual painting.
Korea, Joseon period, dated 1759. This enormous painting details funerary rituals designed to ensure a rebirth in a Buddhist paradise.

JAPAN

IN 1568, Oda Nobunaga (1524–1582), the son of a minor vassal, entered Kyoto and deposed the last Ashikaga shogun, briefly ending the civil war that had begun in the late fifteenth century and plagued Japan for nearly one hundred years. Nobunaga's rule ended when he was assassinated, and a low-ranking samurai named Toyotomi Hideyoshi (1536–1598) assumed control. Hideyoshi, who invaded Korea twice, failed in his attempt to attack China as well. The time of both their rules, during which Japan remained unstable, is known as the Momoyama period (1573–1615) after a location in Kyoto. Hideyori (1593–1615), who succeeded his father, Hideyoshi, could not maintain control of the country. Warring factions once again split Japan until 1603, when Tokugawa Ieyasu (1542–1616) defeated his most serious rivals during the Battle of Sekighara. Ieyasu revised the title of shogun and moved the government to Edo (now Tokyo). During the Tokugawa or Edo period (1615–1868), members of the shogunate

controlled the large cities and about one quarter of the countryside, while approximately 270 regional lords (*daimyo*) ruled smaller domains and owed fealty to the shoguns. The era ended in 1868 with the restoration of imperial rule. Shinto, the complex of native ideas and deities that had long been melded with Buddhism, became the official religion of Japan during the Meiji period (1868–1912).

Like their counterparts in Korea, the Tokugawa shoguns chose Chinese Neo-Confucianism as the philosophical basis for their government, classifying people into four groups based on their presumed value to society: warrior/administrators, peasants, artisans, and city dwellers and merchants. The latter were thought to have little value because they consumed goods as opposed to producing them or were merely responsible for moving necessities and luxuries from one place to another. Monks, who received support from a broad range of individuals, functioned outside the rigid social structure. Nonetheless, the Tokugawa government maintained control of Buddhist temples and often used them for political purposes such as registering the local populace to ensure that Christianity—introduced to Japan in 1549 by Francis Xavier (1506–1552) and later proscribed—was no longer practiced.

In the late sixteenth and early seventeenth centuries, ties between Japan and Europe, which began around 1543 when Portuguese sailors landed on Tanegashima Island, led to an intense but brief fascination with Western commodities such as firearms, glassware, eyeglasses, bread, fried foods (*tempura*), and pantaloons and to the development of goods specifically for trade with the West. Trade with the Portuguese and Spanish (known in Japanese as *nanban*, or "foreign barbarians") was officially ended in 1639, when the Japanese expelled them from the country. Dutch and Chinese traders, however, were allowed to continue working from Deshima, a man-made island in the Bay of Nagasaki, and the arrival there of Chinese monks fleeing the Manchus led to the introduction of a new variation of Zen in Japan.

Known as Ōbaku after the Japanese pronunciation of Huangbo, a mountain in Fujian Province famous for its Buddhist temples, this practice is characterized by its syncretic blending of Zen with Pure Land and other traditions. Although Ingen Ryuki (Yinyuan Longqi, 1592–1673) and his followers first served Chinese traders in the Nagasaki area, Ōbaku soon spread throughout Japan. In 1661, a headquarters known as Mampuku-ji (after the Japanese pronunciation of the Chinese temple Wanfo-si) was established in Uji

near Kyoto; by the early eighteenth century, there were more than four hundred Ōbaku temples in Japan.

Ingen Ryuki and other Ōbaku monks such as Sokuhi Nyoichi (Jifei Rui, 1616–1671) introduced a sparse and dramatic tradition of ink painting, as well as new variants of religious sculpture and portraiture to Japan. Sokuhi Nyoichi, who was born in Fujian Province, entered religious life after the death of his father when he was thirteen. He spent the early years of his career traveling between monasteries in southern China and working with the noted masters of his day, including Ingen, who summoned him to Nagasaki in 1657. After serving as the abbot of Sōfuku-ji in Nagasaki, one of the three principal temples in that city catering to Chinese merchants and settlers, Sokuhi Nyoichi decided to return to China in 1663. He was dissuaded by the *daimyo* of Kokura, who built Fukushū-ji Temple for him, and he remained there for the rest of his life. Sokuhi, who was noted for the quick, angular strokes of his calligraphy, was also a painter. He used a few thick, rapid brushstrokes to create an elegant painting of a monk reading a text while seated against an empty background [15.3]. Images of monks reading sutras in the moonlight and sewing under the morning sun are established themes in Chan painting and can be traced to the Song period in China. Sokuhi's inscription, which fills the left side of the painting, is written with a beautifully flowing brush and states:

FIGURE 15.3
Reading a Sutra Under the Moonlight.

Japan, Edo period, seventeenth century. Artist: Sokuhi Nyoichi. Interest in quotidian activities such as reading a sutra or performing chores is typical of the imagery associated with the Zen sect of Buddhism.

The moon and the paper are the same white,
The pupil of the eye and the ink, both black
This mysterious meaning remains a circle,
Beyond the possibility of understanding.[1]

Like many of his contemporaries in China and Korea, the monk-artist Shoun Genkei (1648–1710) chose a life as a wandering mendicant, working in various centers, including those with ties to the Ōbaku tradition. A sculpture showing an emaciated arhat [15.4] seated with his legs and arms crossed is one of five hundred created by Shoun Genkei between 1691 and 1696 for Gohyaku Rakan-ji, a temple on the outskirts of Tokyo. The concept of a nearly life-size sculpted figure of an arhat, which derives from earlier Chinese traditions, was most likely inspired by an earlier set of arhats made by Handōsei (Fan Daosheng, 1637–1701), who accompanied Ingen Ryuki to Japan and worked at the Mampuku-ji. The raised patterns on the hems of the garments also derive from Chinese art where such

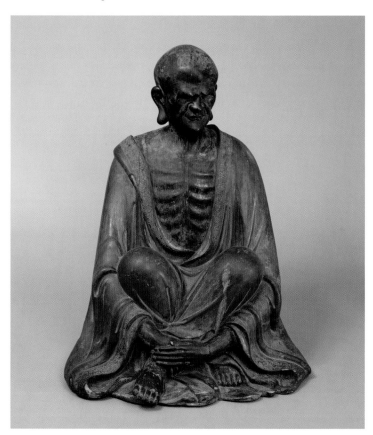

FIGURE 15.4
An arhat (rakan).
One of set of five hundred from Gohyaku Rakan-ji, Japan, Edo period, 1688–1695. Artist: Shoun Genkei. The large scale of this powerful sculpture displays a Chinese influence.

decoration was often applied to sculptures in the sixteenth and seventeenth centuries. The rounded surface of the folds, however, is typical of seventeenth-century Japanese sculpture, as is the somewhat masklike rendering of the face and features.

Several distinctive figures in Japanese Buddhism were active in the second half of the seventeenth century, an era in which new patrons, including merchants and other urbanites, helped to promote an extraordinary creativity in the visual and performing arts. The monk-artist Enkū (1628–1695) is one of several figures whose work was supported by a range of patrons, including rural inhabitants. Although questions remain about his biography, Enkū is thought to have become a monk when he was about twenty. Like many monks at the time, his practice comprised various Buddhist traditions, including Pure Land as well as the mixed ascetic traditions known as *shugendō* that remained popular in Japan. Enkū, who produced sculptures depicting a range of Buddhist deities, revived an unusual form of sculpture found in eastern Japan from the tenth to the thirteenth century and known as *natabori*, in which the surface of the wood is left unfinished and the chisel or ax marks are allowed to show. Enku's work ranges widely in size. A set of 1,020 figures [15.5] in the collection of the Arako-Kannon-ji in Nagoya was carved from wood chips left over from a larger carving. This group is enigmatically known as the "thousand-faces of the bodhisattva," a possible reference to Avalokiteshvara, the primary deity in the temple.

The work of Hakuin Ekaku (1685–1769), one of the most influential figures in later Japanese Buddhism, also shows an immediacy and sense of humor designed to appeal to a wide range of individuals. Hakuin was born in the small village of Hara near Mount Fuji as the youngest of five children. His mother was a devout Buddhist, and he entered the monastery at the age of thirteen and studied a standard curriculum that included Chinese classics as well as Buddhist literature. Hakuin apparently became disillusioned with Buddhism in his late teens and early twenties and spent some time wandering through Japan studying literature and calligraphy. By 1718, he had returned to practicing and was named "first monk" at Myōshin-ji, a temple in Kyoto. He later returned to Shōin-ji in his hometown of Hara. Hakuin, who is credited with revitalizing Rinzai Zen stressed arduous meditation and is renowned for creating new koans, particularly the famous question regarding the sound of one hand clapping, which he described in 1753 as follows:

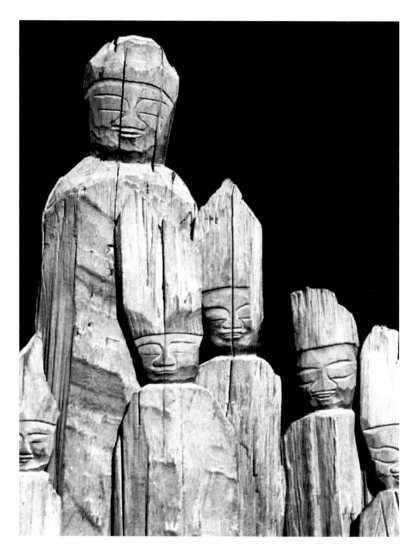

FIGURE 15.5
*Thousand faces
of the bodhisattva.*

Arako Kannon-ji, Nagoya,
Japan, Edo period, seventeenth
century. Artist: Enkū. The artist
spent much of his life in rural
Japan creating bold but relatively
unfinished sculptures for the use
of local devotees.

FIGURE 15.6
Hakuin Ekaku (1685–1769).

Self-portrait. Japan, Edo period,
1764. Eisai Bunko Museum,
Tokyo. Artist: Hakuin Ekaku.
Hakuin coined the famous koan
regarding the sound of one hand
clapping and was one of the more
influential monk-artists in
eighteenth-century Japan.

Five or six years ago I made up my mind to instruct everyone by
saying "Listen to the Sound of a Single Hand." I have come to realize
that this koan is infinitely more effective in instructing people than
any of the methods I have used before . . . When you clap together
both hands a sharp sound is heard: when you raise the one hand,
there is . . . something which can by no means be heard with the
ear . . . At this time the basis of mind, consciousness, and emotion is
suddenly shattered: the realm of illusion is overturned.[2]

A self-portrait painted by Hakuin in 1764 [15.6] reinterprets the
traditional rendering of such icons. Although the use of a circle to

enclose the monk and the bust portrait can be traced to the Song period in China, the choppy treatment of the brush-strokes in both the painting and the calligraphy distance the painting from other formal portraits. Hakuin also exaggerates the long oval of his face and his noticeable, somewhat misshapen noise. His challenging poem at the top of the painting reads,

> Within the Meditation Hall
> I am hated by the thousand Buddhas:
> In the company of myriad demons
> I am despised by the myriad demons.
> I crush those who practice fake Zen
> And annihilate those blind monks who
> can't penetrate *Mu* [nothingness]
> This evil worn-out old shavepate
> Adds one more layer of ugliness
> to ugliness.[3]

The monk-artist Sengai Gibon (1750–1838) also reinterpreted traditional religious images, added new themes to the repertory of Chan painting, and used his painting and poetry to reach a broad audience. He was born into a farming family in Mino, became a monk at the age of eleven, and spent much of his early life traveling throughout Japan and studying with noted masters in varying traditions. Like Hakuin, he had the opportunity to work in a major center but chose to spend the latter part of his career in a smaller, rural temple, teaching students from all walks of life. A circle, a triangle, and a square [15.7], painted with diminishing amounts of ink, are the subjects of a striking work by Sengai, one of the more interesting painters of the late Edo period. The three shapes in the painting are sometimes explained as references to body, mind, and speech—three aspects of practice frequently mentioned in later Buddhism. However the boldly written inscription at the left of the painting reads, "the first Zen monastery in Japan," a reference to Shōkoku-ji, where he

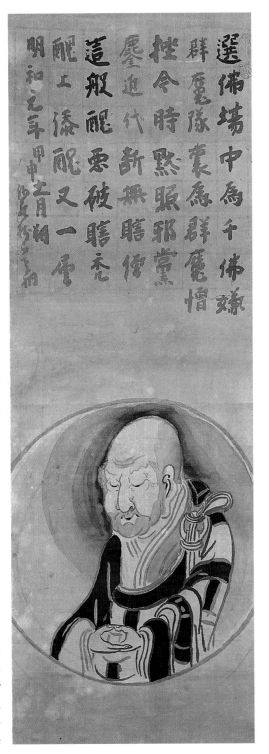

FIGURE 15.7
Circle, Triangle, Square.
Japan, Edo period, eighteenth century. Artist: Sengai Gibon. Several interpretations have been given to this enigmatic painting, which refers to the famous Shōkoku-ji monastery in Kyoto in the inscription.

served both as the "first monk" and as abbot from 1788 to 1811, and this title suggests that the piece may also be understood as a reference to that famous complex.

The dramatic pattern of phoenixlike birds flying around one another in roundels set against wavy diagonal lines in an early-nineteenth-century surplice [15.8], one of many preserved in Japan from the Edo period, illustrates the luxuriousness often found in religious clothing and implements. The making of shawls is still considered a religious act. Such garments serve as a reminder of the teachings of the Buddha, and some, which can pass from a master to a disciple, contain relics and presumably the wisdom and understanding of a deceased master. Other shawls were made from clothing, including theatrical costumes, donated to monasteries upon the death of a devotee in the hopes that the prayers associated with making the clothing into a religious garment would also protect the soul of the deceased.

A standard part of monastic costume, shawls are generally subdivided into horizontal and vertical registers as an allusion to the

rags and other pieces of discarded clothing used by the Buddha and other early practitioners. Shawls with five such bands are used daily, while more elaborate pieces, which can be divided into up to twenty-five bands, are used by high-ranking monks during formal events. The shawl shown here is made of silk decorated with pieces of paper and covered with gold thread; it required the weaving of an excessive amount of cloth in order to create a garment with seven bands of five pieces each and six additional squares. The two square panels at the center of the top of the shawl show Bodhisattvas Manjushri (Monju) and Samantabhadra (Fugen). The four at the upper and lower edges portray the guardians of the four cardinal directions and many of the images, and the ideas they embody continue to inspire artists throughout the world. Belief in this group of protective figures is one small part of the astounding array of images, texts, and practices that developed in India and Central Asia, and spread with Buddhism throughout the Asian world adapting to and adopting numerous other traditions as it traveled.

FIGURE 15.8
A monk's shawl (kesa).

Japan, Meiji period, nineteenth century. Monks' garments were sometimes seen as relics of the figures who wore them. They are still collected and treasured in Japanese monasteries.

NOTES

Chapter 1. Pillars and Stupas

1. Vincent A. Smith, *Asoka, the Buddhist Emperor of India* (Oxford: Clarendon Press, 1901), 123.

2. E. B. Cowell, ed., *The Jataka: Or Stories of the Buddha's Former Births,* vol. 5, trans. H. T. Francis (Cambridge: Cambridge University Press, 1905), 5:30–31.

3. Ibid.

4. Bijoya Goswami, trans., *Lalitavistara* (Calcutta: Asiatic Society, 2001), 282.

Chapter 2. The Buddha Image

1. Edwin Arnold, *Light of Asia* (London: Trubner and Co., 1879), 172–73.

Chapter 3. Caves and Caravans

1. Luis O. Gomez, "A Mahayana Liturgy," in *Buddhism in Practice*, ed. Donald S. Lopez, Jr. (Princeton, NJ: Princeton University Press, 1995), 183–96.

2. John S. Strong, *The Experience of Buddhism: Sources and Interpretations* (Belmont, CA: Wadsworth, 2002), 78.

3. Hiuen Tsiang (Xuanzang), *Si-yu-ki: Buddhist Records of the Western World*, vol. 1, trans. Samuel Beal (London: Trubner and Co., 1884), 50–51.

4. Ren Lingjuan, ed. *Frescoes and Fables: Mural Stories from the Mogao Grottoes in Dunhuang,* trans. Li Guishan (Beijing: New World Press, 1998), 154–55.

Chapter 4. China

1. John S. Strong, *The Experience of Buddhism: Source and Interpretations* (Belmont, CA: Wadsworth, 2002), 187.

2. Victor H. Mair, Nancy S. Steinhardt, and Paul R. Goldin, eds., *Hawai'i Reader in Traditional Chinese Culture* (Honolulu: University of Hawaii Press, 2005), 356–57.

Chapter 5. Korea and Japan

1. W. G. Aston, trans., *Nihongi: Chronicles of Japan from the Earliest Times to A.D. 697* (London: Allen and Unwin, 1956), 66.

2. David L. Gardiner, "Mandala, Mandala on the Wall: Variations of Usage in the Shingon School," *Journal of the International Association of Buddhist Studies* 19, no. 2 (1996): 253–54.

Chapter 6. South Asia

1. Glenn H. Mullin with Jeff J. Watt, *Female Buddhas: Women of Enlightenment in Tibetan Mystical Art* (Santa Fe, NM: Clear Light Publishers, 2003), 121.

2. Ananda W. P. Guruge, trans., *Mahavamsa* (Calcutta: M. P. Birla Foundation, 1990), 104.

3. John S. Strong, *The Experience of Buddhism: Sources and Interpretations* (Belmont, CA: Wadsworth, 2002), 186.

Chapter 7. The Himalayan Region

1. Luis O. Gomez, "Two Tantric Meditations: Visualizing the Deity," in *Buddhism in Practice*, ed. Donald S. Lopez, Jr. (Princeton, NJ: Princeton Uni-versity Press, 1995), 320.

2. John S. Strong, *The Experience of Buddhism: Sources and Interpretations* (Belmont, CA: Wadsworth, 2002), 260–61.

3. Steven M. Kossak and Jane Casey Singer, *Sacred Visions:Early Paintings from Central Tibet* (New York: The Metropolitan Museum of Art, 1998), 57.

Chapter 8. Southeast Asia

1. Trian Nyugen, "Laksmindralokesvara, Main Deity of the Dong Duong Monastery: A Masterpiece of Cham Art and a New Interpretation," *Artibus Asiae* 65, no. 1 (2005): 11.

2. Robert Linrothe, *Ruthless Compassion: Wrathful Deities in Early Indo-Tibetan Esoteric Buddhist Art* (London: Serindia Publications, 1999), 268–69.

3. Michel Jacq-Hergoualc'h, *The Malay Peninsula: Crossroads of the Maritime Silk Road (100 B.C.–1300 A.D.)*, trans. Victoria Hobson (Leiden: Brill Academic Publishers, 2002), 238.

4. Hubert Decler, "Atisa's Journey to Sumatra," in *Buddhism in Practice*, ed. Donald S. Lopez, Jr. (Princeton, NJ: Princeton University Press, 1995), 502–40.

5. John S. Strong, *The Experience of Buddhism: Sources and Interpretations* (Belmont, CA: Wadsworth, 2002), 159–60.

Chapter 9. China Under Foreign Rule

1. Henrik H. Sorensen, "A Study of the 'Ox-herding Theme' as Sculptures at Mt. Baoding in Dazu County, Sichuan," *Artibus Asiae* 51, no. 3/4 (1991): 225.

2. *Asiatic Art in the Museum of Fine Arts, Boston* (Boston: Museum of Fine Arts, 1982), 9–10.

3. Yu Chun-fang, "Chung-feng Ming-pen and Ch'an Buddhism," in *Yuan Thought: Chinese Thought and Religion Under the Mongols,* ed. Hok-lam Chan and William Theodore de Bary (New York: Columbia University Press, 1982), 442.

4. Ibid, 427.

Chapter 10. Aristocrats and Warriors in Korea and Japan

1. Itō Yūshin, "Hōnen," in *Shapers of Japanese Buddhism,* ed. Yūsen Kashiwahara and Kōyū Sonoda, trans. Gaynor Sekimori (Tokyo: Kōsei Publishing Co., 1993), 69.

2. Furata Takehiko, "Shinran," in *Shapers of Japanese Buddhism*, ed. Yūsen Kashiwahara and Kōyū Sonoda, trans. Gaynor Sekimori (Tokyo: Kōsei Publishing Co., 1993), 90–91.

3. Barbara Brennan Ford, "The Arts of Japan," *Metropolitan Museum of Art Bulletin* 45 (Summer 1987): 36.

Chapter 12. The Dalai Lamas in Tibet

1. Helmut Uhlig, *On the Path to Enlightenment: The Berti Aschman Foundation of Tibetan Art at the Museum Rietberg Zurich* (Zurich: Museum Rietberg, 1995), 176.

2. *Rituels tibetains: Vision secretes de Ve Dalai Lama* (Paris: Reunion des Musées Nationaux, 2002), 27.

3. Marilyn M. Rhie, Robert A. Thurman, and John B. Taylor, *Wisdom and Compassion: The Sacred Art of Tibet* (New York: Harry N. Abrams, Inc., 1996), 290.

Chapter 13. Sri Lanka, Myanmar, and Thailand

1. Robert Knox, *An Historical Relation of the Island of Ceylon in the East Indies* (1691; repr., New Delhi: Navrang Publishers, 1983), 72.

2. Rajendralal L. Mitra, *Lalita-Vistara: Memoirs of the Early Life of Sakya Sinha* (Delhi: Sri Satguru Publications, 1998), 259.

3. John S. Strong, *The Experience of Buddhism: Sources and Interpretations* (Belmont, CA: Wadsworth, 2002), 119.

4. Bonnie Pacala Brereton, *Thai Tellings of Phra Malai: Texts and Rituals Concerning a Popular Buddhist Saint* (Tempe, AZ: Arizona State University, 1995), 100.

Chapter 14. Ming, Manchu, and Mongol in China

1. Helen Chapin, "The Ch'an Master Pu-tai," *Journal of the American Oriental Society* 53 (1933): 49, 51–52.

Chapter 15. Revivals in Korea and Japan

1. Stephen Addis and Kwan S. Wong, *Obaku: Zen Painting and Calligraphy* (Lawrence, KS: Helen Foresman Spencer Museum of Art, 1978), 11.

2. Philip B. Yampolsky, trans. *The Zen Master Hakuin: Selected Writings* (New York: Columbia University Press, 1971), 163–64.

3. Stephen Addiss, *The Art of Zen: Paintings and Calligraphy by Japanese Monks, 1600–1925* (New York: Harry N. Abrams, 1989), 128.

SELECTED BIBLIOGRAPHY

The literature on Buddhist thought, practice, and art is voluminous and includes material in both Western and Asian languages. With the exception of a few volumes in Chinese that have no Western equivalents, this bibliography, like the rest of the book, is designed for the general reader or undergraduate student and is by no means exhaustive. It should be understood as an extended endnote to the text and primarily contains works used during the writing of this book. Interested readers are encouraged to look beyond the works cited; many important and interesting studies are not included here.

Images (Art)

Introductory Texts

Dallapiccola, Anna Libera. *The Stupa: Its Religious, Historical, and Archaeological Significance*. Wiesbaden: Franz Steiner Verlag, 1980.

Fisher, Robert E. *Buddhist Art and Architecture*. London: Thames and Hudson, 1993.

Karetzky, Patricia E. *Early Buddhist Narrative Art: Illustrations of the Life of the Buddha from Central Asia to China, Korea, and Japan*. Lanham, NY: University Press of America, 2000.

Niyogi, Puspa. *Buddhist Divinities*. Delhi: Munishiram Manoharlal Publishers, 2001.

Pichard, Pierre, and Francois Lagirarde. *The Buddhist Monastery: A Cross-Cultural Survey*. Paris: École Francaise d'Extrême Orient, 2003.

Pratapaditya, Pal, and Julia Meech-Pekarik. *Buddhist Book Illumination*. New York: Ravi Kumar, 1988.

Snellgrove, David L., and Jean Boisselier. *The Image of the Buddha*. Paris: Unesco, 1978.

Wassman, Bill, Joe Cummings, and Robert Thurman. *Buddhist Stupas in Asia: The Shape of Perfection*. Melbourne: Lonely Planet Publications, 2001.

Zwalf, Wladimir. *Buddhism: Art and Faith*. New York: Macmillan, 1989.

Regional Studies

AFGHANISTAN AND CENTRAL ASIA

Brancaccio, Pia, and Kurt Behrendt, eds. *Gandharan Buddhism: Archaeology, Art, and Texts*. Vancouver: University of British Columbia Press, 2006.

Chuvin, Pierre, Marthe Bernus-Taylor, Therese Bittar, and Lisa Golombek. *Les arts de l'Asie centrale*. Paris: Citadelles et Mazenod, 1999.

Duan Wenjie, et al. *Zhongguo bihua quanji: Kezi'er* [Compendium of Chinese Wall Paintings: Kizil]. Vol. 1. Tianjin: Tianjin renmin meishu chubanshe, 1992.

Errington, Elizabeth, Joe Cribb, and Maggie Claringbull. *The Crossroads of Asia: Transformation in Image and Symbol in the Art of Ancient Afghanistan and Pakistan*. Cambridge: Ancient India and Iran Trust, 1992.

Hartel, Herbert. *Along the Ancient Silk Routes: Central Asian Art from the West Berlin State Museums.* New York: Harry N. Abrams, 1982.

Lesbre, Emmanuelle. "An Attempt to Identify and Classify Scenes with a Central Buddha Depicted on Ceilings of the Kyzil Caves." *Artibus Asiae* 61, no. 2 (2001): 305–52.

Rice, Francis Mortimer, Benjamin Rowland, and Muzah-i Kabul. *Art in Afghanistan: Objects from the Kabul Museum.* London: The Penguin Press, 1971.

Serinde, terre de Bouddha: Dix siècles d'art sur la Route de la Soie. Paris: Galeries Nationale du Grand Palais, 1995.

CHINA

Abe, Stanley K. *Ordinary Images.* Chicago: University of Chicago Press, 2002.

Alphen, Jan Van. *Buddha in the Dragon Gate.* Ghent: Snoeck-Ducaju & Zoon, 2001.

Baker, Janet. *The Flowering of a Foreign Faith: New Studies in Chinese Buddhist Art.* Mumbai: Marg Publications, 1999.

Berger, Patricia Ann. *Empire of Emptiness: Buddhist Art and Political Authority in Qing China.* Honololu: University of Hawaii Press, 2003.

Berger, Patricia Ann, Terese Tse Bartholomew, James E. Bosson, et al. *Mongolia: The Legacy of Chinggis Khan.* London: Thames and Hudson, 1995.

Cahill, James. "Continuation of Ch'an Ink Painting into the Ming-Ch'ing and the Prevalence of Type-Images." *Archives of Asian Art* 50 (1997–1998): 17–41.

Caswell, James O. *Written and Unwritten: A New History of the Buddhist Caves at Yungang.* Vancouver: University of British Columbia Press, 1988.

Fo jiao chu chuan nan fang zhi lu [The Introduction of Buddhism on the Southern Route]. Beijing: Wenwu Chubanshe, 1993.

Fraser, Sarah. *Performing the Visual: The Practice of Buddhist Wall Painting in China and Central Asia, 618–960.* Stanford, CA: Stanford University Press, 2003.

Fu Xinian, Guo Daiheng, Liu Xujie, et al. *Chinese Architecture.* Edited by Nancy S. Steinhardt. New Haven, CT: Yale University Press, 2002.

Gridley, Marilyn. *Chinese Buddhist Sculpture Under the Liao.* New Delhi: Aditya Prakashan, 1993.

Howard, Angela Falco. *Imagery of the Cosmological Buddha.* Leiden: Brill Academic Publishers, 1986.

Jang, Scarlett Ju-Yu. "Ox-herding Painting in the Sung Dynasty." *Artibus Asiae* 52, no. 1/2 (1992): 54–93.

Kieschnick, John. *The Impact of Buddhism on Chinese Material Culture.* Princeton, NJ: Princeton University Press, 2003.

Larson, John. *Guanyin: A Masterpiece Revealed.* London: Victoria and Albert Museum, 1985.

Lee, Junghee. "The Origins and Development of the Pensive Bodhisattva Images of Asia." *Artibus Asiae* 53, no. 3/4 (1993): 311–57.

Leidy, Denise Patry. "The Ssu-wei Figure in Sixth-Century A.D. Chinese Buddhist Sculpture." *Archives of Asian Art* 43 (1990): 21–37.

Little, Stephen. "The Arhats in China and Tibet." *Artibus Asiae* 52, no. 3/4 (1992): 285–308.

Ma Shichang. *Zhongguo fojia shiku kaogu wenji* [Essays on the Buddhist Cave Temples of China]. Xinzhu: Juefeng fojiao yishu wenhuaji jinhui, 2001.

Nickel, Lukas, ed. *The Return of the Buddha: Buddhist sculptures of the 6ᵗʰ century from Qingzhou, China.* Zurich: Museum Rietberg, 2002.

Ran Wei. *Buddhist Buildings: Ancient Chinese Architecture.* New York: Springer, 1999.

Rhie, Marylin M. *Early Buddhist Art of China and Central Asia.* 2 vols. Leiden: Brill Academic Publishers, 1999–2002.

Steinhardt, Nancy Shatzman. *Chinese Traditional Architecture.* New York: China Institute in America, 1984.

———. "The Mizong Hall of Qinglong Si: Space, Ritual, and Classicism in Tang Architecture." *Archives of Asian Art* 44 (1991): 27–50.

Su Bai. *Zhongguo shikusi yanjiu* [Studies on Chinese Cave Temples]. Beijing: Wenwu Chubanshe, 1996.

Tsiang, Katherine R. "Embodiments of Buddhist Texts in Early Medieval Chinese Visual Culture." In *Body and Face in Chinese Visual Culture,* edited by Wu Hung and Katherine R. Tsiang, 49–78. Cambridge, MA: Harvard University Asian Center, 2004.

Wang, Eugene Yuejin. "Of the True Body: The Famen Monastery Relics and Corporeal Transformation in Tang Imperial Culture" In *Body and Face in Chinese Visual Culture* edited by Wu Hung and Katherine R. Tsiang, 79–120. Cambridge, MA: Harvard University Asian Center, 2004.

Watson, William. *The Arts of China, 900–1620.* New Haven, CT: Yale University Press, 2000.

———. *The Arts of China to AD 900.* New Haven, CT: Yale University Press, 1995.

Watt, James C. Y., and Denise Patry Leidy. *Defining Yongle: Imperial Art in Early Fifteenth-Century China.* New York: Metropolitan Museum of Art, 2005.

Watt, James C. Y., and Anne E. Wardwell. *When Silk Was Gold: Central Asian and Chinese Textiles.* New York: Metropolitan Museum of Art, 1998.

Weidner, Marsha. *Latter Days of the Law: Images of Chinese Buddhism 850–1850.* Lawrence, KS: University of Kansas, 1994.

Weidner, Marsha Smith. *Cultural Intersections in Later Chinese Buddhism.* Honololu: University of Hawaii Press, 2001.

Whitfield, Roderick. " Esoteric Buddhist Elements in the Famensi Reliquary Deposit." *Asiatische Studien/Etudes Asiatiques* 44 (1990): 247–66.

Whitfield, Roderick, Susan Whitfield, and Neville Agnew. *Cave Temples of Mogao: Art and History on the Silk Road.* Los Angeles: Getty Trust Publications, 2000.

Wong, Dorothy C. *Chinese Steles: Pre-Buddhist and Buddhist Use of a Symbolic Form.* Honolulu: University of Hawaii Press, 2004.

Wu Hung. "Buddhist Elements in Early Chinese Art." *Artibus Asiae* 47 (1986): 263–352.

Wu Limin and Han Jinke. *Famensi digong Tangmi mantuluozhi yanjiu* [Research on Mandalas from the Underground Palace at Famensi]. Hong Kong: Zhongguo fojiao wenhua chuban youxian gongsi, 1998.

Yen Chuan-ying. "The Double Tree Motif in Chinese Buddhist Iconography." *National Palace Museum Bulletin* 14, no. 5 (November-December 1979): 1–14, and 14, no. 6 (January-February, 1980): 1–13.

Zhu Qixin. "Buddhist Treasures from Famensi: The Recent Excavation of a Tang Underground Palace." *Orientations* 21 (May 1990): 77–83.

THE HIMALAYAN REGION (KASHMIR, LADAKH, NEPAL, AND TIBET)

Brauen, Martin. *Mandala.* Boston: Shambhala, 1998.

Goepper, Roger, Jaroslav Poncar, Robert N. Linrothe, and Karl Dasser. *Alchi: Ladakh's Hidden Buddhist Sanctuary.* Boston: Shambhala, 1996.

Heller, Amy. "Indian style, Kashmiri style: Aesthetics of Choice in Eleventh-Century Tibet." *Orientations* 32 (December 2001): 18–23.

———. *Tibetan Art: Tracing the Development of Spiritual Ideals and Art in Tibet, 600–2000 A.D.* Milan: Editoriale Jaca Book SPA, 1999.

———. "The *Vajravali Mandala* of Shalu and Sakya: The Legacy of Buton (1290–1364)." *Orientations* 35 (May 2004): 69–73.

Klimburg-Salter, Deborah. *The Kingdom of Bamiyan: Buddhist Art and Culture of the Hindu Kush.* Boston: Shambhala, 1985.

———. *The Silk Route and the Diamond Path: Esoteric Buddhist Art on Transhimalayan Trade Routes.* Los Angeles: University of California, 1982.

Klimburg-Salter, Deborah, and Eva Allinger, eds. *Buddhist Art and Tibetan Patronage: Ninth to Fourteenth Centuries.* Leiden: Brill Academic Publishers, 2002.

Kossak, Steven M. "Pala Painting and the Tibetan Variant of the Pala Style." *The Tibet Journal,* 27, no. 3/4 (Autumn–Winter 2002): 3–22.

Kossak, Steven M., and Jane Casey Singer. *Sacred Visions: Early Paintings from Central Tibet.* New York: Metropolitan Museum of Art, 1999.

Jackson, David Paul. *A History of Tibetan Painting: The Great Tibetan Painters and Their Traditions.* Wien: Verlag Der Osterreichischen Akademie der Wissenschaften, 1996.

Leidy, Denise Patry, and Robert A. F. Thurman. *Mandala: The Architecture of Enlightenment.* New York: Tibet House, 2000.

Linrothe, Robert N., ed. *Holy Madness: Portraits of Tantric Siddhas.* New York: Serindia Publications and Rubin Museum of Art, 2006.

Linrothe, Robert N. *Ruthless Compassion: Wrathful Deities in Early Indo-Tibetan Esoteric Buddhist Art.* London: Serindia Publications, 1999.

Linrothe Robert N., and Marylin M. Rhie, eds. *Demonic Divine: Himalayan Art and Beyond.* New York: Rubin Museum of Art, 2004.

Pratapaditya, Pal, ed. *Art and Architecture of Ancient Kashmir.* Bombay: Marg Publications, 1989.

Pratapaditya, Pal. *Bengal: Sites and Sights.* Mumbai: Marg Publications, 2006.

———. *Himalayas: An Aesthetic Adventure.* Berkeley, CA: University of California Press, 2003.

Pratapaditya, Pal, and Valrae Reynolds. *Art of the Himalayas: Treasures from Nepal and Tibet.* New York: Hudson Hills Press, 1991.

Pan Shicong, Yang Keling, eds. *The Potala Palace of Tibet.* Hong Kong: Joint Publishing Co., 1982.

Ricca, Franco, and Eberto Lo Bue. *The Great Stupa of Gyantse.* London: Serindia Publications, 1994.

Rhie, Marylin M. *Worlds of Transformation: Tibetan Art of Compassion and Wisdom*. New York: Tibet House in association with The Shelley and Donald Rubin Foundation, 1999.

Rhie, Marylin M., and Robert A. F. Thurman. *Wisdom and Compassion: The Sacred Art of Tibet*. New York: Asian Art Museum of San Francisco and Tibet House, 1991.

Stoddard, Heather. *Early Sino-Tibetan Art*. Warminster, England: Aris and Phillips Ltd., 1975.

Von Hinuber, Oskar. "The Magnificent Bronze of Nandivikramadityanandi: A Delight for the Beholder, a Worry for the Epigraphist. *Orientations*, 34, no. 4 (April 2003): 35–39.

JAPAN

Addiss, Stephen. *The Art of Zen: Paintings and Calligraphies by Japanese Monks, 1600–1925*. New York: Henry N. Abrams, 1998.

Barnet, Sylvan. *Zen Ink Paintings*. New York: Kodansha America, 1982.

Berthier, Francois. *Reading Zen in the Rocks: The Japanese Dry Landscape Garden*. Translated by Graham Parkes. Chicago: University of Chicago Press, 2005.

Breen, John, and Mark Teeuwen, eds. *Shinto in History: Ways of the Kami*. Honolulu: University of Hawaii Press, 2000.

Brinker, Helmut, and Hiroshi Kanazawa. *Zen Masters of Meditation in Images and Writings*. Translated by Andreas Leisinger. Zurich: Museum Rietberg, 1996.

Cunningham, Michael R., John M. Rosenfield, Mimi Hall Yiengpruksawan, and Cleveland Museum of Art. *Buddhist Treasures from Nara*. Cleveland: Cleveland Museum of Art, 1998.

Fontein, Jan, and Money L. Hickman. *Zen Painting and Calligraphy*. Boston: Museum of Fine Arts, 1971.

Fowler, Sherry Dianne. "Hibutsu: Secret Buddhist Images of Japan." *Journal of Asian Culture* 15 (1991–1992): 138–61.

———. *Muroji: Rearranging Art and History at the Japanese Buddhist Temple*. Honolulu: University of Hawaii Press, 2005.

Goodwin, Janet R. *Alms and Vagabonds: Buddhist Temples and Popular Patronage in Medieval Japan*. Honolulu: University of Hawaii Press, 1994.

Grapard, Allan. "Flying Mountains and Walkers of Emptiness: Toward a Definition of Sacred Space in Japanese Religions." *History of Religions* 21, no. 3 (1981–1982) 195–221.

———. "Honjisuijaku." In *The Encyclopedia of Religion*. New York: Macmillan, 1987: 455–57.

Guth, Christine, and Haruki Kageyama. *The Arts of Shinto*. New York: Art Media Resources, 1973.

Hiroshi Kanazawa. *Japanese Ink Painting: Early Zen Masterpieces*. Tokyo: Kodansha International, 1979.

Hisatoyo Ishida and E. Dale Saunders. *Esoteric Buddhist Painting*. New York: Kodansha America, 1987.

Kennedy, Alan. *Manteau de Nuages: Kesa Japonais, XVIIIe–XIXe Siecles*. With Vera Linhartova. Paris: Réunions des musée nationaux, 1991.

Levine, Gregory, and Yukio Lippit. *Awakenings: Zen Figure Painting in Medieval Japan*. New York: Japan Society, 2007.

Levine, Gregory P. A. *Daitokuji: The Visual Cultures of a Zen Monastery*. Seattle: University of Washington Press, 2006.

Mason, Penelope. *History of Japanese Art*. New York: Prentice Hall, 2004.

McCallum, Donald F. "The Earliest Buddhist Statues in Japan." *Artibus Asiae* 61, no. 2 (2001): 149–88.

Murase, Miyeko. *Bridge of Dreams: The Mary Griggs Burke Collection of Japanese Art*. New York: The Metropolitan Museum of Art, 2000.

Murase, Miyeko. *Emaki, Narrative Scrolls from Japan*. New York: Asia Society, 1983.

Morse, Ann Nishimura, and Samuel Crowell Morse, et al. *Object as Insight: Japanese Buddhist Art and Ritual*. New York: Katonah Museum of Art, 1995.

Parker, Joseph D. "Attaining Landscape in the Mind: Nature Poetry and Painting in Gozan Zen." *Monumenta Nipponica* 52 (Summer 1997): 235–57.

———. *Zen Buddhist Landscapes Arts of Early Muromachi Japan (1336–1573)*. Albany, NY: State University of New York Press, 1999.

Rosenfield, John, and Elizabeth ten Grotenhuis. *Journey of the Three Jewels: Japanese Buddhist Paintings from Western Collections*. New York: Asia Society, 1979.

Ruppert, Brian. *Jewel in the Ashes: Buddha Relics and Power in Early Medieval Japan*. Cambridge, MA: Harvard University Press, 2000.

Sanford, James, ed. *Buddhism and the Literary and Visual Arts of Japan*. Princeton, NJ: Princeton University Press, 1992.

Saunder, Dale. *Mudra: A Study of Symbolic Gestures in Japanese Buddhist Sculpture*. Princeton, NJ: Princeton University Press, 1960.

Sawa Ryūken. *Art in Japanese Esoteric Buddhism*. Translated by Richard L. Gage. New York: Weatherhill, 1971.

Sharf, Robert, and Elizabeth Horton Sharf, eds. *Living Images: Japanese Buddhist Icons in Context*. Stanford, CA: Stanford University Press, 2001.

Shōkin Furuta. *Sengai: Master Zen Painter*. Tokyo: Kodansha International, 2000.

Sugiyama, Jirō. *Classic Buddhist Sculpture: The Tempyō Period*. Translated by Samuel Crowell Morse. Tokyo: Kodansha International, 1982.

Suzuki Kakichi. *Early Buddhist Architecture in Japan*. Translated by Mary Neighbour Parent and Nancy Shatzman Steinhardt. Tokyo: Kodansha International, 1980.

Takeshi Kobayashi. *Nara Buddhist Art: Todai-Ji*. New York: Weatherhill, 1975.

Ten Grotenhuis, Elizabeth. *Japanese Mandalas: Representations of Sacred Geography*. Honolulu: University of Hawaii Press, 1999.

Till, Barry, and Paula Swart. *Kesa:The Elegance of Japanese Monks' Robes*. Victoria, BC: Art Gallery of Greater Victoria, 1996.

Washizuka Hiromitsu and Roger Goepper, et al. *Enlightenment Embodied: The Art of the Japanese Buddhist Sculptor (Seventh–Fourteenth Centuries)*. New York: Japan Society, Inc., 1997.

Yamamoto Tsutomu. "Buddhist Sculptures of the Kamakura Period in New York Collections." In *The Arts of Japan: An International Symposium*. Edited by Miyeko Murase and Judith G. Smith, 11–30. New York: Metropolitan Museum of Art, 2000.

Yiengpruksawan, Mimi Hall. *Hiraizumi: Budddhist Art and Regional Politics in Twelfth-Century Japan*. Cambridge, MA: Harvard University Asian Center, 1998

———. "The Phoenix Hall at Uji and the symmetries of replication." *The Art Bulletin* 77 (December 1995): 64–72.

KOREA

Hiromitsu Washizuka, Kang Woo-Bang, Tanabe Saburosuke, et al. *Transmitting the Forms of Divinity: Early Buddhist Art from Korea and Japan.* New York: Harry N. Abrams, 2003.

Hongnam Kim. *Korean Arts of the Eighteenth Century: Splendor and Simplicity.* New York: Weatherhill, 1993.

———. *The Story of a Painting: A Korean Buddhist Treasure from the Mary and Jackson Burke Foundation.* New York: Asia Society Galleries, 1991.

Korean Buddhist Research Institute. *The History and Culture of Buddhism in Korea.* Seoul: Dongguk University Press, 1995.

Kumja Paik Kim, Asian Art Museum, Kungnip Chungang Pangmulgwan, and Nara Kokuritsu Hakubutsukan. *Goryeo Dynasty: Korea's Age of Enlightenment, 918–1392.* San Francisco: Asian Art Museum in cooperation with the National Museum of Korea and the Nara National Museum, 2003.

Portal, Jane. *Korea Art and Archaeology.* London: British Museum, 2000.

Yang-mo Chung. *Arts of Korea.* New York: Metropolitan Museum of Art, 1998.

Youngsook Pak. "Kshitigarbha as Supreme Lord of the Underworld." *Oriental Art* (Spring 1977): 96–104.

Youngsook Pak and Roderick Whitfield. *Buddhist Sculpture.* London, Laurence King, 2003.

SOUTH ASIA (INDIA, PAKISTAN, BANGLADESH, AND SRI LANKA)

Barrett, Douglas. *Sculpture from Amaravati in the British Museum.* London: British Museum, 1954.

Behl, Benoy K. *The Ajanta Caves: Artistic Wonder of Ancient Buddhist India.* New York: Harry N. Abrams, Inc., 1998.

Behrendt, Kurt. *The Buddhist Architecture of Gandhara.* Leiden: Brill Academic Publishers, 2004.

Bhattacharya, G. "Buddha Shakyamuni and *Panca-Tathagatas*: A Dilemma in Bihar-Bengal." *South Asian Archaeology.* Edited by Janine Schobman and Maurino Taddei (1983): 350–71.

Brancaccio, Pia. "The Buddhist Caves at Aurangabad: The Impact of Laity." Supplement 1, *Ars Orientalis* (2000): 41–50.

Brown, Robert L. "The Emaciated Gandharan Buddha Images: Asceticism, Health, and the Body" In *Living a Life in Accord with Dhamma: Papers in Honor of Professor Jean Boisselier on His Eightieth Birthday.* Edited by Natasha Eilenberg, M. C. Subhadradis Diskul, and Robert L. Brown, 105–15. Bangkok: Silpahorn University, 1997.

Bussagli, Mario. *Oriental Architecture1.* Translated by John Shepley. New York: Rizzoli, 1981.

Czuma, Stanislaw J. *Kushan Sculpture: Images from Early India.* Cleveland, OH: Cleveland Museum of Art and Indiana University Press, 1985.

Dehejia, Vidya. "Aniconism and the Multivalence of Emblems." *Ars Orientalis* 21 (1991); 45–66.

———. *Discourse in Early Buddhist Art: Visual Narratives of India.* New Delhi: Munshiram Manoharlal, 1997.

———. *Indian Art.* London: Phaidon, 1997.

Dehejia, Vidya, et al. *Unseen Presence: The Buddha and Sanchi.* Mumbai: Marg Publications, 1996.

Dutt, Sukumar. *Buddhist Monks and Monasteries of India.* London: George Allen and Unwin Ltd., 1962.

Fontein, Jan. "A Buddhist Altarpiece from South India." *Bulletin of the Museum of Fine Arts, Boston* 78 (1981): 4–21.

Goyal, S. R., and Shankar Goyal, eds. *Indian Art of the Gupta Age: From Pre-classical Roots to the Emergence of Medieval Trends.* Jodhpur: Kusumanjali Book World, 2000.

Hallade, Madeleine. *The Gandhara Style and the Evolution of Buddhist Art.* London: Thames and Hudson, 1968.

Harle, J. C. *The Art and Architecture of the Indian Subcontinent.* Middlesex: Penguin Books, 1986.

Huntington, John C. "Cave Six at Aurangabad: A Tantrayana Monument?" In *Kaladarsana: American Studies in the Art of India.* Edited by Joanna G. Williams, 45–55. Leiden: Brill Academic Publishers, 1981.

Huntington, John C. "A Gandharan Image of Amitayus' Sukhavati." *Annali dell'Istituto Orientale di Napoli* 30 (1980): 651–72.

Huntington, Susan L. "Aniconism and the Multivalence of Emblems: Another Look." *Ars Orientalis* 22 (1992): 111–56.

———. *The Art of Ancient India: Buddhist, Hindu, Jain.* With John C. Huntington. New York: Weatherhill, 1985.

Huntington, Susan L., and John C. Huntington. *Leaves of the Bodhi Tree: The Art of Pala India.* Dayton, OH: Dayton Art Institute, 1990.

Irwin, John. *The Sanchi Torso.* London: Victoria and Albert Museum, 1972.

Kinnard, Jacob N. *Imaging Wisdom: Seeing and Knowing in the Art of Indian Buddhism.* Richmond, England: Curzon, 1999.

———. "Reevaluation the Eighth–Ninth Century Pala Milieu: Icono-Conservatism and the Persistence of Shakyamuni." *Journal of the International Association of Buddhist Studies* 19, no. 2 (1996): 281–300.

Knox, Robert. *Amaravati: Buddhist Sculpture from the Great Stupa.* London: British Museum, 1992.

Lancaster, Lewis. "An Early Mahayana Sermon About the Body of the Buddha and the Making of Images." *Artibus Asiae* (1974): 287–91.

Leoshko, Janice, ed. *Bodhgaya:Tthe Site of Enlightenment.* Bombay: Marg Publications, 1989.

Leoshko, Janice. "Scenes of the Buddha's Life in Pala-Period Art." *Silk Road Art and Archaeology* 3 (1994): 251–76.

Lohuizen-de Leeuw, J. E. van. "New Evidence with Regard to the Origin of the Buddha Image." In *South Asian Archaeology 1979.* Edited by H. Hartel, 377–400. Berlin: Dietrich Reimer Verlag, 1981.

Malandra, Geri Hockfield. "Mara's Army: Text and Image in Early India Art." *East and West* 31 (1981): 121–30.

———. *Unfolding a Mandala: The Buddhist Cave Temple at Ellora.* Albany, NY: State University of New York Press, 1993.

Maxwell, T. S. *The Gods of Asia: Image, Text and Meaning.* Delhi: Oxford University Press, 1997.

Myer, Prudence R. "Bodhisattvas and Buddhas: Early Buddhist Images from Mathura." *Artibus Asiae* 47 (1986): 107–42.

Okada Amina. *Ajanta*. Paris: Imprimerie nationale, 1991.

Narain, A. K., ed. *Studies in Buddhist Art of South Asia*. New Delhi: Kanak Publication, 1985.

Pratapaditya, Pal, ed. *A Pot-pourri of Indian Art*. Bombay, Marg Publications, 1987.

Quagliotto, A. M. "Another Look at the Mohamed Nari Stele with the So-called Miracle of Sravasti. *Annali del Istituto Universitario Orientale Napoli* 56 (1996): 274–89.

Regnier, Rita. *L'arbre et le lotus: L'art bouddhique en Inde a Sanchi et a Bharhut*. Paris: Editions Findakly, 1998.

Ju-Hyung Rhi. "From Bodhisattva to Buddha: The Beginning of Iconic Representation in Buddhist Art." *Artibus Asiae* 54, no. 3/4 (1994): 207–225.

———. *Gandharan Images of the "Sravasti Miracle": An Iconographic Reassessment*. Ph.D. diss., University of California, Berkeley, 1991.

Rosenfield, John. *The Dynastic Arts of the Kushans*. Berkeley: University of California Press, 1967.

Schlingloff, Dieter. *Guide to the Ajanta Paintings*. New Delhi: Munshiram Manoharlal, 1999.

———. *Studies in the Ajanta Paintings*. Delhi: Ajanta Publications, 1988.

Schroeder, Ulrich von. *Buddhist Sculpture of Sri Lanka*. Hong Kong: Visual Dharma Publications, 1990.

Schroeder, Ulrich von, and Amina Okada. *Bronzes Bouddhiques et Hindous de l'antique Ceylan: Chefs-d'oeuvre des musées du Sri Lanka*. Paris: Musée National des Arts Asiatiques Guimet, 1991.

Sharma, R. C. *Buddhist Art: Mathura School*. New Delhi: Wiley Eastern Limited, New Age International, 1995.

———. *Buddhist Art of Mathura*. Delhi: Agam Kala Prakashan, 1984.

Shimada, Akira. " The Great Railing at Amaravati: An Architectural and Archaeological Reconstruction." *Artibus Asiae* 66, no. 1 (2006): 89–143.

Spink, Walter. "Ajanta: A Brief History." In *Aspects of Indian Art*. Edited by Pal Pratapaditya, Leiden: Brill Academic Publishers, 1972.

———. "Ajanta Chronology: Cave 1's Patronage and Related Problems." *Cchavi* 2 (1981): 102–8.

———. "Ajanta's Chronology: The Crucial Cave." *Ars Orientalis* 10 (1975): 143–69.

———. "The Splendours of Indra's Crown: A Study of Mahayana Developments at Ajanta." *Journal of the Royal Society for the Encouragement of Arts, Manufactures and Commerce* (1974): 743–67.

Srinivasan, Doris Meth, ed. *Mathura: The Cultural Heritage*. New Delhi: Manohar Publications, 1989.

Stone, Elizabeth Rosen. *The Buddhist Art of Nagarjunakonda*. Delhi: Motilal Banarsidass, 1994.

Tiwari, Usha Rani. *Sculptures of Mathura and Sarnath: A Comparative Study up to the Gupta Period*. Delhi: Sundeep Prakashan, 1998.

Verardi, Giovanni. "Avatarana: A Note on the Bodhisattva Image Dated in the Third Year of Kanishka in the Sarnath Museum." *East and West* 35 (September 1985): 67–101.

Williams, Joanna. "On Viewing Sanchi." *Archives of Asian Art* 50 (1997–1998): 93–96.

———. "Sarnath Gupta Steles of the Buddha's Life." *Ars Orientalis* 10 (1975): 171–92.

———. *The Art of Gupta India: Empire and Province*. Princeton, NJ: Princeton University Press, 1982.

Willis, Michael. *Buddhist Reliquaries from Ancient India*. With Joe Cribb and Julia Shaw. London: British Museum, 2000.

Woodward, Hiram. "The Life of the Buddha in a Pala Monastic Environment." *The Journal of the Walters Art Gallery* 48 (1990): 13–27.

Zwalf, W. *A Catalogue of the Gandhara Sculpture in the British Museum.* 2 vols. London: British Museum, 1996.

SOUTHEAST ASIA

Boisselier, Jean. *The Heritage of Thai Sculpture.* New York: Weatherhill, 1975.

———. *Thai Painting.* Tokyo: Kodansha, 1976.

Bowie, Theodore, M. C. Subhadradis Diskul, and A. B. Griswold. *The Sculpture of Thailand.* New York: Asia Society, 1972.

Brereton, Bonnie Pacala. *Thai Tellings of Phra Malai: Texts and Rituals Concerning a Popular Buddhist Saint.* Tempe, AZ: Arizona State University, 1995.

Brown, Robert L. "God on Earth: The Walking Buddha in the Art of South and Southeast Asia." *Artibus Asiae* 50 (1990): 73–107.

Brown, Robert L., ed. *Art from Thailand.* Mumbai: Marg Publications, 1999.

Chutiwongs, Nandana, and Denise Patry Leidy. *Buddha of the Future: An Early Maitreya from Thailand.* New York: Asia Society Galleries, 1994.

Diskul, M. C. Subhadradis, ed. *The Art of Srivijiya.* Paris: Unesco, 1980.

Diskul, M. C. Subhadradis. *Art in Thailand: A Brief History,* 2nd ed. Bangkok: Silpakorn University, 1971.

Dumarcay, Jacques, and Pascal Royère. *Cambodian Architecture: Eighth to the Thirteenth Centuries.* Translated by Michael Smithies. Leiden: Brill Academic Publishers, 2001.

Dumarcay, Jacques, and Michael Smithies. *Cultural Sites of Burma, Thailand, and Cambodia.* New York: Oxford University Press, 1995.

Fontein, Jan. *The Pilgrimage of Sudhana: A Study of Gandavyuha Illustrations in China, Japan, and Java.* The Hague: Mouton, 1966.

Fontein, Jan. *The Sculpture of Indonesia.* With essays by R. Soekmono and Edi Sedyawati. Washington, DC: National Gallery of Art, 1990.

Gerard-Geslan, Maud, et al. *Arts of Southeast Asia.* Translated by J. A. Underwood. New York: Harry N. Abrams, Inc., 1998.

Ginsburg, Henry. *Thai Manuscript Painting.* Honolulu: University of Hawaii Press, 1989.

Gomez, Luis, and Hiram W. Woodward, Jr., eds. *Barabudur: History and Significance of a Buddhist Monument.* Berkeley, CA: University of California, 1981.

Gosling, Betty. *Sukothai: Its History, Culture, and Art.* Singapore: Oxford University Press, 1991.

Green, Lexandra, and T. Richard Blurton, eds. *Burma: Art and Archaeology.* London: British Museum, 2002.

Guillon, Emmanuel. *Cham Art: Treasures from the Da Nang Museum, Vietnam.* Translated by Tom White. London: Thames and Hudson, 2001.

Herbert, Patricia M. *The Life of the Buddha.* London: The British Library, 1993.

Jacq-Hergoualc'h, Michel. *The Malay Peninsula: Crossroads of the Maritime Silk Road (100 B.C.–1300 A.D.).* Translated by Victoria Hobson. Leiden: Brill Academic Publishers, 2002.

Jessup, Helen Ibbitson, and Thierry Zephir, eds. *Sculpture of Angkor and Ancient Cambodia: Millennium of Glory*. Washington, DC: National Gallery of Art, 1997.

Klokke, Marijke H. "Borobudur, A Mandala: A Contextual Approach to Function and Meaning." *International Institute for Asian Studies Yearbook* (1995): 191–219.

Krairiksh, Piriya. *The Sacred Image: Sculpture from Thailand*. Cologne: Museum fur Ostasiatische Kunst, 1979.

Lagirarde, Francois. "Gavampati et la tradition des quatres-vingts disciple du Buddha: texts et iconographie du Laos et de Thailande." *Bulletin de l'École Francaise d'Extrême-Orient* 87/1 (2000): 57–78.

Lunsingh-Scheurleer, Pauline, and Marijke J. Klokke. *Divine Bronze: Ancient Indonesian Bronze from A.D. 600 to 1600*. Leiden: Brill Academic Publishers, 1998.

McGill, Forest, ed. *The Kingdom of Siam: The Art of Central Thailand, 1350–1800*. Belgium: Snoeck Publishers, 2005.

Mus, Paul. *Barabudur: Esquisse d'une histoire du bouddhisme foundée sure la critique archéologiques des texts*. Hanoi: Imprimerie d'Extrême-Orient, 1935.

Nou, Jean-Louis, and Louis Frederic. *Borobudur*. Paris: Imprimerie Nationale Editions, 1994.

Nguyen, Trian. "Laksmindralokesvara, Main Deity of the Dong Duong Monastery: A Masterpiece of Cham Art and a New Interpretation." *Artibus Asiae* 65, no. 1 (2005): 5–38.

Prematilleke, L. "The Identity and Significance of the Standing Figure at the Gal-Vihara, Polonnaruva, Ceylon." *Artibus Asiae* 28 (1966): 61–66.

Stadtner, Donald, ed. *The Art of Burma: New Studies*. Mumbai: Marg Publications, 1999.

Stratton, Carol, and Miriam McNair Scott. *The Art of Sukothai: Thailand's Golden Age: From the Mid-Thirteenth to the Mid-Fifteenth Century*. Kuala Lumpar: Oxford University Press, 1981.

Woodward, Hiram W., Jr. *The Art and Architecture of Thailand: From Prehistoric Times through the Thirteenth Century*. Leiden: Brill Academic Publishers, 2003.

Woodward, Hiram W., Jr., and Donna K. Strahan. *The Sacred Sculpture of Thailand: The Alexander B. Griswold Collection, the Walters Art Gallery*. Seattle: University of Washington Press, 1997.

Ideas (Buddhism)

Introductions

Armstrong, Karen. *Buddha*. New York: Viking, 2001.

Buswell, Robert E., Jr., ed. *Encyclopedia of Buddhism*. New York: Macmillan, 2004.

Gethin, Rupert. *The Foundations of Buddhism*. Oxford: Oxford University Press, 1998.

Grey, Leslie. *A Concordance of Buddhist Birth Stories*. Oxford: The Pali Text Society, 1990.

Keown, Damien, et al. *Dictionary of Buddhism*. Oxford: Oxford University Press, 2003.

Lopez, Donald S., Jr. *The Story of Buddhism: A Concise Guide to Its History and Teachings*. San Francisco: Harper Collins, 2001.

Matsunaga, Daigan, and Alicia Matsunaga. *Foundations of Japanese Buddhism*. 2 vols. Los Angeles: Buddhist Books International, 1974.

Reynolds, Frank E., and Jason A. Carbine. *The Life of Buddhism*. Berkeley, CA: University of California Press, 2000.

Robinson, Richard H., Willard L. Johnson, et al. *The Buddhist Religion: A Historical Introduction*, 4th ed. Belmont, CA: Wadsworth Publishing Group, 1996.

Skilton, Andrew. *A Concise History of Buddhism*. New York: Barnes and Nobles Books, 1994.

Snellgrove, David L. *Indo-Tibetan Buddhism: Indian Buddhists and Their Tibetan Successors*. Boston: Shambhala, 1987.

Strong, John S. *The Experience of Buddhism: Sources and Interpretations*, 2nd ed. Belmont, CA: Wadsworth Publishing Group, 2002.

Thurman, Robert A. F. *Essential Tibetan Buddhism*. San Francisco: Harper, 1995.

Trainor, Kevin, ed. *Buddhism: The Illustrated Guide*. Oxford: Oxford University Press, 2001.

Wayman, Alex. *The Buddhist Tantras: Light on Indo-Tibetan Esotericism*. Delhi: Motilal Barnasidas, 1973.

Yoshinori, Takeuchi, et al. *Buddhist Spirituality*. 2 vols. New York: Crossroads, 1997.

Specialized Studies

Abe Ryūichi. *The Weaving of Mantra: Kūkai and the Construction of Esoteric Buddhist Discourse*. New York: Columbia University Press, 1999.

Baroni, Helen Josephine. *Obaku Zen: The Emergence of a Third Sect of Zen in Tokugawa Japan*. Honolulu: University of Hawaii Press, 2000.

Bechert, Heinz. "Notes on the Formation of Buddhist Sects and the Origins of the Mahayana." In *German Scholars on India, Contributions to India Studies*. Edited by Cultural Department of the Embassy of The Federal Republic of Germany. New Delhi: Varanasi, 1973.

———. *When Did the Buddha Live?: The Controversy on the Dating of the Historical Buddha*. Delhi: Sri Satguru Publications, 1995.

Brook, Timothy. *Praying for Power: Buddhism and the Formation of Gentry Society in Late Ming China*. Cambridge, MA: Harvard University Press, 1993.

Buswell, Robert E., Jr., and Robert M. Gimello, eds. *Path to Liberation: The Marga and Its Transformation in Buddhist Thought*. Honolulu: University of Hawaii Press, 1992.

Chun-fang Yu. *Kuan-yin: The Chinese Transformation of Avalokitesvara*. New York: Columbia University Press, 2001.

———. *The Renewal of Buddhism in China: Chu-hung and the Late Ming Synthesis*. New York: Columbia University Press, 1981.

Collcut, Martin. *Five Mountains: The Rinzai Zen Monastic Institution in Medieval Japan*. Cambridge, MA: Harvard University Press, 1981.

Collins, Steven. *Nirvana and Other Buddhist Felicities*. Cambridge, MA: Cambridge University Press, 1998.

Crosby, Kate. "Tantric Theravada: A Bibliographic Essay on the Writings of Francois Bizot and Others on the Yogavacara Tradition." *Contemporary Buddhism* 1 (2000): 141–98.

Davidson, Ronald M. *Indian Esoteric Buddhism: A Social History of the Tantric Movement*. New York: Columbia University Press, 2002.

Faure, Bernard. *Chan Buddhism in Ritual Context*. London: Routledge/Curzon, 2003.

————. *Vision of Power: Imagining Medieval Japanese Buddhism.* Translated by Phyllis Brook. Princeton, NJ: Princeton University Press, 1996.

Granoff, Phyllis, and Koichi Shinohara, eds. *Images in Asian Religions: Texts and Contexts.* Vancouver: University of British Columbia Press, 2004.

Gregory, Peter N., and Daniel A. Getz, Jr., eds. *Buddhism in the Song.* Honolulu: University of Hawaii Press, 1999.

Groner, Paul. *Saichō: The Establishment of the Japanese Tendai School.* Berkeley, CA: University of California Institute of Buddhist Studies, 1984.

Harris, Ian. *Cambodian Buddhism: History and Practice.* Honolulu: University of Hawaii Press, 2005.

Harrison, Paul. "Is the *Dharma-kaya* the Real 'Phantom Body' of the Buddha?" *Journal of the International Association of Buddhist Studies* 15 (1992): 44–94.

————. "Searching for the Origins of the Mahayana: What Are We Looking For?" *The Eastern Buddhist* 28 (1995): 48–69.

————. "Who Gets to Ride the Great Vehicle? Self-Image and Identity Among the Followers of Early Mahayana." *Journal of the International Association of Buddhist Studies* 10 (1987): 67–89.

Horton, Sarah, "The Influence of the *Ōjōyōshū* in Late Tenth- and Early Eleventh-Century Japan" *Japanese Journal of Religious Studies* 31 (2004): 29–54.

Kapstein, Mathew T. *The Tibetan Assimilation of Buddhism: Conversion, Contestation, and Memory.* London: Oxford University Press, 2000.

Kitagawa. Joseph M. *Religion in Japanese History.* New York: Columbia University Press, 1990.

Lancaster, Lewis, ed. *Prajnaparamita and Related Systems.* Berkeley, CA: University of California, 1977.

Lopez, Donald. *Prisoner of Shangri-la: Tibetan Buddhism and the West.* Chicago: University of Chicago Press, 1998.

Mallmann, Marie-Thérèse de. *Introduction a l'étude d'Avaloktecvara.* Paris: Civilisations du Sud, 1948.

McRae, John R. *The Northern School and the Formation of Early Ch'an Buddhism.* Honolulu: University of Hawaii Press, 1986.

————. *Seeing though Zen: Encounter, Transformation, and Genealogy in Chinese Chan Buddhism.* Berkeley, CA: University of California Press, 2003.

Orzech, Charles D. "Seeing Chen-yen Buddhism: Traditional Scholarship and the Vajrayana in China." *History of Religions* 29 (1989): 86–114.

Sasaki Shizuka. "A Study on the Origin of Mahayana Buddhism." *The Eastern Buddhist* (1997): 79–113.

Schober, Juliane, ed. *Sacred Biography in the Buddhist Traditions of South and Southeast Asia.* Honolulu: University of Hawaii Press, 1997.

Schopen, Gregory. *Bones, Stones, and Buddhist Monks: Collected Papers on the Archaeology, Epigraphy, and Texts of Monastic Buddhism in India.* Honolulu: University of Hawaii Press, 1997.

Schopen, Gregory. *Buddhist Monks and Business Matters: Still More Papers on Monastic Buddhism in India.* Honolulu: University of Hawaii Press, 2004.

Sengupta, Sudha. *Buddhism in the Classical Age (c. 400–750).* Delhi: Sundeep Prakashan, 1985.

Sharf, Robert H. "The Idolization of Enlightenment: On the Mummification of Ch'an Masters in Medieval China." *History of Religions* 32 (August 1992): 1–31.

Silk, Jonathan A. "What, if Anything Is Mahayana Buddhism?" *Numen* 49 (2002): 355–405.

Strickmann, Michel. *Mantras et mandarins: Le bouddhisme tantrique en Chine.* Paris: Editions Gallimard, 1996.

Trainor, Kevin. *Relics, Ritual, and Representation in Buddhism: Rematerializing the Sri Lankan Theravada Tradition.* Cambridge, MA: Cambridge University Press, 1997.

Yamasaki Taikō. *Shingon: Japanese Esoteric Buddhism.* Translated by Richard Peterson and Cynthia Peterson. Boston: Shambhala, 1988.

Yampolsky, Philip B., trans. *The Zen Master Hakuin: Selected Writing.* New York: Columbia University Press, 1971.

Yoshida Kazuhiko. "Revisioning Religion in Ancient Japan." *Japanese Journal of Religious Studies* 30 (2003): 1–26.

———. "The Thesis that Prince Shōtoku Did Not Exist." *Acta Asiatica* 91 (2006): 1–20.

Yūsen Kashiwahara and Kōyū Sonoda. *Shapers of Japanese Buddhism.* Translated by Gaynor Sekimori. Tokyo: Kosei Publishing, 1994.

CREDITS

1.1. A column. Bihar, Lauriya Nandangarh, India, Mauryan period, third century B.C.E. Sandstone; H. about 39 feet (12 meters). © Borromeo/Art Resource, N.Y.

1.2. A capital from a column. Sarnath, Uttar Pradesh, India, Mauryan period, mid-third century B.C.E. Sandstone; H. 84 in. (213.5 cm.). Archaeological Museum, Sarnath. © Borromeo/Art Resource, N.Y.

1.3. The plan and elevation of the Bharhut stupa. Madhya Pradesh, India, Shunga period, second century B.C.E.

1.4. Yaksha Kubera and Yakshi Chanda. Detail from the east gate, Bharhut Stupa, Madhya Pradesh, India, Shunga period, second century B.C.E. Indian Museum, Calcutta.

1.5. Siddartha's Great Departure from his home and family. Detail from a railing pillar, Bharhut Stupa, Madhya Pradesh, India, Shunga period, second century B.C.E. Sandstone; H. 54 in. (137.2 cm.). The Norton Simon Foundation F. 1972.55.2.

1.6. A reconstruction of the Sanchi complex. Madhya Pradesh, India, Shunga period, first century B.C.E. to first century C.E. After Volwahsen, Andreas. *Living architecture: Indian.* Translated by Ann E. Keep. New York: Grosset and Dunlap, 1969, p. 91.

1.7. Stupa 1 (Great Stupa). Sanchi, Madhya Pradesh, India, Shunga period, first century B.C.E. to first century C.E.

1.8. Siddhartha's life as the elephant Chaddanta (*Chaddanta jataka*). Detail from a crossbar, south gate, Stupa 1, Sanchi, Madhya Pradesh, India, Shunga period, first century B.C.E. to first century C.E. Sandstone. American Institute of Indian Studies.

1.9. Shakyamuni's Great Departure from his home and family. Detail from a crossbar, east gate, Stupa 1, Sanchi, Madhya Pradesh, India, Shunga period, first century B.C.E. to first century C.E. Sandstone. American Institute of Indian Studies.

1.10. Siddhartha's defeat of Mara's army (Buddha Maravijaya). Detail from a crossbar, north gate, Stupa 1, Sanchi, Madhya Pradesh, India, Shunga period, first century B.C.E. to first century C.E. Sandstone. American Institute of Indian Studies.

1.11. Siddhartha's conversion of the Kashyapa brothers. Detail from a railing pillar, east gate, Stupa 1, Sanchi, Madhya Pradesh, India, Shunga period, first century B.C.E. to first century C.E. Sandstone.

1.12. A seated buddha and attendants. Detail from a crossbar, gate to an unidentified stupa, Mathura area, Uttar Pradesh, India, first century B.C.E. Sandstone. Mathura Museum (M.3). American Institute of Indian Studies.

1.13. Scenes from the life of Shakyamuni. Casing, Amaravati Stupa, Andhra Pradesh, India, Satavahana period, second century C.E. Limestone; 62 x 37 in. (157.5 x 94 cm.). British Museum, Elliot Collection (OA 1880.7-9.44). © HIP/Art Resource, N.Y.

1.14. A reconstruction of Amaravati Stupa. Andhra Pradesh, India, Satavahana period, second century C.E. Trustees of the British Museum.

1.15. Buddha Shakyamuni and scenes from his life. Casing, Amaravati Stupa, Andhra Pradesh, India, Satavahana period, second to third century. Limestone; 48¾ x 34 in. (122.9 x 86.4 cm.). British Museum, Mackenzie Collection (OA 1880.79). © Eric Lessing/Art Resource, N.Y.

1.16. Buddha Shakyamuni. Amaravati region, Andhra Pradesh, India, Satavahana period, late second to third century. Limestone; H. 76 in. (193.4 cm.). Amaravati Site Museum. The John C. and Susan L. Huntington Archive.

2.1. Bodhisattva/Buddha Shakyamuni. Katra, Uttar Pradesh, India, Kushan period, ca. 130. Sandstone; H. 9½ ft. (289.5 cm.). Mathura Museum No. L.55.25. The John C. and Susan L. Huntington Archive.

2.2. Bodhisattva/Buddha Shakyamuni. Mathura region, Uttar Pradesh, India, Kushan period, second century. Sandstone; H. 27¼ in. (69 cm.). Sarnath Site Museum, No. B (b)1. American Committee on South Asian Art.

2.3. Bodhisattva Maitreya. Ahichattra, Uttar Pradesh, India, Kushan period, second century. Schist; H. 26⅝ in. (67.5 cm.). National Museum, New Delhi (59.530/1). The John C. and Susan L. Huntington Archive.

2.4. Worship of a stupa. Stupa casing, site unknown, Pakistan, Kushan period, second century. Schist; 10⅞ x 10⅞ in. (2.8 x 27.8 cm.). Berlin, Museum fur Indische Kunst. © Bildarchiv Presussischer Kulturbesitz/Art Resource, N.Y.

2.5. The birth of Siddhartha/Shakyamuni. Stupa casing, Loriyan Tangai, Pakistan, Kushan period, second to third century. Schist; 19 x 13¾ in. (48 x 34.9 cm.). Indian Museum Calcutta (5054/A23277). After Deborah Klimburg Salter, *Buddha in Indien,* Vienna, Kunsthistorisches Museum, 1995, fig. 157.

2.6. Siddhartha/Shakyamuni preaching the First Sermon. Stupa casing, Loriyan Tangai, Pakistan, Kushan period, second to third century. Schist; 15⅛ x 27 inc. (38.5 x 68.5 cm.). Indian Museum Calcutta (2054/ A23277). The John C. and Susan L Huntington Archive.

2.7. The *parinirvana* of Siddhartha/Shakyamuni. Stupa casing, site unknown, Pakistan, Kushan period, second to third century. Schist; 26 x 26 in. (66 x 66 cm.). Lent by Florence and Herbert Irving (L. 1993.69.4). The Metropolitan Museum of Art. Image © The Metropolitan Museum of Art.

2.8. A buddha, presumably Shakyamuni. Takht-i-Bahi, Pakistan, third century. Schist; H. 36¼ in. (92 cm.). Purchase from General C.S. MacLean (OA 1899.7-15.1). The British Museum. © HIP/Art Resource, N.Y.

2.9. A view of Takht-i-Bahi complex. Pakistan. Kurt Behrendt.

2.10. A bodhisattva, possibly Shakyamuni. Shahbaz Garhi, Pakistan, third to fourth century. Schist; H. 47¼ in. (120 cm.). Musée National des Arts Asiatiques Guimet (AO 2907). © Réunion des Musées Nationaux/Art Resource, N.Y.

2.11. Siddhartha as an ascetic. Sikri, Pakistan, third to fourth century. Schist; H. 33⅛ in. (84 cm.). Lahore Museum. © Scala/Art Resource, N.Y.

2.12. A Buddha field, or pure land (*buddhakshetra*). Mohamed Nari, Pakistan, fourth century. Schist; H. 48⅛ in. (117 cm.). National Museum, New Delhi No. L. 55.75. © Borromeo/Art Resource, N.Y.

2.13. A buddha, possibly Shakyamuni. Uttar Pradesh, India, Gupta period, ca. 435. Sandstone; H. 33¾ in. (85.5 cm.). Purchase, Enid A Haupt Gift, 1979 (1979.6). The Metropolitan Museum of Art. Image © The Metropolitan Museum of Art.

2.14. A buddha, possibly Shakyamuni. Sarnath, Uttar Pradesh, India, Gupta period, ca. 465–485. Sandstone; H. 63 in. (160 cm.). Sarnath Museum, No. 340. akg-images/Jean Louis Nou.

2.15. Scenes from the life of Siddhartha/Shakyamuni. Sarnath region, Uttar Pradesh, India, Gupta period, late fifth century. Sandstone; H. 41½ in. (105.5 cm.). Indian Museum, Calcutta. The John C. and Susan L. Huntington Archive.

2.16. Bodhisattva Avalokiteshvara. Sarnath region, Uttar Pradesh, India, Gupta period, late fifth century. Sandstone; H. 46⅞ in. (119 cm.). Indian Museum Calcutta (S37/A 25802). The John C. and Susan L. Huntington Archive.

2.17. A buddha. Sultanganj, Bihar, India, seventh century. Bronze; H. 88⅝ in. (225 cm.). Birmingham Museum and Art Gallery, N.N. 849-96 and 856.96 (N.M.).

3.1. The cave temple complex at Ajanta. Maharashtra Province, India, late fifth century. Kurt Behrendt.

3.2. The interior of Cave 19 at Ajanta. Maharashtra Province, India, late fifth century. Kurt Behrendt.

3.3. Plan of Cave 1 at Ajanta. Maharasthra Province, India, late fifth century.

3.4. Siddhartha's life as King Janaka (*Mahajanaka jataka*). Detail from a painting on side wall, Cave 1, Ajanta, Maharashtra Province, India, late fifth century. Benoy Behl.

3.5. Bodhisattva Avalokiteshvara as Padmapani. Detail from a painting on the back wall, Cave 1, Ajanta, Maharashtra Province, India, late fifth century. Benoy Behl.

3.6. Bodhisattva Avalokiteshvara as the "savior from perils." Detail from the right wall, Cave 90, Kanheri, Maharashtra Province, India, sixth century. American Committee for South Asian Art.

3.7. A mandala. Detail from the left wall, Cave 90, Kanheri, Maharashtra Province, India, sixth century. American Committee for South Asian Art.

3.8. The cave temple complex at Bamiyan, Afghanistan, sixth to early seventh century.

3.9. A buddha. Bamiyan, Afghanistan, sixth to early seventh century. Sandstone; H. 180½ ft. (55 m). American Committee for South Asian Art.

3.10. The cave temple complex at Kizil. Kucha, Xinjiang Uighur Autonomous Region.

3.11. Bodhisattva Maitreya with attendants. Detail from a painting over the doorway, Cave 224, Kizil Kucha area, Xinjiang Uighur Autonomous Region, fifth to sixth century. 41 x 102¾ in. (104 x 261 cm.). Berlin, Museum fur Indische Kunst (MIK III 8836). © Bildarchiv Preussischer Kulturbesitz/Art Resource, N.Y.

3.12. Buddha Vairocana. Detail from a painting on a side wall, Cave 13, Kizil, Kucha area, Xinjiang Uighur Autonomous Region, fifth to sixth century. 61 ½ x 33⅞ in. (156 x 86 cm.). Berlin, Museum fur Indische Kunst (MIK III 8868). © Bildarchiv Preussischer Kulturbesitz/Art Resource, N.Y.

3.13. A buddha and other figures. Mount Kongwang, Jiangsu Province, China, Eastern Han Dynasty, second to third century. Nancy Schatzman Steinhardt.

3.14. Buddha. Shijiazhuang, Hebei Province, China, Sixteen Kingdoms period, third to fourth century. Gilt bronze; H. 8⅜ in. (21.4 cm.). Hebei Provincial Museum. Nancy Schatzman Steinhardt.

3.15. The cave temple complex at Mogao. Dunhuang, Gansu Province, China, Northern Wei period, late fifth century.

3.16. The interior of Cave 254 at Mogao. Dunhuang, Gansu Province, China, Northern Wei period, late fifth century.

3.17. Siddhartha's life as King Sibi (*Sibi jataka*). A painting on the north wall of Cave 254 at Mogao. Dunhuang, Gansu Province, China, Northern Wei period, late fifth century. After Li Yongning, et. al. Ben sheng yin yuan gu shi hua juan, Hong Kong, Commercial Press, 2000, pl. 16.

3.18. Buddha. Cave 20, Yungang, Shanxi Province, China, Northern Wei period, ca. 460–470. Sandstone; H. 45 ft. (13.7 m.).

3.19. A view of the northeast corner of the antechamber of Cave 10. Yungang, Shanxi Province, China, Northern Wei period, ca. 483.

4.1. The cave temple complex at Longmen. Henan Province, China.

4.2. A buddha with attendants. The back wall of Cave 140 (Middle Binyang Cave). Longmen, Henan Province, China, Northern Wei period, ca. 523. Limestone; Height of Buddha 21⅛ ft. (645 cm.). © Werner Forman/Art Resource, N.Y.

4.3. Buddha Maitreya (Mile). Hebei Province, China, Northern Wei period, dated 524. Gilt Bronze; H. 30¼ in. 76.8 cm.). Rogers Fund, 1938 (38.158.1a-n). The Metropolitan Museum of Art. Image © The Metropolitan Museum of Art.

4.4. Buddhas Shakyamuni (Shijiamouni) and Prabhutaratna (Duobao) with attendants. Chengdu, Sichuan Province, China, Liang dynasty, dated 545. Sandstone; H. 16⅞ in. (43 cm.). Chengdu Institute of Archaeology. Hu Chui.

4.5. A stele commissioned by Zhang Dangui and others. China, Northern Qi period, dated 557. Limestone; H. 42½ in. (108 cm.). Henan Provincial Museum.

4.6. A bodhisattva in the pensive pose. China, Northern Qi period, ca. 550–560. Marble; H. 13 in. (33 cm.). The Freer Gallery of Art, Smithsonian Institution, Washington, D.C. Gift of Charles Lang Freer (11.411)

4.7. Buddha Amitabha (Amitou). Zhaozhou, Hebei Province, China, Sui dynasty, dated 593. Bronze; H. 30⅛ in. (76.5 cm.). Gift of Mrs. W. Scott Fitz (22. 407); Gift of Edward Jackson Homes in Memory of his Mother, Mrs. W. Scott Fitz (47.1407–1412). Museum of Fine Arts, Boston. Photograph © Museum of Fine Arts, Boston.

4.8. Buddha Vairocana (Dari or Piluzhena). Detail of a painting on the south wall of Cave 428, Mogao complex, Dunhuang, Gansu Province, China, Northern Zhou period, 557–581.

4.9. Buddha Vairocana (Dari or Piluzhena) and attendant bodhisattvas. Cave 1280 (Fengxian-si), Longmen, Henan Province, China, Tang dynasty, ca. 675. Limestone; Height of Buddha 56¼ ft. (17.14 m.).

4.10. The guardian Vaishravana (Pishamen) and an entry guardian. Cave 1280 (Fengxian-si), Longmen, Henan Province, China, Tang dynasty, ca. 672–675. Limestone

4.11. A buddha. Cave 21, Tianlongshan, Shanxi Province, China, Tang dynasty, ca. 700. Sandstone; H. 42½ in. (108 cm.). Grenville L. Winthrop Bequest (1943.53.22). Harvard University Art Museums. Photo: Imaging Department © President and Fellows of Harvard College.

4.12. Bodhisattva Avalokiteshvara with a horse's head (Matou Guanyin). Forest of Steles, Xi'an, Shaanxi Province, China, Tang dynasty, mid-eighth century. Marble with Pigment; H. 35⅛ in. (89 cm.).

4.13. A set of four reliquaries. Famen-si, Fufeng, Shaanxi Province, China, Tang dynasty, eighth to ninth century. Jade, crystal, gilt bronze and bronze; H. 1⅚–6½ in. (4.8–16.6 cm.). After Wei, Han, and Christian Deydier. *Ancient Chinese Gold*. Paris: Les Editions d'Art et d'Histoire, 2001, fig. 609.

5.1. A buddha with attendant bodhisattvas. Korea, Baekje period, late sixth to seventh century. Gilt bronze; Height of Buddha 11½ in. (29.1 cm.). Hōryū-ji treasure number 143, Tokyo National Museum. Reprinted with permission from Hōryū-ji. *The Dawn of Japanese Buddhist Art*. Japan: Nara National Museum, 2004, cat. no. 12.

5.2. A pensive bodhisattva, probably Maitreya (Mireuk). Korea, Silla period, early seventh century. Gilt bronze; H. 36¾ in. (93.5 cm.). National Treasure No. 83, National Museum of Korea, Seoul. Han Seok-Hong, Han's Photo Studio, Seoul.

5.3. Elevation of Seogkuram. North Kyongsang Province, Korea, United Silla period, second half of the eighth century. After McCune, Evelyn. *The Arts of Korea*, North Clarendon, V.T.: Tuttle, 1961, fig. 80.

5.4. Bodhisattva Avalokiteshvara (Gwaneum) with eleven heads. Back wall, Seokguram, Korea, North Kyongsang Province, United Silla period, second half of the eighth century. Granite; H. about 7 ft. (220 cm.). National Treasure. Han Seok-Hong, Han's Photo Studio, Seoul.

5.5. The buddha inside Seokguram. North Kyongsang Province, Korea, United Silla period, second half of the eighth century. Granite; H. 10½ ft. (326 cm.). Han Seok-Hong, Han's Photo Studio, Seoul.

5.6. Buddha Bhaishajyaguru (Yaksa). Korea, United Silla period, ninth century. Gilt bronze; H. 14⅛ in. (36 cm.). Gift of Edward J. Homes in Memory of his Mother, Mrs. W. Scott Fitz (32.436). Museum of Fine Arts, Boston. Photograph © 2008 Museum of Fine Arts, Boston.

5.7. View. Hōryū-ji Temple. Nara, Japan, Asuka period, seventh century.

5.8. The five-storied pagoda at Hōryū-ji Temple. Nara, Japan, Asuka period, seventh century. Miyeko Murase.

5.9. The main hall (*kondō*) at Hōryū-ji Temple. Nara, Japan, Asuka period, seventh century. Miyeko Murase.

5.10. Buddha Shakyamuni and attendant bodhisattvas attributed to Torii Bushi. Interior of the main hall at Hōryū-ji Temple, Nara, Japan, Asuka period, dated 623. Gilt bronze; H. 46 in. (116.8 cm.). Asukaen.

5.11. Tamamushi shrine. Hōryū-ji treasure house, Nara, Japan, Asuka period, ca. 650. Cypress and camphor wood with lacquer and metalwork; H. 7 feet (213.4 cm.). Reprinted with permission from Hōryū-ji. *The Dawn of Japanese Buddhist Art*. Japan: Nara National Museum, 2004, cat. no. 35.

5.12. Siddhartha as a bodhisattva feeding a hungry tigress (*Mahasattva*, or *Vyaghri Jataka*). Detail of the Tamamushi shrine, Hōryū-ji treasure house, Nara, Japan, Asuka period, ca. 650. Reprinted with permission from Hōryū-ji. *The Dawn of Japanese Buddhist Art*. Japan: Nara National Museum, 2004, cat. no. 35.

5.13. A bodhisattva, possibly Maitreya (Miroku), in the pensive pose. Chūgū-ji, Japan, Asuka period, seventh century. Camphor wood; H. 52 in. (132.1 cm.). Asukaen.

5.14. Detail from the *Sutra of the Kings of Golden Light*. Japan, Nara period, eighth century. One of a set of 10 handscrolls; gold powder on paper dyed purple; 10⅓ in. x 27½ ft. (26.4 x 841 cm.). National Treasure, Nara National Museum.

5.15. Buddha Bhaishajyaguru (Yakushi) with attendant bodhisattvas. Main hall, Yakushi-ji Temple, Nara, Japan, Nara period, late seventh or early eighth century. Japan. Bronze; Height of Buddha 8 ft. 7 in. (254.7 cm.). © Scala/Art Resource, N.Y.

5.16. Buddha Vairochana (Dainichi or Roshana). Tōshōdai-ji, Nara, Japan, Nara period, second half of the eighth century. Dry lacquer with gold leaf; H. 10 ft. (3.4 m). Asukaen.

5.17. Jianzhen (Ganjin). Tōshōdai-ji, Nara, Japan, Nara period, mid-eighth century. Dry lacquer with pigment; H. 31¾ in. (30.6 cm.). Asukaen.

5.18. The main hall at Tōshōdai-ji Temple. Nara, Japan, Nara period, ca. 759. The John C. and Susan L. Huntington Archive.

5.19. The main hall at Mūro-ji Temple. Japan, early Heian period, early ninth century.

5.20. Buddha Shakyamuni (Shaka). Mūro-ji Temple, Japan, early Heian period, second half of the ninth century. Cypress wood with traces of gofun and pigment; H. 41 in. (104.1 cm.). Benrido.

5.21. Womb World Mandala, or Garbhadhatu (Taizōkai). Kyōōgokoku-ji (Tō-ji), Kyoto, Japan, early Heian period, second half of the ninth century. Hanging scroll, color on silk; 72⅛ x 60⅝ in. (183 x 154 cm.). Benrido.

5.22. Diamond World Mandala, or Vajradhatu (Kongōkai). Kyōōgokoku-ji (Tō-ji), Kyoto, Japan, early Heian period, second half of the ninth century. Hanging Scroll, color on silk; 72⅛ x 50⅝ in. (183 x 154 cm.). Benrido.

6.1. Torso of Bodhisattva Avalokiteshvara. Madhya Pradesh, India, ca. 900. This sculpture was once part of a triad containing a seated Buddha and another standing bodhisattva. Sandstone; H. 34 in. (86.4 cm.). Inv. No. IM 184–1910, Victoria and Albert Museum. Victoria and Albert Museum.

6.2. A reconstruction showing the original location of the torso of Bodhisattva Avalokiteshvara, probably along the back wall of Temple 45 at the Sanchi complex in Madhya Pradesh, India. After Irwin, John. *The Sanchi Torso*. London: Victoria and Albert Museum, 1972.

6.3. Goddess Chundi. Sirapur, Madhya Pradesh, India, ca. eighth century. Metal with silver and copper inlay; H. 15 in. (38 cm.). From the Nasli and Heeramaneck Collection, Museum Associates Purchase (M.84.32.1a-d). Los Angeles County Museum of Art. Photograph © 2006 Museum Associates/ LACMA.

6.4. Mahabodhi Temple. Bodh Gaya, Bihar Province, India. Kurt Behrendt.

6.5. Buddha Akshobhya with Bodhisattvas Avalokiteshvara and Maitreya. Bangladesh or West Bengal, India, Pala period, eleventh century. Limestone; H. 39½ in. (100.3 cm.). The Nasli and Alice Heeramaneck Collection, gift of Paul Mellon (68.8.15). Virginia Museum of Fine Arts.

6.6. Buddha Shakyamuni with eight great events. Bihar Province, India, Pala period, twelfth century. Phyllite; H. 29¾ in. (75.5 cm.). Helen and Alice Coburn Fund (24.153) Museum of Fine Arts, Boston. Photograph © 2008 Museum of Fine Arts, Boston.

6.7. Bodhisattva Manjushri as Manjuvajra with his consort. Bangladesh or West Bengal, India, Pala period, eleventh to twelfth century. Mudstone; H. 2⅞ in. (7.3 cm.). Edwin R. and Harriet Pelton Perkins Memorial Fund (87.44). The Cleveland Museum of Art.

6.8. Four leaves from a dispersed *Perfection of Wisdom* manuscript. Nalanda Monastery, Bihar Province, India, Pala period, dated 1073. Ink and opaque watercolor on palm leaf; each page approximately 2⅞ x 22⅜ in. (7.3 x 56.8 cm.). Mr. and Mrs. John D. Rockefeller 3rd Acquisition Fund (1987.1). Asia Society, New York. Susumu Wakisaka, Idemitsu Museum of Art, Tokyo.

6.9. Goddess Kurukulla. Detail from a page from a dispersed *Perfection of Wisdom* manuscript. Bangladesh or West Bengal, India, Pala period, early twelfth century. Ink and opaque watercolor on palm leaf; each ¾ x 16½ in. (1 x 41.5 cm.). Purchase, Lila Acheson Wallace Gift (2001.445i). The Metropolitan Museum of Art. Photograph © 2002 The Metropolitan Museum of Art.

6.10. A buddha, presumably Shakyamuni. Nagapattinam, Tamil Nadu Province, India, Chola period, ca. ninth century. Gilt bronze with silver inlay; H. 39 in. (99 cm.). Marshall H. Gould and Keith McLeod Fund (1970.3 and 67.4). Museum of Fine Arts, Boston. Photograph © 2008 Museum of Fine Arts, Boston.

6.11. A buddha, presumably Shakyamuni. Nagapattinam, Tamil Nadu Province, India, Chola period, ca. 1070–1120. Gilt bronze; H. 27¼ in. (69.2 cm.). The Mr. and Mrs. John D. Rockefeller 3rd Collection (1979.15). Asia Society, New York. Susumu Wakisaka, Idemitsu Museum of Arts, Tokyo.

6.12. A buddha, presumably Shakyamuni. Sri Lanka, late Anuradhapura period, ca. 750–850. Gilt bronze with traces of pigment; H. 26 in. (66 cm.). Archaeological Museum, Anuradhapura, Sri Lanka. akg-images/Jean Louis Nou.

6.13. Bodhisattva Avalokiteshvara. Sri Lanka, late Anuradhapura period, ca. 750–850. Gilt bronze with rock crystal eyes; H. 19⅝ in. (49.8 cm.). National Museum, Columbo. akg-images/Jean Louis Nou.

6.14. A view of Gal Vihara. Pollonnaruva, Sri Lanka, Pollonnaruva period, 1153–1186. American Committee for South Asian Art.

6.15. A buddha. Gal Vihara, Pollonnaruva, Sri Lanka, Pollonnaruva period, 1153–1186. Granite; H. 15½ feet. The John C. and Susan L.Huntington Archive.

7.1. Bodhisattva Avalokiteshvara. Nepal, Transitional period, late tenth to early eleventh century. Gilt copper with inlays of semi-precious stones; H. 26¾ in. (67.9 cm.). The Mr. and Mrs. John D. Rockefeller 3rd Collection (1979.47). Asia Society, New York. Susumu Wakisaka, Idemitsu Museum of Arts, Tokyo.

7.2. Mandala of Paramasukha-Chakrasamvara, and Vajravarahi. Nepal, Transitional period, ca. 1100. Mineral pigment on cloth; 26⅞ x 19⅞ in. (68.2 x 50.5 cm.). Rogers Fund, 1995 (1995.233). The Metropolitan Museum of Art. Photograph © 1997 The Metropolitan Museum of Art.

7.3. Buddha Shakyamuni as an ascetic with attendants. Kashmir region, India, eighth century. Ivory; 4⅞ x 3¾ in. (12.4 x 9.5 cm.). Leonard C. Hanna Jr. Fund (1986.70). The Cleveland Museum of Art.

7.4. Crowned Buddha Shakyamuni or Vairocana. Kashmir region, India, or Gilgit region, Pakistan, early eighth century. Brass with inlays of copper, silver and zinc; H. 12¼ in. (31.1 cm.). The Mr. and Mrs. John D. Rockefeller 3rd Collection (1979.44). Asia Society, New York. Susumu Wakisaka, Idemitsu Museum of Arts, Tokyo.

7.5. A bodhisattva. Western regions, Tibet, 1000–1050. Brass with copper and silver; H. 27¼ in. (69.2 cm.). the Mr. and Mrs. John D. Rockefeller 3rd Collection (1979.45). Asia Society, New York. Lynton Gardiner.

7.6. Alchi Monastery at Ladakh. Kashmir region, India, tenth to thirteenth century. C. Luczanits (HUAV).

7.7. Bodhisattva Manjushri. Right wall of the Sumstek, Alchi Monastery, Ladakh, Kashmir region, India, ca. 1100. Clay with pigment; H. about 13 feet (about 4 meters). Jaroslav Ponccar.

7.8. The Diamond World Mandala (Vajradhatu). Second upper story of the Sumstek, Alchi Monastery, Ladakh, Kashmir region, India, ca. 1100. Jaroslav Ponccar.

7.9. The goddess Tara in her green manifestation. Tibet or India, late eleventh to twelfth century. Mineral pigment on cloth; 48¼ x 31½ in. (122.6 x 79.4 cm.). The John and Berthe Ford Collection. Photograph © 1998 The Metropolitan Museum of Art.

8.1. A reliquary decorated with buddhas and attendants. Myanmar (Burma), fifth to sixth century. Silver; H. 26⅛ in. (66.4 cm.). National Museum, Yangan. Alain Mahuzier.

8.2. A view of the temples at Pagan. Myanmar (Burma), Pagan period, eleventh to thirteenth century. © Giraudon/Art Resource, N.Y.

8.3. Buddha Shakyamuni. Pagan, Myanmar (Burma), Pagan period, ca. 1100. Bronze; H. 13⅜ in. (34 cm.). Brooke Sewell Fund (1971.7-27.1). The British Museum. British Museum/Art Resource, N.Y.

8.4. Bodhisattva Avalokiteshvara. Thailand, possibly Banban culture, late sixth to seventh century. Sand-stone; H. 17¼ in. (45.1 cm.). Purchase, Lila Acheson Wallace Gift, 1987 (1987.218.16). The Metropolitan Museum of Art. Image © The Metropolitan Museum of Art.

8.5. A buddha, presumably Shakyamuni. Thailand, Mon style, ninth century. Bronze; 22½ x 8¼ in. (57.2 x 21 cm.). The Norton Simon Foundation F. 1973.12.S.

8.6. A goddess, possibly Lakshmindralokeshvara. Dong Duong, Vietnam, Champa style, ca. 875–910. Bronze with inlaid jade and stones; H. 47¼ in. (120 cm.). Cham Museum (Inv. No. BTDN 535). After *Trésors d'art du Vietnam: la sculpture du Champa*, ve-xve siècles. Paris: Réunion des Musées Nationaux, 2005, fig. 8.

8.7. A reconstructed plan of the Dong Duong complex. Vietnam, ca. 875–910.

8.8. Bodhisattva Maitreya. Prakhon Chai, Buriram Province, Thailand, Pre-Angkor period, eighth century. Copper alloy with inlays of silver and black stone; H. 38 in. (96.5 cm.). The Mr. and Mrs. John D. Rockefeller 3rd Collection (1973.63) Asia Society, New York. Lynton Gardiner.

8.9. A plan of Bayon Temple. Cambodia, Angkor period, late twelfth to early thirteenth century.

8.10. Towers at Bayon Temple. Cambodia, Angkor period, late twelfth to early thirteenth century. © Vanni/Art Resource, N.Y.

8.11. Bodhisattva Avalokiteshvara as Lokeshvara. Bayon, Cambodia, Ankgor period, late twelfth to early thirteenth century. Sandstone; H. 44½ in. (113cm.). Musée National des Arts Asiatiques Guimet (MG 18139). © Réunion des Musées Nationaux/Art Resource, N.Y.

8.12. Hevajra. Cambodia, Angkor period, late twelfth to early thirteenth century. Bronze; H. 12 in. (30.7 cm.). Museum fur Indische Kunst, Berlin (Inv. 11 138). © Bildarchiv Preussischer Kulturbesitz/Art Resource, N.Y.

8.13. Bodhisattva Avalokiteshvara. Thailand, Srivijaya style, eighth to ninth century. Bronze; H. 27⅝ in. (70 cm.). National Museum Bangkok. American Committee South Asian Art.

8.14. A Buddhist goddess. Sumatra, Indonesia, Srivijaya style, early ninth century. Bronze: H. 6¼ in. (15.9 cm.). The Mr. and Mrs. John D. Rockefeller 3rd Collection (1979.84). Asia Society, New York. Lynton Gardiner.

8.15. Borobudur. Central Java, Indonesia, early ninth century. © Borromeo/Art Resource, N.Y.

8.16. A side view of Borobudur. Central Java, Indonesia, ninth century. American Committee South Asian Art.

8.17. Sudhana visits Bodhisattva Manjushri. Detail from the third terrace, Borobudur, central Java, Indonesia, early ninth century. The John C. and Susan L. Huntington Archive.

8.18. Buddha Amitabha. Borobudur, central Java, Indonesia, early ninth century. Andesite; H. 41¾ in. (106 cm.). National Museum Jakarta, Inv. #226. The John C. and Susan L. Huntington Archive.

8.19. Four deities from a Diamond World Mandala (Vajradhatu). Nganjuk, east Java, Indonesia, Kadiri period, late tenth to early eleventh century. Bronze; each approximately 3¼ in. (8.3 cm.) high. The Mr. and Mrs. John D. Rockefeller 3rd Collection (1989.87.1-4). Asia Society, New York. Lynton Gardiner.

8.20. Goddess Prajnaparamita. Candi Singasari, Malang, east Java, Indonesia, Singasari period, thirteenth century. Andesite; H. 49½ in. (126 cm.). National Museum of Jakarta, Inv. No. 1403/XI 1587. Dirk Bakker.

9.1. Bodhisattva Manjushri (Wenshu) with five knots of hair. China, Liao dynasty, tenth to eleventh century. Gilt bronze; H. 6¾ in. (17.1 cm.). Bequest of Mr. Laurence Sickman F-37/75. The Nelson Atkins Museum. Photograph by Jamison Miller.

9.2. Bodhisattva Avalokiteshvara (Guanyin). China, Jin dynasty, ca. 1200. Wood with pigment; H. 45 in. (114. 2cm.). Victoria and Albert Museum (A.7-1935).

9.3. Mandala of Avalokiteshvara as Amoghapasha (Amojia Guanyin). Dunhuang, Gansu Province, China, Five Dynasties period, tenth century. Hanging scroll, ink and pigment on silk; 45¼ x 25⅝ in. (115 x 65 cm.). Musée National des Arts Asiatiques Guimet (EO 3579). © Réunion des Musées Nationaux/ Art Resource, N.Y.

9.4. Bodhisattva Avalokiteshvara. Yunnan Province, China, Dali kingdom, twelfth century. Gilt bronze; H. 19¾ in. (50.2 cm.). Gift of Abby Aldrich Rockefeller, 1942 (42.25.28). The Metropolitan Museum of Art. Image © The Metropolitan Museum of Art.

9.5. Detail from a relief illustrating the Ten Oxherding Songs. Mount Baoding, Sichuan Province, China, Southern Song dynasty, twelfth century. Sandstone; Average height of figures 4½ ft. (1.4 m). After Chubanshe, Chongqing, *Dazu Shiku Diaosu Quanji*, vol. 3, 1999, pl. 33.

9.6. An arhat manifesting himself as the eleven-headed Avalokiteshvara (Guanyin). China, Southern Song dynasty, ca. 1178. Artist: Zhou Jichang. Hanging scroll mounted as panel, ink and color on silk; 43⅞ x 20⅞ in. (111.5 x 53.1 cm.). Denman Waldo Ross Collection 06.289. Museum of Fine Arts, Boston. Photograph © 2008 Museum of Fine Arts, Boston.

9.7. Yama, the fifth king of hell. China, Southern Song dynasty, late twelfth century. Artist: Jin Chushi. Hanging scroll, ink and color on silk; 44 x 18 ¾ in. (111.8 x 47.6 cm.). Rogers Fund, 1929 (30.76.293). The Metropolitan Museum of Art. Image © The Metropolitan Museum of Art.

9.8. The Sixth Patriarch cutting bamboo. China, Southern Song period, thirteenth century. Artist: Liang Kai. Hanging Scroll, ink on paper; 28⅝ x 12⅜ in. (72.7 x 31.5 cm.). Tokyo National Museum. TNM Image Archive.

9.9. A set of paintings showing a crane, Bodhisattva Avalokiteshvara, and monkeys. China, Southern Song dynasty, late thirteenth century. Artist: Fachang Muqi. Triptych of three hanging scrolls, ink on silk; H. 70 in. (177.8 cm.). Daitoku-ji, Kyoto, Japan.

9.10. A portrait of Chan Master Zhongfang Mingben (1263–1323). China, Yuan dynasty, ca. 1318–1323. Hanging scroll, ink and colors on silk; 49¼ x 20⅜ in. (125.2 x 51.9 cm.). Important Cultural Property. Senbutsu-ji, Kyoto. Photograph: Kyoto National Museum.

10.1. The water-moon form of Bodhisattva Avalokiteshvara (Suwol Gwaneum). Korea, Goryeo period, early fourteenth century. Hanging scroll, ink and color on silk; 44¾ x 21¾ in. (113.7 x 55.3 cm.). Charles Stewart Smith Collection (14.76.6). Metropolitan Museum of Art. Photograph © 1997 The Metropolitan Museum of Art.

10.2. Bodhisattva Kshitigarbha (Jijang). Korea, Goryeo period, fourteenth century. Hanging scroll, ink, color and gold on silk; 43 x 22½ in. (109 x 57.2 cm.). Museum fur Ostasiatische Kunst, Berlin. © Bildarchiv Preussischer Kulturbesitz/Art Resource, N.Y.

10.3. Phoenix Hall (Byōdō-in). Kyoto Prefecture, Uji, Japan, Heian period, eleventh century.

10.4. Buddha Amitabha (Amida). Byōdō-in, Uji, Japan, Heian period, ca. 1053. Artist: Jōchō. Cypress wood with lacquered cloth and gold leaf; H. 9ft. 2 in. (279 cm.). © Art Resource, N.Y.

10.5. Bodhisattva Avalokiteshvara with a horse's head (Batō Kannon). Kyoto, Japan, Heian period, twelfth century. Hanging scroll, ink color on silk; 65 x 32¼ in. (165 x 83 cm.). Fenollosa-Weld Collection (11.4035). Museum of Fine Arts, Boston. Photograph © 2008 Museum of Fine Arts, Boston.

10.6. The monk Asanga (Muchaku). Kōfuku-ji, Nara, Japan, Kamakura period, 1212. Artist: Unkei. Wood with paint and inlaid eyes; H. 74 in. (187.9 cm.).

10.7. The monk Vasubandu (Seishin). Kōfuku-ji, Nara, Japan, Kamakura period, 1212. Artist: Unkei. Wood with paint and inlaid eyes; H. 74 in. (188 cm.). Asukaen.

10.8. Achala (Fudo Myōō). Japan, Kamakura period, early thirteenth century. Artist: Circle of Kaikei. Cypress with lacquer, color, gold and kirikane and inlaid crystal eyes; H. 20¼ in. (51.5 cm.). Mary Griggs Burke Collection. Photograph © 2000 The Metropolitan Museum of Art.

10.9. The hell of Dissections. Detail from the *Jigoku zōshi* (*Hell Scroll*), Japan, Kamakura period, late twelfth century. Hanging scroll, ink and color on paper; 10¼ x 35½ in. (26.1 x 90.3 cm.). Setsu Iwao, Kanagawa Prefecture. Miho Museum.

10.10. Detail from a scroll illustrating the life of Hōnen. Japan, Kamakura period, early fourteenth century. Fragment from the Hōnen Shōnin eden mounted as a hanging scroll, ink and color on paper; 16⅛ x 23¼ in. (41 x 59 cm.). Gift of Mrs. Russell Sage, by exchange, and funds from various donors, 1980 (1980.221). The Metropolitan Museum of Art. Photograph © 1987 The Metropolitan Museum of Art.

10.11. The pure land of Buddha Amitabha (Amida), or Taima Mandala. Japan, Kamakura period, fourteenth century. Hanging scroll, ink, color and gold on silk; 55⅛ x 53⅛ in. (140 x 134.8 cm.). The Severance and Greta Millikin Purchase Fund 1990.82. The Cleveland Museum of Art.

10.12. The descent of Buddha Amitabha (Amida Raigō). Chion-in, Kyoto, Japan, Kamakura period, early thirteenth century. Hanging scroll, gold and color on silk; H. 57 in. (144.7 cm.). Photo: Kyoto National Museum

10.13. Mandala of the Kasuga Shrine. Japan, Kamakura period, early fourteenth century. Hanging scroll, ink and color on silk; 31 x 11 in. (78.7 x 27.9 cm.). Sylvan Barnett and Bill Burto Collection.

10.14. Bodhisattva Kshitigarbha (Jizō). Japan, Kamakura period, 1223–1226. Cypress wood with gold leaf and pigment; H. 22¾ in. (57.8 cm.). The Mr. and Mrs. John D. Rockefeller 3rd Collection (1979.202). Asia Society, New York. Susumu Wakisaka, Idemitsu Museum of Arts, Tokyo.

10.15. *The Four Sleepers*. Japan, Kamakura period, early fourteenth century. Artist: Moku'an Reien. Hanging scroll, ink on paper; 28¾ x 12⅝ in. (73 x 32.2 cm.). Tokyo National Museum. Important Cultural Property. Maeda Ikutoku Foundation.

10.16. *Orchids and Rocks*. Japan, Muromachi period, mid-fourteenth to early fifteenth century. Artist: Gyokuen Bonpō. Hanging scroll, ink on paper, 39½ x 13⅛ in. (100.3 x 33.3 cm.). The Harry G. Packard Collection of Asian Art, Gift of Harry G.C. Packard, and Purchase, Fletcher, Rogers, Harris Brisbane Dick, and Louis V. Bell Funds, and Joseph Pulitzer Bequest, and the Annenberg Fund Inc. Gift, 1975 (1975.268.38). Photograph © The Metropolitan Museum of Art.

10.17. *Haboku Landscape*. Japan, Muromachi period, 1495. Artist: Sesshū Tōyō. Hanging scroll, ink on paper; 58¾ x 13 in. (149 x 33 cm.). Tokyo National Museum. TNM Image Archive.

10.18. A view of a dry landscape garden (*karesansui*). Ryōan-ji, Myoshin-ji, Kyoto, Japan, Muromachi period, late fifteenth century.

11.1. A bodhisattva, possibly Avalokiteshvara. Nepal, thirteenth century. Gilt copper inlaid with semiprecious stones; H. 19 in. (48.3 cm.). The Mr. and Mrs. John D. Rockefeller 3rd Collection (1979.49). Asia Society, New York. Lynton Gardiner.

11.2. Buddha Amoghasiddhi. Central regions, Tibet, first half of the thirteenth century. Mineral pigment on cloth; 15½ x 12¼ in. (39.5 x 31 cm.). Stella Kramrisch Collection (1994.148.69). The Philadelphia Museum of Art.

11.3. A thirteen-deity Jnanadakini mandala. Central regions, Tibet, ca. 1375. Mineral pigment on cloth; 33¼ x 28⅞ in. (84.5 x 73.3 cm.). Lita Annenberg Hazen Charitable Trust Gift (1987.16). The Metropolitan Museum of Art. Photograph © 1997 The Metropolitan Museum of Art.

11.4. A bodhisattva. China, Yuan dynasty, mid-fourteenth century. Dry lacquer; H. 22^{15}/$_{16}$ in. (58.3 cm.). Freer Gallery of Art, Smithsonian Institution, Washington, D.C, Purchase (F1945.4).

11.5. The Mandala of Yamantaka (*Yemandejia*) with imperial portraits. China, Yuan dynasty, ca. 1330–1332. Silk tapestry (kesi); 96^5/$_8$ x 82^1/$_4$ in. (245.4 x 208.9 cm.). Purchase, Lila Acheson Wallace Gift, 1992 (1992.54). The Metropolitan Museum of Art. Photograph © 1995 The Metropolitan Museum of Art.

11.6. Buddha Akshobhya. China, Ming dynasty, Yongle period, 1403–1424. Gilt bronze; H. 23^1/$_4$ in. (59 cm.). British Museum (1908.4-10.4). © HIP/Art Resource, N.Y.

11.7. The Great Stupa at Palcho Monastery, Gyanste. Tibet, ca. 1427–1440. © Erich Lessing/Art Resource, N.Y.

11.8. Bodhisattva Avalokiteshvara as Lokeshvara. Chapel S3, Palcho Monastery, Gyantse, Tibet, ca. 1427–1440. After Ricca, Franco and Eberto Lo Bue. *The Great Stupa of Gyantse.* London: Serindia Publications, 2003, p. 126.

11.9. An arhat (*luohan*). China, Ming dynasty, Yongle period, 1403–1424. Hanging scroll mounted as a framed painting, ink and color on silk; 30 x 19^1/$_2$ in. (78 x 50 cm.). Robert Rosenkranz Collection. Roger Asselberghs.

11.10. An arhat. Central regions, Tibet, mid- to late-fifteenth century. Mineral pigment and gold on cloth; 39 x 22^1/$_2$ in. (99.0 x 57.1 cm.). Rubin Museum of Art (C2003.50.3/HAR 129).

11.11. A ritual ax, mace, and chopper. Tibet, mid- to late fifteenth century. Iron inlaid with gold and silver. John L. Severance Fund (1978.1-3). The Cleveland Museum of Art.

12.1. Padmasambhava. Tibet, late sixteenth to seventeenth century. Gilt bronze; H. 12^5/$_8$ in. (32.1 cm.). Berti Aschmann Foundation. Rietberg Museum, Zurich.

12.2. The monk Mawai Senge. Central regions, Tibet, sixteenth century. Mineral pigment on cloth; 48 x 26 in. (121.9 x 66.4 cm.). Rubin Museum of Art (F1996.26.1/ HAR 493).

12.3. Adepts Shavaripa and Dharikapa. Eastern region, Tibet, ca. 1600. Mineral pigment on cloth; 25^1/$_4$ x 15 in. (65.5 x 38.1 cm.). Walters Museum of Art, Baltimore, the Berthe and John Ford Collection (F.110).

12.4. Ngawang Lobsang Gyatso, the Great Fifth Dalai Lama. Central regions, Tibet, late seventeenth century. Gilt bronze; H. 7^1/$_8$ in. (20 cm.). Photograph courtesy of Rose Art Museum, Brandeis University, Waltham, Mass., Gift of N. and L. Horch to the Riverside Museum Collection.

12.5. The Potala Palace. Lhasa, Tibet, first constructed 1645. © Eric Lessing/Art Resource, N.Y.

12.6. Kalachakra Mandala. Central regions, Tibet, seventeenth century. Mineral pigment on cloth; 47^3/$_8$ x 30^7/$_8$ in. (120.4 x 78.4 cm.). Frederick L. Jack Fund 58.691. Museum of Fine Arts, Boston. Photograph © 2008 Museum of Fine Arts, Boston.

12.7. Schematic, Mandala of Kalachakra. After Leidy, Denise Patry and Robert A. F. Thurman. *Mandala: The Sacred Architecture of Enlightenment.* New York: The Asia Society Galleries, 1997, p. 149.

12.8. King of Shambhala. Eastern regions, Tibet, eighteenth century. Mineral pigment on cloth; 17 x 13^3/$_4$ in. (43 x 35 cm.). Denman Waldo Ross Collection (06.234). Museum of Fine Arts, Boston. Photograph @ 2008 Museum of Fine Arts, Boston.

12.9. Yama Dharmaraja. Central regions, Tibet, mid-seventeenth century. Mineral pigment on cloth; 27 x 18 in. (68.6 x 45.7 cm.). The Zimmerman Family Collection.

12.10. Protector Mahakala. Central regions, Tibet, eighteenth century. Min-eral pigment and gold with black background on cloth; 26 x 18 in. (66 x 45.7 cm.). Collection of the Rubin Museum of Art (F 1996.32/HAR 544).

12.11. Sinpoi Tsomo Jigje Mar, or the "red zombie-riding protectress." Tibet, mid-nineteenth century. Mineral pigment on cloth; 33 x 23¼ in. (83.8 x 60.3 cm.). Collection of Shelley and Don Rubin (HAR 193). www.himalayanart.org.

13.1. Buddha Shakyamuni. Kandy, Sri Lanka, ca. fourteenth century. Bronze; H. 19½ in. (49.5 cm.). Royal Scottish Museum, Edinburgh (395.9). © Trustees of the National Museum of Scotland.

13.2. Buddha Shakyamuni. Sri Lanka, eighteenth century. Silver and gilt silver; H. 12⅝ in. (32 cm.). British Museum (OA1905.6-16.86&89). © HIP/Art Resource, N.Y.

13.3. Buddha Shakyamuni with attendants. Myanmar (Burma), fourteenth to fifteenth century. Gilt copper; H. 16 in. (40.6 cm.). The Mr. and Mrs. John D. Rockefeller 3rd Collection (1979.91). Asia Society, New York. Lynton Gardiner.

13.4. Siddhartha's Great Departure. Detail from a manuscript, Myanmar (Burma), nineteenth century. Paper book with written text and pigment; 19 ⅕ x 7½ in. (49 x 17 cm.). The British Library (OR.14927).

13.5. Buddha Shakyamuni. Thailand, Lan Na style, fifteenth to sixteenth century. Bronze with partial gilding; H. 14¾ in. (36.5 cm.). National Museum, Bangkok. Alain Mahuzier.

13.6. Buddha Shakyamuni. Thailand, Sukothai period, fourteenth to fifteenth century. Bronze with inlaid mother-of-pearl; H. 65⅜ in. (166 cm.). National Museum Bangkok, on loan from Wat Benchamabopitr. After Girard-Geslan, Madu et. al. *Art of Southeast Asia*. New York: Narry N. Abrams, Inc., 1998, fig. 60.

13.7. A plan of Wat Phra Si Sanphet. Ayudhya, Thailand, founded fifteenth century.

13.8. A view showing three stupas (*chedi*) at Wat Phra Si Sanphet. Ayudhya, Thailand, founded fifteenth century. © David Murcko, Garage Photography.

13.9. Phra Sankachai. Thailand, late seventeenth to early eighteenth century. Bronze with traces of gilt and inlaid shell and garnet eyes; H. 14½ in. (36.8 cm.). Purchase, Gifts of friends of Jim Thompson, in his memory, 2001 (2001.27). The Metropolitan Museum of Art. Image © The Metropolitan Museum of Art.

13.10. Phra Malai visiting hell. Detail from a larger manuscript, Thailand, dated 1844. Pigment on paper; 5⅛ x 27 in. (13.6 x 68.5 cm.). The Museum General Acquisition Fund (1993.10). Asian Art Museum of San Francisco. (Used by permission.)

14.1. The Buddha Hall in Zhihua Monastery. Beijing, Hebei Province, China, Ming dynasty, fifteenth century.

14.2. Gods of the twenty-eight lunar mansions. China, Ming dynasty, Jingtai period, dated 1454. Hanging scroll, ink, colors and gold on silk; 55½ x 31¼ in. (141 x 79.5 cm.). Musée National des Arts Asiatiques Guimet (EO 668).

14.3. The monk Budai as Bodhisattva Maitreya (Mile). China, Ming dynasty, dated 1504. Hanging scroll, ink and color on silk; 66⅞ x 38½ in. (169.8 x 97.8 cm.). Chinese and Japanese Special Fund (12.883). Museum of Fine Arts, Boston. Photograph © 2008 Museum of Fine Arts, Boston.

14.4. Buddha Shakyamuni (Shijiamouni) in a landscape. China, Ming dynasty, first half of seventeenth century. Hanging scroll, ink and color on silk; 50⅞ x 24¼ in. (129 x 62.2 cm.). Purchase from the J.H. Wade, Fund (1971-68). Cleveland Museum of Art.

14.5. *Mynah Birds, Old Tree, and Rock*. China, Qing dynasty, seventeenth century. Artist: Bada Shanren (Zhu Da). Pair of hanging scrolls, ink on satin; each 80½ x 21¼ in. (204.6 x 54 cm.). The Nelson Atkins Museum 67-4/1-2. Photograph by Jamison Miller.

14.6. Bodhisattva Maitreya. Mongolia or China, seventeenth century. Artist: Attributed to Zanabazar. Gilt bronze with cold painted pigments; H. 24½ in. Gift of John Welsh, 1963.5. Harvard University Art Museums. Imaging Department © President and Fellows of Harvard University.

14.7. The Diamond Throne Pagoda at Biyun Monastery. Beijing, Hebei Province, China, Qing dynasty, Qianlong period, founded ca. 1748.

14.8. Bodhisattva Samantabhadra (Puxian). China, Qing dynasty, Qianlong period, ca. 1779–1780. Hanging scroll, color on cotton; 54½ x 27¾ in. (138.5 x 70.5 cm.). Asian Art Museum, San Francisco (B72.D67). (Used by permission.)

15.1. An arhat (*nahan*). Korea, Joseon period, dated 1562. Hanging scroll, ink and colors on silk; 17½ x 11⅕ in. (44.5 x 28.4 cm.). The Los Angeles County Museum of Art (84.112). Photograph © 2006 Museum Associates LACMA.

15.2. A Nectar Ritual painting. Korea, Joseon period, dated 1759. Hanging banner, color on silk; 89¾ x 71⅝ in. (228 x 182 cm.). Leeum Samsung Museum of Art.

15.3. *Reading a Sutra Under the Moonlight.* Japan, Edo period, seventeenth century. Artist: Sokuhi Nyoichi. Hanging scroll, ink on paper; 10¾ x 24 in. (27.4 x 60 cm.). The Harry G.C. Packard Collection of Asian Art, Gift of Harry G.C. Packard and Purchase, Fletcher, Rogers, Harris Brisbane Dick and Louis V. Bells Funds, Joseph Pulitzer Bequest and the Annenberg Fund, Inc Gift, 1975 (1975.268.79). The Metropolitan Museum of Art. Image © The Metropolitan Museum of Art.

15.4. An arhat (*rakan*). One of set of five hundred from Gohyaku Rakan-ji, Japan, Edo period, 1688–1695. Artist: Shoun Genkei. Wood with lacquer; H. 32 2/4 in. (85.7 cm.). Seattle Art Museum (35.7).

15.5. "Thousand faces of the bodhisattva" (*Sennen bosatu*), Enku, Japan, Edo period, 17th century. Wood; H. 16⅝ x 29⅝ in. (42.3 x 74.5 cm). Reprinted from Tanahashi, Kazuaki, *Enku,* Boston: Shambhala Publications, 1982, fig. 74.

15.6. Hakuin Ekaku (1685–1769). Self-portrait. Japan, Edo period, 1764. Eisai Bunko Museum, Tokyo. Artist: Hakuin Ekaku. Hanging scroll, ink on silk; 40⅛ x 11¼ in. (101.9 x 28.6 cm.). Eisai Bunko Museum, Tokyo.

15.7. *Circle, Triangle, Square.* Japan, Edo period, eighteenth century. Artist: Sengai Gibon. Hanging scroll, ink on paper; 11⅛ x 19 in. (28.3 x 48.2 cm.). Idemitsu Museum of Art.

15.8. A monk's shawl (*kesa*). Japan, Meiji period, nineteenth century. Silk with gold paper; 46⅞ x 80⅛ in. (119 x 204 cm.). Musée des Tissus de Lyon (n. 32540).

INDEX

Page numbers for artwork are in boldface type.
Abbreviations: C. = Chinese, J. = Japanese, K. = Korean